Serial
Killers

Serial Killers

Death
and
Life
in
America's
Wound Culture

MARK SELTZER

ROUTLEDGE
New York and London

Published in 1998 by
Routledge
29 West 35th Street
New York, NY 10001

Published in Great Britain in 1998 by
Routledge
11 New Fetter Lane
London EC4P 4EE

Printed in the United States of America on acid-free paper
Design and composition: Jack Donner

Library of Congress Cataloging-in-Publication Data

Seltzer, Mark.
 Serial killers: death and life in America's wound culture / Mark Seltzer.
 p. cm.
 Includes bibliographical references and index.
 ISBN 0–415–91480–9 (cloth). — ISBN 0–415–91481–7 (paper)
 1. Serial murderers—United States. 2. Homicide in popular culture.
 3. Violence in popular culture—United States. I. Title.
 HV6529.S45 1998
 364.15'23'0973—dc21 97–26176
 CIP

For my son, John

Contents

Acknowledgments

I want to thank my students at Cornell, and the numerous audiences at other places, who allowed me to try out pieces of the book. Many friends and colleagues contributed, directly and indirectly, to this work — too many to list. These debts are registered in the pages that follow. Here I want to set out a few that are not.

Naomi Schor instigated this book, by suggesting to me that I might write up something about the matters of violence, sex, and addiction we were discussing one evening in North Carolina. That conversation, with many detours, led to this book.

Hal Foster's critical generosity was indispensable in sustaining this work; a good friend through some testing times.

Sandy Tait's wonderfully articulate sense of contemporary visual and popular culture was crucial to me at many points in writing this book; so too her vivid friendship.

Shirley Samuels, once more, read and reread these chapters with a discerning and thoroughgoing intelligence; once more, my gratitude. The book is for our wild, sweet boy John.

Earlier versions of several pieces of the book were published in the journals *Critical Inquiry*, *differences*, and *October* and in the electronic magazine *Feed*. I thank the editors for permission to reuse them here. Richard Misrach generously made available the image on the cover; I am grateful to him and to his inspiring work. Bill Germano was, once again, the best of editors.

Serial Killing for Beginners

She loved accidents: any mention of an animal run over, a man cut to
pieces by a train, was bound to make her rush to the spot.
— Émile Zola, *La Bête humaine* (1890)

Hence the new millenium's passion for standing live witness to things. A
whole sub-rosa schedule of public spectation opportunities, "spect-ops,"
the priceless chance to be part of a live crowd, watching. Thus the
Gapers' Blocks at traffic accidents, sewer-gas explosions, muggings . . .
people leaving their front doors agape in their rush to get out and mill
around and spectate at the circle of impacted waste drawing sober and
studious crowds, milling in rings around the impact.
— David Foster Wallace, *Infinite Jest* (1996)

Serial killing has its place in a public culture in which addic-
tive violence has become not merely a collective spectacle but one of the
crucial sites where private desire and public fantasy cross. The convening
of the public around scenes of violence — the rushing to the scene of the
accident, the milling around the point of impact — has come to make up
a *wound culture*: the public fascination with torn and open bodies and
torn and opened persons, a collective gathering around shock, trauma,
and the wound.

Serial killing, by all accounts, became a career option at the turn of the
century. Serial murder and its representations, for example, have by now
largely replaced the Western as the most popular genre-fiction of the
body and of bodily violence in our culture. And recent splatterpunk
Westerns, such as Cormac MacCarthy's novel *Blood Meridian* or films
like Clint Eastwood's *The Unforgiven* or Jim Jarmusch's *Dead Man*, make
the case that the Western was really about serial killing all along. But

accounting for this style of addictive violence and its fascinations is another story.

What is it about modern culture that makes the type of person called the serial killer possible? The spectacle of the wounded body has, of course, always had its lurid attractions. Nor did the last century invent murder in large numbers or the sex crime. But by 1900 something strange and something new appears on the scene. The wound, for one thing, is by now no longer the mark, the stigmata, of the sacred or heroic: it is the icon, or stigma, of the everyday openness of every body. This is a culture centered on trauma (Greek for wound): a culture of the atrocity exhibition, in which people wear their damage like badges of identity, or fashion accessories. And by 1900 a new kind of person has come into being and into view, one of the superstars of our wound culture: the lust-murderer or stranger-killer or serial killer.

If murder is where bodies and history cross, "senseless" murder is where our most basic senses of the body and society, identity and desire, violence and intimacy, are secured, or brought to crisis. The emergence of the kind of individual called the serial killer is bound up, it will be seen, with a basic shift in our understanding of the individuality of the individual. And this is bound, in turn, to a general mutation in our understanding of both "the criminal" and "the sexual."

First, then, what does it mean for the serial killer to emerge as a species of person? And, second, why has this species of person, and the intimacies of sex and violence, pleasure and power that drive him, become a flashpoint in contemporary society? These are some of the large questions I will be taking up in the pages that follow. We can begin to approach them by way of a brief look at a recent change in public policy with regard to the sex offender. This is not a book about the sex offender; nor is the serial killer simply to be located at the extreme end of a continuum of male sexual violence, with the "minor" sex offender at the other. Serial killing has its own logic. But that logic is inseparable from renovated experiences of both sex and crime.

On July 1, 1997, the State of California released a database of nearly 64,000 convicted sex offenders statewide, now available on CD-ROM at county sheriff's offices and larger police departments. "Serious" sex offenders must register with local police each year, and failure to register may count as a "third strike," punishable by life imprisonment. The intent, according to the State Attorney General, is a "'lifting of the veil of anonymity' shielding sex offenders from their neighbors"; the effect, opponents of the law contend, are "dangerous intrusions into privacy,

sweeping a wide array of past offenders into a permanent class of stigma-tized, second class citizens." Although targetted at "serious" offenders— "alerting parents and communities to the presence of potentially dangerous people," the broad brush of the law threatens to tar "adults convicted of committing same-sex consensual acts in public," and even public exposure of people convicted of crimes like indecent exposure. The law also imposes penalties on anyone who "misuses the CD-ROM information to commit crimes against sex offenders," who now "may face invasions of privacy or violence by their neighbors." The new California database supplements the earlier establishment of a statewide 900 number adults may call to check on "whether people are registered sex offenders." (The sex-offender 900 number fee is $10.) It moves beyond, at least with respect to its information technologies, the practice of other states, such as Louisiana, where sex offenders must inform neighbors of their presence via postcards.[1]

It is not merely that the protection of privacy and the public's right to know come into conflict in such cases: that the right to privacy gives way to the crime of anonymity, where the sex criminal is concerned. Some of the most severe stress-points in the American nervous system become visible here.[2] Here I want, in very preliminary fashion, to touch on three of them. First, there is the matter of the public/private divide, in all its normalcy and in all its incoherence. The public/private divide is always what is at issue, what trembles, in the sex offense and in responses to it. If this is most evident in the case of pornography—the exposure of sex and fantasy in public, the sex crime, more generally, is routinely experienced in terms of the violent passage of fantasy into act, private desire into public spectacle.

Second, and along the same lines, there is the way in which such crimes are everywhere marked by the "looping" of collective bodies of information and individual desire; and here I refer not simply to the CD-ROMs and 900 numbers that register and locate the sex criminal. Repetitive, compulsive, serial violence, it will be seen, does not exist without this radical entanglement between forms of eroticized violence and mass technologies of registration, identification, and reduplication, forms of copy-catting and simulation.

Third, there is the permanent *branding* of potentially dangerous people: the formation of a permanent class of the stigmatized person, a brand of person, marked and identified for all time by his criminal acts. This enters the law despite the fact that rates of recidivism (that is, the rate at which acts reconfirm identities) are in fact lower for the high-risk offenders required to register themselves than for other groups (about

19% compared to about 22%).[3] The very category of the "potentially dangerous individual"—here, the notion of the sex criminal as a *kind of person*—has by now taken on the self-evident and obdurate banality of common sense. But it is perhaps necessary to recover some of the strangeness of this notion.

During the course of the nineteenth century, there is a radical shift in the understanding of crime, a shift in focus from the criminal act to the character of the actor: the positing of the category of the dangerous individual.[4] And during the course of the nineteenth century, there is a shift in the understanding of desire, a shift in focus from sexual acts to sexual identity: from the vagrancies of sexual desire and sexual relations to a category of person, specified and rendered intelligible by the singular nature of his sexual identity—a social intelligibility and self-intelligibililty bound up through and through with the indelible nature of one's sexuality. A kind of act was now a species of person. This twin shift in understanding from act to life form—from the character of acts to the character and identity of the actor—is perfected in the dangerous individual called the sex-criminal.[5]

The serial killer emerges at the dark intersection of all these strands. By the turn of the century, serial killing has become something to do (a lifestyle, or career, or calling) and the serial killer has become something to be (a species of person). The serial killer becomes a type of person, a body, a case history, a childhood, an alien life form. In 1996 in New York City a serial rapist and murderer was arrested who had in his possession a manuscript-in-progress entitled, "How to Be a Successful Serial Killer or Mass Murderer." In the words of the serial killer Henry Lee Lucas, "I'm not one of a kind. There's lots of others out there just like me."[6] Murder by numbers is the work of the individual I describe as the statistical person: the serial killer, that is, is not merely one of an indeterminate number of others but an individual who, in the most radical form, experiences identity, his own and others, as a matter of numbers, kinds, types, and as a matter of simulation and likeness ("just like me").

He is a case history and, perhaps above all on the popular understanding, a childhood. This follows in part from the modern belief that childhood experience forms the adult, the founding premise, for example, of psychoanalysis. It is also the basic premise of a contemporary scene in which public life is everywhere referred back to scenes of an endangered, or dangerous, domesticity or privacy, and not least to the scenes of childhood trauma. Child abuse—wounded as a child, wounding as an adult—is one of the foundational scripts in accounting for the serial killer. It has

a sort of a priori status, even when evidence for it is absent. But even where evidence is absent, this is not to say that this governing belief does not loop back on these cases: framing not merely the public intelligibility of the serial killer but also his self-intelligibility.[7]

I will be returning to this script but also to its limits. What counts as abuse, depersonalization, wounding takes strange detours in these cases. Ted Bundy, for example, illegitimate but not physically or sexually abused, described himself as a "very verbal person." He described his mother, in his bizarre, third-person "confessions," entirely in terms of her relation to words and writing: "My mother taught me the English language . . . How many times did she type my papers as I dictated them to her? [She] gave me great verbal skills . . . I could have written them out in shorthand but would dictate things I had left out." His mother, he continued, has "beautiful handwriting, very good vocabulary, but she never *says* anything! She says, 'I love you,' or 'I'm sorry we haven't written. Everything's fine,' or 'We miss you . . . Everything will turn out. . . . 'Blah, blah, blah.'"[8]

Persons, for Bundy, were faceless numbers and types: "I mean, there are *so* many people . . . Terrible with names . . . *and* faces. Can't remember faces."[9] That is, persons, faces, names, for this very verbal person, are a defaced and dead language, the dead repetitions and clichés that register intimacy ("I love you") only as a worn quotation, a dictated, typed, stereotyped interiority. In his adolescence, Bundy became what he called a "radio freak," addicted to the public intimacies of talk radio. Awaiting execution, he attributed his acts to "his warping by printed matter that involved violence and sexual violence."[10] Writing, dictation, typing, shorthand, communication technologies, the data stream, pulp fiction and the true crime genre, the mass media and mediatronic intimacy: all traverse these cases, enter into the interiority of this style of violence, from the later nineteenth century on.

Serial Killers makes a case for the significance of experiences such as these, alongside the popular and general modes of "explanation," such as early trauma—explanations that often remain so general, so self-evident, or so transparently tautological that they miss a large part of reality. For what would it look like to experience oneself, through and through, as a type of person? What would it feel like to experience this perpetual looping of information and desire, technology and intimacy, violence and pleasure as one's form of life?

"It is impossible to estimate how many children come of age in violent, loveless homes across the land," one recent encyclopedist of serial

violence writes: "If every child produced from a dysfunctional relationship was homicidal, the United States would be one giant charnel house by now."[11] What this study, among many others, describes as "America's murder epidemic," amounts to the positing of a national malady of trauma and violence. Serial killing is thus represented as at once an horrific departure from normalcy and as abnormally normal: wounds to an idealized and intact American culture that is at the same time seen *as* a wound culture. "As the influence of American culture spreads to less developed countries," another popular study of serial killing observes, "the fear is that, unless checked somehow, the disease of serial murder will spread as well."[12] Hence if such crimes "appal the nation," the national landscape itself seems spectral, pathological, unreal: "1.8 million children vanish from home every year. . . . The case of vanishing adults is even more obscure"; the serial killer's "mask of normalcy" means that he "will have developed an uncanny knack for becoming invisible and fading into the background."[13] What this vanishing means and what this fading into the background means are parts of the story I will be telling. Testifying before a Senate committee on motiveless violence, the true crime writer Ann Rule argued that the national distribution of serial murder cases indicates that serial killers "run to the borders" of the country, in a physical expression of their mental extremity.[14] Cases, in fact, tend to cluster in the most populous regions. But this style of explanation—like the notions of a "murder epidemic" (Newton) or "serial murder as an infectious disease" (Norris)—makes visible the tendency to merge the natural and national body, where pathological violence is concerned. This version of a lurid sociobiology is commonplace enough: the body typically is drawn on, lends the weight of its apparent "givenness" to, social and cultural representations. But it is also more than that. It is more than that to the extent that the boundaries between the natural and collective body, private fantasy and public space, intimacy and publicity, are just what are, as we say, "at risk" in the matter of corporeal compulsive violence.

Serial Killers maps the psychotopography of that violence. The first part of this book traces the typical scenes of serial murder and the type of persons who inhabit them. Here I set out the strange form of intimacy—the form of life that I will be calling *stranger-intimacy*—that occupies these scenes. These sites, acts, and figures make up the overlit national landscapes of compulsion, addiction, and violence that define *the pathological public sphere*. In the second chapter of this part, I turn to the ways in which serial sexual violence—its maladies of agency, its addictive

relation to mass-produced images and representations, its identification of destruction and possession, its logic of killing for pleasure—depends on an intricate rapport between murder and machine culture. It depends not least on the intimacies between graphic violence and the technologies of registration, recording, and reproduction: the graphomanias of the Second Industrial Revolution. My examples include some of the inaugural writings on lust-killing (among others, Bram Stoker's *Dracula* and Zola's *La Bête humaine*) and some of the most extraordinary accounts of the inner experience of addiction (from Jack London's *John Barleycorn* to the cybernetics of the self in AA programs).

The chapters that make up the second part of this book are about the formation of the serial killer as the species of person proper to a mass-mediated public culture: *the mass in person*. It is often remarked of the serial killer that "the absence of a sense of self allows the criminal to fade back into society as a common individual."[15] But what sort of violence is incipient in the very notion of "the common individual" in a culture that mandates at the same time that one must "Be Your Self" and "Obey Your Thirst"? And how does the very banality of this way of thinking about "self" and "society" make the experience of one's everyday openness to collective forces and mass identifications traumatic and insupportable: turn the mandate of "each for each" into the war of "all against all"? The profile of the serial killer—his composite portrait or statistical picture— emerges as the very icon of the mass in person. Crucially, these maladies of self-difference, or self-distinction, are, in the case of the serial killer, immediately translated into violence along the lines of sexual difference: the sex-violence thing and the identity-thing reinforce each other at every point. In this part I draw my examples, first, from the range of official, psychological, and popular accounts of the serial killer; second, from the mass-market genre of bodily violence, pulp fiction (particularly Jim Thompson's novel *The Killer Inside Me*), tracking the popular psychology of the serial murderer pulp fiction sets in place; third, from the technologies of simulation and "lifelikeness" that enter into pornographic violence; and, finally, from the career of Jeffrey Dahmer—a career in which the *splatter codes* of sex and violence, public sex and pathologized privacy, and machine culture's turn of the life-like against life itself take on the most explicit and terminal form.

The third part of the book draws together all these elements, in part by way of one of the most sensational American episodes of serial violence: the 1890s case of the Chicago inventor, entrepreneur, medical practitioner, and serial murderer Herman Webster Mudgett, alias H. H. Holmes. This

case, one of the most extensively documented (albeit in documentations that seldom move beyond lurid redescription), sets in place many of the components of serial killing. It spectacularly foregrounds the lethal spaces in which these crimes take place: here, the 100-room "Murder Castle" Holmes constructed and operated. It makes explicit the intimacies of serial violence and machine culture: the strange, prosthetic devices Holmes invented to process his victims, his utter absorption in technologies of writing and communication, his technophilias and graphomanias. Holmes's inventions and self-inventions make him something like an extreme limit-case of the self-made man. Finally, the spectacular character of his crimes registers at every point *the entering of the mass spectacle into the interior of addictive bodily violence.*

The last part of this book centers on America's wound culture: the torn bodies and torn persons about which the crowd gathers. It maps, that is, the wound landscapes of contemporary culture and locates some of its landmarks. Here I pressure the psychoanalytic, and popular, understanding of trauma toward an account of what might be described as the sociality of the wound. And I pressure the popular understanding of the body-machine-image complex toward a different account of what it means to inhabit the pathological public sphere today.

In the concluding pages of this introduction I want less to explain than briefly to exemplify some of the interlaced components in these crimes, and to indicate some of the basic limits in governing accounts of serial killing and its fascinations. Such accounts, on both popular and professional fronts, have in effect dramatized rather than specified such fascinations, hence functioning as something of an antidote to registering their most radical cultural implications. Which is perhaps one indication of the extraordinary complex of concerns—sexual, social, technological, and artistic—that the concept of the serial killer makes visible and draws into relation.

Word Counts and Body Counts

The prototype of the serial killer is, of course, the case of Jack the Ripper, who killed a series of women in 1880s London. This case put in place the popular model of the serial killer as white-male-sadist-performance artist, although such criminals are by no means all white or all male or their victims all women, and although the ritualistic or "artistic" aspect of these crimes means, for the most part, that patterns or "signatures" emerge. That nothing reliable is known about the identity or motives of this London

killer is itself a central part of the model: the endless rituals of noncomprehension that continue to surround the kind of person called the serial killer.
Only two things are known for certain about the Ripper case. There was for a time a series of torn and opened bodies of too public women on the public streets (the victims it seems of professional sex in public). And there was a series of more than 300 letters (none authenticated) mailed to the London press, signed Jack the Ripper. In such cases, the boundaries come down between private desire and public life, along with the boundaries between private bodies and the public media. Letters and bodies, word counts and body counts, go together from the inception of serial murder.

Abnormally Normal

Here is something like a personal confession, part of an anonymous letter received by an Ohio newspaper in November 1991:

> I've killed people. . . . Technically I meet the definition of a serial killer (three or more victims with a cooling-off period in between) but I'm an average-looking person with a family, job and home just like yourself. . . . I've thought about getting professional help but how can I ever approach a mental health professional? I can't just blurt out in an interview that I've killed people.[16]

There is by now nothing extraordinary about such communications to the mass media, from the Ripper letters to the letter bomber called Unabom. Nor is there anything extraordinary about the "technical" self-definition of the serial killer that centers this confession, although there is some disagreement about the baseline qualifying number. (The FBI defines serial murder simply "as involving an offender associated with the killing of at least four victims, over a period greater than seventy-two hours."[17]) And the "cooling-off period," distributing the murders serially over time, has come to provide the working distinction between serial and mass murder (with "spree-killing" falling somewhere in between).

But if this is a personal confession, it is also strangely *im*personal, and not merely because the killer's desire to approach the "mental health professional" is just one step from a twelve-step outlook on addictive killing. This is an anonymous letter on several counts. The writer experiences the technical definition of the serial killer as a self-definition: the killer takes the FBI's composite picture or standard "profile" of the serial killer as a self-portrait.

One refrain in coverage of serial killing is just this dead average and look-alike character of the killer. The forensic psychiatrist Helen Morrison, who has done thousands of hours of interviews with serial killers, puts it this way: "These are basically cookie-cutter people, so much alike psychologically I could close my eyes and be talking to any one of them." There is something uncanny about how these killers are so much alike, living composites, how easily they blend in. The serial killer, as one prosecutor of these cases expressed it, is "abnormally normal": "just like you or me."[18]

One of the court psychiatrists in the case of the Milwaukee killer Jeffrey Dahmer remarked about the "chameleon-like" character of the killer: "Dress him in a suit and he looks like 10 other men." In the recent serial killer movie *Virtuosity*, the computer composite of the serial killer comes to life, takes life. In another recent movie, *Copycat*, there is no deeper motive to killing than turning oneself into a copy of someone else. This is the killer as "the devoid" or (to borrow a term from Dennis Cooper's serial killer fantasy novel *Frisk*) as "Mr. Xerox." The serial killer is "citizen X" (the "Russian Ripper" Chikitilo) or "the monochrome man" (the self-description of the London serial killer, Dennis Nilsen, who murdered and dismembered 15 young men in the early 1980s). In his remarkable novel on the abnormal normality of serial killing, *The Minus Man*, Lew McCreary describes the profile of the killer, the minus man, this way: "He looks like a million people."[19]

The Stranger-Killer

Serial killing is also called stranger-killing. The serial killer is always "the stranger beside me" or "everyone's nextdoor neighbor": "average-looking" and "just like yourself." The stranger, in the lonely crowd, is one who is near but also far. *The Stranger Beside Me* is the title of Ann Rule's book on Ted Bundy. Bundy, while a student at the University of Washington — majoring in abnormal psychology, of course — had a work-study job at a suicide prevention and crisis hotline. One of his volunteer co-workers and friends at the hotline was the true crime writer, Rule, a contributor to *True Detective* magazine who had contracted to write a book on the recent "Ted" killings in the Seattle area (that is, on Bundy himself). Her book on the stranger beside her wavers between shock (he couldn't have done it, I *know* him!) and journalistic glee (what luck!).[20] [See figures 1, 2, 3: composite sketch, Bundy photograph, mug shot.]

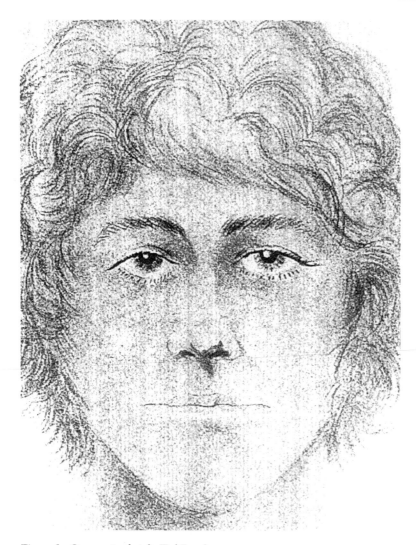

Figure 1. Composite sketch: Ted Bundy.

Ted Bundy himself struck everyone as perfectly *chameleon-like*: it was observed again and again that "he never looked the same from photograph to photograph." Bundy's death-row interviews are endless strings of mass media and pop-academic clichés. The interviews read as if the pages of *Psychology Today* were time-sharing his words, his eyes, his face, his mind. They are spoken in the third person, where he lived. In the words of the serial killer Henry Lee Lucas (who was the loose prototype

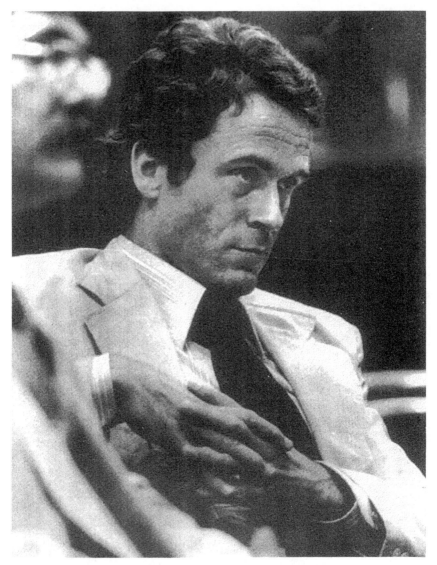

Figure 2. Ted Bundy listens to comments from judge (Bettman Archive).

for the John McNaughton film *Henry: Portrait of a Serial Killer*): "A person was a blank." The complete yielding to nonpersonality is one of the serial killer's signatures, the proper name of the minus man. Or, as Bundy, "a type of nonperson" who was also such a verbal person, expressed it: "Personalized stationery is one of the small but truly necessary luxuries of life."[21]

Figure 3. Ted Bundy: FBI wanted poster.

The Serial Killer Profile

The FBI serial-crime unit attempts to fill in the blank—through its vaunted profiling system and fifteen-page, fill-in-the-blanks Violent Crime and Apprehension Program (VICAP) form—for police reports on repeat crimes. [See figures 4, 5: VICAP page, FBI facial identification page.] But the profilers have in all been generally ineffectual in tracking down killers. As one ex-agent in serial homicide investigations put it, "I mean, how many serial killer cases has the FBI solved—*if any!*"[22]

III. OFFENDER INFORMATION

OFFENDER DEFINED. As used in this VICAP Crime Analysis Report, "offender" includes arrestees, perpetrators, or persons the investigator has reasonable cause to believe are responsible for the commission of the crime.

OFFENDER STATUS

55. This Is Offender _____ of _____ Offender(s) in This Incident.
 (number) (total)

56. The Offender Is (check one only):
 1 □ Unknown——Not Seen (go to Item 85)
 2 □ Unknown——Seen
 3 □ Identified (named)——Not in Custody
 4 □ In Custody
 5 □ Deceased

OFFENDER IDENTIFICATION

57. Name: _____
 (last, first, middle)

58. Alias(es) (including maiden name and prior married names):

59. Resident City: _____ 60. State: _____ 61. ZIP: _____

62. Social Security Number: _____ - ____ - _____ 63. FBI Number: _____

PHYSICAL DESCRIPTION

64. Sex:
 1 □ Male 2 □ Female 99 □ Unknown

65. Race:
 1 □ Black 3 □ Hispanic 5 □ Other
 2 □ Caucasian 4 □ Oriental/Asian 99 □ Unknown

66. Date of Birth: ___/___/___
 (mo) / (da) / (yr)
 99 □ Unknown

67. Age (or best estimate) at Time of Incident: _____
 99 □ Unknown (years)

68. Height (or best estimate): ____ feet ____ inches (to ____ feet ____ inches)
 99 □ Unknown

69. Build (check one only):
 1 □ Small (thin) 3 □ Large (stocky)
 2 □ Medium (average) 99 □ Unknown

70. Hair Length (check one only):
 1 □ Bald or Shaved 4 □ Shoulder Length
 2 □ Shorter Than Collar Length 5 □ Longer Than Shoulder Length
 3 □ Collar Length 99 □ Unknown

71. Hair Shade (check one only):
 1 □ Light 3 □ Neither 1 or 2 Above
 2 □ Dark 99 □ Unknown

72. Predominant Hair Color (check one only):
 1 □ Gray and/or White 5 □ Black
 2 □ Blond 6 □ Other
 3 □ Red 99 □ Unknown
 4 □ Brown

Figure 4. Violent Crime and Apprehension Program police form.

But the FBI has managed to put in place something like a job description, a sort of "most wanted" ad. "Serial killers," as one recent sociologist of serial homicide notes, "are influenced by the media as well as by academic psychology, and many make a specific study of earlier offenders."[23] Serial killers make a study of their own kind of person. The Ohio killer-letter writer is only one among many others who had, it turns out, "read many books about serial killers."

Figure 5. FBI Facial Identification catalog page.

The designation of the serial killer as a type of person has had, we have noted, a sort of switchback or looping effect: public knowledge about kinds of people has a way of interacting with the people who are known about and how these people conceive of themselves. Serial-killer, virtual-reality profiles come to life and copy-catting as motive are fictional versions of the "technical definition" of the serial killer lifting itself up by its own bootstraps.

The Copycat Killer

Fact and fiction have a way of changing places here: virtual reality, after all, has its own reality. Robert Ressler, the cofounder of the FBI's Behavioral Science Unit (BSU) who coined the term "serial killer" in the mid-1970s, had two things on his mind at what he called this "naming-event": the British designation, "crimes in series," and "the serial adventures we used to see on Saturday at the movies."[24]

Ressler's story of the profilers, *Whoever Fights Monsters*, carries as its frontispiece a reproduction of William Blake's *Red Dragon*, with this inscription: "For Bob Ressler with best wishes, Francis Dolarhyde and Thomas Harris." Dolarhyde is the fictional serial killer who identifies himself with Blake's Dragon in Harris's novel *Red Dragon*. That novel is the prequel to *Silence of the Lambs*, in which Ressler and his colleague at the BSU, John Douglas, are brought together as the composite for the FBI chief. According to Douglas, in his recent book on the FBI's serial crime unit, *Mindhunter*, "Harris picked up the story while sitting in on our courses at Quantico." Douglas's own recent account of the FBI's serial-crime unit makes clear the FBI's own recourse to fiction and film. "Our antecedents," as he puts it, "actually do go back to crime fiction more than crime fact."[25]

The distinctions between fact and fiction and between bodies and information vanish, along the lines of an identification without reserve. In the early 1980s, Douglas was holding in his head about 150 cases at a time, without active backup and without, as yet, computer backup. The serial killer simulates others and fades into his environment. As the Son of Sam profile expressed it, "He's the kind of guy . . . who probably goes to work everyday. Maybe he does something with statistics. An accountant or a clerk. He just kind of melts into the city scene."[26] The mindhunter works by simulation, too. He works—like Poe's prototype detective, Dupin (one of the crime-fiction sources Douglas cites)—by identifying himself with the killer. He copies the copy, xeroxes Mr. Xerox: "I'm one of them . . . put yourself inside these guys shoes—or in their minds."

The mindhunter identifies with a criminal whose own identity has yielded to an identification with accounts of his kind of person, accounts that, in circular fashion, include the profiler's own. Bodies, identities, and information are drawn into an absolute and violent proximity. In 1983, Douglas relates, the mindhunter's mind exploded from the information overload: "The right side of [the] brain had ruptured . . . in layman's terms, his brain has been fried to a crisp."[27] This is, of course, John

Douglas as Johnny Mnemonic. And this begins to intimate how serial killing inhabits the information society, where nothing could be less certain than the line between bodies of information and other kinds of bodies.

The Letter Bomb

There is a standard sense of serial killing as "senseless," as "murder with no apparent motive." And this happens even when the motives are laid out right on the surface. Consider, for example, the serial bomber called UNABOM's 35,000-word manifesto, where the links between word counts and body counts, hacking information and bodies, are clear enough:

> Then in June, the Unabomer sent his 35,000 word diatribe to the Times and the Post. . . . If papers did not print the tract, he warned, he would kill again. . . . That same month he mailed a fatal package bomb to a California timber lobbyist whose body parts had to be collected in 11 separate bags.[28]

Serial killing is "murder by numbers." Information processing and serial killing, computer profiles and torn bodies, feed on each other in these cases:

> Sixteen bombings in 17 years; 23 wounded and maimed, three people dead. . . . Federal agents spent more than $50 million as well as a million work hours . . . agents had developed a vast computer system with 12 million bytes of information.[29]

Serial killing is the form of public violence proper to a machine culture: the era of the Second Industrial Revolution that is also popularly called "the information society" or "digital culture" and might be called the Discourse Network of 2000. In the Network, the unremitting flood of numbers, codes, and letters is popularly seen as replacing real bodies and real persons, threatening to make both obsolete. What it really makes obsolete is the difference between bodies and information. As Norbert Wiener, the founder of cybernetics, put it some time ago, both persons and machines are "communicative organisms." The erosion of the difference between "living beings and inanimate matter" in digital culture means that, as technocrat Wiener blandly put it, "the distinction between

material transportation [bodies] and message transportation [information] is not in any theoretical sense permanent or unbridgeable."[30]

The Unabomber sends back this message in the form of the letter bomb. The Unabom Manifesto is nothing but pop-psychology and pop-sociology about the information society. It is a series of clichés, dead words, about being "swamped by the vast volume of material put out by the media": about being assaulted, bombarded, soul-murdered, by bits of information.[31] The psychotic, we know, is one who takes things literally, to the letter. The psycho-killer, the letter bomber, brings numbers and codes and words back to bodies—with a vengeance.

The slogan of the information society is minds without bodies: "More brains—less sweat." Ted Kaczynski—the brilliant mathematician and prolific letter writer—was a boy with a "thin body" who "hung out with the brains." It is as if he had already left his body behind. But then, we are told, "all the brains fooled around with homemade explosives."[32]

The letter bomber is a writer who dreams of words with a direct physical impact. He dreams of words as weapons aimed at bodies: verboballistics. "In order to get our message before the public, *with some chance of making a lasting impression*, we've had to kill people."[33] Bodies and writing come together in the letter bomb and its victims: "All of my fingers were missing two sections . . . My Air Force Academy ring shot six feet through the air and bounced off a wall. The impact was so strong, you could read the word ACADEMY in the plaster."[34] The "signature" letter bomb—the point of impact of bodies, technologies, and words—is the letter bomber's way of reconnecting brains to bodies. Going postal is his way of reconnecting what for him the information society disconnects: private desire and public life. "An intensely private man" who "lunges for publicity": sending his signature bombs through the postal system is his way of writing on the wall.[35]

The Mass in Person

The British serial killer, Dennis Nilsen, arrested in 1983 for the murder of a number of young men, described himself as a "professionally perfect person";[36] he was diagnosed (in a court psychiatrist's forensic psychologese) as suffering from "False Self Syndrome."[37] After an earlier career in the military and as a policeman, he entered the civil service, where he interviewed hundreds of people looking for work (*K* 18). He imagined his career as the killer of a series of anonymous men in the same workaday terms: "If I had been arrested at sixty-five years of age there might have

been thousands of bodies behind me" (*K* 19). Imagining arrest for murder at the age of retirement from civil service is to imagine the stranger-intimacies of his public life and the stranger-killings of his private life as two versions of the same thing.

In public service, Nilsen "frankly revelled in the equality that [his] uniform provided" (*K* 57). The uniform served as a sort of social exoskeleton: a social ego, an external "muscle armor that is merely borrowed ... and fused onto the individual," maintaining his boundaries and identity from without.[38] It formed part of what Nilsen called his "union principles." Nilsen was an ardent union activist, but his union principles, and his devotion to what he called "the machinery of democracy," went deeper. He dreamed of a "total natural unity": "My best friends were the sea, sky, rivers, trees ... I was at one with the natural environment" (*K* 51, 285). These numberless "friends" — sea, sky, rivers, trees — are traditional *crowd-symbols*.[39] The dream of a direct filiation with Nature is the dream of a direct *fusion* with an indistinct mass of others: the complete fusion with the mass at the expense of the individual that forms the inner experience of what I will be calling *the mass in person*. The machinery of democracy, for the mass in person, perfects itself in the dead levelling by which all individual distinctions vanish: "dead people," as the *Badlands* spree killer Charles Starkweather put it, "are all on the same level."

Nilsen dismembered bodies while blasting Aaron Copland's *Fanfare for the Common Man* on his personal stereo. (Conversely, Laurie Anderson's prosthetic ballad *O Superman* was another favorite [*K* 9].) As he expressed it: "I want crowds around me to listen to my solitude" (*K* 246) The killer described the bonfire he made of the bodies he had taken apart as a return to a total natural unity: "A mixing of flesh in a common flame and a single unity of ashes ... a uniform and anonymous corporation cemetery" (*K* 149). He described his ultimate place in the mass public sphere as a sort of corporate and collective gathering point: or, more exactly, his final public service was as a mass spectacle of pathology and abjection. He was a black hole of violation and pollution about which the contemporary national body gathers, spectates, and discharges itself: in his words, he was "a national receptacle into which all the nation will urinate" (*K* 175).

Lifelikeness

The public/private divide and its transgressions are crucial, I have begun to suggest, in cases of serial killing and in instances of sexual violence more generally. Nilsen called himself "a tragically private person not

given to public tears" (*K* 206). For him, among others, stranger inti-macy—what he described as "entertaining strangers" and "killing for company"—was inseparable from stranger-killing (*K* 184, 85). It pro-vided the missing point of contact between private desire and public life: "No sex, just a feeling of oneness" (*K* 124).

Cruising the London scene, Nilsen experienced an anonymous same-sexuality in terms of "the idea of sex in public" (*K* 124, 87). This feeling of oneness in public sex made for an experience of homosexual-ity (same-sexuality) as a radical experience of self-sameness: same-sexu-ality and self-sameness referred back to each other at every point. This violent translation of sexual difference into self difference, sexual same-ness into self sameness, will be taken up in detail in the pages that follow. It is one of the central components in the inner logic of serial killing. On this logic, the killer's disorders of identity yield to a sheer identification with others. Hence, for Nilsen, "it starts in narcissism and ends in confusion" (*K* 69). Stranger killing takes the form of a suicide by proxy: "I was killing myself only but it was always the bystander who died" (*K* 252).[40]

The complete failure of distinction between self and others is yet more complicated. In this case, among many others, the yielding of identity to identification proceeds by way of an utter absorption in *technologies of reflection, reduplication, and simulation.* For Nilsen, it involved, above all, a fixation on mirror images of his own made-up body and on the mir-roring and photographing and filming of the made-up, taken apart, and artifactualized bodies of his victims. Nilsen, self-described as a "central camera," was addicted to the lifeless model body, his own and others: to the body made up as corpse. He was addicted to images of what he called the unreflectiveness and "ineffectiveness of a non-personality." The unreflectiveness of a non-personality depended in turn on technologies of modeling and reflection. Mirror-images, "a visually perfect state," con-stituted, for him, "an unresisting model of life": that is, the visually per-fect state of the corpse, the *tableau vivant* of the *nature morte*, of death mimicking life, such that life takes a step backward. (*K* 75, 263). For the serial killer, *lifelikeness*—what I will call the *primary mediation* of the modern body and modern subject, in its technical simulation and repro-ducibility—substitutes for the imperfection and threat of living life itself. Chameleon-like, the serial killer copies and simulates others; the mono-chrome man, he melts into place; the minus man, predead, he plays dead and takes life.

Wound Culture

Serial Killers is about forms of public violence in our culture: what these acts and representations of violence look like, why they have emerged as a cultural flashpoint, and how the very idea of "the public" has become inseparable from spectacles of bodily and mass violence. The spectacular public representation of violated bodies, across a burgeoning range of official, academic, and media accounts, in fiction and in film, has come to function as a way of imagining and situating our notions of public, social, and collective identity. Hence these "atrocity exhibitions" indicate something more than a taste for senseless violence. They have come to function as a way of imagining the relations of private bodies and private persons to public spaces. These exhibitions make up the contemporary pathological public sphere, our wound culture.

Mass murder in America has had two popular sites: the fast-food system (The McDonald's Massacre) and the postal system (Going Postal). On these sites systems, numbers, and bodies collide. Personal communications, in the postal system, are the property of the impersonal clerks of the system. David Berkowitz, the mailman/serial killer called the Son of Sam, had a lifetime appointment in that system. He traced his killings to a letter to his father that "stated a devine [sic] mission that I felt was intended for me." A sort of dimestore Schreber (Freud's prototype paranoiac, "soul-murdered" by divine messages), Berkowitz continued to be letter-bombed by demons. They set up in him what one character in the recent film about trauma, machine violence, and virtual reality, *Strange Days*, calls a "switchboard of the soul."

In prison, Berkowitz longed for "more personal freedoms such as keeping a pen in my cell, being able to go out, under guard and mail letters, go to the post office, and have a hotline telephone in my cell that leads directly to Chief of Detectives."[41] In the Belgian serial killer film *Man Bites Dog* (1992), in which the mass media and mass murder foment each other, the psycho-killer Benoit blithely remarks: "I usually start the month with a postman."

The fast-food world, as Lew McCreary describes it in *The Minus Man* — a novel in which the serial killer is a postal worker, too — is a place of stranger-intimacy: "These are the kinds of places where people don't look at each other much, where many come in alone and eat alone. . . . No one could describe anyone they ever saw in such a place who was not crazy and babbling."[42] Or, as Denis Johnson, one of the great communi-

cators of America's contemporary trauma culture, describes it in his novel *Angels*: "the fast-food universe" is a "tiny world half machinery and half meat."[43]

This world of half meat and half machinery is one of the lethal places that make up our wound culture, in which death is theater for the living. The crowd gathered around the fallen body, the wrecked machine, and the wound has become a commonplace in our culture: a version of collective experience that centers the pathological public sphere. The current a-la-modality of trauma—the cliché du jour of the therapeutic society of the nineties—makes this clear enough. So too does the most recent (1996) national election. The election was a contest about trauma and wounds: the shattered and already posthumous war veteran—dead man talking—and the make-love-not-warrior whose tag-line is "I feel your pain."

In the early days of television there was a program called *Queen for a Day*. The premise was this: three unfortunate, over-embodied and underclassed women engaged in a competition in abjection by relating the horror stories of their lives. An audience applause meter determined the outcome of the competition. Coronation and prize—generally labor-saving household appliances, as I remember it—followed. This public spectacle of private exposure has been generalized, of course, as the program of talk radio and confession TV, where the only prize is appearing in the stocks, in the virtual town meeting gathered to witness wounds.

The most popular current television series, *ER*, is pure wound culture: the world, half-meat and half-machinery, in a perpetual state of emergency. *ER* is an endless series of torn and opened bodies and an endless series of emotionally torn and exposed bio-technicians. There are the routine hook-ups of bodies and appliances; trauma and techno-speak; cardiac arrest and broken hearts. These are the spectacles of persons, bodies, and technologies that make up a wound culture and the scenes that make up the pathological public sphere: the scenes, and the culture, in which serial killing finds its place.

Notes

1. Todd S. Purdum, "Registry Laws Tar Sex-Crime Convicts With Broad Brush," *New York Times*, July, 1, 1997, pp. A1, A19.
2. I am here drawing on Michael Taussig, *The Nervous System* (New York: Routledge, 1992).
3. For these numbers, see ibid., p. A19.
4. See Michel Foucault, "The Dangerous Individual," *Michel Foucault: Poli-*

tics, *Philosophy, Culture: Interviews and Other Writings 1977–1984*, trans. Alan Sheridan, et al., ed. Lawrence D. Kritzman (New York: Routledge, 1988). I will be returning to the notion of the dangerous individual and its implications in the following chapter.

5. The shift from act to species is central to the orbitting of a wide range of contemporary thinking around the problem of *identity*. On this shift and some of its implications, see, for example: Michel Foucault, *The History of Sexuality*, vol. 1 (New York: Pantheon, 1978); Judith Butler, *Gender Trouble: Feminism and the Subversion of Identity* (New York: Routledge, 1990); Wendy Brown, *States of Injury: Power and Freedom in Late Modernity* (Princeton, N.J.: Princeton University Press, 1995); Jonathan Ned Katz, *The Invention of Heterosexuality* (New York: Dutton, 1995).

6. Lucas quoted in Michael Newton, *Serial Slaughter: What's Behind America's Murder Epidemic* (Port Townshend, WA: Loompanics Unlimited, 1992), p. 7.

7. On the modelling of child abuse and the a priori status of trauma more generally, see Ian Hacking, *Rewriting the Soul: Multiple Personality and the Sciences of Memory* (Princeton, N.J.: Princeton University Press, 1995).

8. Bundy quoted in Stephen G. Michaud and Hugh Aynesworth, *Ted Bundy: Conversations with a Killer* (New York: Signet, 1989), p. 7, 10.

9. Ibid., 104.

10. Ibid., pp. 10–11; Ann Rule, *The Stranger Beside Me* (New York: Signet, 1989), p. 495.

11. Newton, *Serial Slaughter*, p. 23.

12. Joel Norris, *Serial Killers* (New York: Anchor Books, 1988), p. 19.

13. Newton, *Serial Slaugher*, p. 23; Norris, *Serial Killers*, pp. 79, 84.

14. Rule, Testimony before the U.S. Senate, July 12, 1983; U.S. Senate Judiciary Committee. *Serial Murders: Hearing on Patterns of Murders Committed by One Person, in Large Numbers with No Apparent Rhyme, Reason, or Motivation.* (Washington, D.C.: U.S. Government Printing Office, 1984).

15. Norris, *Serial Killers*, pp. 40–41.

16. Quoted in Eugene H. Methvin, "The Face of Evil," *National Review*, Jan. 23, 1995, 34. I will be returning to this case, and its implications, in chapter 3.

17. This is the definition adopted, for instance, in Philip Jenkins, *Using Murder: The Social Construction of Serial Homicide* (New York: Aldine de Gruyter, 1994), p. 23.

18. See Helen Morrison, *Serial Killers and Murderers* (Lincolnwood, IL: Publications International, 1991), pp. 7–9, and Methvin, "The Face of Evil," p. 42.

19. Dennis Cooper, *Frisk* (New York: Grove, 1991), p. 53; Lew McCreary, *The Minus Man* (New York: Penguin, 1991), p. 221. On Cooper's *Frisk*, see chapter 6; on McCreary's *The Minus Man*, the concluding part of this study, "Wound Culture."

20. Rule, *The Stranger Beside Me*.
21. Bundy, quoted in Rule, p. 221.
22. Quoted in Ron Rosenbaum, "The FBI's Agent Provocateur," *Vanity Fair* (Apr. 1993), p. 124.
23. Jenkins, *Using Murder*, p. 224.
24. Robert K. Ressler (and Tom Shachtman), *Whoever Fights Monsters* (New York: St. Martin's, 1992), pp. 29–30.
25. John Douglas (and Mark Olshaker), *Mindhunter: Inside the FBI's Elite Serial Crime Unit* (New York: Scribner, 1995), pp. 95, 32.
26. NYPD Commissioner Tim Dowd, quoted in Elliot Leyton, *Hunting Humans: Inside the Minds of Mass Murderers* (New York: Pocket, 1988), p. 174.
27. Douglas, *Mindhunter*, pp. 17, 20.
28. "Probing the Mind of a Killer," *Newsweek*, Apr. 15, 1996: 36–38.
29. "Chasing the Unabomer," *Newsweek* 10 July 1995, 40–43; "Probing the Mind of a Killer," *Newsweek* 15 April 1996, 36, 37; *New York Times* 2 Aug. 1995, pp. A1, A16; *Washington Post* 2 Aug. 1995, pp. A1, A16, A17.
30. Norbert Wiener, *The Human Use of Human Beings: Cybernetics and Society* (Garden City, NJ: Doubleday, 1954), pp. 98, 136.
31. Unabom Manifesto, excerpted in *The New York Times* 2 Aug. 1995, p. A16.
32. "Probing the Mind of a Killer," *Newsweek*, 15 Apr. 1996, p. 34.
33. Unabom Manifesto, excerpted in *The New York Times*, 2 Aug. 1995, p. A16 (my emphasis).
34. John Hauser, "What the Unabomer Did to Me," *Newsweek*, 15 Apr. 1996, p. 40.
35. "Probing the Mind of a Killer," *Newsweek*, 15 Apr. 1996, p. 30.
36. Nilsen, quoted in John Lisners, *House of Horrors* (London: Corgi, 1983), pp. 178, 180.
37. Brian Masters, *Killing for Company: The Story of a Man Addicted to Murder* (New York: Random House, 1993), p. 214; the following quotations are drawn from the Nilsen Papers, (notes and prison journals written by Nilsen in 1983), as excerpted by Masters; hereafter abbreviated *K*.
38. Klaus Theweleit, *Male Bodies: Psychoanalyzing the White Terror*, vol. 2 of *Male Fantasies*, trans. Erica Carter and Chris Turner (Minneapolis: University of Minnesota Press, 1989), pp. 222–23.
39. See Elias Canetti, *Crowds and Power*, trans. Carol Stewart (New York: Noonday Press, 1984), pp. 75–92.
40. Pet-killing is one leg of the "triad" of indicators in the genesis of the serial killer, with bed-wetting and firestarting forming the other two. Nilsen, however, was a devoted pet-keeper. He stated about his pet dog that "her great redeeming feature was that she was not formed in my image," (*K* 163). It is as if the union principles that made for a fusion of all persons in his own image required something to mark the difference between self and other

and between persons and nonpersons. The dog's name—Bleep—seems itself a figure for censorship: that is, for the desired, but also insupportable, noncommunication between private desire and public expression.

41. The prison diary of David Berkowitz (1981), as quoted by Leyton, *Hunting Humans*, p. 166.

42. McCreary, *The Minus Man*, pp. 156–57.

43. Denis Johnson, *Angels* (New York: Vintage, 1989), p. 62. Johnson's most recent novel, *Already Dead: A California Gothic* (New York: Harper Collins, 1997), brilliantly inhabits the techno-gothic landscapes, the psychotopographies, of this traumatized, predead, or "already dead" culture.

PART 1.

The Pathological Public Sphere

1 · The Scene
of the Crime

In 1932, the Hungarian Sylvestre Matushka went on trial for engineering a series of train crashes that had killed more than thirty railway passengers. He stated his profession in these terms: "Train wrecker, before that, businessman." At the time of his arrest, police discovered in Matushka's possession train schedules and a map with sites marked out that were planned for future wrecks, at the regular rate of one a month. Matushka, it turned out, was something of a "train fiend," albeit of a markedly singular style. He explained at his trial that he could only achieve sexual release when witnessing a train crashing and, consequently, made a career of staging these spectacular accidents. Sentenced to life imprisonment, Matushka escaped confinement. He reappeared in 1953 during the Korean War—as the head of a military unit for blowing up trains.[1]

It is not merely that repetitive murder appears in this case in the form of a distinctly modern choice of occupation. Nor is it merely the conjunction of compulsive sexualized violence, on the one side, and technological system, schedule, and routine, on the other, that defines these crimes. These components in instances of serial violence will be tracked in the pages that follow. Clearly, the murderous railway accident (as Wolfgang Schivelbusch has argued) dramatically concretizes the "migration" between the orders of physiology and technology that make up what I have been calling the body-machine complex, and it concretizes as well the forms of violence the body-machine complex solicits. The railway accident provides, moreover, the take-off point for the psychoanalytic

theorization of shock and trauma—the intricate connections between accident, crisis, and psychopathology—as the characteristically modern form of life.[2] For the moment, however, I am interested in such cases on somewhat different grounds.

What are we to make of such *planned* accidents and the dangerous individuals who execute them? The very concept of the "dangerous individual" seems inseparable from a general reconceptualization of the category of "the accident." For one thing, the concept of the dangerous individual, as Foucault traces it, involves a shift in focus from the criminal act to the character of the actor: that is, it involves the elaboration of a technical knowledge-system "capable of characterizing a criminal individual in himself and in a sense beneath his acts."[3] But this characterization depends in turn on a new understanding of the individuality of the individual: a new understanding that involves something more than the "psychologization" of crime on which Foucault, among others, focuses.

The singling out of the dangerous individual, in himself and beneath his acts, brought forward a radically different account of both individual and act. It brought forward, that is, the notion of the potential risks posed by types of individuals and the causal probabilities of certain types of acts being committed. And if that technical knowledge-system referred such risks back to the intrinsically dangerous personality of the criminal, it also referred that danger to a social calculus of probability: the social calculation of risk and the calculable accident. As the pioneer statistician Adolphe Quételet noted, "Nothing would seem more to escape foreknowledge than murder." Yet he went on to observe "the terrifying exactness with which crimes reproduce themselves": "We know in advance how many men will bloody their hands with violent murders, how many will be counterfeiters, how many poisoners, just as one can enumerate in advance the births and deaths that will occur in a single year." One can construct in advance, therefore, a kind of "budget of the scaffold."[4]

One effect of this shift in the social understanding of risk is to draw the "accident" away from an association with sheer contingency and into relation to the law of large numbers. This has generally been seen in terms of the elaboration of a social prophylaxis by which accident or crisis may be "tamed" by statistical regularities or crisis management.[5] The large question that predictably arises, at this point, is whether this way of counting persons and acts, from the outside, is not also a way of "accounting for" them, from within. That is, another and more radical effect of this shift in understanding is to make visible *an experience of typicality at the level of the subject.* The serial killer, I will be arguing, is in part

defined by such a radicalized experience of typicality within. Simply put, "murder by numbers" (as serial murder has been called) is the form of violence proper to statistical persons. That such a generalized experience of a generality within is insupportable may go some way to explaining the explosive violence through which it becomes visible and its localization, and pathologization, in the figure of the serial killer. That such an experience of a generality within is at the same time alluring or compelling may go some way in explaining why that figure has come to exercise such an extraordinary fascination, a fascination at once social, erotic, and aesthetic. "There is," as Gilles Deleuze and Félix Guattari observe, "always something statistical in our loves, and something belonging to the law of large numbers."6

But this, of course, is still not quite to locate the forms of that violence and its typical scenes. Matushka's planned accidents, for example, eroticize the shock of contact between bodies and technologies. More precisely, they disclose an erotics at the crossing point of private fantasy and public space. These "atrocity exhibitions" disclose, in the form of a spectacular corporeal/machinal violence, a drive to make mass technology and public space a vehicle of private desire and, collaterally, to identify — or better, to realize — private desire in public spectacle: the spectacles of public sex and public violence. These intrications of the collective and the individual provide one version of what might be described as *the pathological public sphere.*

The coupling of bodies and machines is thus also, at least in these cases, a coupling of private and public spaces. It is not surprising, then, that these linkages are most powerfully literalized in the machinal systems of public transport that speed the movement, or commuting, of bodies between these spaces: the railway system and the highway system. The Matushka case might be framed on one side by Zola's mapping of the *psychotopography* of machine culture in his 1890 novel *La Bête humaine*: a novel in which the railway accident and eroticized violence indicate each other at every point. This is a novel in which public and private spaces "tear away" at each other ("nowadays nobody could stay at home . . . so many men and women were rushing past in the thunder of trains shaking the house, and then tearing away at full speed"); in which intimacy is inseparable from the shock of contact with the public in ceaseless motion, with faceless crowds of strangers ("Yet this idea of the tide of people that up and down trains bore along past her every day in the deep silence of her solitude left her pensive . . . she thought she recognized faces . . . she tried to count them roughly . . . [but] all the faces got

blurred and merged one into another, indistinguishable. . . . Behind this non-stop movement . . . the breathless crowd had no idea she was there, in danger of death)."[7] And the Matushka case might be framed, on the other side, by a more recent representation of the landscapes, or cityscapes, of corporeality in machine culture. I am referring to the thriller film *Speed*, which provides a virtual inventory of the public vehicles of what might be called stranger-intimacy (the elevator, the bus, the plane, the subway system); in which the only private space represented is the scene of an eerily immaculate and empty home converted into a lethal weapon, exploding when entered; and in which the only erotic coupling takes place in public at the close, in the wrecked subway car that has burst through the LA streets—as if it were the logical outcome of the demolition, one by one by one, of the transport networks crisscrossing the city scene: in effect, demolition as foreplay.

These small examples bring us a bit closer to defining, in a very preliminary fashion, the links between repetitive or machinal violence and the pathological public sphere. Another instance, this time drawn from the burgeoning writing explicitly focused on the scenes of serial murder, can take things a step further. Here is the opening of one recent and relatively unsensationalizing representation of the landscape of serial murder: the California case of the "freeway killer" Randy Kraft (believed to have committed sixty-seven murders from 1972 until his arrest in 1983). This account of the scene of the crime makes conspicuous what might be called a lurid sociobiology. The account centers on the distribution of bodies across constructed landscapes:

> Looking down on southern California from above, the strands of freeway seem to pump from the heart of Los Angeles like contorted veins that twist and knot and stretch out to Santa Barbara in the north, San Bernardino in the east, and as far south as the Mexican border. Only to the west are the freeways missing, sutured off at the coastline so that automobiles don't spill into the brooding Pacific Ocean like so much lost blood.
>
> At daybreak, the freeways brim with slow-moving vehicles, clotting into traffic jams from one end of the megalopolis to the other. At night, the strands glow red and white with the head- and taillights of a million cars oozing homeward.
>
> The rest of the time the freeway system is an open road—an invitation to move unfettered through this dense, smoggy wonderland of subdivision after subdivision. . . . Strange things happen on southern California freeways. Things that happen elsewhere while people are usually stationary.[8]

On this view, the conceptual psychotopography of serial violence, its living spaces, intertwines corporeal and technological systems of circulation, such that blood flows around every axle. Bodies, technologies, and landscapes are thus immediately assimilated to each other.

There is, of course, a century-long history to such descriptions.[9] The *incorporations* of the technological process and the life process have become by now a thoroughly naturalized component of machine culture. One rediscovers here the familiar intersections of natural bodies and technologies, somatic and machinal systems of circulation: the miscegenations of the body and the machine that make up the prosthetic environment of "American nervousness," from the later nineteenth century on. One rediscovers, beyond that, a precise coordination of bodies and spaces. This involves not merely the spectacle of stilled bodies in moving machines, in the relentless and endless commuting "homeward." The strange permeability of bodies and landscapes is mapped onto the strange permeability of homelike and "open" or public spaces. For if things happen on the open road that are normally confined to "stationary places," this means that the home site has here become the anonymously mass-produced "homelike" (a dense "wonderland of subdivision after subdivision"). The nominal "division" between public and private has in effect given way to the unfettered movements that ceaselessly mingle bodies and places: the stationary and the homelike become strange and the freeway system as intimately personated as the violated and opened natural body.

The wild analogism that structures accounts such as this one is not merely a transparency to be "read through." For it is precisely such an exorbitant analogism, it will be seen, that structures the inner experience of serial violence. Serial killing, that is, devolves in part on a violent *literalization* of the analogies between bodies and technologies, persons and landscapes, one identity and another, one body and another, one death and another.

The two large questions that arise at this point concern, then, the *subject* of repetitive violence and the typical *scene* of his crimes. Serial killing, I will be arguing, is inseparable from the problem of the body in machine culture: an intimacy with technology that will be set out in terms of the intersecting logics of seriality, prosthesis, and primary mediation.[10] Yet such a "situating" or "contextualizing" of the serial killer, I suggest, makes for some basic difficulties, not least because a sort of *hyperidentification with place, or context, or situation* seems typical in cases of serial violence. What seems typical in such cases, that is, is the

subject's feeling of a radical determination from the outside in. In the most general terms, this amounts to an utter failure of distance or distinction between subject and scene. Which is to say that typical in these cases is the experience of a deep absorption in typicality itself: the serial killer, it will be seen, typifies typicality, the becoming abstract and general of the individuality of the individual.[11] It is in part the empty circularity this form of personation contains that concerns me here. Such an absorption in typicality is inseparable from an absorption in place, situation, or context. Hence it is not merely that the serial killer is seen as utterly typical: "abnormally normal" or "too normal" or "alarmingly normal," as three recent accounts of the serial killer formulate it.[12] Beyond that, such hypertypicality appears as a function of an utter transparency to context—as a function of the killer's compulsive way of "fading into the background" (SK 83.)[13]

In the pages that follow I want to take up, more centrally, these relays between serial violence and such a pathologized experience of public spaces. What becomes visible in these cases is an extraordinary absorption in place and place making: an absorption in place and place construction that becomes indistinguishable from programs of self-making and self-construction. That is, what becomes visible in these cases (as we will see) are the *reciprocal topographies* of subject and context. The effects of violence and horror precipitated by the radical failure of distinction between subject and place are absolutely crucial in understanding cases of repetitive violence. "Situating" or "contextualizing" the subject of violence is thus one of the components in these cases, and not merely a way of explicating them. It is therefore necessary to test out, and to pressure, the intimacies between subject and position (the inner logic of what is loosely called "subject-position") that surface in serial killing. Such intimacies between the subject and the scene of the crime inflect, at the least, the "new historicist" conviction, or assumption, of the context-made subject. For this reason, I want to proceed somewhat circuitously, mapping out, first, the constitution of the pathological public sphere and tracing, ultimately, a composite picture of what such lethal persons and what such lethal spaces have come to look like.

Atrocity Exhibitions

"As you and I know," the novelist J. G. Ballard writes, in *The Atrocity Exhibition*, "the act of intercourse is now always a model for something else."[14] The body, one might say, always becomes visible as a model for

something else. The something else for which the body increasingly appears as a model is the public sphere, and not merely because the proliferating histories of bodies and sexualities amount to the thrilled exhibition of private bodies and private desires in public. The spectacular public representation of violated bodies has come to function as a way of imagining and situating, albeit in violently pathologized form, the very idea of "the public" and, more exactly, the relations of bodies and persons to public spaces.

Paradoxically enough, public corporeal violence has come to provide one of the most powerful ways of keeping visible the possibility of the shared social spaces of the public sphere itself, albeit a way of conserving that possibility in markedly negative or aversive form. Along these lines, public violence has come to provide one of the most powerful registers of the generalized intimacies with technology (technologies of reproduction, information, and mediation) in machine culture. But it has thus, conversely, become a way of pathologizing the promise of a "democratizing" or a spreading of technology throughout the social body. Such a pathologized relation to technology encodes, in short, a "general fear of mass formation" in the general fear of technology.[15] This has characteristically amounted to the representation of a deepening *opposition* between humanity and machinery at the very moment of their deepest *intimacy*. Rendering pleasure in technology, or at least its shared intimacies and mediations, relentlessly in terms of the public display of destruction and rendering mass formation relentlessly in terms of the pathological public sphere in effect conserves the opposition between the individual and the mass (between private and public) *as* the opposition between humanity and machinery.[16]

These are, at the least, some of the ways in which mass spectacle and mass violence have come to indicate each other in machine culture: the private and natural body has, in unprecedented ways, become publicly relevant. More specifically, the body has insistently become relevant as spectacle or representation—and, most insistently, as spectacle or representation of crisis, disaster, or atrocity. It has by now become commonplace to observe that crisis, catastrophe, accident, and collective destruction center mass-media accounts and, further, that these accounts center on mass corporeal violence: "bodies strewn everywhere." "Catastrophe," as one commentator on the mass media, Mary Ann Doane, has recently expressed it, "is at some level always about the body, about the encounter with death."[17] But centrally, then, the encounters with the body and with death are also encounters with *exhibitions* of catastrophe.

Such encounters have generally been understood in terms of the *loss* of body to spectacle, or (as Doane, among others, has it) in terms of the "removal" or "conceal[ment]" of bodies and death "through representation."[18] What this involves, the story goes, is the "containment" or parrying of death by representation: the distancing of bodily violence by visual technologies. From this perspective, the spectator of media-spectacular violence is in effect transformed into a sort of "noncorporeal mass witness," relatively disembodied in witnessing spectacles of deep and violent embodiment.[19] Clearly, the conferring of a privilege of relative disembodiment makes for part of the fascination with such spectacles. But the relations between bodies and representations in these cases are in fact more complicated. What these cases bring into view is less an opposition between bodies and representations than their radical involution: a basic entanglement of bodily processes and technologies of reproduction and visualization, reproduction and mimesis, that is not simply reducible to, or contained by, the order of representation.

The containment thesis, as a condition of the representation of death, was incisively set out some time ago by Walter Benjamin. As Benjamin expresses it:

> In the course of the nineteenth century bourgeois society has, by means of hygienic and social, private and public institutions, realized a secondary effect which may have been its subconscious main purpose: to make it possible for people to avoid the sight of dying. Dying was once a public process in the life of the individual and a most exemplary one.... In the course of modern times dying has been pushed further and further out of the perceptual world of the living.[20]

Or, as Philippe Ariès has recently summarized it: "the denial of death is openly acknowledged as a significant trait of our culture." Society is "determined to repress the real image of death."[21]

But, as with most logics of repression, a certain ambivalence surfaces in the public processing of death. For one thing, there is a somewhat paradoxical character to such *open* acknowledgments of repression, openly acknowledged secrets that have therefore more the double character of disavowal than of simple denial. Hence, as Ariès also, and somewhat contradictorily, observes: "It is as if one whole part of the culture were pushing America to erase every vestige of death, while another part is holding on to it and keeping death in a place that is still quite visible."[22] One version of this double movement of erasure and visibility appears, of

course, in the tableaux vivants of the American funeral parlor image of death: living images of death that figure centrally in some cases of serial murder.[23]

But this double movement might be understood a bit differently: if the avoidance of death takes the form of an avoidance of "the sight of dying," or the "real image of death," it might be argued that sights of dying and images of death have in fact *flooded* the perceptual fields of the living, from the later nineteenth century on. It might be argued further that if the avoidance of death equals the avoidance of *the sight* of dying, then it is scarcely possible to arrange death and representation, the matter of the body and its images or mediations, simply in the form of an opposition such that each holds the other at bay. What is intimated here instead is a rapport between death and representation, between the body and mechanisms of reproduction and reduplication, that has itself seemed insupportable and necessary to hold at bay.

What is intimated here, that is, is one version of the volatile forms of embodiment and disembodiment in machine culture that I have described in terms of *the double-logic of prosthesis*.[24] What this logic entails is the inseparability of identity in machine culture from a rapport with technologies—particularly technologies of writing, reproduction, and information (*primary mediation*). The containment thesis in effect reduces mimesis or simulation or mediation to a distancing or loss of the real, and reduces the *contagious* relations between bodies and reproductive technologies to distanced or voyeuristic representation. It reduces, in short, disorders of identification to a simple ratification of identity. (This tendency is only the most visible in the range of film theory that programatically reduces modes of seeing to a form of panoptic or voyeuristic objectification.[25]) The containment thesis thus conserves the familiar, and axiomatic, oppositions between the natural and the artifactual, matter and representation, the real and its substitutes. It conserves, that is, a basic opposition between the life process and the machine process: between bodies and technologies.

This is the case even where the prosthetic or "constructed" character of persons and bodies is avowed or endorsed. The avowals of a radical constructionism (the standard formula is "the social construction of x") tend nevertheless to understand the constructedness of persons, bodies, and desires in terms of repression, limitation, or violation. The critique of the naturalness of the natural body, in theory, has tended to mean, in practice, the natural history of its violations.[26] Hence it is necessary to take up both the imperative of construction and the *regressive* appeals to

the body that pressure it. It is necessary to turn from the largely metaphoric and abstracting understanding of construction toward the material constructions and materialized self-constructions that become obtrusive in cases of addictive male violence.[27] These processes of materialization "carry" the passion for construction, and male self-construction, in machine culture and the links between these forms of making and construction. The passion for construction, I will be arguing, takes the form of an assimilation to the machine or the machine-like. (Or, in Ernst Jünger's terms: "we must transfer what is inside us onto the machine."[28]). This takes the form, centrally, of an assimilation to machines for living in.[29]

On one level, this is merely to observe that forms of self-making make explicit a basic disorder in subject formation. As the psychoanalytic theorist Mikkel Borch-Jacobsen argues, identity formation can be understood in terms of the transformations of passionate identifications into claims of identity, such that identification precedes identity and not the other way around.[30] Hence the turning round of identifications into claims of identity might be turned round again: the passion for assimilation may take the form of an assimilation or melting of the subject back into its identificatory sites. In the cases under consideration here, this amounts to an identification with machinal constructs or "housings" for the subject, a process of identification that takes the form, above all, of a melting or fading or vanishing into place. What then governs these relays between place and "place-identity," between popular violence and "the little tactics of the habitat"?[31]

Stranger Killing

Another factor that is almost indispensable to this kind of behavior is the mobility of contemporary American life. Living in a large center of population and living with lots of people, you can get used to dealing with strangers. It's the anonymity factor.

—Ted Bundy[32]

Dress him in a suit and he looks like 10 other men.

—Ann Burgess, psychiatric consultant
on the Jeffrey Dahmer case (on Dahmer)

A day will come when, by means of similitude relayed indefinitely along the length of a series, the image itself, along with the name it bears, will lose its identity. Campbell, Campbell, Campbell, Campbell.

—Michel Foucault, on Andy Warhol[33]

The burgeoning popular writing on serial murder provides a remarkably transparent register of these disturbances, and excitations, of identification and assimilation, and the wild analogism that marks them. One of the governing premises of the popular representation of serial killing is the obsessive analogy, even identification, of writing and corporeal violence: their identification as twin forms of compulsion or addiction. As a lead article in the "Living Arts" section of the New York Times has it: "In the annals of crime, there are serial murderers, and then there are the serial authors. . . . 'Stop me before I write again.'"[34] Such an equation has become familiar enough. But what makes such equations plausible or compelling is perhaps less evident.

The commutability of the scene of writing and the scene of the crime operates on several levels. It operates, most obviously, in the "fit" between criminality and bureaucracies of information-processing: in the ways in which crime and information processing have solicited and ratified each other, from the mid-nineteenth century on.[35] As one study of "crime and information theory" simply summarizes it, the criminal is "an emitter of signals during the commission of a crime."[36] Yet the blurring of the frontier between word counts and body counts extends beyond the "containment" or "coverage" of death and violence by mass media information technologies. This blurring of frontiers is a bit less "functional" and a bit more "gothic" than the containment model tends to suggest.

Consider, for example, a recent piece on serial murder in the pages of Vanity Fair—which I take to be an exemplary article on a number of counts, and not least in its display of that peculiar mixture of moral and feral intentions that seems to animate the media fascination with serial murder. The story is about the work of the FBI agent and serial-killer "hunter" Paul Lindsay. But the article, characteristically, tells two stories at once: the agent's investigations of several cases of serial murder in the Detroit area, but also the FBI's investigation of the agent himself—"His crime: committing fiction. One count of aggravated novel writing."[37] The crime of writing involves something more than the writing of an "insider" book critical of the FBI's Behavioral Science Unit (BSU) and serial-killer task force. One of its targets is the "sort of popular misconception of serial-killer investigation" propagated by the work of ex-BSU agent Robert K. Ressler, himself in turn a model for the agent-savant of Thomas Harris's The Silence of the Lambs. These popular misconceptions are, for Lindsay, "totally fiction" ("FAP," 126). And it is just this conflation of "real police work" and fiction—just such uncanny simulations and failures of distinction—that Lindsay wants to expose ("FAP," 124).[38]

Hence, for Lindsay, the basic antagonism is between "real cops" and "paper-pushing suits," between real work and its simulation by "the suits, the bureaucrats, the paper-pushers" ("FAP," 124). The simple opposition between "real police work" and "paperwork" or "going by the book" is of course one, quasi-automatic version of the practice/theory, bodies/representations, production/simulation chain of oppositions: the metonymic series of oppositions that, characteristically again, turns on the basic opposition between "real work" and mere writing or mere simulation. The policing of these oppositions works on at least two closely related levels. The popular representation of serial violence tends to turn on a fundamental disavowal: a fundamental disavowal of the radical link between technologies of writing and the work process—the linkage that may be said to define machine culture and the Second Industrial Revolution (the information-control revolution) generally, from the turn of the century on.[39] But it turns also then on a disavowal of the mechanisms of simulation or reduplication—the primary mediations—that everywhere traverse cases of serial violence.

The effects of the basic rewriting of the work process—the convergence of information and production in the machine process (production *as* information-processing)—can scarcely be overestimated. Its most basic effect is the convergence of the life process and the machine process as collateral forms of information processing. Such failures of distinction with respect to simulation, reproduction, and substitution appear again and again in cases of addictive or repetitive violence. What surfaces in these cases is the anxiety-producing erosion of the distinction between living and machinal processes: their mutual absorption into the flows of information. The commutability of word counts and body counts provides one register of the way in which the life process and the technological process have come to indicate each other in machine culture: one meaning passes over to the other and feeds on it. Hence the representation of serial violence as a fascinating, albeit insupportable and insistently disavowed, version of what work comes to look like in machine culture.

Popular and professional accounts of serial killing instance again and again the absolute proximities between bodies and representations, implicitly understanding serial murder as a kind of machine work and even a pathologized work ethic. It is not merely that the *Vanity Fair* piece, for example, consistently collates stories of writing and stories of multiple murders. The account is saturated, line by line, with numbers,

statistics, calculations. It is the thick multiplication of instances such as these that becomes significant here: "*Word* spread fast that a serial killer was *at work*. By June the body *count* had climbed to 10 . . . *Two* factors made the Highland Park Strangler disturbingly different from all other serial killers in U.S. history. *One* was his bloodthirsty pace: FBI *statisticians* would later *calculate* he was among the '*fastest-working* serial killers' *on record*, killing at a *pace* (ultimately *11* in *nine* months) that surpassed even that of Ted Bundy" ("FAP," 122; emphasis added). The avalanche of numbers and data that textures such accounts involves, it becomes clear, less the conveying than the signifying of "information."[40]

But it involves something more than the parrying or managing of death and violence through the control technologies of informatics and bureaucratization. What surfaces is the intimacy between the life process and the information process—and the gothicization, or rendering uncanny, of both. This gothic "contagion" appears, for example, in the series of analogies and likenesses that structure such accounts: in the relays between the debris of data "gathering dust in creaky file cabinets" and the debris of bodies, i.e., in the notion that the "real killer might still be buried there in that mountain of tips" ("FAP," 134, 126). It reappears in the equivalences drawn between the subject and the dossier, in the "profiler's" understanding of a person's life in terms of "a file that . . . never close[s]."[41] As Lindsay puts it: "When they started fucking with my cases—which was my life—I thought that was enough" ("FAP," p. 128).

The type-profiling system devised in serial murder investigations posits the serial killer as one of the ideal-typical inhabitants of machine culture: the statistical person. But it is the intimate experience of self-generalization—again, the at once alluring and insupportable experience of a sort of hyper-generalization in typicality—that seems to define the *case-likeness* of these cases. As one of the most influential popular surveyors of the serial murder scene expresses it, the serial killer is a simulated person, "a type of nonperson" (*SK*, 124). As the serial killer Henry Lee Lucas puts it, "a person was a blank" (quoted in *SK*, 124).[42] Or, as the serial killer Ted Bundy experienced such a statistical identity in typicality: "Personalized stationery is one of the small but truly necessary luxuries of life."[43]

The sociologist Georg Simmel approached a description of this strange form of intimacy in his account of "the stranger" in modern urban society. The strangeness of the stranger, as Simmel traces it, is not his otherness, but rather his close "spatial relations" that are yet marked by "remoteness": he is a neighbor but yet without particularized "human

relations."[44] An embodiment of an uncanny spatial relation, the stranger's "strangeness means that he, who also is far, is actually near" ("S," 402). That is, the stranger's "connecting forces" are *general* qualities in common," such that "the feeling of uniqueness vanishes from the relationship" and is assimilated to an estranging similarity or generalization ("S," 405, 406). Strangeness, for Simmel, is thus "caused by the fact that similarity, harmony, and nearness are accompanied by the feeling that they are not really the unique property of this particular relationship; they are something more general, something which potentially prevails between the partners and an indeterminate number of others, and therefore gives the relation . . . no inner and exclusive necessity" ("S," 407). The stranger, if not (quite) yet the statistical person, begins to make visible the uncanny stranger-intimacy that defines the serial killer: the "deliberate stranger" or "the stranger beside me."[45] On this view, the fascination generated by the serial killer is bound up through and through with the uncertain and rival determinations of the individuality of the individual. At one extreme, the "abnormal normality" of the serial killer, utterly absorbed in psychotic fantasies, appears as a sort of reservoir of the psychic order itself—"the psycho," or something like the drive in person. At the other, the "too normal" character of the serial killer appears as nothing but the social determination of the individual from the outside in: something like the mass in person.[46]

Now the genre-term "serial killing" has, of course, generally replaced the earlier designation "stranger-killing." The replacement in terms is in itself telling. The shift in terms registers a progressive migration or inflection in the understanding of "impersonal" violence—a shift in the understanding of the conditions of personation and impersonality. The brutality of serial violence is consistently linked to its impersonality, as if its brutality consists above all in the feeling of sheer typicality: in the substitutability of one for "an indeterminate number of others." As a recent criminological study of serial murder summarizes it: "One of the most brutal facts of serial murder is that it usually involves the killing of one person by another who is a stranger. There need be no motives of hatred, rage, fear, jealousy, or greed at work; the victim need not have taunted, threatened, or abused the killer" (*SM*, 24).

The accretion of negatives in such accounts (no motives, no relations) makes the case for the notion of serial killing as "motiveless" crime. What this involves is a transfer of motive from psychology to typicality *tout court*: the "serial killer typically has a conscious goal of eliminating a particular group or category of people" (*SM*, 57). The classification of "the types of

serial murder in modern society" (characteristically: the "visionary type," the "mission-oriented type," the "hedonistic type," the "power/control oriented type") often appears in terms of an achievement in the possibilities of coding and typology as such (*SM*, 56, 57, 58, 59).[47]

Stranger Intimacy

This exorbitant typicality seems inseparable from two forms of identification or over-identification: the subject's over-identification with others and the subject's over-identification with place. For one thing, "stranger-killing" depends on an intimacy with others that depends in turn on the proximities of statistical persons in statistical communities, on the logics of equivalence and phantasmagorias of equality generated in the mass-mediated consumer public sphere.[48] The phantasmagorias of equivalence in the statistical agora induce (as Simmel's account broaches) forms of stranger-intimacy. Or, better, they induce an anxious renegotiation of interior distances and proximities.[49] To the elementary forms of statistical life, then, "[o]ne response was a growing sense of unity among people formerly isolated in distance and lack of communication. This was not, however, unambiguous, because proximity also generated anxiety—apprehension that the neighbours were seen as getting a bit too close."[50] The strange resemblance among strangers makes self-identity indistinguishable from identification with others, and inseparable from media-facilitated processes of imitation, simulation, and identity-contagion. This is the psychic process of subject-formation that Mikkel Borch-Jacobsen (following Lacan) describes in terms of a *primary identification* and that I have, focusing on the transferential relation to technologies in these cases, described in terms of a *primary mediation*.

For this reason, it is not a matter of "choosing" between psychic and social determinants of the subject: the uncertain translation of processes of (other)identification into claims of (self)identity foregrounds the rivalrous claims of the internal and external, psychic and social. What must be emphasized then is the manner in which the experience of this incoherence—the subject's radically uncertain formation from the inside out or from the outside in—lends itself to forms of agonistic violence. What becomes visible is the excruciated crossing of the subject's social interest in *having* a social interest and the subject's self-interest in *protecting* its nonsociality or autonomy: "I am not myself and . . . my most proper being is over there, in that double who enrages me." "No doubt the double is loved, since I love myself in him; but that is also why he provokes hatred

and hostility, precisely inasmuch as he is close to me, too close." In the community of strangers the apprehension of the too-closeness of neighbors provokes stranger violence: "'To love one's neighbor as oneself' is no doubt the shortest route to cutting his throat." [51]

The overidentification with others induces, in the statistical communities of machine culture, its typical forms of violence. Or, rather, the forms of typicality that are facilitated, or exacerbated, by machine culture make for the translation of the general problematic of over-identification into particular programs of type-violence. From the later nineteenth century on, the over-identification of the subject has been understood in terms of the "social determination of the self": an identification of identities with "the social." The becoming-normative of the notion of cultural or social determination is clear enough. But its normalization has perhaps made the assumption of social determination a bit too self-evident.

Over-identification, that is, is experienced in terms of a feeling of *oversocialization*. In a recent study of the Victorian serial killer Dr. Thomas Neill Cream, for instance, the historian Angus McLaren argues against the notion that such killers are rebels or outlaws. McLaren argues instead that their actions "were determined largely by the society that produced them." Hence the serial murderer is "likely best understood not so much as an 'outlaw' as an 'oversocialized' individual who saw himself simply carrying out sentences that society at large levelled" (in this case, among others, leveled against "rebellious females").[52] But it is possible to understand the notion of over-socialization somewhat differently, as something more complicated than the subject's internalization of social "roles." That is, it is possible to understand the notion of the *determination* or *production* of the individual by "society" as involving a more complex relation of the subject to his situation or *being-in-context*. As another social historian observes, in commenting on the case of the presidential assassin Charles Jules Guiteau: "It has frequently been noted that the delusional systems of the mentally ill have a chameleon-like quality, an ability to find themes, tunes, specific menaces in the atmosphere and events of their times."[53] Or, as Joel Norris describes "the chameleon-like demeanor of a traditional serial killer," their "chameleon-like ability to blend in with their background": "*Like a* Bundy or *a* Long, he could blend into any group quickly. He could *actually become* the significant other of any person he met ... [and] he was constantly changing from second to second, becoming anybody he wanted to be" (*SK*, 165, 229, 165; emphasis added). It is this *chameleon-like quality* that can perhaps help to define the pathogenic aspect in these cases of over-identification:

an over-identification with respect to others that folds into an over-identification with respect to place or context itself. These likeness or similarity effects (persons as indefinite articles or nonpersons: "like a Bundy or a Long"—or the redundancy of the chameleon-*like* itself) perhaps provide evidence of something more than a tendency toward dissimulation. They make visible the disorders of similarity and identification, and the latent violences, of what might be called *the mimetic compulsion.*

Melting into Place

> He's the kind of guy . . . who probably goes to work every day. Maybe he does something with statistics. An Accountant or a clerk. He just kind of melts into the city scene.
>
> —Tim Dowd, New York City Police Commissioner,
> "Son of Sam" profile[54]

The mimetic or "imitative" character of serial criminals has frequently been noted. Frequently noted as well is the "redundant" character of serial violence, i.e., a redundant violence that has routinely been described as a tendency toward "over-kill" (see *SM*, 46; *SK*, 216–19). What becomes apparent is a hypertelic violence, exceeding its function or purpose—or, at least, exceeding the end of ending life. The chameleon character of these crimes takes the form of such an exorbitant, or extra-functional, drive: a drive toward likeness itself. It enacts a hypertelic imitation not merely of an indeterminate number of others but also of the determining conditions of place. That is, it enacts, chameleon-like, the subject's assimilation to ground: his melting into or fading into or being devoured by space.

The descriptions of the recent case of the Detroit serial murderer and his investigators provides a way of further specifying these imbricated relations of subject and space. The tabloid-style account, we have seen, is typically structured by a ramifying series of analogies, such that, by the logic of a sympathetic magic—"like produces like"—analogy or likeness operates as productive cause. This appears as a sort of imitative contagion: these accounts proceed by way of a species of magical thinking by which bodies and imitations or likenesses reciprocally indicate each other. One detects throughout such stories of serial violence, for example, a series of promiscuous substitutions between bodies and representations (e.g., the book that "will cause bodily harm to the image of the FBI"); between the serial consumption of visual spectacles and repetitive acts of violence (e.g., "serial viewing of these death scenes has a powerful

... effect"); between, most literally, ink and blood (e.g., the desire "to capture in cold print" the real work of detection); between, most excessively, the processing of information and the life process itself (e.g., the FBI as a kind of vampire, "as a relic ... living off past successes") ("FAP," 124, 132, 124).

This promiscuous analogism operates by way of the logic of substitution and simulation that everywhere inhabits the milieu of addictive violence.[55] Such a logic of simulation—conflating bodies and writing, the subject and the ground of representation—issues in an excessive literalization. It issues, that is, in the materialization of writing itself, such that writing and bodies and places stand in for each other. For one thing, the incantation of resemblance makes for an uncannily "graphic" representation of landscape or place. In the Detroit case, for example, the scene of the crime under investigation is a "strange little place" (one of the few places given a name in the piece), "a little urban hamlet called Inkster" ("FAP," 126, 124). The magical equivalence of writing, bodies, and scenes could not be *literalized* in more graphic fashion than in the incarnation of a place named Inkster.

The merger of bodies and scenes could not be *realized* in more gothic fashion than in the astonishing account of the physical situation of the bodies discovered in abandoned motel rooms. In each case, "the body had been so thoroughly transformed by the damp, fetid air that nothing was left but an efflorescence of mold, 'a kind of white shape where the body had been' ... the spectral efflorescence that once had been a body" ("FAP," 127, 132).[56] The manias of simulation and assimilation that occupy the imaginary of serial murder are perfected in this substitution and assimilation of body to place. The devouring force of the scene of the crime makes visible, in the spectral outline of the white shape, the sheer transparency of body to scene. It figures the violent becoming-transparent of the subject (criminal or victim) to his or her milieu. It figures the subject of violence melting into the city scene—absorbed, or eaten up, by space.

The lethal absorption in place is nowhere clearer than in the representation of such quasi-domestic environments: these home*like* motel and hotel spaces. This is the description of the larger scene of one of the Detroit serial killings we have been looking at:

Highland Park, an urban enclave just north of the Detroit city line, had once been home to auto moguls who built stately mansions there and housed the overflow of weekend guests in the then elegant Monterey on

Woodward Avenue [where the corpses were found]. But by the time the 90s dawned, the avenue had turned into a hellish corridor of crack-addicted hookers trading their ravaged bodies for rocks to smoke, drifting in and out of refuse-choked abandoned buildings like the Monterey, which the city was too poor to tear down. And now someone was checking another kind of guest into the Monterey. ("FAP," 122)

Detroit is, of course, the prototypical site of postindustrial violence: motor city transformed into murder city. If the Matushka case of railway-system violence realizes something like the modernization of murder and its typical scenes in machine culture, this "bombed out" postindustrial and post-Fordist cityscape realizes something like its postmodernization. This registers, above all, in the dissolution of private and public "lines" of demarcation, in the "hellish corridors" traversing places neither private nor public, in the abject homelessness of "ravaged bodies" drifting through the corridors of abandoned urban spaces. The hotel district initially "housed the overflow" of what had "once been home" to the auto producers. But the domestic "enclave" itself has become outmoded, and these homes away from home have given way to the consumption-and-addiction economies of the pathological public sphere.[57]

This breach of boundaries is experienced as the deep horror of these crime scenes: "the *real* horror is this: the reeking, bombed out skeletons of housing the victims *died* in were, for the most part, the same places they had *lived* in" ("FAP," p. 132). The breaking of these boundaries utterly collapses the feeling of distinction between subject and surroundings—a collapse concisely registered, for instance, in the prosthetic architecture of "the skeletons of housing." Most fundamentally, it dissolves identities into place, leaving, ultimately, only "the spectral efflorescence that once had been a body."

There is, in the experience of serial killing, a compulsive location of the scene of the crime in such homes away from home—hotel and motel spaces as murdering places. This is one indication of the radical redefinition of "the homelike" on the American scene: not exactly "no place like home," but rather only places "like" home. If stranger-killing is premised on a fundamental typicality, then the making of what came to be called, at the turn of the century, American "hotel-civilization"[58] is premised on the mass replication of ideal-typical domestic spaces ("a smoggy wonderland of subdivision after subdivision"). It is premised, that is, on the uncanniness (unhomelikeness) of the domestic as such (an uncanniness perhaps inseparable from the psychic shocks of the machine culture of

mass-reproducibility). Hence the repeated location of American serial violence in hotel and motel hells: the murder motel in Robert Bloch's novel *Psycho*, for example (the novel on which the 1960 Hitchcock film is based), or the even more lethal tourist hotel in his subsequent novel, *American Gothic*.[59] But, for the moment, I want to conclude by setting out one final, and basic, constituent of the compulsive and violent lure of place that recurs in episodes of serial murder.

The Mimetic Compulsion

Consider these two very different, but ultimately complementary, ways of constructing and representing scenes of serial violence. First: The *scenes of the crime* make up the premises of the serial-killer task force's vaunted (albeit generally ineffective) *profiling system*. These scenes provide the basis for drawing, or, more properly, codifying, the typical and composite outline or "profile" of the killer. Scene and profile thus are seen exactly to image each other. From the bodily outline drawn on the surface of the scene of the crime, a kind of white shape on the ground where the body had been, what progressively emerges is the outlined shape of the killer, his composite portrait or statistical picture.[60]

Second: The Jack the Ripper exhibition in Madame Tussaud's London wax museum is a Chamber of Horrors installation opened only in April 1980 (commemorating the "second wave" of serial murder). The exhibit includes no effigy of Jack the Ripper himself, masked or otherwise. This centering absence has to do, of course, with his storied anonymity (from the start, a projective surface for all sorts of stories). But it has perhaps more to do with the pathogenic style of that anonymity. As tabloid coverage of the exhibit reported, the Ripper was "nowhere to be seen." Or, rather, he is seen only spectrally, as an obscure shadow or dark shape minimally but therefore dispersively on the scene. What makes up the exhibit—in addition to the bodies of his victims, who *are* represented—is the *locale* of the crime: the exhibit is called "The Jack the Ripper Street."[61]

Foregrounded in both these representations of serial killing, the BSU profile and the mimetic house of horrors, is thus an emergence from, and merging back into, milieu or ground. This intimates that, if the agent of violence is imagined as the oversocialized individual, then one way of imagining this oversocialization is in terms of a radical failure of distance with respect to context. Such a failure of distance is realized in the subject's absorption into "background." Most generally, the formation of the

modernist self through the "impact" of external conditions ("the determination of the individual by the social context that produces him") posits the subject determined from the outside in (in effect, the subject in a state of shock). More locally, the profile of the killer emerging from the scene of the crime, the merging of the killer back into context or locale: we might describe these transferences between persons and scenes as the subject's emergency conditions. These transferences devolve on a minimalist distinction between the subject and dark space—the minimalist representation of the killer that defines, for instance, the cinematographic formula, and the terrible and deadly places, of the film noir.[62]

What comes into view in such cases is a "gothic" rapport between persons and places. That rapport consists in an affinity between person and habitat such that degrees of aliveness are distributed across living, or semi-alive, spaces. One discovers in such semi-animate environments, however, something more than a gothic "homology thus established between subject and space."[63] The tendency toward identification involves something more than a homology, or structural similarity, between distinct identities associated by likeness. One detects in the tendency toward resemblance a basic nondistinction. What marks these cases, above all, is the "reciprocal topography" of persons and places: a reciprocal provocation to identity such that self-construction or self-realization becomes indistinguishable from habitat-construction. What must be analyzed, then, is a generalized failure of distinction between subject and space, a failure of distinction which means that forms of personation (self-making) are scarcely separable from a radical depersonation (self-absorption in space). This is, in brief, the assimilation of the subject to dark spaces: a chameleon-like melting or fading into place that is experienced at once as the lure of anonymity (disguise or impersonation) and as the threat of anonymity (impersonation as impersonality: the serial killer as "nonperson").

Emerging here is something like a mimetic drive or compulsion. The gift of "seeing resemblances," Walter Benjamin observed, in a very brief essay of 1933, is nothing other "than a rudiment of the powerful compulsion in former times to become and behave like something else."[64] The logic of this compulsive identification is further defined in an essay written several years after Benjamin's: the surrealist/sociologist Roger Caillois's extraordinary speculations on imitation as a form of automatism and as a form of pathology. Caillois theorizes the imitative drive as a sort of primary mimesis on the level of the life process. This is a mimetic drive anterior to the order of the subject (Caillois's examples are drawn primarily from the

species of the insect order). Caillois, in brief, locates this drive in terms of a hyperidentification with others (being "like" everyone else). But this takes the form, above all, of a hyperidentification with physical ground or context. What this involves is "the generalization of space at the expense of the individual": that is, the failure of distinction "between the organism and its surroundings."[65] The imitative mechanism, a sort of likeness machine, undermines the subject's feeling of singularity.[66] The tendency toward imitation, on this account, extends beyond the protective mimic-ries of camouflage to a tendency toward simulation. The tendency toward similarity exceeds its life function (the function of preserving life); more exactly, the automatistic (tropic) character of the *attraction by milieu* means that "life takes a step backward" ("MLP," 30). This amounts to a sort of corporeal mimesis: a "photography at the level of the object." In Caillois's astonishing formulation: "He is similar, not similar to some-thing, but just *similar*" ("MLP," 23, 30).[67]

Such a centering on the attraction to milieu makes possible a recon-sideration of the individual's attraction to context and "social context" as such. For our purposes, there is, at the least, a compelling relation between the assimilation to space in the condition of psychasthenia and the conditions of place identity solicited by what I have described as the pathological public sphere. There is a good deal more to be said about these convergences of the radical experience of contextualization and the experience of devivification. But for the moment it is possible merely to indicate some of the lines of that convergence. Caillois's account of the decline in the feeling of personality programmatically focuses on an order of life and an order of mimesis and identification anterior to the formation of the subject (the insect order). But his social entomology posits something a bit different. It posits, from the different point of view, not merely the psychasthenic *vanishing* of the subject in identification but also the *emergence* of a different order of the subject through identification.

This new order of the subject of violence is perhaps most provocatively delineated by Klaus Theweleit, in his investigations of the "fascist" male or "soldier male" and his logic of killing for pleasure. The formation of the ego has generally been understood (reprising Lacan) in terms of the consolidation of the boundaries of the subject through the fantasy of the secured and "armored body."[68] But this "psychic" model of subject for-mation might be shifted in the direction of the radicalized experience of "social" organization in the subject of violence. Here is Theweleit's sum-mary of what he calls the "social ego":

The "ego" these processes seem to produce is admittedly a particularly peculiar formation: it can certainly not be conceived as a psychic agency pertaining to the person. It has, rather, to be understood as a social ego, a muscle-armor that is merely borrowed, painfully drilled into and fused onto the individual. An ego of the kind described seems likely to be incapable of escaping the danger of immediate fragmentation on contact with living life, unless it is inserted into some larger social formation that guarantees and maintains its boundaries. Any social organization, from the family to the army, might fulfill this function, as long as it functions as . . . a "totality." . . . The "ego" described here is unremittingly dependent on external support; if it breaks down, the ego in turn disintegrates.[69]

This is then not exactly the psychic armored ego but, instead, the social ego, formed from the outside in: its social substitute skin forming its insect-like exoskeleton. And this is exactly the ego of the kind one finds described, again and again, in accounts of the serial killer. If the serial killer, as we have seen, "fades back," chameleon-like, "into society," he seems to depend utterly on the support of this social exoskeleton. As Joel Norris, among others, expresses it, the serial killers have "no internal structure to their lives . . . the killers amalgamate the rules system of the institution as a form of external skeleton" (SK, 37). The serial killer's abnormal normality, his "uncanny knack for becoming invisible and fading into the background," thus seems inseparable from this peculiar style of oversocialization (SK, 83). The serial killers, that is, are seen to require "a kind of behavioral skeleton—much like an insect—to provide an architecture for their fantasies and a structure to the violence that informs their conscious existence" (SK, 216). This is, in short, the formation of the killer with a machine-like or devivified periphery: the man whose interior has lost its meaning in its utter dependence on the mechanical drills relentlessly binding him to external and social forms.

The Dutch novel *Het Gouden Ei* (*The Golden Egg*) (1984) provides one of the most astonishing contemporary analyses of sexual serial killing: its landscapes, its fascinations, and its motivations. Its *landscapes* are the anonymous crowd scenes of tourist and mass culture: its auto routes and fuel stops and post offices and public homes away from home, a "Milky Way of wrappings and empty cigarette packs stretching all the way to the pumps."[70] The *fascinations* of stranger-intimacy it incites are mediated by endless enumeration, counting, quotation, and copying; picture albums, maps, photographs, news clippings, mass-produced "identification" bracelets. The *motivation* of stranger-killing becomes inseparable from the

possibility of absolute "ownership." But this is an ownership that, in turn, becomes inseparable from the terrifying pleasures of an endless replication: "Another time he had needed a quote from a book that he couldn't find right away but knew she also owned. As he dialed her number he suddenly remembered where his own copy was, but later he had called her anyway. And as she dictated the passage to him, and he read along in his own copy, he experienced a frightening pleasure" (V, 12). Finally, these mediated intimacies devolve on a drive toward absolute identification, a drive toward identification that emerges as the logic of stranger-killing: not merely the singling out of one from an indeterminate number of others, but also the drive "to be one with her" (V, 26). Hence we rediscover the compulsion to extend "likeness" or similarity into identity: "Saskia was the only one with whom he had really wanted to be *one*—" (V, 12). And thus the "rare moments" of primary identification induce at the same time the excitations of a primary mimesis: "only the exciting awareness remained that he was imitating something" (V, 99).

If this novel of stranger-killing thus foregrounds the pleasures and horrors of sheer identification, the devouring by space and the devouring by others, then the prolonged opening and closing shots of the first film version of the novel, the Dutch film *The Vanishing*, provide an incisive (and extraordinarily Cailloisian) way of figuring these pleasures and horrors. The opening shot gradually brings into view a barely visible stick insect, "playing dead" in its vanishing into its background; the closing shot brings into view the surreal insect figure of "sex-death," the praying mantis. It is the uncanny logic of this way of framing the inner experience of serial killing that I have been tracing.

Notes

1. Colin Wilson and Patricia Pitman, *Encyclopedia of Murder* (New York: Putnam, 1962), pp. 382–83. See also Wilson, *A Criminal History of Mankind* (New York: Putnam, 1984), p. 608.

2. See Mark Seltzer, *Bodies and Machines* (New York: Routledge, 1992). Wolfgang Schivelbusch, *The Railway Journey: The Industrialization of Time and Space in the 19th Century* (Berkeley and Los Angeles: University of California Press, 1986), pp. 128–33; Sigmund Freud, *Beyond the Pleasure Principle*, Vol. 18, in *The Standard Edition of the Complete Psychological Works of Sigmund Freud*, trans. and ed. James Strachey, 24 vols. (London: Hogarth, 1953–74), pp. 12–13; Freud, *A General Introduction to Psychoanalysis*, trans. Joan Riviere (New York: Pocket, 1953), p. 285; Walter Benjamin "The Work of Art in the Age of Mechanical Reproduction," in *Illuminations:*

Essays and Reflections, trans. Harry Zohn, ed. Hannah Arendt (New York: Schocken, 1969), pp. 238–42.

3. Michel Foucault, "The Dangerous Individual," in *Michel Foucault: Politics, Philosophy, Culture: Interviews and Other Writings 1977–1984*, trans. Alan Sheridan et al., ed. Lawrence D. Kritzman (New York: Routledge, 1988), p. 144; see also, Foucault, *Discipline and Punish: The Birth of the Prison*, trans. Alan Sheridan (New York: Pantheon, 1977), pp. 304–308.

4. Adolphe Quételet, quoted in Ian Hacking, "Nineteenth-Century Cracks in the Concept of Determinism," *Journal of the History of Ideas* (July–September 1983): 469; see also Hacking, *The Taming of Chance* (Cambridge: Cambridge University Press, 1990), p. 105.

5. See Hacking, *The Taming of Chance*, esp. chaps. 12, 13, and 14.

6. Gilles Deleuze and Félix Guattari, *Anti-Oedipus: Capitalism and Schizophrenia*, trans. Robert Hurley, Mark Seem, and Helen R. Hunt (Minneapolis: University of Minnesota Press, 1983), p. 294.

7. Émile Zola, *La Bête humaine*, trans. Leonard Tancock (Harmondsworth, UK: Penguin, 1977), pp. 55, 56.

8. Dennis McDougal, *Angel of Darkness* (New York: Warner, 1991), p. xi.

9. Consider, for example, Walter Rathenau's description of the modern metropolis: "In their structure and mechanics, all larger cities of the white world are identical. Situated at the midpoint of a web of rails, they shoot their petrified street-threads over the countryside. Visible and invisible networks of rolling traffic crisscross and undermine the vehicular ravines and twice daily pump human bodies from the limbs to the heart. A second, third, fourth network distributes water, heat, and power, an electrical bundle of nerves carries the resonances of the spirit." Walter Rathenau, *On the Critique of the Times* (1912), quoted in Peter Sloterdijk, *The Critique of Cynical Reason*, trans. Michael Eldred (Minneapolis: University of Minnesota Press, 1987), p. 436.

10. In the following chapters, I take up more directly than I will here the complex relays between accounts of serial murder and the more general questions of shock and trauma, mass-mediated violence, and the repetition-automatisms at work in "addictive" murder. I will also discuss in detail the assumptions about gender and sexual difference that become visible in these cases and in popular and professional accounts of serial killing. Suffice it to note here that one of the governing popular assumptions about serial killing is the assumption that serial killers are almost invariably white males, despite the fact that the percentage of known black male serial killers is closely comparable to their proportion in the U.S. population as a whole (the estimates run from 13 percent to 16 percent) and despite the fact that perhaps 10 percent to 15 percent of known American serial killers are women. The construction of serial killing as "femicide" and as a Hannibal Lecter-style crime of awry intellection goes some way in accounting for

these reverse biases. For a compelling account of a black male serial killer, the Seattle area murderer, George Russell Jr., see Jack Olsen, *Charmer: A Ladies' Man and His Victims* (New York: William Morrow, 1994). There is an extensive range of work on serial killing as male femicide; see, for instance, Jane Caputi, *The Age of Sex Crime* (Bowling Green: Bowling Green State University Popular Press, 1987); Deborah Cameron and Elizabeth Frazer, *The Lust to Kill: A Feminist Investigation of Sexual Murder* (New York: New York University Press, 1987); Deborah Cameron and Elizabeth Frazer, "Cultural Difference and the Lust to Kill," in *Sex and Violence: Issues in Representation and Experience*, ed. Penelope Harvey and Peter Gow (New York: Routledge, 1994), pp. 156–71; Deborah Cameron, "Still Going: The Quest for Jack the Ripper," *Social Text* (Fall 1994): 147–54; Jill Radford and Diana E. H. Russell, ed. *Femicide: The Politics of Woman Killing* (New York: Twayne, 1992); Lynda Hart, *Fatal Women: Lesbian Sexuality and the Mark of Aggression* (Princeton: Princeton University Press, 1994); Helen Birch, ed., *Moving Targets: Women, Murder and Representation* (Berkeley and Los Angeles: University of California Press, 1994). See also Robert R. Hazlewood and John E. Douglas, "The Lust Murderer," *FBI Law Enforcement Bulletin* 49:4 (1980); and Belea T. Keeney and Kathleen M. Heide, "Gender Differences in Serial Murderers: A Preliminary Analysis," *Journal of Interpersonal Violence* 9 (September 1994): 383–98. For an astute and generally reliable reassessment of the institutional, governmental, and media "constructions" of serial murder along these racial and gender lines (and for an account of the statistics cited earlier in this paragraph), see Philip Jenkins, *Using Murder: The Social Construction of Serial Homicide* (New York: de Gruyter, 1994).

11. See my *Bodies and Machines* (New York: Routledge, 1992), especially part 3, "Statistical Persons," pp. 91–118.

12. McDougal, *Angel of Darkness*, p. xiii; Joel Norris, *Serial Killers: The Growing Menace* (New York: Doubleday, 1988), p. 80, hereafter abbreviated *SK*; and Brian Masters, *Killing for Company: The Story of a Man Addicted to Murder* (New York: Random House, 1993), p. 254.

13. See also Joel Norris, *Jeffrey Dahmer* (New York: Pinnacle Books, 1992), pp. 186, 291.

14. J. G. Ballard, *The Atrocity Exhibition* (San Francisco: Re/Search, 1990), p. 77.

15. Klaus Theweleit, *Male Bodies: Psychoanalyzing the White Terror*, vol. 2 of *Male Fantasies*, trans. Erica Carter and Chris Turner (Minneapolis: University of Minnesota Press, 1989), p. 201.

16. On technology and mass formation I am here drawing on Theweleit, *Male Bodies*, pp. 200–201.

17. Mary Anne Doane, "Information, Crisis, Catastrophe," in *Logics of Television: Essays in Cultural Criticism*, ed. Patricia Mellencamp (Bloomington, IN: Indiana University Press, 1990), p. 233.

18. Ibid.
19. Michael Warner, "The Mass Public and the Mass Subject," in *The Phantom Public Sphere*, ed. Bruce Robbins (Minneapolis: University of Minnesota Press, 1993), p. 250. Along these lines, see Lauren Berlant, "National Brands/National Body: *Imitation of Life*," in *Comparative American Identities: Race, Sex, and Nationality in the Modern Text*, ed. Hortense J. Spillers (New York: Routledge, 1990), pp. 110–140.
20. Walter Benjamin, "The Storyteller: Reflections on the Works of Nikolai Leskov," in Arendt, *Illuminations*, pp. 93–94.
21. Philippe Ariès, *The Hour of Our Death*, trans. Helen Weaver (New York: Oxford, 1991), pp. 580, 593.
22. Ibid., p. 596.
23. For instance, in the stylized *nature morte* exhibitions—torn between enshrinement and desecration—constructed by the British serial killer Dennis Nilsen (see Masters, *Killing for Company*, esp. pp. 105–38) and by the American serial killer Jeffrey Dahmer (see Norris, *Jeffrey Dahmer*). There is, as I will be setting out in the next chapter, a drive in a number of cases of serial murder to reproduce living images, often in taxidermic form, that makes up what is called the killer's "signature."
24. On "the double-logic of prosthesis," see chapter 2. See also my *Bodies and Machines*, especially "Introduction: Case Studies and Cultural Logistics," pp. 1–21, and part 5, "The Love-Master," pp. 147–72. The more general implications of the logic of prosthesis are further developed in my "Writing Technologies," *New German Critique* 57 (Fall 1992): 170–81.
25. For a similar critique of this by now semi-automatic, and implausibly reductive, account of the spectatorial position, see Slavoj Žižek, *Metastases of Enjoyment: Six Essays on Woman and Causality* (London: Verso, 1994), pp. 73–75.
26. On the vicissitudes of constructionism, see Judith Butler, *Bodies That Matter: On the Discursive Limits of "Sex"* (New York: Routledge, 1993), pp. 6ff. Through a circular detour, the constructionist argument in effect renaturalizes the body. That is, if the large metaphor of "construction" continues to ground, and serves to ratify, a wide range of accounts of the history of the body, the afterlife of the body continues to "ghost" these accounts.
27. I am referring not merely to those prominent cases of serial killers who are also building contractors—for instance, the Chicago case of John Wayne Gacy or the 1994 English case of Frederick West—but also, more generally, to cases in which the imperatives of self-construction or self-invention and material construction or material invention dramatically ratify each other: for example, in the extraordinary career of the 1890s serial killer H. H. Holmes, the subject of "Lethal Spaces" below.
28. Ernst Jünger, *Feuer und Blut: Ein kleiner Ausschnitt aus einer grossen Schlacht* (Stuttgart, 1960), p. 84.
29. That is, an assimilation to the habitats of machine culture, not in the sense

of a modernist *functionalism* but, rather, in the undersense of a compulsive and violent *identification*.

30. See Mikkel Borch-Jacobsen, *The Freudian Subject*, trans. Catherine Porter (Stanford, CA: Stanford University Press, 1988); and Catherine Clément, *The Lives and Legends of Jacques Lacan*, trans. Arthur Goldhammer (New York: Columbia University Press, 1983).

31. The quoted phrases are from, respectively, David Harvey *The Condition of Postmodernity: An Enquiry into the Origins of Cultural Change* (Oxford: Basil Blackwell, 1990), p. 302; and Michel Foucault, "The Eye of Power," *Power/Knowledge: Selected Interviews and Other Writings, 1972–1977*, trans. Colin Gordon et al., ed. Colin Gordon (New York: Pantheon, 1980), pp. 149.

32. Bundy, quoted in Stephen G. Michaud and Hugh Aynesworth, *The Only Living Witness* (New York: New American Library, 1983), p. 324.

33. Michel Foucault, *This Is Not a Pipe*, trans. and ed. James Harkness (Berkeley and Los Angeles: University of California Press, 1983), p. 54.

34. Alessandra Stanley, "For Joe McGinniss, Another Grisly Killing Means Another Book," *New York Times*, 1 October 1991, p. C11, city edition.

35. Marie-Christine Leps, *Apprehending the Criminal: The Production of Deviance in Nineteenth-Century Discourse* (Durham, NC: Duke University Press, 1992).

36. Robert K. Ressler, Ann. W. Burgess, and John E. Douglas, *Sexual Homicide: Patterns and Motives* (Lexington, MA: D.C. Heath, 1988), p. 9. See M. Willmer, *Crime and Information Theory* (Edinburgh: University of Edinburgh, 1970).

37. Ron Rosenbaum, "The FBI's Agent Provocateur," *Vanity Fair*, April 1993, 124; hereafter abbreviated "FAP."

38. Conveniently enough, Ressler's account (with Tom Shachtman) of the creation of the BSU carries as its frontispiece a reproduction of Blake's *The Great Red Dragon and the Woman Clothed with the Sun* and this dedication: "For Bob Ressler with best wishes, Francis Dolarhyde and Thomas Harris." (Ressler and Tom Shachtman, *Whoever Fights Monsters* [New York: St. Martin's, 1992], p. [ii]). Dolarhyde is the fictional serial killer self-identified with Blake's Red Dragon in Harris's novel. See Thomas Harris, *Red Dragon* (New York: Dell, 1981).

39. See my *Bodies and Machines*, and "Writing Technologies"; on the Second Industrial Revolution, see James R. Beniger, *The Control Revolution: Technological and Economic Origins of the Information Society* (Cambridge, MA: Harvard University Press, 1986).

40. On the "avalanche of numbers" in statistical communities, see Ian Hacking, "Biopower and the Avalanche of Numbers," *Humanities and Society* 5 (Summer/Fall 1983): 279–95. The normative connections between numbers and body counts and information processing are evident enough in the

criminology of serial murder. For example: "It must be recognized that the very nature of serial murder tends to pose difficulties when we try to do systematic counting and tabulation." In the Green River case, "the task force included 46 full-time police officers in a search involving 200 suspects. About 2000 pages of paperwork were being generated daily and the operational costs were running $2 million per year." (Ronald M. Holmes and James De Burger, *Serial Murder. Studies in Crime, Law and Justice,* vol. 2 [Newbury Park, CA: Sage, 1988], p. 20; hereafter abbreviated *SM*). Not surprisingly, the CNN 1993 prime-time series on serial murder was called *Murder by Numbers,* the title lifted from Grierson Dickson, *Murder by Numbers* (London: Robin Hale, 1958).

41. Foucault, *Discipline and Punish,* p. 227.
42. See also Mike Cox, *The Confessions of Henry Lee Lucas* (New York: Pocket, 1991).
43. Bundy, quoted in Ann Rule, *The Stranger Beside Me* (New York: New American Library, 1980), p. 221.
44. Georg Simmel, "The Stranger," *The Sociology of Georg Simmel,* trans. and ed. Kurt H. Wolff (Glencoe, IL: Free Press, 1950), p. 402; hereafter abbreviated "S."
45. These are the titles of two best-selling books on the case of Ted Bundy, the case that has tended to define the popular sense of the serial killer. See R. W. Larsen, *Bundy: The Deliberate Stranger* (Englewood Cliffs, NJ: Prentice Hall, 1980); and Rule, *The Stranger Beside Me.*
46. On the serial killer as the mass in person, and on the difference between the psycho killer and what might be called the psychic killer, see the chapters that make up the second part of this study, "The Mass in Person." For the moment it is not possible to do more than indicate the form these shifting determinations (sociological and psychological) of the dangerous individual have tended to take. (See also n. 49, below.) As the Lacanian theorist Slavoj Žižek summarizes what has come to be the default cultural-psychoanalytic position: "we *are* murderers in the unconscious of our desire," that is, *we* are *all* killers in the unconscious (Žižek, *Looking Awry: An Introduction to Jacques Lacan Through Popular Culture* [Cambridge, MA: MIT Press, 1991], p. 59). Such an account not merely elides the difference between the psycho killer and the psychic killer. It effectively elides the difference between individual and group psychology—albeit not, as we might expect (in the familiar charge made against psychoanalysis), by way of the understanding of the group on the model of the individual and individual psychology. For what Freud refers to as "the unconscious foundations, which are similar in everyone"—that is, the "average character" of the unconscious foundations of the subject—in effect folds individual psychology into group psychology. See Freud, *Group Psychology and the Analysis of the Ego,* in

Standard Edition, 18:74). Hence the individual appears as a sort of group of one: the composite embodiment of the average, the mass within, or (as we will see in a moment) the "just similar."

47. "Independent coding of types for the 110 cases showed slightly over 96% agreement between two coders. We consider this typology to be an initial working step toward a better understanding of many puzzling factors at work in serial homicide" (*SM*, 60).

48. On the market's phantasmagorias of equality, see Benjamin, "The Work of Art in the Age of Mechanical Reproduction"; for a lucid summary of some of its effects, see Jonathan Crary, *Techniques of the Observer: On Vision and Modernity in the Nineteenth Century* (Cambridge, MA: MIT Press, 1990), pp. 10–12.

49. In sociological terms, this renegotiation has been seen as a radical "other-directedness"—the central diagnosis of modern society in, for example, David Riesman, *The Lonely Crowd: A Study of the Changing American Character* (New Haven, CT: Yale University Press, 1961). In psychological terms, it may be seen as a primary form of *extimacy*: "extimacy is not the contrary of intimacy . . . extimacy says that the intimate is Other" (Jacques-Alain Miller, "*Extimité*," trans. Françoise Massardier-Kenney, *Prose Studies* 11 [December 1988]: 123). The tensions between these sociological and psychological accountings of the subject—these rival, but coupled, accounts of the subject's formation from the outside in—are what I mean to pressure here.

50. Stephen Kern, *The Culture of Time and Space: 1880–1918* (Cambridge, MA: Harvard University Press, 1983), p. 88.

51. Borch-Jacobsen, *The Freudian Subject*, pp. 93, 89. In *Group Psychology and the Analysis of the Ego*, Freud retells Schopenhauer's animal fable as a way of understanding these renegotiations of proximity and distance, a way of understanding how "no one can tolerate a too intimate approach to his neighbor": "A company of porcupines crowded themselves very close together one cold winter's day so as to profit by one another's warmth and so save themselves from being frozen to death. But soon they felt one another's quills, which induced them to separate again. And now, when the need for warmth brought them nearer together again, the second evil arose once more. So that they were driven backwards and forwards from one trouble to the other, until they had discovered a mean distance at which they could most tolerably exist" (p. 41). It is, more radically, the intolerability of *the neighbor within* that stranger-intimacy forces into view.

52. Angus McLaren, *A Prescription for Murder: The Victorian Serial Killings of Dr. Thomas Neill Cream* (Chicago: University of Chicago Press, 1993), pp. xiv, xiii; see also Elliot Leyton, *Hunting Humans: Inside the Minds of Mass Murderers* (New York: Simon and Schuster, 1986), pp. 279–324.

53. Charles Rosenberg, quoted in McLaren, *A Prescription for Murder*, p. 62.

54. Quoted in Leyton, *Hunting Humans*, p. 174.

55. See chapter 3, below, on the links between addiction, violence, and sexual difference.

56. The tendency toward disembodiment in such cases is marked here not merely by the assimilation of body by space but also by the racialized transformations of the more deeply embodied black bodies of the victims into white, i.e., disembodied and spectral, shapes. On the racialized drive toward disembodiment/whiteness that surfaces in some of these cases, see also Olsen, *Charmer*.

57. Compare also a recent report by Mireya Navarro, "Prostitutes Defy Killer by Working," *New York Times*, 28 December 1994, p. A8, city edition, concerning the serial killing of five prostitutes in Dade County, Florida. As the report indicates, from the title on, the prostitute-victims are here represented as the victims of a certain work ethic and as the repository of family values (for example, "I have to pay the bills. I have four kids My bills are paid. My kids are always clean")—even as they inhabit the city's transit corridors, lethal spaces neither public nor private (for example, they now "would work only in parked cars, within screaming distance of the others"). The dislocated familialism of the report is underlined by the single identifying feature of the killer provided: he drives "a red Toyota with a 'child-restraint seat behind the driver's seat.'" The report, it is perhaps worth noting, includes also two "overview" maps of the crime corridor, maps that are useless and illegible to readers unfamiliar to the area but that signify, graphically locate, and secure, the intimacy, or identification, of violence and public space.

58. See, for instance, Henry James, *The American Scene*, ed. Leon Edel (Bloomington, IN: Indiana University Press, 1968), p. 438.

59. The latter is a novelization of the career of the 1890s' serial killer H. H. Holmes and the 100-room hotel/murder factory that came to be called The Holmes Castle; on Holmes, see "Lethal Spaces," in this study. See Robert Bloch, *Psycho* (New York: Simon and Schuster, 1959), and Bloch, *American Gothic* (New York: Simon and Schuster, 1974).

60. Colin Wilson and Donald Seaman, *The Serial Killers: A Study in the Psychology of Violence* (New York: Carol, 1992), pp. 81–136; SK, pp. 210–42; Ressler, Burgess, and Douglas, *Sexual Homicide*, pp. 135–52; SM, pp. 82–96; and Jenkins, *Using Murder*, pp. 70–78. A former high-school classmate of Jeffrey Dahmer reports that Dahmer, in his senior year, "traced bodies on the [schoolroom] floor in chalk It was an eerie sight to see the outline of a body on the floor" (quoted in Norris, *Jeffrey Dahmer*, p. 75).

61. Judith R. Walkowitz, *City of Dreadful Delight: Narratives of Sexual Danger in Late-Victorian London* (Chicago: University of Chicago Press, 1992), pp. 1–4.

62. On film noir, see *Shades of Noir: A Reader*, ed. Joan Copjec, (London: Verso,

1993), esp. Copjec, "The Phenomenal Nonphenomenal: Private Space in *Film Noir*," pp. 167–97; Žižek, "'The Thing That Thinks': The Kantian Background of the *Noir* Subject," pp. 199–226; and Dean MacCannell, "Democracy's Turn: On Homeless *Noir*," pp. 279–97.
63. Anthony Vidler, *The Architectural Uncanny: Essays in the Modern Unhomely* (Cambridge, MA: MIT Press, 1992), p. 178.
64. Walter Benjamin, "On the Mimetic Faculty," *Reflections: Essays, Aphorisms, Autobiographical Writings*, trans. Edmund Jephcott, ed. Peter Demetz (New York: Schocken, 1978), pp. 333–36. This compulsion, which Benjamin called "the mimetic faculty," involves a tendency toward "magical correspondences and analogies." This entails not merely an identification of natural and visible correspondences. It entails, more enigmatically, "the concept of non-sensuous similarity": an intimation of relation, irreducible to the order of reference or representation, "through which, like a flash, similarity appears." (See Michel Foucault on the dominant order of resemblance in premodern culture, in *The Order of Things* [New York: Vintage, 1976].) What is perhaps most enigmatic in Benjamin's account of "non-sensuous correspondences" is the radically uncertain status of the sensuous and the bodily with respect to mimesis and representation. (It is this uncertainty that, it seems, leads one recent commentator, Michael Taussig, to gloss "non-sensuous similarity" as exactly the opposite—as "*sensuous* correspondence"—and thus in effect to rewrite the concept of correspondence in the by-now familiar terms of the return of the repressed body to representation [Taussig, *Mimesis and Alterity* (New York: Routledge, 1992), p. 170]. Taussig elsewhere acknowledges that the point is not "to indulge in the tired game of emotion versus thought, body versus mind, recycled by current academic fashion into concern with 'the body' as the key to wisdom" [147]. These contradictory tendencies can perhaps serve as a reminder about how the acknowledgment of a difficulty may in fact obviate against taking it into account.) It is above all the "decay" of the mimetic faculty in "the world of modern man" that Benjamin here emphasizes, although he finds in the materiality of writing itself "an archive of non-sensuous similarities"—a sort of graphic unconscious ("Graphology has taught us to recognize in handwriting images that the unconscious of the writer conceals in it") (333–36).

The link between the mimetic faculty and the graphic unconscious is interesting enough for our purposes: the couplings of graphomania and addictive violence (*une langue inconnue* of the body-machine complex) will be traced in chapter 2. But the "minimal residues" of magical and nonsensuous correspondence are by no means limited to the matter of writing. If Benjamin here emphasizes the decay of the mimetic faculty, it might be suggested that what he elsewhere calls the phantasmagorias of equality of market culture represent not that faculty's liquidation but its transformation—albeit a transformation officially denigrated in modern culture.

(One sign of the cultural denigration of "simulation" consists in the understanding of simulation in terms of the "pretending to be what one is not"— that is, a conflation of simulation with dissimulation.) The links between the mimetic faculty and capitalist mimesis are perhaps clear enough. The mimetic compulsion becomes visible, for example, in the market's logic of equivalence and its advertising aesthetics. It becomes visible in the similarity-effects generated by the mass media: the proliferating series of likenesses by which discrete events blur into "like" events, such that likeness and analogy replace cause. It surfaces in the contagious series of likenesses that traverse cases of addictive consumption. And it surfaces in the logics of substitution that traverse cases of repetitive corporeal violence: the lures of imitation (copy-cat killing, for example) and the function of camouflage (the chameleon-like anonymity of the killer).

65. Roger Caillois, "Mimicry and Legendary Psychasthenia," trans. John Shepley, *October* 31 (Winter 1984); hereafter abbreviated "MLP."

66. "The feeling of personality," as Caillois puts it, "considered as the organism's feeling of distinction from its surroundings, of the connection between consciousness and a particular point in space, cannot fail under these conditions [of the "imitating mechanism"] to be seriously undermined; one then enters into the psychology of psychasthenia, and more specifically of *legendary psychasthenia*, if we agree to use this name for the disturbance in the . . . relations between personality and space." ("MLP," 28).

67. On Caillois's account of mimesis (and its incorporations into Lacanian accounts of the subject), see Denis Hollier, "Mimesis and Castration, 1937," *October* 31 (Winter 1984): 3–15; Hollier, "The Word of God: 'I Am Dead'," *October* 44 (Spring 1988): 75–87; Rosalind Krauss, "Corpus Delicti" *October* 33 (Summer 1985): 31–72; Martin Jay, *Downcast Eyes: The Denigration of Vision in Twentieth-Century French Thought* (Berkeley: University of California Press, 1993), pp. 342–43. It's not difficult to detect the links (tentatively broached at the close of Caillois's essay) between this account of the "mimetic assimilations of the animate to the inanimate" by way of mechanisms of imitation—imitative mechanisms that make for "a decline in the feeling of personality and life"—and of Freud's positing, a decade or so earlier, of the repetition-compulsions or automatisms of the death drive: the instinctual tendency of the organism to the inorganic ("MLP," 31, 30). One advantage of Caillois's reformulation is the foregrounding of a pathological relation to milieu in such cases: if "life seems to lose ground," in its mechanical attraction to the inanimate, *it seems to lose ground to ground or context itself* ("MLP," 32). One of the most powerful contemporary figurations, virtually illustrations, of these relations is to be found in the subject- and body-devouring landscapes of Cindy Sherman's photographs. For a related account, along more "properly" psychoanalytic lines, see Krauss, "A Note on Photography and the Simulacral," *October* 31 (Winter 1984): 49–68.

68. See Sloterdijk, *Critique of Cynical Reason*, pp. 461–64; and Hal Foster, "Armor Fou," *October* 56 (Spring 1991): 65–97.
69. Theweleit, *Male Bodies*, pp. 222, 223.
70. Tim Krabbé, *Het Gouden Ei* (Amsterdam: Uitgererij Bert Bakker, 1984), trans. Claire Nicholas White under the title *The Vanishing* (New York: Random House, 1993), p. 10; hereafter abbreviated V.

2 · Murder and Machine Culture

In this chapter, I want to consider some of the relays between serial killing and what I have elsewhere described as the *body-machine complex* (*Bodies and Machines*). The intent here is to trace the links between the problem of serial murder and the more general problem of the body in "machine culture": to trace, that is, the forms of repetitive and addictive violence produced, or solicited, by the styles of production and reproduction that make up machine culture. In what follows I will be focusing on several case studies. First, two of the inaugural writings of the age of the sex crime—centering on the entanglements of blood lust and technology, particularly technologies of writing and information—Zola's *La Bête humaine* (1890) briefly, and, at some length, Bram Stoker's *Dracula* (1897). Second, the representation of the radical entanglement between addiction and the body-machine complex—the "white logic" of alcoholism and male repetitive violence—set out, for example, in Jack London's autobiographical *John Barleycorn* (1913) and in some "cybernetic" analyses of the addictive subject. In the ensuing parts of this study, I will take up more directly some of the recent accounts and representations of serial murder. At this point, though, I want to proceed somewhat obliquely, risking, for reasons that I hope will become clear, a certain abstraction and generalization as to the status of such cases of repetitive violence. Therefore, before turning to these case histories, I want to outline some of the constitutive elements of these cases: namely, seriality, prosthesis, and what might be called primary mediation.

Maladies of Agency

It's not difficult to detect some of the more general points of contact between murder and machine culture. For example: the term *serial killer* was coined in the mid-1970s by the FBI special agent Robert Ressler, who developed the psychological profiling technique that has become standard in the FBI's Behavioral Science Unit. This "naming event," as he recently described it, had two sources. The first was the British designation of "crimes in series": crimes—"a series of rapes, burglaries, arsons, murders"—committed "one ... then another and another in a fairly repetitive way." The second involved the repetitive ways of mass cultural representations: "also in my mind were the serial adventures we used to see on Saturday at the movies. ... Each week you'd be lured back to see another episode, because at the end of each one was a cliff-hanger. In dramatic terms, this wasn't a satisfactory ending, because it increased, not lessened the tension. The same dissatisfaction occurs in the mind of serial killers." Thus, for Ressler, "the real meaning behind the term *serial killer*" is the internal competition between repetition and representation. "Obsessed with a fantasy" unfulfilled in its enactments, the act is repeated in line with what Ressler calls "an improvement continuum." But as in the cliff-hanger, the repetition "leaves the murderer hanging"— a suspense plot that fails to convert series into narrative. On this account, then, the real meaning of serial killing is a failed series of attempts to make the scene of the crime equivalent to the scene of the fantasy—that is (taking Ressler's profile a bit further) a failed series of attempts to make the content of the act and the fantasy of the actor, act and motive, perfectly coincide.[1]

This summary profile of the serial killer is thoroughly unexceptionable—and not least in its semicircular (and predictably uncanny) "explanation" of the compulsion to repeat as the repeating of one thing and "then another ... in a fairly repetitive way" and in the radically underspecified analogy between an addiction to representations and acts of killing. The question of serial killing cannot be separated from the general forms of seriality, collection, and counting conspicuous in consumer society (Stewart), and the forms of fetishism—the collecting of things and representations, persons and person-things like bodies—that traverse it (Baudrillard).[2] In these pages, I further indicate some of the connections between body counts and commodity fetishism, word counts and "statistical persons," in the representations of serial murder. This genre of American psychosis—for example, in Brett Easton Ellis's

notorious *American Psycho* (1991)—advertises, and trades on, the analogies, or causal relations, between these two forms of compulsive repetition, consumerism and serialized killing. (And, as we will see, it's in part this tension between analogy and cause—particularly in correlating economic and sexual motives—that is re-enacted in scenarios of addictive violence.) But for the moment I am interested precisely in what such underspecification—underspecification of motive and of the relation between motivation and representation—might itself make visible in such scenarios.

The connection drawn here between crimes in series and serial adventures would seem to posit something like an equation between acts of killing and an addiction to representations: that is, something like an equation between acts of violence and the relative passivity of "just looking." On one level, such an equation, or at least analogy, has become something of a commonplace (in debates about pornography and in the not-unrelated debates about serial violence and its causes). It has become something of a commonplace, that is, to posit a connection between murder and imitation or mimesis—most visibly in the notion of "copy-cat killing" and in the notion that serial killing may in fact be an artifact of "a media feeding frenzy" (for example, the media-borne "serial killer panic of 1983 to 1985"). But insofar as such accounts posit a pathological addiction to representation as the cause of violence, they implicitly understand such media representations as impinging on the subject "from the outside": the confiscation of identity and motive through a failure of distance with respect to representation, such that identification replaces identity.[3] The addiction to representations would consist then in the *contagious* relation of the subject to imitation, simulation, or identification, such that identification brings the subject, and the subject's desires, into being, and not the other way around.

From one point of view, the account of the real meaning of the serial killer provided by Ressler simply leaves unmarked and utterly uncertain just how acts in series and mere watching fit together. From another, it is just this radical uncertainty about the relation between repetition and representation—between the passive action of acting addictively and serially and the active passivity of deriving identity from repeated processes of identification—that such an account begins to make clear. At the end of the section of *Beyond the Pleasure Principle* (1920) in that Freud retells the story of the fort-da game, he adds a "reminder" which, as he puts it, is "of no use for *our* purposes." The story of the fort-da game is of course the story of repetition as a means of retroactive mastery by

way of the conversion of an unpleasurable passivity into a pleasurable activity. The useless reminder concerns the "artistic play and artistic imitation carried out by adults"; these scenes, "aimed at an audience, do not spare the spectators (for instance, in tragedy) the most painful experiences and can yet be felt by them as highly enjoyable." The attraction to scenes of violence "aimed at" the spectator is for Freud an "aesthetic" matter (its consideration "should be undertaken by some system of aesthetics") and in no way "beyond" the pleasure principle, since "there are ways and means enough of making what is itself unpleasurable into a subject to be recollected and worked over in the mind."[4] But it is perhaps the ways and means of making unpleasurable things into a subject, in the other but here pointedly revoked sense of the term, that the subjection to scenes of imitation and representation intimates.

For one thing, the very centrality of the category of representation, in Freud's account, may be what necessitates its local exclusion or suppression here. As Mikkel Borch-Jacobsen traces, in the Freudian account of the subject "the 'content' of the unconscious is defined essentially as representation."[5] That is, the understanding of the unconscious as the scene of representation not merely posits the subject as spectator but also implicitly posits the priority of the subject to the spectacle or scene: the priority of the subject to, and its "proper" distance from, its representations and identifications. The logic of the subject and the logic of representation are thus inseparable, opposed on part of their surface but communicating on another level. Put simply, the logic of the subject is its coming into being through processes of identification (and it is this emphasis on primary identification or primary mimesis that centers Borch-Jacobsen's account of "the Freudian subject"). Yet if the logic of the subject depends on such a primary mimesis, the subject's logic works the other way round. The subject's logic is "to see oneself . . . by suppressing all reference to mimetic identification": "it is as if the process of identification were regularly transformed into a claim of identity."[6] The claim of identity is thus precipitated by this tension between the mimetic logic of the subject and the subject's "own" antimimetic logic—a claim of self-determination and self-possession as antimimetic in principle as it is fundamentally mimetic in practice.

What such transformations in the claims of identity look like, and the part they play in repetitive killing for pleasure, will be filled in by way of the case studies that follow. The double-logic of the subject—the primary mimesis that brings the desiring subject into being, the violent suppression of all reference to identification and mimesis: this double-logic may

begin to make intelligible the ultimate, and ultimately insupportable, analogy upon which the serial murder depends: that is, the analogy between, or substitution of, one death and another and between one's own death and another's.[7]

It may begin to make intelligible as well the notion of serial violence as "motiveless" crime. The description of repetitive sexual murder as "serial killing" and of serial killing as "motiveless" has, of course, the effect of making *in*visible the nearly consistent gendering of serial violence: a male violence that is anti-female and anti-homosexual, or more exactly a male violence that is directed at the antimale or "*un*male." But the notion of such crimes as "motiveless" may do more than ideologically deflect from recognition of the gender of killing for pleasure.[8] If serial violence can be related to the violent transformation of primary identification into claims of identity, then one might say that the motive of the crime is the effect of the crime and not its cause (put simply, the repeated, and repeatedly flawed, production of a subject as an agent that can have something like a motive). Such a transformation in the name of the subject appears as the urgent transformation of the egoistic into the erotic — the instant translation of the uncertain difference between self and other into the "basic" difference between male and female (unmale). On this account, the appeal to a radical and ineradicable sexual difference translates, and ratifies, the difference between self and other that, in turn, becomes the equivalent of sexual difference.[9]

There is of course a good deal more that needs to be said about the logic of such translations. And clearly, if such a preliminary and abstract account of the transformation of the egoistic into the sexual has some explanatory force in understanding serial killing, the sheer generalizability of this account of identity scarcely locates the *singularity* of sexual murder. But if one problem with such an account is thus its underspecification of particular identities and desires, one of its contributions may be to intimate the violence that proceeds from the subject's logic of singularity. "The sacrosanct value of selfhood," as Leo Bersani expresses it (and precisely in considering the violent sexualization of the egoistic), appears as "a value that accounts for human beings' extraordinary willingness to kill in order to protect the seriousness of their statements," in effect converting the protection of a "proud subjectivity" into a "sanction for violence."[10] The commonplace description of serial killing as motiveless is therefore perhaps inseparable from the commonplace description of the serial killer as anonymous or, as one prosecutor of such cases concisely put it, as "abnormally normal." This abnormal normality is the "complete

disguise" of looking and being just like everybody else. The crime of anonymity makes for the utterly generic profile of the criminal: the non-identification ("'He didn't do it. He couldn't do it. I *know* him!'") as well as a fundamental nonidentity (the "wisdom [LA County Sheriff's Sergeant] Sett learned from a quarter-century of chasing down murderers is that 'nobody knows anybody else'").[11] Such failures of identity virtually register just how such abnormal normality is premised on a primary imitation: "To go unnoticed is by no means easy. To be a stranger, even to one's doorman or neighbors. If it is so difficult to be 'like' everybody else, it is because it is an affair of becoming."[12] This is an affair of becoming or self-making premised on the self as an empty category and as an effect of imitation and not its cause.

This notion of the self as effect or empty category has of course become something of a standard in recent cultural criticism. This is not to suggest that culturalism or "new historicism is the theory, serial killing the practice," although it is to suggest an internal connection between what might be called an addiction to self-making or self-transformation and these maladies of agency and pathologies of will or motive (for example, the phenomenon of corporeal self-transformation or *surgical addiction*, which I will take up in the next part of this study). On the one side, the problem of "periodizing" persons, bodies, and desires that centers a good deal of recent cultural criticism has at the least its counterpart representations, in popular or mass culture, in terminator versions of thrillingly, and violently, artifactual persons. On the other, the violent negotiation of the singularity or generality of persons makes reference to a kind of serial individuality, in effect referring the individuality of the individual to his location within the system, series, and repetitive standardization. By this logic, the making of persons inhabits the logic of systematic management and its products: that is, the production of "statistical persons" and disciplinary individuals.[13]

This indicates one way of further specifying and extending such accounts of primary imitation and the translation of egoistic into erotic violence. I have argued elsewhere (in *Bodies and Machines*) that the matter of periodizing persons, bodies, and desires is inseparable from the anxieties and appeals of the body-machine complex. This is the case not merely because such matters are bound up, through and through, with an intimacy with machines and machine culture. It is also because the fascinations and panics about "accounting for" persons (their singularity or generality) and, collaterally, about negotiating the problem of the body (its natural or artifactual status) are not separable from the body-machine

complex but instead are another way of inhabiting the body-machine complex. I want to suggest, then, that it's not quite a primary identification or imitation that becomes conspicuous in, for instance, cases of serial violence but, beyond that, an intimacy with technologies (and not least media technologies of relay and communication—clearly, there is a sort of CNN effect by which serial killing and ramifying bureaucracies of information-processing solicit, and ratify, each other; these links are explicit enough, from the Jack the Ripper media events on). This intimacy with machines amounts to what might be described as a *primary mediation*. I have in mind here something more than the mass media representation of such intimacies—for example, the popular sense that serial killers and "necrophiles are often fascinated by machinery and addicted to routine."[14] Something more because if such accounts register the internal relations between the organic and technological in these cases, and register also the "addiction to routine" (that is, *the addiction to addiction*) that marks them, they do so by pathologizing and thus disavowing the everyday intimacies with technology in machine culture; this everyday intimacy is thus routinely pathologized and exoticized in the alien and terminator versions of lurid tech-noir.

Put somewhat differently, accounts of "the question concerning technology" seem indissociable from the melodramas of uncertain agency. As Gilles Deleuze concisely summarizes it: "Types of machines are easily matched with each type of society—not that machines are determining, but because they express those social forms capable of generating and using them."[15] But if such a caution about technological determinism is convincing enough, how exactly to define the status of such forms or *agencies of expression and determination* (the status of such "matches") remains, here and elsewhere, radically underdetermined. Consider, for instance, the small fantasy that appears in Henry Ford's autobiographical *My Life and Work* (1923). The production of the Model T required 7,882 distinct work operations, but, Ford observed, only 12 percent of these tasks—only 949 operations—required "strong, able-bodied, and practically physically perfect men." Of the remainder—and this is clearly what Ford saw as the central achievement of his method of production—"we found that 670 could be filled by legless men, 2,637 by one-legged men, two by armless men, 715 by one-armed men and ten by blind men."[16] If, from one point of view, such a fantasy projects a violent dismemberment of the natural body and an *emptying out of human agency*, from another it projects a transcendence of the natural body and the *extension of human agency through the forms of technology that supplement it*. This

double-logic of technology as prosthesis (as self-extension and as self-mutilation or even self-cancelation) begins to elucidate the interlaced problems of the body and uncertain agency that primary mediation entails. Systematic management correlates, in the work process, serial production and the disarticulation of natural bodies, correlates dispassionate sequences of cause and effect and an eroticized violence.[17] It's the attraction of such *correlations* that, for example, Bram Stoker's novel of lust-killing and body counts, unnatural persons and unnatural reproductions, compulsively and programmatically represents.

Fatal Series

One of the most conspicuous representations of the unnaturalness of bodies and persons in *Dracula* appears in the novel's version of "bio-economics," its correlations between economic and bodily states: "The blow was a powerful one; only the diabolical quickness of the Count's leap back saved him. . . . As it was, the point just cut the cloth of his coat, making a wide gap whence a bundle of bank-notes and a stream of gold fell out."[18] The conflation of the bodily and the economic, blood and money, could not be more explicitly marked. Scenes such as this one have underwritten accounts of the novel as a displaced figuration of newly experienced economic states: a figurative rewriting of monopoly capital (hence "the vampire is a metaphor for capital . . . the capital of 1897")[19] or, more recently, of consumer society (hence "situat[ing] Dracula unmistakably as a figure for consumption").[20] The analogy between vampirism and capitalism has, of course, a long history. (Consider Marx, for example: "Capital is dead labour which, vampire-like, lives only by sucking living labour, and lives the more, the more labour it sucks."[21]) And the analogy between vampirism and the drive to quantitative equivalences and compulsive seriality in the culture of consumption—the vampire as a sort of adding machine—is also clear enough. (Consider, for example, William Burroughs on "the basic nature of the vampiric process of inconspicuous but inexorable consumption. The vampire converts quality, live blood, youth, talent into quantity food and time for himself . . . reducing all human dreams to his shit."[22])

But it's precisely the status of such "new historicist" analogies between the bodily and the economic that it seems necessary to pressure here. For one thing, the melodramas of endangered agency in cases of sexual violence involve a similar logic of analogy or substitution. That is, they involve an insistent, at times desperate, conversion of analogy into cause.

By this logic, a series of equivalences between the economic and the sexual are generated. Or, as Zola's version of Jack the Ripper in *La Bête humaine* (1890) — the *mécanicien de locomotive* Jacques Lantier — experiences these mechanisms of self-motivation: "Was it that physical possession satisfied this lust for death? Were possession and killing the same thing in the dark inner recesses of the human brute?"[23] Here, possession and sexual murder indicate each other and this logic of equivalence makes their substitution plausible — what Jacques concisely expresses in terms of a "destruction for fuller possession" (*BH*, 330). Possession and sexual killing thus appear as two forms of "the same thing" and the first as the effect of the second: in short, by the logic of destruction *for* fuller possession, "Was not one the logical outcome of the other?" (*BH*, 332).

Such a self-understanding of sexual murder appeals to an understanding of interior states as products of exterior (here, economic) determination: in effect, blood-thirst or lust-killing as the limit case of possessive individualism. In the case of Lantier, among others, what surfaces is a male hysterical restoration of agency. This involves an identification of killing and possession, and a way of accounting for sexual violence through the appeal to an extrinsic and automatistic motivation. (The "new historicist" subject is filled, as it were, from the outside in. This assumes the sheer transparency of interior states to external conditions and hence obviates the necessity of theorizing those states, those panics and desires.) To see such possession in strictly economic terms is thus to perform precisely the overly hasty historicization that makes the act of killing do the work of agency-recovery and self-possession.

The identification of destruction and possession identifies possession as prosthesis — destruction as possession, and possession as self-possession. This version of possessive individualism depends not merely on the transparency or permeability of interior states to external (primarily, economic) conditions but also on the panics induced by such experiences of permeability: the turning inside out of the self. Here, the struggle to stabilize relations between inside and outside depends, most basically, on the shoring up of a fundamental "leakiness" of the self, a leaking away of agency and identity. This is most explicit in Lantier's panic about the locus of personality and the bodily boundaries of the self: "But there were sudden attacks of instability in his being, like cracks or holes through which his personality seemed to leak away" (*BH*, 66). The conversion of analogy (like cracks or holes) into cause (destruction for possession) governs the channeling of the egoistic into the sexual (self-possession by way of lust-killing). In these cases, one finds again and again the struggle to

make interior states visible, to gain mastery over bodies and interiors by tearing them open to view ("the primitive male carrying off females and ripping them open in an embrace!" [*BH*, 267]). But such self-mastery depends in turn on an opposition between leaky selves and bounded ones that is translated into an opposition between the defined and bounded body and the body of insupportable openings, leaks, flows. Hence the very evidence of the torn and leaking body retroactively ratifies the difference between bounded identities and torn ones *as* the difference between male and female.

What this pathologizing of possessive individualism indicates, at the least, is a wearing out of that model of individuality and the violent regressions that conserve it. Such a pathologizing of the model of possessive individualism indicates a fundamental shift in the understanding of the individuality of the individual—and one that makes it possible to fill in the recalcitrantly abstract account of "the self" and its vicissitudes that governs the self-understanding of killing for possession I have briefly set out.

This shift, which becomes visible at the turn of the century and at the beginning of the "age of the sex crime," might be described in terms of the difference, and tension, between possessive individualism and market culture, on the one side, and disciplinary individualism and machine culture, on the other. It is not possible here to do more than indicate what these rival determinations of the individuality of the individual look like, or how the "regressive" appeals to the logic of the market in machine culture make for the violent regressions (atavism, degeneration, recapitulation, wilding) that mark, for example, Jacques Lantier's coupling of possession and the *primitivisms* of sexual violence.[24]

Here I am concerned with the *localization* of these large matters of agency in cases of sexual violence: with what the localization and "management" of the melodramas of agency in machine culture *as* pathologies of addiction and repetitive sexual violence indicate. The discourse of possessive individualism posits a world animated through and through with intentions, a pan-intentionalism that appears in the understanding of things as prosthetic extensions of the self and its desires: the promiscuous personifications of "living property." The persistence of this style of animism, in consumer society (the desire-economy), serves as something of an antidote to the disciplinary individualism of machine culture. But the tension between possessive and disciplinary styles of individualization is in fact a bit more complicated. Machine culture progressively redraws the vague and shifting line between the animate and the inanimate: rewriting

the opposition between life and death in terms of the calculation of degrees of aliveness, and rewriting the opposition between reproduction (sexual, biological) and production (mechanical) in terms of an experience of reproduction without gender (though not without its own erotics). Machine culture thus posits not an essential opposition between persons or bodies and machines but rather their essential intimacy. As the great communicator of the technocratic imaginary Ernst Jünger expressed it: "We have to transfer what is inside us onto the machine."[25] What this transference involves are the calculations of degrees of aliveness and the fascinations of a reproduction without gender: the calculations and fascinations that flow from an intimacy with new reproductive technologies. Stoker's story of blood-lust and "corporeal transference," for example, everywhere registers these processes of identification: the transferences between the animate and the inanimate and between bodies and machines—the transfer of what is inside us onto the machine, making "our blood . . . flow around every axle," such that identities are inseparable from these new technologies of reproduction.[26]

The transference onto the machine intimates a nonhumanity experienced in persons, a nonhumanity experienced within the body as such.[27] In *Dracula*, this is imagined as a "foreign body" in the self, or more exactly the foreign body about which something like a self accretes (D, 127). This foreignness, in *Dracula*, is above all bound up with an experience of technologies of reproduction: recording, writing, shorthand, type-writing, and mechanical impression or registration. The novel's *writing of writing* powerfully instances the relays between writing and the machine that make up what Friedrich Kittler describes as the "discourse network" of 1900: "in 1900 a type of writing assumes power that does not conform to traditional writing systems but rather radicalizes the technology of writing in general."[28]

It is not merely that the novel insists on the becoming visible of the materiality of writing and writing technologies ("I laid my hand on the typewritten matter" [D, 270]). Nor is it that the novel everywhere pressures the links between writing and self-expression (for instance, in the shorthand system that is "like whispering to one's self and listening at the same time" [D, 75]). If there is "something about the shorthand symbols that makes it different from writing" (D, 75), this is because the private shorthand language appears as an uncertain attempt to maintain a self-expression and self-communion very different from the experience of writing as foreign body—very different, for example, from the series of *dictated/personal* letters that initiate "that fatal series" of the novel's

events ("It does not read like him, and yet it is his own writing" [D, 77]). The novel translates the struggle to "read one's thoughts" into the struggle to "read your own face" (D, 58): translates introspection into a psychophysics correlating interior states and the "shifty movement" (D, 107) of bodies—and bodies thoroughly mediated by technologies of writing and registration.

Graphic Violence

There is nothing atypical about this process of mediation, an experience indissociable from the *assemblages* of bodies and technologies that make up the body-machine complex. Nor is there anything "deeper" than the assemblages themselves. The alienist Jean-Martin Charcot, for example, applied the name "l'homme du petit papier" to those neurasthenic patients who "frequently appeared with slips of paper or manuscripts endlessly listing their ailments." Like those other victims of fin-de-siècle maladies of energy and will—the patients suffering from "fatigue-amnesia," that is, the condition of "being too tired to remember to feel tired"—Charcot's men with little pieces of paper have only external access to their interior states, as if they know how they feel only by reading about it.[29]

In such cases, pathologies of energy and will, and maladies of leaky agency, appear as a sort of "corporeal text." This is not merely because of the imitative or mimetic character of these cases (not merely, that is, because like hysteria they are seen to mime or resemble other, demonstrably corporeal, maladies). These maladies of energy, motive, and agency were in effect understood, around 1900, as maladies of mimesis, representation, and writing: the addiction to imitation and particularly imitative writing that marks the degenerate, and highly contagious, condition of *graphomaniacs*. They were understood, more generally, in terms of what the time-motion expert Etienne-Jules Marey called *une langue inconnue* of the body-machine complex writing itself. The unknown language of the body-machine complex becomes visible precisely through the new technologies of registration and inscription, the graphic methods and writing instruments, that proliferated around the workplace at the turn of the century. As Marey expressed it: "When the eye can no longer see, the ear cannot hear, or touch cannot feel, or even when the senses appear to deceive us, these instruments perform like a new sense with astonishing precision."[30] What these graphic technologies register and decipher, then, is something like languages issuing from matter, automatized bodies writing themselves.

Renfield—the "homicidal maniac" and life-eater who collects and con-
sumes flies, spiders, etc.—is *Dracula's* man with little pieces of paper. The
victim of corporeal transference and of the vampiric reproduction by con-
tagion, Renfield embodies the radical instability in "the self" the novel
traces. Or, rather, he epitomizes the uncertain localization and bound-
aries of the self: the noncoincidence of the boundaries of the body and
boundaries of self or consciousness or agency. Thus, in him there "seemed
none of that unity of purpose between the parts of the body" or between
the mental and bodily parts of the self (*D*, 288). At once absorbing "as
many lives as he can" (*D*, 75) and "mixed up with the Count in an indexy
kind of way" (*D*, 262), Renfield's style of self-absorption is indistinguish-
able from the experience of self as foreign body or foreign bodies. On the
one side, that is, Renfield is represented as utterly selfless—utterly lacking
the containing boundary or protective shield that is "in selfish men . . . as
secure an armour for their foes and for themselves" (*D*, 64); on the other,
he is represented as utterly selfish and self-absorbed (*D*, 72). These insis-
tently contradictory representations of the double-logic of self-aborption
register a basic dysfunctioning of the distinctions between self and other;
as his analyst Dr. Seward remarks, "In his sublime self-feeling the differ-
ence between myself and attendant seemed to him as nothings." And this
mixing of self and other is everywhere contagious. Here it leads Seward in
turn to an extraordinarily rapid series of promiscuous mixings: mixings of
agency and automatism ("I must be careful not to let it grow into a habit");
of male and female ("I shall not dishonour [Lucy] by mixing the two");
mixings of "living life" and the "chemical world" (bodily rest, for example,
and "the modern Morpheus—$C_2HCl_3O.H_2O$"); and, most basically, of
the animate and inanimate ("life is all I want" and yet "life—animal life—
was not the only thing that could pass away" [*D*, 207]).[31]

Renfield appears as "a sort of index" (*D*, 238) of the unnatural unions
and unnatural breedings, the uncertain degrees of aliveness, the promis-
cuous mixings across the uncertain lines between individuals, genders,
and bodies, that traverse this novel of homicidal mania and blood-lust.
But Renfield is also a sort of index both in his mania to kill in order to in-
corporate himself and in his graphomania or, more exactly, his arithmo-
mania—that is, in the communications between murdering/consuming
bodies and writing/counting bodies.[32] I am referring here not merely to
his collections of ascending series of "live things" and not merely to his
serial consumption of them (following the "program" of "There was an
old lady who swallowed a fly"). I am referring, above all, to the relays thus
articulated between bodies, numbers, and writing:

He keeps a little note-book in which he is always jotting down something. Whole pages of it are filled with masses of figures, generally single numbers added up in batches, and then the totals added in batches again, as though he were "focussing" some account, as the auditors put it. . . . Spiders are at present his hobby and the note-book is filling up with columns of small figures (D, 73, 107).

By this quantitative accounting of life, what becomes conspicuous are the ways in which numbers, writing, and bodies indicate each other in circular fashion, such that writing and counting, word counts and body counts, figures and masses, mathematical series and serial killing, addictive consumerism and addictive cannibalism, are all drawn into taut relation—and not least in the figure of "The Count" himself.

These are some of the lines of communication progressively articulated between forms of systematic management and forms of systematic and repetitive violence. It is not possible here to set out in any detail what these lines of communication look like.[33] We might consider, for instance, the links elaborated, around 1900, between systematic management and an erotics of violence: for instance, the links between the mechanisms of scientific management and the modeling of sadomasochism, which also occurred at the turn of the century. One discovers in both these systems of bodily discipline "a naturalistic and mechanistic approach imbued with the mathematical spirit"; one discovers in both these systems a linking of bound and disciplined bodies and a form of graphomania—"everything must be stated, promised, announced, and carefully described before being accomplished"; one discovers (and I will be returning to this in a moment) a "transmutation" of animal nature and the natural body into the human and the artifactual, a redrawing of the line between natural and artifactual forms of reproduction (a line drawn, in the anti-natural disciplines of masochism, by the whip).[34]

We might consider as well some of the basic implications of the rewriting of production as conversion. One effect of such a collapsing of the distinction between production and processing is a collapsing of the distinction between the life process and the machine process. Taylor's application of the principles of scientific management to the work process closely parallel, for instance, Jacques Loeb's application of the principles of scientific engineering to the life process.[35] The turn-of-the-century rewriting of production as conversion effectively unlinks work and the natural body, severing the links between labor and self-realization—*homo faber*—and breaking with the Lockean prosthetics binding labor

and the natural body—binding the laboring body, self-making, and property-in-the-self. Moreover, the rewriting of production as conversion—the rewriting of *creation* as *processing*—radically realigns the *gender* of production. Put simply (and perhaps too simply), the modeling of production on creation and generation aligns production and female/bodily reproduction. The modeling of production on processing projects a different set of relations. It projects, on the one side, an antibiological and emphatically male counter-model of reproduction but threatens, on the other, to empty out the categories of production and agency *as such*. Hence the melodramas of uncertain agency in machine culture are neither reducible to nor separable from such anxieties about the gender of production and reproduction.

What these rewritings of the work process entail, then, is the erosion of the differences between "living beings and inanimate matter"—the upsetting of what François Jacob describes as the "notion of a rigid separation between beings and things" and between the life process and the machine process.[36] It entails also (in Stoker's terms) that "life—animal life—was not the only thing that could pass away" (*D*, 207). The life process and the machine process both appear as "living systems," as self-reproducing programs: as James Beniger puts it, "information-processing and communication, insofar as they distinguish living systems from the inorganic universe, might be said to define life itself—except for a few recent artifacts of our own species."[37] But it's precisely that exception—the invention of technological systems of information and communication—that redefines the frontier between the animate and the inanimate. This shift is perhaps perfected in the 1980 Supreme Court decision on the patenting of bioengineered forms of life: according to that decision, "the relevant distinction was not between living and inanimate things, but between products of nature, whether living or not, and human-made inventions."[38]

What I have been calling primary mediation involves precisely these suturings of the life process and the machine process, of erotics and mechanics. These are centered on the "living systems" of information and communication. It's not hard to see, by now, that *Dracula*, for example, everywhere instances the virtually spontaneous formation of bureaucracies of information processing (channeled through the typewriter/secretary-wife/processor Mina). What this amounts to, in the novel, is the spontaneous formation of a kind of Vampire Reading Group, sorting Dracula's paper trail of records and transactions: Dracula is, in effect, pursued across Europe by the moral equivalent of the IRS.

But the novel's version of primary mediation appears, above all, in the sheer everydayness of the body-machine complex and its operations, in the abnormal normality of passages such as this one:

> "Then, Dr. Seward, you had better let me copy it out for you on my type-writer." He grew to a positively deathly pallor. . . . Then it was terrible; my intuition was right! For a moment I thought, and as my eyes ranged the room, unconsciously looking for something or some opportunity to aid me, they lit on a great batch of typewriting on the table. His eyes caught the look in mine, and without his thinking, followed their direction. As they saw the parcel he realised my meaning. (D, 234)

This is what it means to have a thought in the novel. These thoughts are *realized* (in both senses) not merely through a process of telepathy or transference ("there was no need to put our fear, nay our conviction, into words—we shared them in common" [D, 297]). They are realized through these *assemblages* of writing machines and machine-written matter, and through the relays traced between the "opacity of our bodies," bodily movements, and the directed visual scanning of unconscious or unthinking "systems of agency" ("my eyes ranged the room")—systems at once growing and death like, undead and semi-animate ("He grew to a positively deathly pallor"). "That is a wonderful machine, but it is cruelly true. It told me, in its very tones, the anguish of your heart . . . and none other need now hear your heart beat, as I did": this is *une langue incon-nue* of the body-machine complex and the astonishing precision of its instruments of registration.

The arrangements of bodies, technologies, and flows of information realize also the erotics of primary mediation and, again, realize it in the astonishing ordinariness of the body-machine complex and its intimacies. This is how the representation and processing of the materials of sexual violence—"the multitude of horrors . . . so wild, and mysterious, and strange"—is experienced in machine culture. What this amounts to is an early version of the erotic communion through media in the modern home entertainment center: "After dinner I came with Dr. Seward to his study. He brought back the phonograph from my room and I took my typewriter. He placed me in a comfortable chair, and arranged the phonograph so that I could touch it without getting up . . . he sat near me, reading, so that I did not feel too lonely whilst I worked . . . the world seems full of good men" (D, 236–37). And then, in case we've missed it: "Harker and his wife went back to their own room, and as I passed a while

ago I heard the click of the typewriter. They are hard at it" (D, 237). This is then one version of what sex in machine culture looks like.

It might therefore be argued that the closing movement of the novel, with its turn to the slasher-style male violence of the vampire hunt, provides something of an alternative or antidote to such mediated intimacies. This turn represents a violent remasculinization that "corrects" for what has appeared as a merely comparative manliness (a more or less "good specimen of manhood" [D, 236]) and, beyond that, "corrects" what appears as a technologized erotics without gender. This is the "wild work" of "our little band of men" without women: "There is work—wild work—to be done there, that her eyes may not see. We men here . . ." (D, 376).

This closing movement, for one thing, appears as a violent reheterosexualization of relations that the promiscuous mixing across body and gender lines in the novel everywhere erodes ("various bodies began to converge close upon us" [D, 396]). But it would seem that the real threat here is not that of a homosexual desire that must be violently "corrected," although this is certainly part of the story.[39] The real threat here is not a dangerous homosexuality and not an endangered heterosexuality but the threat of an erotics irreducible to gendered bodies and gendered persons and without specific relation to female or male bodies: the panic/thrill of the highly eroticized uncertainty as to the status of identity and sexual identity. From this point of view, the closing movement of the novel represents something of an antidote to an erotics irreducible to "the human order": an antidote to a new order of erotics and the making of "a new order of beings . . . fathered or furthered" (D, 320) in the miscegenation of bodies and machines. The returning desire to persons thus works as a reassertion of an unmediated difference and network of differences. To the extent that the uncertain difference between self and other is obsessively referred to the terms of sexual difference—to the extent that epistemological uncertainties about identity are referred to the oppositional terms of sexual identity—this personation and demarcation of desire works as a reassertion of the differences between same and other and between same-sexuality and other-sexuality both, each translating the other.

But this "wild work" is yet more complicated. In a recent study of the genre-fictions of the body in modern horror film, Carol Clover has suggested that "horror may in fact be the premier repository of one-sex reasoning in our time."[40] Clover is here appealing to the shift, posited by Thomas Laqueur, from one-sex to two-sex reasoning, roughly around the end of the eighteenth century. By Laqueur's account, this represented a shift in models of sexual difference: "An anatomy and physiology of

incommensurablity replaced a metaphysics of hierachy in the representation of woman in relation to man."[41] In short, the two-sex model replaced a model of sliding scales between genders, the mobilities of analogy and resemblance that governed the one-sex model, with a "biology of incommensurability in which the relationship was not inherently one of equality or inequality but rather of difference."[42] Difference by the two-sex model is grounded on "physical fact," on "nature as the bedrock of distinctions": "the natural body itself became the gold standard of social discourse."[43]

There are a number of basic problems with this periodization of a shift from one genre-fiction of the body to another, and not least because the models put forth here seem less to mark a historical shift (however complicated or qualified) than to serve as "stand-in" for the nature/culture opposition and its vicissitudes. That is, in Laqueur's account, the shift from one sex to two sex models is aligned with a shift from gender to sex as the sign of difference. As Clover summarizes it, "The world of one-sex reasoning is one in which gender is primary and sex secondary."[44] This operates in effect as a move from culture to nature, a periodization that leaves this opposition intact, that is, conserves it by periodizing it. As Laqueur puts it, in the one-sex model "culture, in short, suffused and changed the body that to modern sensibility seems so closed, autarchic, and outside the realm of meaning."[45]

But at least in that variant of the "modern sensibility" represented by naturalist discourse the natural and the natural body are scarcely outside the cultural realm of meaning: the unnaturalness of Nature is one of the governing premises of naturalist discourse.[46] The discourse of naturalism, from the turn of the century on, is a discourse premised on the notion that bodies and persons are things that can be made and, more basically, on the *miscegenation of nature and culture, bodies and machines*. The closing "turn to nature" in *Dracula*, for example, represents something more than a regression from culture back to nature or from the one-sex model of horror's culturalism to the two-sex model of natural and "physical fact." The "wild work" that makes up this final turn might better be understood as a version of *wilding*. I have in mind here, of course, the recent episode of male anti-female violence that took place in that repository of nature in the heart of the city—New York's Central Park, designed as an antidote to urban overcivilization. That episode concisely evokes the naturalist idiom of a violent primitivism and male regeneration: a primitivism that finds its place in the reproduction or simulation of "the natural" represented by the park or "nature museum."

It has been argued that "the emotional terrain" of the horror genre is "pretechnological."[47] But it might be suggested that the experiential terrain of such regressions to male violence represents not the pretechnological but a sort of *techno-primitivism*: a simulated primitivism mediated through and through by technologies of reproduction. Hence it does not finally matter whether the regression to male violence in this "wild adventure" (*D*, 378) is imagined in terms of a becoming-animal ("such a wonderful lot of fur coats and wraps" [*D*, 381]) or of a becoming-machine ("the engines are throbbing" [*D*, 379]). The call of the wild — drawing into relation the simulated nature of men in furs and the simulated nature of throbbing male engines — is the wild work of a techno-primitivism: the replicant nature of the body-machine complex. This is what appears as the wild work of male repetitive violence: wild work that incorporates the life process and the machine process such that the call of the wild represents not the antidote to machine culture but its realization.

Notes

1. Robert Ressler (and Tom Schachtman), *Whoever Fights Monsters* (New York: St. Martin's, 1992), pp. 29–30.

2. See Jean Baudrillard, *Le Système des objets* (Paris: Denoël, 1968); Susan Stewart, *Crimes of Writing: Problems in the Containment of Representation* (New York: Oxford University Press, 1991). On the implications of these accounts of serial consumption and fetishization, and on seriality as the "crucial motivating factor of the true collector," see Naomi Schor, "*Cartes Postales*: Representing Paris 1900," *Critical Inquiry* 18.2 (1992): 188–244. The internal tensions between the repetition-automatisms of seriality and the status of motivation as such are part of what I will be discussing in the following.

3. Such an understanding of the links between murder and the mass media in terms of the pathological identification with representations or simulations tends to govern Joel Black's account in *The Aesthetics of Murder: A Study in Romantic Literature and Contemporary Culture* (Baltimore: Johns Hopkins University Press, 1991), pp. 135–87.

4. Sigmund Freud, *Beyond the Pleasure Principle*, vol. 18 of *The Standard Edition of the Complete Psychological Works of Sigmund Freud*, trans. and ed. James Strachey (London: Hogarth, 1955; 1920). p. 17.

5. Mikkel Borch-Jacobsen, *The Freudian Subject*, trans. Catherine Porter (Stanford: Stanford University Press, 1988), p. 9.

6. Ibid., p. 54.

7. Such a mimesis of identity or self-appropriation may be one component of

the compulsive return to the scene of the crime: the conversion of violent act into scene, the conversion of time into place, such that one can return to the crime as scene. See, for instance, the conversion of time into place and act into scene in Zola's *La Bête humaine*: "An intensely vivid memory came back to him of the other murdered body ... which he had seen on that terrible night only five hundred metres from there" (Émile Zola, *La Bête humaine*, trans. Leonard Tancock [Harmondsworth, UK: Penguin, 1977; 1890], p. 322). In such cases, the conversion of actor into spectator and act into scene not only makes the act and actor visible in their repetition in representation. It also allows for the analogy between one murdered body and another. And it indicates the ways in which traumatic violence is inseparable from its repetition: its repetition in representation and, collaterally, the exposure of representation as mere repetition. On the problems of analogy and causality in such scenarios of violent and traumatic repetition—and on the ways in which "the trauma is a product of its repetition," see Susan Stewart, *Crimes of Writing*, pp. 273–90.

The sense of traumatic repetition set out here relies on Laplanche and Pontalis's pressuring of the concept of trauma in psychoanalytic interpretation. For Laplanche and Pontalis, the notion of trauma gives evidence of the limits of the integrity of the event and the subject both:

> It may thus be seen how psycho-analytic investigation throws the concept of traumatic neurosis into question: it contests the decisive function of the traumatic event—first by stressing its relativity vis-à-vis the subject's tolerance and secondly, by inserting the traumatic experience into the context of the subject's particular history and organisation. Seen in this light, the notion of traumatic neurosis appears as nothing more than an initial, purely descriptive approximation which cannot survive any deeper analysis of the factors in question. (Jean Laplanche and J. B. Pontalis, *The Language of Psychoanalysis*, trans. Jeffrey Mehlman [Baltimore: Johns Hopkins University Press, 1976], p. 472).

The notion of trauma as "purely descriptive approximation" hesitates both the notion of trauma as experience of an event and the notion of the impossibility of experience as such. If the first conserves a causal relation to the event, the second makes anything less than a causal relation—"mere" approximations—no relation at all. Hence whereas the first simply refers trauma back to the event, the second simply refers it to a general problematic of representation or experience. One might say then that, either way, the specificity of trauma is evacuated. It is evacuated in the first case by overspecifying the causal relation of trauma to event (what might be called an overly hasty historicization), and in the second by shifting the problem of trauma to a general problematic of reference or specification—or the impossibility of specification—as such (an overly hasty theorization).

The move to shift attention from a "descriptive approximation" to the problematic of conceptualization (which appears as the failure or impossibility of conceptualization) provides an instructive caution against overly hasty historicizations. But it also in effect enacts a version of theory as repetition compulsion. Theory as repetition compulsion urgently nullifies the particular "content" repeated and therefore immunizes itself to the mere approximations and differences that may make a difference (even as difference, the particular, and the unpredictable are rigorously acknowledged, albeit in resolutely abstract terms). This condition of an immunity to difference, which is also a subjection to differences that don't make a difference, would thus make for both the pleasure and unpleasure of such theory-trauma. But such melodramatic and absolutized pleasures and unpleasures (this all-or-nothing logic of the subject) seem more tolerable than the uncertain causalities and agencies of merely "descriptive approximation." In any case, these are the symmetrical alternatives that have governed some recent attempts to understand historical experience, or failure of experience, on the model of shock or trauma. The carrying over of the concept of trauma as a generalizable model of historical interpretation governs some recent work that makes use of psychoanalytic investigation as a model for historical investigation. On the tendencies of such generalizations of trauma or shock as coterminous with "the historical," see notes 30 and 52, below, and the more extensive account of trauma in "Wound Culture," the final part of this study.

8. The notion of repetitive sexual crimes as motiveless is a commonplace in popular representations of serial killing. See, for example, Patricia Cornwell's *Body of Evidence* (New York: Avon, 1991): "The most common motive in sexual homicides is no motive at all. The perpetrators do it because they enjoy it and because the opportunity is there" (54). The FBI's Behavioral Science Unit's strictly behaviorist classification of serial killers into the categories "organized" and "disorganized" redirects attention from motive or gender to something like preparation and neatness. On the gender of serial murder, see Deborah Cameron and Elizabeth Frazier's somewhat programmatic *The Lust to Kill: A Feminist Investigation of Sexual Murder* (New York: New York University Press, 1987) and Jane Caputi's utterly programmatic *The Age of Sex Crime* (Bowling Green: Bowling Green State University Popular Press, 1987). Such accounts not merely motivate motiveless violence as expressions of "male power" but also invoke a cultural or social determinism in accounting for actions: the killer is "a product of his social order," that is, in what has become a quasi-automatic and radically underspecified formulation, "our desires themselves are social constructs" (Cameron and Frazer, *The Lust to Kill*, pp. 33, 143). I am centrally concerned here with the links between the melodramas of uncertain or vexed agency and the virtually automatic appeals to sheer culturalism — "the

cultural construction of the individual" — in these cases. For a strictly "individualist" account of serial murder ("there is no such thing as 'society,' only individuals"), see Colin Wilson and Donald Seaman, *The Serial Killers: A Study in the Psychology of Violence* (New York: Carol, 1992). For a strictly sociologistic one, see Elliott Leyton, *Hunting Humans: Inside the Minds of Mass Murderers* (New York: Pocket, 1988). On the relays between the rise of sexual murder and the new woman movement at the turn of the last century, see Judith R. Walkowitz, "Jack the Ripper and the Myth of Male Violence," *Feminist Studies* (1982): 543–74 and *City of Dreadful Delight: Narratives of Sexual Danger in Late-Victorian London*, (Chicago: University of Chicago Press, 1992). On the relays between serial killing and the new woman's movement at the turn of this one, see Carol J. Clover, *Men, Women, and Chainsaws: Gender in the Modern Horror Film* (Princeton: Princeton University Press, 1992), pp. 4, 62–63, 231.

9. My reading of Borch-Jacobsen here is indebted to Judith Butler, "Imitation and Gender Insubordination," in *Inside/Out: Lesbian Theories, Gay Thoughts*, ed. Diana Fuss (New York: Routledge, 1991), pp. 13–31; Ruth Leys, "The Real Miss Beauchamp: Gender and the Subject of Imitation," in *Feminists Theorize the Political*, ed. Judith Butler and Joan W. Scott (New York: Routledge, 1992), pp. 167–214; and Michael Warner, "Homo-Narcissism; or Heterosexuality," in *Engendering Men: The Question of Male Feminist Criticism*, ed. Joseph A. Boone and Michael Cadden (New York: Routledge, 1990), pp. 190–206.

10. Leo Bersani, "Is the Rectum a Grave?" *October* 43 (1989): 222.

11. Dennis McDougal, *Angel of Darkness* (New York: Warner, 1991), p. xiv.

12. Gilles Deleuze and Félix Guattari, *A Thousand Plateaus: Capitalism and Schizophrenia*, trans. Brian Massumi (Minneapolis: University of Minnesota Press, 1987), p. 279.

13. On the making of statistical persons and disciplinary individualism, see my *Bodies and Machines* (New York: Routledge, 1992), especially parts 3 and 5.

14. Brian Masters, "Dahmer's Inferno," *Vanity Fair*, November 1991, 188.

15. Gilles Deleuze, "Postscript on the Societies of Control," *October* 59 (1992): 6.

16. Henry Ford, *My Life and Work* (Garden City, NY: Doubleday, 1923), pp. 108–109.

17. For a more detailed account of the double-logic of prosthesis, see my "Writing Technologies," *New German Critique* 57 (1992): 170–81.

18. Bram Stoker, *Dracula* (New York: Bantam, 1981), p. 324. Hereafter abbreviated *D* in text.

19. Franco Moretti, *Signs Taken for Wonders: Essays in the Sociology of Literary Forms*, trans. Susan Fischer, David Forgacs, and David Miller (London: Verso, 1983), p. 92.

20. Jennifer Wicke, "Vampiric Typewriting: *Dracula* and Its Media," *ELH* 59 (1992): 476. On *Dracula*, see Elisabeth Bronfen, *Over Her Dead Body: Death*,

Femininity and the Aesthetic (New York: Routledge, 1992), pp. 313–22; Christopher Craft, "'Kiss Me with Those Red Lips': Gender and Inversion in Bram Stoker's *Dracula*," *Representations* 8 (1984): 107–33; Laurence A. Rickels, *Aberrations of Mourning: Writing on German Crypts* (Detroit: Wayne State University Press, 1988), pp. 318–23; and especially Friedrich A. Kittler, *Discourse Networks: 1800/1900*, trans. Michael Metteer with Chris Cullens, (Stanford, CA: Stanford University Press, 1990), pp. 353–56, and "Draculas Vermächtnis," *Zeta* 02 (1982): 103–33.

21. Karl Marx, *Capital*. trans. Ben Fowkes (Harmondsworth, UK: Penguin, 1976), 1: 342.

22. William S. Burroughs, *The Adding Machine: Collected Essays* (London: Calder, 1985), p. 131.

23. Zola, *La Bête humaine*, p. 182. Hereafter abbreviated *BH* in text.

24. I have elsewhere traced the rival determination of the individuality of the individual at the turn of the century in some detail and the styles of regression and the melodramas of uncertain agency it solicits. See my *Bodies and Machines*, especially parts 2 and 5.

25. Ernst Jünger, *Feuer und Blut* (Stuttgart, 1960), p. 84.

26. Ibid.

27. On the machinic as prepersonal or unpersonal, see Deleuze and Guattari, *A Thousand Plateaus*, pp. 259, 273, and passim.

28. Kittler, *Discourse Networks*, p. 212.

29. I am indebted here to Anson Rabinbach, *The Human Motor: Energy, Fatigue, and the Origins of Modernity* (New York: Basic, 1990), 154–63; see also my "Writing Technologies."

30. Etienne-Jules Marey, *La Méthode graphique dans les sciences expérimentales et principalement en physiologie et en médicine*, 2d. ed. (Paris: Masson, 1878), p. 108.

31. The redrawing of the vague and shifting line between the animate and the inanimate, and these shiftings of agency and automatism, might be understood in terms of a general problematic of identity and identification. As Borch-Jacobsen puts it, in an account that seamlessly analogizes the vampire and "the double" generally: "He is what moves of his own accord in my place (the double is always an automaton), lives unduly in my place (the double is always of the living dead), enjoys my place (the double is always hateful), and so on" (*The Freudian Subject*, p.89). Such an account, at once compelling and abstracting, refers the specificity of what I am here calling primary mediation in machine culture to a general problematic of singularity and identity (primary identification). What is at issue here is not merely the question of "historical specificity," since the question of historical specificity or singularity is, as we have seen, bound up with the same question of self-demarcation and "properly" discrete identities. What seems crucially at issue is the *manner* in which, as Jacqueline Rose puts it, "the characterization of the object shifts into the field of its conceptualization" ("Where Does the Misery Come From? Psychoanalysis, Feminism, and the Event," *Feminism*

and Psychoanalysis, ed. Richard Feldstein and Judith Roof [Ithaca, NY: Cornell University Press, 1989]. p. 34): that is, the way in which, for instance, differences in technology and technologies of individualization are referred to "the question concerning technology as such." I have earlier (note 7) commented on the tensions between overly hasty historicizations, on the one side, and versions of theory as repetition compulsion, on the other. Two large matters present themselves at this point: first, the insistent experience of determination as violence (the matter of cause, determination, and agency) and, second, the insistent conversion of such agency-panic and violence into sexual violence (the referring of agency-panic to the matter of sexual difference). Both these matters seem emptied out through the overly rapid historizations or overly rapid theorizations I have sketched.

More locally, the tendency to proceed by way of analogy or pun in some recent work on the technology question—for instance, the work of Ronell and Rickels—has the effect of invoking without specifying the relays between persons, bodies, and forms of technology. That is, analogizing or punning into relation persons and machines, insides and outsides, bypasses the articulation of the relays between inside and outside (what Freud called "the system between the outside and the inside "). Hence the equivalences posited by pun and analogy bypass articulation of the work of making-equivalent and in effect bypass technological differences generally. Such work puts in place of such an articulation of relays, resistances, and differences that make a difference a sort of black box. Proceeding by way of analogies immune to differences is troubling not least because it's precisely the violence-inducing tensions between analogy and cause that traverse these cases of murder and machine culture. It's troubling, also, because such black-box accounts are remarkably inattentive to what I take to be two of the governing premises of the *cultural logistics* I mean to instance here: that things are in part what they appear to be, and that nothing is simply reducible to anything else.

32. The "pathological instance of arithmomania" is set out in William James's Lowell lecture on degeneration (1896). Arithmomania, on James's account, is an addictive disorder of repetition and substitution, a conversion of repetition into counting and counting into series:

> If we are worried about the state of our finances generally, the counting may also express this more general anxiety. . . . [W]e might turn over and over in our minds both the needed and the available sums. . . . The case he describes concerned a young man whose malady began with an obsession for finding lost words. He, too, like the earlier subject, resorted to writing down names of people he met on the street lest he forget them. . . . [H]e developed an obsession for numbers. . . He counted everything at the dinner table . . . even the drops of milk in a spoonful and the spoons in a glassful, keeping track of it all with a black board he carried to the table with him. If he ate a tomato, he had to count the seeds. . . . One day he was given twenty cherries but counted

only nineteen pits. He kneaded feverishly through his own feces for days until he found it. . . . Questions of infinity . . . particularly frightened him. (William James, *William James on Exceptional Mental States: The 1896 Lowell Lectures*, ed. Eugene Taylor [Amherst: University of Massachusetts Press, 1984], pp. 138–39)

Counting and writing and the quantification/regulation of interior and bodily states exactly indicate each other in this case; possession ("the state of our finances") and bodily sums and states are not merely substitutable for each other but also here function in a general logic of substitution (an instance, again, of possessive individualism pathologized). I will return to this addictive logic of substitution in the next chapter. (It might be added that such accounts of the additive and addictive self, in James for example, pressure the notion of multiple personality disorders to the extent that the notion of multiple personality effectively conserves self-identity by converting multiplicities "within" the self into a multiplicity of self-identical selves. Renfield's arithmomania seems to invoke both possibilities, in its radical "unselfishness" and its manias of self-incorporation.)

33. Here again I must refer back to the more detailed, albeit differently directed, accounts set out in my *Bodies and Machines*.

34. I am relying on Deleuze's redescription of the masochistic, and its basic differences from the sadistic, in *Coldness and Cruelty* (New York: Zone, 1989).

35. The references are to Frederick Winslow Taylor's *Principles of Scientific Management* (New York: Harper's, 1911), and Jacques Loeb's *The Mechanistic Conception of Life* (Chicago: University of Chicago Press, 1912).

36. François Jacob, *The Logic of Life: A History of Heredity*, trans. Betty E. Spillman (New York: Pantheon, 1973), 194.

37. James R. Beniger, *The Control Revolution: Technological and Economic Origins of the Information Society* (Cambridge, MA.: Harvard University Press, 1986), p. 10.

38. Cited in David F. Channell, *The Vital Machine: A Study of Technology and Organic Life* (New York: Oxford University Press, 1991), pp. 132–33.

39. On the management of homosexuality in *Dracula*, see Craft, "Kiss Me with Those Red Lips."

40. Carol J. Clover, *Men, Women, and Chainsaws: Gender in the Modern Horror Film* (Princeton: Princeton University Press, 1992), p. 15.

41. Thomas Laqueur, *Making Sex: Body and Gender from the Greeks to Freud* (Cambridge, MA: Harvard University Press, 1990), p. 6.

42. Ibid., p. 150–52.

43. Ibid.

44. Clover, *Men, Women, and Chainsaws*, p. 158.

45. Laqueur, *Making Sex*, p. 7.

46. One of the rules that has governed recent cultural criticism might be restated in these terms: When confronted by the nature/culture distinction, choose the culture side. Laqueur's account of "making sex" in effect relies upon the nature/culture distinction—the shift from models of gender and

culture to sex and nature—while choosing the culturalist side ("making" sex). Paradoxically enough, that account would thus seem strikingly immune to the very "modern sensibility" it posits. But these contradictions have perhaps their own logic. For one thing, if the choice of the culture side continues to rely on the naughty thrill of rewriting nature as culture (nature as something that can be made), it would seem by now that the thrill has pretty much gone out of this "postmodern" way of proceeding. The thrill has gone out of it not least (as I have argued in detail in *Bodies and Machines*) because this alleged postrealism or postmodernism so thoroughly re-enacts the "naturalist" fascination with the project of producing and reproducing bodies and persons. Moreover, it's never quite clear whether the notion of "the postmodern," for example, refers to a period or an attitude, an historical distance (the post-natural) or a critical one (the anti-natural). Nor is it quite clear what status the body, its simulations or body doubles, has in a double discourse that, like naturalism, compulsively appeals to and denigrates the natural and the natural body. But the uncertainties that have accreted around the category—around the aggressively antinatural but body-centered discourse of "postmodernism"—may suggest, at the least, how the problem of the body and the problem of periodization may stand in for each other in such accounts.

47. Clover, *Men, Women, and Chainsaws*, p. 31.

3 · Addiction, Violence, Sexual Difference

A "bit" of information is definable as a difference which
makes a difference.
— Gregory Bateson (on the "cybernetics of the self")

It's always the same and it's always different.
— *Henry: Portrait of a Serial Killer* (on murder)

The Addiction to Addiction

The shift in the understanding of production—the shift
to an understanding of production as conversion and processing—
involves, we have seen, the most basic questions of nature, labor, and
mediation. The shift to processing as production pressures the basic
assumptions of a social order premised on "real work"—that is, on the
relays between work and nature, and, correlatively, on the fundamental
differences between "real work" and "mere" representation or mediation
or processing. Hence it jeopardizes the axiomatic oppositions of
body/mind, body/machine, nature/culture, "real work"/simulation, and
thus solicits the pathologies of agency we have been examining. For
example: the ship that transports *Dracula* to "up-to-date with a
vengeance" modern Britain seems guided by the hand of a "dead steers-
man" (*D*, 85). The dead governing hand is represented (in the clipping
from the mass media, reproduced in the novel at this point) as
"emblemship" of "delegated possession." It is perhaps worth recalling
that the term *cybernetics* was derived by Norbert Wiener from the Greek
word *kubernetes*, or steersman.[1] The notion of the dead steersman is a

concise emblem of the "systems of agency" and primary mediation: the living system of the body-machine complex, the incorporations of the machine process and life process.

From one point of view—that of cybernetics—this redefining of the work process utterly empties the "popular notion" of the self. As Gregory Bateson puts it, in a passage that extends the double-logic of prosthesis/ wounding visible in Ford's fantasy of the modern workplace:

> If you ask anybody about the localization and boundaries of the self, these confusions are immediately displayed. Or consider a blindman with a stick. Where does the blindman's self begin? At the tip of the stick? At the handle of the stick? Or at some point halfway up the stick? These questions are nonsense, because the stick is a pathway along which differences are transmitted under transformation, so that to draw a delimiting line *across* this pathway is to cut off a part of the systemic circuit which determines the blindman's locomotion.[2]

By this view, the notion of the "self" as a delimited agent, immune to foreign bodies and "bounded by the skin," is simply nonsense.

But it's just such a notion of the system of agency that "is condemned by a society based on work and on the subject answerable as subject."[3] The "real work" theory of production and the theory of the subject who produces and reappropriates himself through "real work" are both defined against the notion of the subject as nothing deeper than the incorporation of foreign bodies, processes of simulation and substitution, primary mediation. That is, from the turn of the century on, the living dead subject—the dead steersman—is at once generalized and patholo-gized. And it is generalized and pathologized precisely as the subject, or quasi-subject, of addiction.

One way of locating these large problems appears in the pathologizing of addiction as a malady of the will. It's not hard to see that machine cul-ture and the body-machine complex solicit, from the start, what has recently been described as "epidemics of the will."[4] For Bateson, for example, the "logic of alcohol addiction" conserves a logic of the proper, and properly appropriated, self: "The whole matter is phrased overtly as a battle between 'self' and 'John Barleycorn.'" Hence the addict displays "an unusually disastrous variant of the Cartesian dualism, the division between Mind and Matter, or, in this case, between conscious will or 'self' and the remainder of the personality" ("CS," 3). The addict is thus abnormally normal in his premises—"somehow more sane than the

people around him"—but his "insane (but conventional) premises [mind versus body, self versus other, nature versus artifice, the real versus substitutes, body versus machine] lead to unsatisfactory results" ("*CS*," 2). This is to imagine addiction as an abnormally normal way of experiencing and inhabiting the determinations of action and individuality, consumption and self-consumption, in machine culture—what might be described as self-destruction for fuller self-possession. And these unsatisfactory results take the form of an accelerating violence, a violence seen (by Bateson and by Alcoholics Anonymous)—as "the same as the 'forces which are today ripping the world apart at its seams'" ("*CS*," 15).[5]

One difficulty with this explanation of the logic of addiction is its sheer banality. As one AA account puts it, "Alcohol simply served as an escape from *personal* enslavement to the false ideals of a materialistic society" and its "insane premises."[6] Which in effect equates addiction and socialization, since the opposition between "the personal" and "the social" simply replays the battle of self or will in another register, that of the cultural "determination" of the individual. For Bateson, for example, "it is not a matter of revolt against insane ideals *around* him but of escaping from his own insane premises, which are continually reinforced by the *surrounding* society" ("*CS*," 2, my emphasis). But since the addict's insane premises are also conventional premises, the uncertain demarcation, in this formulation, of what's *around* him and what's *within* him seems less an explanation than a symptom—a symptom of the insupportable experience of the permeability of the self, flowing from the outside in.

Hence another difficulty with this explanation is its sheer generalizability: the abnormal normality of the addict, somehow more sane than the people around him, makes addiction attribution and the anatomy of insecure agency in machine culture simply two ways of saying the same thing. The problem of localizing and demarcating the subject of addiction, or addictive violence, here appears coextensive with the problem of localizing and demarcating "the personal"—the subject—as such.[7]

But the matter of locating, or producing, the differences between same and other and (thus) between self and other are, in machine culture, inseparable from the production of the differences between male and female: the violent transfer of the terms of self-identity into the terms of sexual difference. The logic of addiction in machine culture seems "hard-wired" to the logic of the subject and its determination. And the uncertain status of production in machine culture seems "hard-wired" to the gendering of production. How, then, are forms of self-production in machine culture tied to both compulsive repetition and compulsive

sexual violence? How might the experience of determination as violence take on and solicit the forms of sexual violence? What relays have progressively been articulated, from the turn of the century on, between repetition and differences that make a difference, between mechanics and erotics, between addiction and sexual difference?

Self-Difference and Sexual-Difference

I want to close this part by glancing briefly at these articulations of addiction, mechanics, and sexual relation, centrally by way of Jack London's remarkable writings on the mechanisms of the work process, repetition, and sexualized violence. As one AA booklet frames the battle of the will in the addict's "myth of self-power": "trying to use will power is like trying to lift yourself by your bootstraps" (quoted in "CS," 3). This is also, of course, the formula for male self-making. As Jack London puts it, in the novel *The Sea-Wolf*, here with reference to the resetting of the fallen masts of a ship: "But where were we to begin? If there had been one mast standing, something high up to which to fasten blocks and tackles! But there was nothing. It reminded me of the problem of lifting oneself by one's bootstraps."[8] It is not merely that the Archimedean paradox is seen here as the paradox of male self-making or that the solution to the problem of mechanics reappears in the mechanics of sexuality in machine culture. As the man's "mate" Maud declares at this moment, "I can scarcely bring myself to realize that that great mast is really up and in; that you have lifted it from the water, swung it through the air, and deposited it where it belongs" (SW, 758).

The paradox of male self-making replicates for London, in his alcoholic memoirs *John Barleycorn* (1913), the double bind of addiction. It defines the hair-of-the-dog logic of repetitive alcoholism: "tuned up by the very poison that caused the damage."[9] Such a logic defines, more generally, the paradoxical economy of repetition-automatisms: for example, London's accounts of machine work—"endlessly repeating, at top speed, my series of mechanical motions"—the double-logic of "working to get away from work" (*JB*, 1040). And this defines above all London's way of experiencing the machine work of writing: the body-wounding repetitions of "the matter of typewriting" ("I had to hit the keys so hard that. . .the ends of my fingers were blisters burst and blistered again" [*JB*, 1049]). This is one way in which writing and counting bodies and wounded bodies come to indicate each other in the machine process.[10]

But what becomes visible above all in London's addiction memoirs is

the complicated and circuitous way in which the machine process and addiction are referred to matters of sexual difference and sexual violence. London's writings again and again follow out a sort of count-down sequence of male serial violence. These writings proceed not by the Renfield-like program of "there was an old lady who swallowed a fly" but instead by a "ten little Indians" program, eliminating persons and bodies one by one by one. London's call-of-the-wild writings are in effect wilding episodes: cases of male self-making mimetized in the abstracted and simulated psychotopography of the Great White Male North.

The addiction memoirs manage the project of self-making a bit differently. The automatisms of alcohol addiction reinvent the series of mechanical motions of the work process. These are automatized and calculated moves, unlinking motion from intention, that London calls the condition of "movelessness": "The only movement I made was to convey that never-ending procession of glasses to my lips. I was a poised and motionless receptacle . . . down[ing] wine with the *sang-froid* of an automaton" (*JB*, 948). The swapping of machine work and addiction is part of a general process of substitution, a "serial indifference" whereby "structures of repetition and substitution take precedence over the 'real' qualities of the other."[11] Hence the series of series, the countings and collections that "stand in" for each other: cigarettes and cigarette-pack pictures ("I had to complete every series issued by every cigarette manufacturer" [*JB*, 977]); reading-addiction ("I read mornings, afternoons, and nights. I read in bed, I read at table, I read as I walked" [*JB*, 954]); and the substitutability of one substitution-mania for another ("I would go up to the Free Library, exchange my books, buy a quarter's worth of all sorts of candy that chewed and lasted . . . and lie there long hours of bliss, reading and chewing" [*JB*, 984]). These equivalent exchanges are epitomized in the exchanges of money meticulously recorded throughout ("Yet the charge was the same—five cents" [*JB*, 977]). They are epitomized, more exactly, in the exchanges, between men, of money and drink.

As London concisely puts it, "There was more in this buying of drinks than mere quantity" (*JB*, 977). The something more that exceeds the sameness of these exchanges of mere quantities is what London calls "the transactions of men" (*JB*, 971). What these transactions involve, in part, is the paradoxical economy of "treating" for drinks: it appears, in miniature, as the tension between a gift economy (the symmetrical rounds of drink buying) and a market competition in drinking (treating as matching, and drinking rounds as drinking bouts). But what the transactions involve

above all is yet another species of substitution: a substitution of equivalents, such that "beer didn't count" and "money no longer counted." This is what London describes as a "grave decision," and this grave decision substitutes monetary transactions of the same for the transactions of men: "I was deciding between money and men" (*JB*, 977).

All this appears, in effect, as the substitution of the equivalences or same-differences of economic exchange for the exchanges of same-sexuality. In *John Barleycorn*, London recounts his cruising of the Pacific Rim as the cruising of a globalized gay bar scene: a "congregating place of men where strange men and stranger men may get in touch, and meet, and know. . . . My manhood according to their queer notions, must compel me to appear to like this wine. . . . The more I saw of the men, the queerer they became" (*JB*, 997, 967, 971). He recounts these scenes also as places of a threatening, and compelling, self-obliteration: "So I continued to drink, and to keep a sharp eye on John Barleycorn, resolved to resist all future suggestions of self-destruction" (*JB*, 997).

The reciprocal pathologizing of addiction and male same-sexuality at the turn of the century in effect refers of matters of identity to maladies of will. It refers, in turn, to maladies of self-difference or self-making—John Barleycorn "talking through me and with me and as me" (*JB*, 959) or the identity-panics that amount to a "tearing off of his opponent's face" (*JB*, 983)—to matters of sexual sameness and sexual difference. The system of relays then might be summarized in this fashion. First, the alcoholic memoirs throughout insist on the radical differences between will and automatism and, correlatively, between mind and body—for example, in the refrain that drinking "is practically entirely a habit of mind . . . the desire for alcohol is peculiarly mental in its origin. . . . I found that among all my bodily needs not the slightest shred of a bodily need for alcohol existed" (*JB*, 1110–11). Second, if addictive desire for London is not biological but mental, this is in part because the opposition between mind and body is aligned with an opposition between the "social" and the biological. As London repeats, "It [alcoholic addiction] is a matter of mental training and growth, and it is cultivated in social soil" (*JB*, 1110). But the difference between mind and body in London, among others, is not merely the difference between social and biological: it also measures the difference between male and female. Hence London's logic of addiction counterposes male-female relations and the "thought" of alcohol: "But girl's love did not immediately come to me. I was excited, interested, and I pursued the quest. And the thought of drink never entered my mind" (*JB*, 1025).

It might then be argued that London posits something like the culturalism of addiction (addiction as sheer culturalism). This is a radical culturalism or anti-biologism that, typically enough, lends itself to a radical anti-feminism. But the logic of addiction sets in motion not only this series of substitutions (mind/body, sociological/biological, male/female). It sets in motion a logic of substitution as such. This is the relay system of primary mediation and also the erotics of primary mediation. Friedrich Kittler, tracing the generalization and radicalization of media technologies at the turn of the century, implicitly modifies Lacan's dictum that "there is no sexual relation." As Kittler incisively puts it, "In the discourse network of 1900—this is its open secret—there is no sexual relation between the sexes. . . . According to a fine tautology, men and women, who are linked together by media, come together in media."[12] But this perhaps is not simply to understand sexual relation as inseparable from technologies of reproduction and communication. The collapsing of the relation "between" the sexes into sheer repetition or tautology is the collapsing of sexual difference into mere mediation. This is to imagine the collapse of sexual relation as the collapse of sexual difference (the coming together of men and women). And the collapse of sexual difference into primary mediation is doubly pathologized in machine culture. *The erotics of primary mediation, sexual relation in machine culture, is pathologized, on the one side, in the representation of same-sexuality as serial indifference, and pathologized, on the other, in the representation of heterosexuality as serial violence.*

London's alcohol memoirs, for example, open with an account of female suffrage (the leveling of political differences between the sexes) and end with counterposing male and female forms of making (the gendered conflict between the biological and the technological). The addiction memoirs repeatedly counterpose, that is, female and biological reproduction—"the wives and mothers of the race"—and male production and self-production—"man's first experiment in chemistry was the making of alcohol, and down all the generations to this day man has continued to manufacture and drink it" (*JB*, 1108). Such a counterposing of male and female styles of generation or production should by now be familiar enough. What I want to suggest here are the internal relations between machine production and addiction and, in turn, between addiction and sexualized violence. These internal relations demonstrate how such a conflict between forms of reproduction is realized in the conceptualized psychopathologies of machine culture. The coupling of addiction and sexual killing that surfaces, for instance, throughout London's

account provides something of a focus on the psychotopography of machine culture and its mediated sexualities.

Skin Games

Drinking places in that account are not merely places where strange men meet stranger men, having "escaped from their womenkind" (*JB*, 937). Beyond that, one must "think of the saloon as a quaint old custom similar to ... the burning of witches" (*JB*, 1109). Such a "similarity" between male addiction and anti-female violence thus suggests something more than that "male is to female as the sociological to the biological." London's experiences with "girl-adventure" indeed work to ratify the differences between sociology and the biology. But they point beyond that to what the investment in those differences looks like and to what latent identities, and erotic intensities, these junctions of biology and technology image and translate:

> My adventures have since given me serious pause when casting sociological generalizations. But it was all good and innocently youthful, and I learned one generalization, biological rather than sociological, namely that the "Colonel's lady and Judy O'Grady are sisters under their skins." (*JB*, 1025)

For Bateson, we recall, the addict's violent conservation of the self "bounded by the skin" sets in motion a violence that is just the same as the "forces which are today ripping the world apart at its seams." London localizes that ripper-style violence in the fantasy, here and elsewhere, of the taking and wearing of skins. Taxidermy is the naturalist form of representation *par excellence*. Consider, for example, the linking of naturalist skin games and the surfaces of the female body in this description of the seal hunter from London's *Sea-Wolf*: the hunter "taking and destroying, flinging the naked carcasses to the shark and salting down the skins so that they might later adorn the fair shoulders of the women of the cities" (*SW*, 603). Sexual identity inheres not merely "under the skin" but also, with the literalizing force of the passage London takes from Kipling, "under their skins."

The taking and wearing of skins at once localizes a female "nature"— biological rather than sociological—and connects the work of that localization with exhibitions of anti-female violence. This is not just the alignment of the anti-natural and the antifemale but rather something

more radical: it's akin to the demonstration of nature's unnaturalness—the replacement of "nature" with a technological reproduction of the natural or, rather, the emptying of the category of nature as such. Here is London's account of female nature: "The silly superficial chatterings of women, who, underneath all their silliness and softness, were as primitive, direct, and deadly in their pursuit of biological destiny as the monkey women were before they shed their furry coats and replaced them with the furs of other animals" (*JB*, 1069). This passage contains a series of startling paradoxes. These paradoxes appear in the rapid relocations of gender identity, located at once on the surface of the body and "underneath" it, uncertainly under the skin or under the body. They appear in the tautological "replacement" of nature for nature, one natural skin replacing or substituting for another ("they shed their furry coats and replaced them with the fur of other animals"). This tautological equivalence makes it impossible to tell the difference between natural skins and their substitutes, between replacement nature and nature itself. The tautological replacement of nature for nature thus posits replacement nature as "nature itself"—the replicant nature of machine culture. Such demonstrations of the unnaturalness of nature make it impossible to tell the difference between positing (female) biology as destiny and positing the "deadly . . . pursuit" of the biological ("deadly in their pursuit of biological destiny"), as if it were a sort of murder victim. This amounts to the deadly pursuit of the natural and the female both. Hence the "culturalist" redemonstration of the unnaturalness of nature appears inseparable from the positing of a replacement nature, and the positing of replicant nature as inseparable from the ripper-style violence of these naturalist skin games.

If naturalist discourse finds its latent identity in the unnatural Nature of taxidermy, the adventures of men in skins realize the techno-primitivism of male wilding. These are the paradoxes of techno-primitivism and wilding that make possible, for example, the understanding of surgical addiction as self-realization and, more generally, self-making as addictive sexual violence. The skin games of naturalism epitomize the problem of the body in machine culture. They epitomize too the programs of production as substitution, and the programmatic and violent rewritings of self-difference as sexual difference. There is something like a resemblance between the taking and wearing of skins in London's stories of repetitive male violence and in other cases of serial violence, at least from the turn of the century on: between the leathered face of the Western adventure hero and Leatherface in *The Texas Chainsaw Massacre*; between the Wild West hero Buffalo Bill's body counts, his

taking and wearing of skins, and the slasher film's investment in taxi-
dermy and addictive killing—from *Psycho* to the serial killer Buffalo Bill,
in Thomas Harris's *The Silence of the Lambs.*

Oliver Wendell Holmes early on (1859) described the technology of
photography as a form of hunting and skinning with a camera: "Form is
henceforth divorced from matter. . . . Men will hunt all curious, beauti-
ful, grand objects, as they hunt cattle in South America, for their skins
and leave the carcasses as of little worth."[13] The erotics of machine cul-
ture is thus realized in the hunting and skinning of beautiful objects. We
might consider, for example, the relays between surgical addiction
("Wound Man") and the excitations of photographic reproduction
("reborn every time a photographer . . . did what?" [ellipses in original])
in *Red Dragon* (1981), the remarkable prequel to *Silence of the Lambs*.[14]
This is a representation of serial killing in which the complex of seriality,
prosthesis, and primary mediation could not be more graphic or more
abnormally normal. These are some of the constituent elements that
make up "the elegant declensions of serial violence"[15] in machine cul-
ture, from the late nineteenth century on.

Notes

1. Norbert Wiener, *The Human Use of Human Beings: Cybernetics and Society*
 (New York: Da Capo, 1954), p. 15.
2. Gregory Bateson, "The Cybernetics of 'Self': A Theory of Alcoholism,"
 Psychiatry 34 (1971): 6. Hereafter abreviated "CS."
3. Jacques Derrida, "The Rhetoric of Drugs," *1–800* 2 (1991): 67. Whereas for
 Bateson the popular conception of the self is nonsense, the Derridean
 account seems to conserve its inevitability—the inevitability of the frayed
 logic of possessive individualism—albeit in agonistic or terminal form. Thus,
 the "fantasy of reappropriation" that defines the form of drug addiction
 dreams of "emancipation and of the restoration of an 'I,' of a self or of the
 self's own body. . . . As convoluted and paradoxical as this 'logic' of reappro-
 priation may be, especially when it's mixed up with the simulacrum, still one
 can never quite get beyond it" (Derrida, "The Rhetoric of Drugs," p. 68). It's
 precisely this abiding in paradox that, for Bateson, makes up the addiction to
 addiction: as Bateson expresses it, "The so-called 'Body-Mind' problem is
 wrongly posed in terms which force the argument toward paradox" ("CS," 7).
 Bateson nevertheless, as I will take up in a moment, cannot avoid represent-
 ing the abnormal normality of addiction—that is, the insecure relation
 between "the personal" and social "forces," the insecure boundaries between
 "self" and "society"—in at least implicitly paradoxical terms.

4. For an incisive characterization of current "epidemics of the will" and addiction-attribution, see Eve Kosofsky Sedgwick, "Epidemics of the Will," Jonathan Crary and Sanford Kwinter, Eds. *Incorporations*. Zone 6. (Cambridge, MA: MIT Press, 1992), pp. 582–95. Sedgwick broaches briefly the coincidental pathologizing of homosexuality and addiction, the "coincidence" I mean to unpack here. On addiction and sexuality, see also Anthony Giddens, *The Transformation of Intimacy: Sexuality, Love and Eroticism in Modern Societies* (Stanford, CA: Stanford University Press, 1992), especially chapters 5–6.

5. *Alcoholics Anonymous* (New York: Works, 1939), pp. 286–94.

6. Bernard Smith, *Alcoholics Anonymous Comes of Age* (New York: Harper, 1957), p. 279; as cited in "CS," 2.

7. The abnormal normality of repetitive violence — its generalizability in the subject of machine culture — might be taken up, as we have seen, by way of the related subjects of shock or trauma: that is, the generalizability of shock as the abnormally normal experience of modern life. For Benjamin, of course, "shock experience" is seen as coterminous with the modern experience, or failure of experience, as such (Walter Benjamin, *Charles Baudelaire*, trans. Harry Zohn. [London: Verso, 1983], pp. 116–17; Susan Buck-Morss, "Aesthetics and Anaesthetics: Walter Benjamin's Artwork Essay Reconsidered," *October* 62 (1992): 17; my sense of the matters of shock and modernism is also indebted to Hal Foster's work on surrealism, "machine dreams," and the (proto)fascist imaginary; see Foster, "Armor Fou," (*October* 57 (1991): 65–97), and *Compulsive Beauty* (Cambridge: MIT Press [1993]).

Such an account makes the psychical category of shock or trauma coextensive with the historical "impact" of modernism generally. My point is that if such a generalization of the repetitive states of shock or trauma as coterminous with modernist subjectivity threatens to empty out the specificity of these states, such a failure of specification might here again make visible the normative abnormality of the subject of machine culture. What this would amount to is the routinization of shock or trauma as the state of the modernist subject. One might in fact describe the culturalist or new historicist subject — determined from the outside in by external forces neither cognized nor recognized — as the subject in a state of shock. That is, the determination of inner states, apart from the subject's cognition or recognition, presupposes the subject as the subject of shock or trauma. One might say that the subject of shock or trauma is thus inseparable from the notion of the cultural construction or historical determination of the subject as such, the subject *determined from the outside in.*

From this point of view, the attempt to "mediate" between historical and psychological accounts, between outside and inside, misses the point: shock or trauma perforce penetrates through what Freud described as "the system between the outside and the inside" (Freud, *Beyond the Pleasure*

Principle (1920). The Standard Edition of the Complete Psychological Works of Sigmund Freud. Trans. and ed. James Strachey. Vol. 18 (London: Hogarth, 1955, p. 32). Stated simply, it's not a matter either of equating inside and outside (the "psychological" and the "sociological") or a matter of choosing between them, since it's precisely the boundaries between inside and outside that are violently transgressed, renegotiated, reaffirmed in these cases. Or, as Siegfried Giedion expresses it in his history of the taking-command of machine culture, "Mechanization implanted itself more deeply. It impinged upon the very center of the human psyche, through all the senses." (Siegfried Giedion, *Mechanization Takes Command: A Contribution to Anonymous History* [New York: Norton, 1969], p. 42) It is not entirely clear here whether mechanization impinges through (by means of) the senses or through (bypassing or breaking through) the senses, and it's exactly this hesitation about the impingement or implantation of the machine at "the center" of the psyche that makes for the radical and violent uncertainties of agency and motivation we have been tracing in these cases of primary mediation. The localization or demarcation of the subject thus appears inseparable from the transferential relation to technology in machine culture ("we must transfer what is inside us onto the machine"). Klaus Theweleit, for example, traces at once the "technological formulas" of the fascist subject ("the utopia of the body machine") and insists that "it has nothing to do with the machine technology" (*Male Fantasies*, trans. Stephen Conway, with Erica Carter and Chris Turner [Minneapolis: University of Minnesota Press 1987, 1989], vol. 2, p. 162) Such hesitations between techno-cultural and psychological determinations of where the subject comes from are, I am arguing, inseparable from the body-machine complex, the uncertain localization and demarcation of agency and motive in machine culture. Or, as Ballard registers the intimacies with technology, or primary mediations, of machine culture: "The failure of his psyche to accept the fact of its own consciousness," this state of shock, is "our trauma mimetized," that is, turned outside in in the mimetic identifications with the machine process (J. G. Ballard, *The Atrocity Exhibition*, San Francisco: Re/Search, 1990; 1969], p. 12).

I have described this uncertainty in terms of the subject's uncannily intimate or *transferential* relation to the machine. This absolute proximity to the machine is, again, most provocatively expressed by Ernst Jünger. To extend the passage earlier excerpted: "We have to transfer what lies inside us onto the machine. That includes the distance and ice-cold mind that transforms the moving lightning stroke of blood into a conscious and logical performance. What would these iron weapons that were directed against the universe be if our nerves had not been intertwined with them and if our blood didn't flow around every axle" (Jünger, *Feuer und Blut*, [Stuttgart, 1960], p. 84). The rapid transfers of inside and outside, distance and fusion,

in the transferential relation between interior states and weapon-machines, make it impossible to disentwine bodies and machines. But this is not merely to project interior states onto the machine. It is, in effect, to understand interiors as the inclusion of an external "distance," such that interiors become visible as a kind of internalized scene or performance (interiors transformed into self-distance and self-distance into a "conscious and logical performance"). This conserves the subject as the object of representation and self-representation—understanding the content of the unconscious "essentially as representation"—and produces the subject precisely by way of the *identification* or *mimetization* of bodily interiors in the machine process. Jünger's transferential logic thus not only registers the uncertain and violent renegotiations of the boundaries between inside and outside, "psychology" and "sociology," interior states and machine culture. It also concisely dramatizes the transformations of processes of identification into claims of conscious, logical, ice-cold identity. More exactly, it makes visible, in astonishingly condensed form, how the identification with the machine operates in such cases of primary mediation.

8. Jack London, *The Sea-Wolf*. *Jack London: Novels and Stories* (New York: Library of America, 1982). p. 732. Hereafter abbreviated *SW*.

9. Jack London, *John Barleycorn*. *Jack London: Novels and Social Writings* (New York: Library of America, 1982), p. 1001. Hereafter abrreviated *JB*.

10. On the relays between writing and counting bodies and wounded bodies in London—and centrally in relation to "the matter of typewriting" and its violent and wounding repetitions—see my *Bodies and Machines* (14–16). On "wound culture" more generally, see the final part of this study.

11. Avital Ronell, *Crack Wars: Literature, Addiction, Mania* (Lincoln: University of Nebraska Press, 1992), p. 101.

12. Kittler, *Discourse Networks, 1800/1900*. Trans. Michael Metteer and Chris Cullens (Stanford, CA: Stanford University Press, 1990), p. 357.

13. Oliver Wendell Holmes, "The Stereoscope and the Stereograph," in *Photography: Essays and Images: Illustrated Readings in the History of Photography*, ed. Beaumont Newhall (New York: Museum of Modern Art, 1980), p. 60. On the links between realism and skin games—or what William Thayer in 1894 called "epidermism"—see Thayer "The New Story-Tellers and the Doom of Realism," in *Realism and Romanticism in Fiction: An Approach to the Novel*, ed. Eugene Current-Garcia and Walton R. Patrick (Chicago: Scott, 1962).

14. Thomas Harris, *Red Dragon* (New York: Dell, 1981); *The Silence of the Lambs* (New York: St. Martin's, 1988).

15. Ballard, *The Atrocity Exhibition*, p. 69.

PART 2.

The Mass
in Person

4 · The Serial Killer as a Type of Person

I have to this point traced some of the components of serial killing: the relays between murder and machine culture; the intersecting logics of seriality, prosthesis, and primary mediation that structure cases of addictive violence — and, more generally, the addiction to addiction in contemporary society; the emergence of the pathological public sphere as the scene of these crimes. In this part I want to reconsider the intimacies between mass culture and mass murder: the making of what I have called the mass in person. I want to focus here on some very basic questions that I have to this point tracked somewhat obliquely. What counts as serial killing? Or, to put it a bit differently, how did the particular kind of person called the serial killer come into being and into view? The answers to these questions are by no means simple, even in what might appear to be the most self-evident of cases.

The New Face of Evil

Here, again, is something approaching a personal confession, part of an anonymous letter received by the Ohio newspaper the *Martin's Ferry Times Leader* in November 1991:

> I've killed people. . . . Technically I meet the definition of a serial killer (three or more victims with a cooling-off period in between) but I'm an average-looking person with a family, job, and home just like yourself.[1]

There is, we have seen, nothing extraordinary about such communications to the mass media. Interactions between the serial killer and public media (or, in some cases, circulation-boosting simulations of that interaction) have formed part of the profile of serial murder, from the inaugural Jack the Ripper case on; for serial murder, we have seen, is bound up through and through with a drive to make sex and violence visible in public. Nor is there is anything extraordinary about the "technical" self-definition of the serial killer that centers this confession, although there is some disagreement as to the baseline qualifying number. (One recent and comprehensive study of the governing views on serial homicide, it will be recalled, simply defines the serial murder case "as involving an offender associated with the killing of at least four victims, over a period greater than seventy-two hours."[2]) And the "cooling-off period"—distributing the murders repetitively and serially over time—has come to provide the working distinction between serial and mass murder (with "spree killing" falling somewhere in between).[3]

Yet if there is then nothing extraordinary in the technical definition cited by the killer, there is perhaps something uncanny, even horrifying, in the sheer ordinariness—in the abnormally normal form—this confession takes.[4] For if this is a personal confession, it is, on several counts, strangely *impersonal*. I am referring not merely to the utterly *average* and *generic* self-description provided by the killer ("average-looking person with *a* family, job, and home") but also to the way in which his identity seems to melt away in his absolute identification with others ("just like yourself"). Both this *abnormal normality* and this compulsive *over-identification* are, we have seen, crucial to the understanding of the serial killer.

But the style of over-identification in such cases remains to be clarified. For if the anonymous writer of the letter here defines himself by way of the working definition of the serial killer, how then do such definitions or characterizations of the subject of repetitive violence enter into the "inner" experience of that subject, seeming in effect to fill—or, better, to replace or to evacuate—his interior?

Here again are the words of the Ohio killer, ultimately identified as Thomas Dillon (a civil servant who confessed to five "motiveless" killings):

> I knew when I left my house that day that someone would die. . . . This compulsion started with just thoughts about murder and progressed from thoughts to action. I've thought about getting professional help but how can I ever approach a mental-health professional? I can't just blurt out in an interview that I've killed people.[5]

The sheer banality these statements contain is perhaps their point. And this is not merely because, as everyone knows, modern, repetitive, systematic, anonymous, machine-like, psycho-dispassionate evil can scarcely be separated from banality.

The killer, for one thing, notes his compulsive drive to repetitive bodily violence with an utterly dispassionate rationality. Anything like a "private" identity or psychology has vanished, disintegrated "into the two poles of expert knowledge and psychotic 'private' truth," with all the links between public knowledge and "private" or hidden truth of desire cut off.[6] Or, rather, private truth has become thoroughly identified with expert knowledge, but as if without subjective force or conviction. The drive to kill is immediately referred to the "psy" sciences—in the form of a client "interview" with the "mental-health professionals." This is, as it were, just one step from a twelve-step outlook on addictive killing. And this is, as it were, one version of the modern replacement of the sense of interior states with information: the replacement of the soul and, in this case, the soul of evil, with knowledge systems, expert and scientific.

The killer's experience of his own identity is directly absorbed in an identification with the personality type called "the serial killer": absorbed into the case-likeness of his own case. On one level, this points to the manner in which the serial killer *internalizes* the public (popular and journalistic) and expert (criminological and psychological) definitions of his kind of person: "serial killers are influenced by the media as well as by academic psychology, and many make a specific study of earlier offenders."[7] Such observations have by now become routine in accounts of the type of person called the serial killer. But the larger implications have perhaps, for that very reason, not quite been registered.

One detects, in the serial killer's identification with his type of person, the empty circularity by which the serial killer typifies typicality. One detects, that is, what has recently been called the "looping-effect" by which "systems of knowledge about kinds of people interact with the people who are known about," affecting the "way in which individual human beings come to conceive of themselves." The concepts of kinds of persons, such as the concept of the serial killer, tend to lift themselves up by their own bootstraps: feeding on the representations and identifications that thus become inseparable from that concept.[8]

The style of this interaction, in the case of the serial killer, assumes extreme, even terminal, form. What disappears—in the thorough self-identification with others and with expert systems of knowledge—is anything like a discrete interiority or individual motive. As Dillon described

the attraction of serial killing to the friend who eventually gave him up: "There is no motive."[9]

The "technical" definition of the serial killer as a kind of person became available in the mid-1970s, with what FBI agent Robert Ressler called a "naming event": the coining of the term "serial killer." A naming event is more complex than a simple nominalism; it is not that the concept or category is simply "made up," but that the make-up of such concepts has its own internal "torque." It involves the positing of a category or type of person as a sort of point of attraction around which a range of acts, effects, fantasies, and representations then begin to orbit. But it involves too the empty circularity by which the social construction of a kind of person becomes the point of attraction of the kind of person who traumatically experiences himself as nothing "deeper" than a social construction.

It is this empty circularity—at the level of social construction and at the level of self construction—to which I want to return here. From the take-off point of the mid-1970s, large quantities of information about the serial killer have accumulated: in the form of criminological and psychological investigations; feminist, gender, and cultural studies; journalistic, fictional, and cinematic representations. A good deal of this material, professional and popular, rehearses a body of confident, if uncertainly reliable, general knowledge about serial murder.[10] But a good deal more has taken the form of lurid, purely descriptive case histories, which often resemble nothing more than collections of evil kitsch.[11]

But even the more interpretive studies of the serial killer have faltered at the impasse we have begun to detect. On the one side, there is the avowed failure, in these accounts, to locate a point of contact between private compulsion and public accounting; on the other, one sees the uncanny intimation that the killer's private compulsion is nothing but these public accountings of the subject, turned outside in.

Recent accounts of the serial killer routinely turn to the *social constructions* of "the serial killer problem," of the malady called serial killing, and of the type of person called the serial killer (serial killing and serial killers as the "symptoms" or "reflections" of social crises and anxieties).[12] It is perhaps possible to invert this perspective: to consider not only the social construction of the malady called serial killing but also serial killing at least in part as a malady of social construction, experienced at the level of the subject.

The social construction assumption, at the level of the social, is that there is nothing deeper to the social order than its structuring of itself by

itself, nothing deeper than its strictly immanent and "indwelling network of relations of power and knowledge." The social construction assumption, at the level of the subject, is that there is nothing deeper to the subject than his formation from the outside in. On this view, interior states become merely "the subjective synonym of the objective fact of the subject's construction," and thus "pleasure becomes a redundant concept and the need to theorize it is largely extinguished."[13] The subject itself, that is, becomes a redundant, and largely extinguished, concept.

It may then be possible to understand the pleasure-killer as one version of the largely extinguished subject: the "devoided" and predead subject, for whom pleasure has become bound to the endless persecution of pleasure and to the endless emptying or voiding of interiors, in himself and in others. This kind of subject may then be one version of the person in whom the "social ego" has replaced the agency pertaining to the person: agency replaced with the merely "personalized" form of a social determination painfully and traumatically drilled into and fused onto the individual. For this reason, I have suggested that there are affinities between what Klaus Theweleit identifies as the soldier-male's regimen of killing for pleasure and the careers of some serial killers. But there are also basic differences, and it is necessary at this point to specify further the social ego of the serial killer and the sort of social order into which it melts into place.

Psychology as Public Culture

Compulsive killing has its place, I have suggested, in a public culture in which addictive violence has become not merely a collective spectacle but also one of the crucial sites where private desire and public culture cross. The convening of the public around scenes of violence has come to make up a *wound culture*: the public fascination with torn and opened private bodies and torn and opened psyches, a public gathering around the wound and the trauma.[14] One of the preconditions of our contemporary wound culture is the emergence of psychology as public culture.

Stranger-intimacy, that is, is bound up not merely with the conditions of urban proximity in anonymity but also with its counterpart: the emergence of intimacy in public.[15] Roughly stated, the late nineteenth century in the United States—the period of the first wave of sexual serial killing and the first wave of feminism—was also the period of the rise of a therapeutic culture of self-realization.[16] And roughly stated, the post-World War II era—the period of the second wave of sexual serial killing

and second wave of feminism—was the period in which "subjectivity and its management" was renovated as a growth industry: the industry of growing persons as both expert professional and popular culture.[17] As C. Wright Mills observed in 1951, "We need to characterize American society of the mid-twentieth century in more psychological terms, for now the problems that concern us most border on the psychiatric."[18]

The bordering of the social on the psychiatric became visible on several fronts in the post war decades: in the spreading of the mental health profession and in the abnormal normality of psychic pain ("psychological help was defined so broadly that everyone needed it"); in the transformation of patient into "client" and "mental health" into something that could be mass produced and purchased; in the rise of sociologistic psychologies of self-actualization (the work of Carl Rogers and Abraham Maslow, among others); in the appearance of psychologistic sociologies of collective and national psychopathology (from the inaugural diagnosis of "American nervousness" to "future shock" and "the culture of narcissism," to "Prozac nation" and the "trauma culture" of the 1990s). There appears an the insatiable public demand—in the print media, drama, films, and television—for accessible, entertaining information on psychological disturbances and psychiatric experts: "private ordeals" become "a matter of great public curiosity and untiring investigation."[19]

Stranger-intimacy and its maladies have become public culture: part of a pathological public sphere. Consider, for example, the talking cure as mass-media event: talk radio. The serial killer Ted Bundy described himself as "a radio freak" who "in my younger years . . . depended a lot on the radio." From about the sixth grade on, one of his favorite programs was a San Francisco radio talk show: "I'd really get into it. It was a call-in show. . . . I'd listen to talk shows all day. . . . I genuinely derived pleasure from listening to people talk at that age. It gave me comfort . . . a lot of the affection I had for programs of that type came not because of their content, but because it was people talking! And I was eavesdropping on their conversations."[20]

This version of stranger-intimacy on the air was taken a step further in the psychology student's university work-study job at a crisis hot line. Bundy's biographer, or thanographer, Ann Rule recounted, "The two of us were all alone in the building, connected to the outside world only by the phone lines. . . . We were locked in a boiler room of other people's crises . . . constantly talking to people about their most intimate problems."[21] Stranger-intimacy and stranger-killing seem uncertainly alternatives and substitutes. The "Russian Ripper," the sex-killer Chikitilo,

simply observed: "I never had sexual relations with a woman and I had no concept of a sex life. I always preferred to listen to the radio."[22]

There is, it has recently been observed, a certain "paradox of radio: a universally public transmission is heard in the most private of circumstances."[23] One might easily reverse the terms of this paradox: the paradox of talk radio is that a private communication is heard in the most public of circumstances. But it is precisely the reversibility, or opening, of the boundaries between public and private that makes up at least in part the appeal of talk radio (and now confession TV). The "pleasure" of these paradoxically open secrets thus goes beyond voyeurism or "eavesdropping": it intimates a collective gathering around private ordeals.

"A hundred years earlier," Stephen Singular remarks in *Talked to Death* (the basis of the film *Talk Radio*), "Walt Whitman had listened to his countrymen speak and written that he could hear America singing. Talk radio became the sound of America singing, arguing, whining, bitching, confessing, and letting raw feelings, private problems, and political or social opinions hang in the air for everyone with a radio to absorb."[24] This popular version of the national body electric, this suspension in the air of "the private" and "the social"—raw feelings and political opinions, the psychological and the national—seems at once a virtual, popular town meeting and its pop-simulation—a version of the consumerist pop-superego. "Pop" may be "popular," but it is also "Dad," the Master's Voice. "My father had gone over to the radio in about 1970," the neo-Nazi Ingo Hasselbach recently recalled: "It was like this disembodied voice that I knew was my father, trying to brainwash all the kids in the nation. . . . My father's voice *was* the state."[25]

The Bordering of the Social on the Psychiatric

This superegotistical voice of the state might be understood in terms of the peculiar formation of the social ego: the depsychologized ego unremittingly dependent on external support, as a sort of insectoid exoskeleton. It is uncertainly the command of the superego as "the 'spirit of community' at its purest," and, at the same time, the "traumatic dimension of the Voice, which functions as a kind of foreign body perturbing the balance of our lives."[26] It may be seen in terms of the advent of a mass psychology that voids individual psychology: the direct enlisting of the subject in the service of the social order, the mass pleasure-drills of a "repressive desublimation" that amounts to "a direct 'socialization' of the unconscious."[27]

On this view, the direct socialization of the unconscious, the replacement of the psychical by the social ego, amounts to the formation of the subject from the outside in: to "psychology" as implant. Something like this notion of a social ego grounds the sociologistic psychology and psychologistic sociology that proliferated in the post war decades. But this work scarcely moves beyond the jargon of authenticity and inauthenticity, the psychologism and sociologism, it deplores. It thus stands as the "paramnesic" symptom of its culture: that is, its image and its disavowal.

A brief sampling must suffice here. One discovers again and again in this work a grim diagnosis of unrestrained self-inflation in the cult of self-actualization ("the culture of narcissism"). This is self-realization as the realization of the merely personalized person—what David Riesman in his best-seller of the early '60s, *The Lonely Crowd*, called the formation of the "pseudo-personalized" subject. Riesman's diagnosis of the fall into stranger-intimacy in the lonely crowd devolves on a basic distinction between the "inner-directed" subject and the "other-directed" pseudo-subject. The inner-directed subject displays, for Riesman, "that endoskeletal quality and hardness, which makes many inner-directed individuals into 'characters' in the colloquial sense." By implication, the other-directed subject displays that exoskeletal, or insectoid, quality that is one refrain in the understanding of the pleasure-killer.[28]

But there is something deceptive in this simple opposition between inner and outer directedness. For inner directedness is "'inner' in the sense that it is implanted early in life . . . and directed toward generalized but nonetheless inescapably destined goals." This amounts to the implantation of a "psychological mechanism" that Riesman describes as the internalization of a "psychological gyroscope." In the other-directed person, this version of the influencing machine is replaced by another. The other-directed person is an endlessly attuned "receiver" of "signals from near and far" "whose relations with the outer world and with oneself are mediated by the flow of mass communication" and by the "anonymous voices of the mass media." His "control equipment" is not like the gyroscope, but instead "like a radar."[29]

In both cases, then, control is implanted from the outside: an outside control experienced, in the first case (inner directedness), as control from within and, in the second (other-directedness), as control from without. In both cases, one discovers the formation of what the psychoanalytic theorist Jean Laplanche has called "an internal alien entity"—or what Ted Bundy, radio freak, simply called "the entity." "Everything comes from without in Freudian theory, it might be maintained," Laplanche observes, "but at the

same time every effect—in its efficacy—comes from within, from an isolated and encysted interior."[30] The psychoanalytic account holds visible the radical uncertainty that Riesman's psychologistic account registers only in the form of a tacit contradiction: the insecurity as to where the subject of machine culture comes from, its feeling of inner-directedness and its intimations of other-directedness, the internal otherness of the subject.

There is a basic uncertainty, too, as to the status of such an other directedness: as one way of understanding the subject *tout court* (a primary extimacy) or as a way of understanding a particular kind of subject (the other-directed subject of mass culture, influencing machines, and stranger-intimacy). This coming down of the boundaries between inside and outside, between the psychological and the social, between public and private orders, is crucial. It may provide one way of understanding the foundational status of trauma in psychoanalysis (trauma as a failure of distinction between inside and outside, private and public registers) and, in turn, may provide one way of understanding how private trauma itself has emerged as public culture on the contemporary scene: how the psychopathologies of shock, trauma, and the wound have emerged as the very model of the public sphere.[31]

In the psychologistic sociology of the postwar years (particularly in its cultural-conservative variants), this breakdown of the distinctions between inside and outside and between private and public—this bordering of the social on the psychiatric—is the malady itself. The very "opening" of the borders between the psychical and the social, the private and the public, is condemned as pathological. As Daniel Bell expresses it: "The private realm—in morals and economics—is one where consenting parties make their own decisions, so long as the spillover effects (pornography in one instance, pollution in the other) do not upset the public realm."[32] The "spillover" of the private into the public, the overflowing of inside into outside, is itself pornography (sex in public) and pollution (shit in public).

Hence, the culture of narcissism—the empty circularity of self-seeking—is also, on this account, the narcissism of culture—the empty circularity of a culture seeking only itself. As Bell summarizes it, "Culture has become supreme . . . given a 'blank check.'" Since "the cultural realm is one of self-expression and self-gratification," sheer culturalism and sheer narcissism become two ways of saying the same thing. The self-made man's fantasies of self-origination give way to self-originating fantasies. For this reason, the modern emphasis on "*self*-expression" amounts to "the erasure of the distinction between art and life." Whatever Bell means

by "life," what he means by "art" is the "acting out of impulse," putting the realm of the imagination and fantasy in place of reality: "The greater price was exacted when the distinction between art and life became blurred so that what was once permitted in the *imagination* (the novels of murder, lust, perversity) has often passed over into *fantasy*, and is acted out by individuals who want to make their 'lives' a work of art."[33]

The transformation of lives into "lives" — the simulations of life — is the eruption of art into life, private into public, interior states into acts: reality and fantasy have changed places. The panic about representations come to life and taking life; about the yielding of "real life" to the image; about the traumatic replacement of perception by representation: all have become familiar enough in accounts of the "fall" into "post-industrial" or "information" society. They have become one way of understanding a culture of narcissism and self-inflation and also its more recent mutation into a culture of trauma and self-evacuation. And they have become one way in which the question of violence and its causes have come to devolve on the question of a failure of distance with respect to representation (an interlacing of violence and representation that it will be necessary to take up, on several fronts, in the pages that follow).

The indictment of a general yielding of the social and psychological orders to pop-sociology and pop-psychology became a general refrain in the postwar decades — and not least as a refrain *within* a burgeoning pop-sociology and pop-psychology. One approaches here what Barbara Ehrenreich has called "the nightmare anomie of the pop psychologists' vision: a world where other people are objects of consumption, or the chance encounters of a 'self' propelled by impulse alone."[34] A strange turn takes place here in the notion of the "pop-psychologists' vision" reduplicating itself in the world. Reality and fantasy change places again, this time as an *effect* of the pop-psychologists' vision of the replacement of real psychology and real sociology by pop-psychology and pop-sociology.

In popular serial-killer fiction, such as Thomas Harris's *Red Dragon*, the killer's career is nothing but an acting out of the drive to self-actualization (what the killer Dolarhyde calls "The Becoming"). It is nothing but the transformation of art into life; the killer experiences pure identification with reproductions of Blake's image "The Red Dragon" and with mass reproduction generally. He literalizes the cannibalistic devouring of other people as objects of consumption (Dolarhyde as "Dollar Hide," bodily flows and money flows referring back to each at every point).[35] That career, in other words, is nothing but a realization in pop-fiction of the pop-psychologist's nightmare vision.

Serial killers read many books about serial killing, and the pop-

psychologists' visions make up part of their curriculum. What is the Unabom Manifesto other than a crash-course in these popular diagnoses? What are psychology student Ted Bundy's conversations in the third person other than personalized pop-psychology and pop-sociology? What is Thomas Dillon's "confession" in the papers other than the inhabiting of the popular understanding of the serial killer as a self-understanding?

"There is some evidence that actual serial killers may pattern themselves on fictional accounts." There is evidence too that these fictional accounts are often based on official accounts, which in turn often draw on fictional accounts: "It is difficult to know whether the bureaucratic law enforcement attitudes toward serial murder preceded or followed changes in popular culture. . . . In turn, the investigative priorities of bureaucratic agencies are formed by public and legislative expectations, which are derived from popular culture and the news media . . . [I]n coverage of serial murder, the boundaries between fiction and real life were often blurred to the point of nondistinction."[36] The Seattle area serial killer, George Russell Jr., a middle-class black male and self-described "Bundy man," "thought he could pull off the perfect crime if he just read enough. . . . He's always talked and read about the hillside stranglers and John Wayne Gacy and Bundy and [popular media misconceptions about] the lack of black serial murderers. . . . He borrowed my books on Ted Bundy and Charles Manson and didn't return them. The things he read ["my books"]—ugh!"[37]

It is in this context that we may reconsider the "empty circularity" of the serial killer: his hyperidentification with place, context, or situation, and his psychasthenic way of melting into place. That is, we may now consider the matters of the "self-construction" or "social construction" of the serial killer from a somewhat different perspective: the becoming abstract and general of the individuality of the individual. In the serial killer—Thomas Dillon, for example—this typicality becomes indistinguishable from self-identity: he takes the FBI profile as a self-portrait. The point is not then that the serial killer problem is a "social construction," nor that the malady called the serial killer is "socially constructed," nor quite that the serial killer is a terminal instance of the self-made or self-constructed man. All these are elements in serial killing. But these intricated notions of construction—social construction and self-construction and the relations between them—indicate something more.

Obey Your Thirst!

There is an empty circularity in the notion of the kind of person called the serial killer lifting itself by its own bootstraps: the conception that

there is nothing more to the subject than what he makes of himself. There is an empty circularity, too, in the notion of the social construction of the social: the strictly "historicist" conception that there is nothing more to the social order that its structuring of itself by itself. These two notions are not merely parallel constructions: they are at once radically inseparable and radically incompatible. The experience of social construction at the level of the subject—to the very extent that it is experienced as a social mandate: "be your self"—in effect evacuates the subject it mandates. The law of self-realization is a law that aborts itself. The injunction to realize yourself, to desire yourself into being—to enjoy your self—is at the same time imposed as an injunction from without. If the formula of the first is "be yourself," the formula of the second is "Obey your thirst!" (Sprite) or "Enjoy your symptom!" (Žižek). "Lifting oneself up by one's own bootstraps" is the logic of the self-made man and the logic of addiction both. The thirst of the self-made man to realize himself is at the same time his obedience to the command: "thirst." On the addictive loop of user and used, substance-abuse and self-abuse, the self-made subject is subjected to an endless drill in self-making that becomes indistinguishable from a repeated self-evacuation.

Tocqueville anticipated this drill in enjoyment of the self-made man (the man who gives birth to himself) in the self-legitimated democratic state (the nation that gives birth to itself) in *Democracy in America*:

> The type of oppression which threatens democracies is different from anything there has ever been in the world before. . . . It likes to see its citizens enjoy themselves, provided they think of nothing but this enjoyment. It gladly works for their happiness but wants to be the sole agent and judge of it. It provides for their security, foresees and supplies their necessities, facilitates their pleasures, manages their principal concerns, directs their industry, makes rules for their testaments, and divides their inheritances. Why should it not entirely relieve them from the trouble of thinking and all the cares of living?

The threat of a totalitarian conformity of desire and thought in mass culture (oppressive enjoyment, repressive desublimation) has by now become one of the commonplaces of mass culture (the emperor reveals that he has no clothes—so much for demystification!).

It is possible provisionally to set out a basic implication of this bordering of the social on the psychiatric, this sociality bound to pathology. In the most general terms, we can detect here one of the constitutive

"psycho-social" paradoxes of liberal society: a paradoxical situatedness within power (social construction) that is at the same time a requirement of radical autonomy (self-construction). It is the unrelieved inhabiting of this paradox that casts the liberal subject into failure: "the failure to make itself in the context of a discourse in which self-making is assumed, indeed, is its assumed nature." This failure intensifies in "late modern secular society, in which individuals are buffeted and controlled by global configurations of disciplinary and capitalist power of extraordinary proportions, and are at the same time nakedly individuated, stripped of reprieve from relentless exposure and accountability for themselves."[38]

It is the suffering of this failure, the avenging of this pain through the redistribution of this pain, that Nietzsche identified early on as the production of the "slave morality" of *ressentiment*. *Ressentiment*, in short, seeks to deaden the pain of relentless self-exposure and failed self-accountability in two directions: by *externalizing* it (locating a site, or another, on which to revenge one's wound) and by *generalizing* it (remaking the world in the image of the wound, an injury landscape and a wound culture). The "sovereign subordinated subject" thus achieves its revenge through the imposition of suffering and through the predication of a culture of suffering. In this way, the subject as victim seeks his victims. Here is Nietzsche's description of the psychophysiology of this traumatic violence:

> For every sufferer instinctively seeks a cause for his suffering, more exactly, an agent; still more specifically, a *guilty* agent who is susceptible to suffering—in short, some living thing which he can, on some pretext or other, vent his affects. . . . This . . . constitutes the actual physiological cause of *ressentiment*, vengefulness, and the like: a desire to *deaden pain by means of affects* [e.g., turning pain to rage] . . . to *deaden*, by means of a more violent emotion of any kind, a tormenting secret pain that is becoming unendurable, and to drive it out of consciousness at least for the moment: for that one requires an affect, as savage an affect as possible, and, in order to excite that, any pretext at all [e.g., the guilty agent, who will be wounded and deadened in turn].[39]

This profile of the wounded, and wounding, subject will be developed in the next chapter. The yielding of autonomy to generality, subject to situation, persons to conditions, individuality to state numbers (statistics)—all are hard wired to the very notion of the "statistical picture" or composite "profile" of the serial killer.

Notes

1. Quoted in Eugene H. Methvin, "The Face of Evil," *National Review*, January 23, 1995, 34.
2. Philip Jenkins, *Using Murder: The Social Construction of Serial Homicide* (New York: de Gruyter, 1994), pp. 23–25. See also Jenkins, "Serial Murder in England 1940–1985," *Journal of Criminal Justice* 16 (1988): 1–15. Jenkins is here in accord with Stephen Egger's criterion of four victims; the U.S. Justice Department, however, in its 1983 study of serial murder, held to the criterion of six. See Egger, "A Working Definition of Serial Murder," *Journal of Police Science and Administration* 12.3 (1984): 348–57. The substance of federal governmental criteria on serial murder, joining sheer numbers to a basic incomprehension as to motive, is made clear in its fulsome title: *Serial Murders: Hearings before the Subcommittee on Juvenile Justice of the Committee on the Judiciary, U.S. Senate, 98th Congress, 1st Session, on patterns of murders committed by one person in large numbers with no apparent rhyme, reason or motivation.* July 12, 1983. Washington, D.C: U.S. Government Printing Office.
3. On the definitions of serial murder, see Ronald M. Holmes and James De Burger, *Serial Murder* (Newbury Park, CA: Sage, 1988), pp. 18–23; Joel Norris, *Serial Killers* (New York: Anchor, 1988), pp. 7–46; Brian Masters, *Killing for Company: The Story of a Man Addicted to Murder* (New York: Random House, 1993), pp. 231–89.
4. See, for instance, Curt Supplee, "Serial Killers: Frighteningly Close to Normal," *Washington Post*, 5 August 1991. That the insanity defense no longer seems to "hold" in defending such cases is one indication of the way in which the abnormal normality of these crimes is assumed (the killer as at once psychotic and as representative cultural symptom). On the serial killer as "too normal," see chapter 1, above. In the final part of this study, I will be returning to the ways in which yielding to the generality of the cultural symptom—the self-evacuating experience of a radical generality within— becomes the measure of the psychotic (the psychotic as totally socialized, shot through by the social) and of psychotic violence as a form—the lowest form—of survival.
5. Quoted in Methvin, "The Face of Evil," 34–44. Dillon, a husband and father who worked as a drafter for the Canton Water Department, is currently serving a term of life imprisonment without possibility of parole. Dillon began by killing animals and tallying—Renfield style—the records of his kills (which totaled several hundred). The relays between tallying and killing are parts of what I call a wound culture: a culture in which the traumatic witnessing of mass or collective death again and again takes the form of making lists, tallying names, making collections of murdered bodies, numbers, and names. The tally and the list as death monument brings into an absolute proximity the materialities of writing and torn and opened

bodies: it stands as "the graphic visualization of information as the new crux of the commemorative act" (Daniel Abramson, "Maya Lin and the 1960s: Monuments, Time Lines, and Minimalism," *Critical Inquiry* 22 [Summer 1996]: 709). This is one form that witnessing and surviving "murder by numbers" and the "senseless" mechanization of death takes. The tally and the list (from Renfield to Dillon, among others; from the Vietnam Memorial to *Schindler's List*) conserve at the same time that way of abiding in noncomprehension (nonrepresentability, speechlessness) that has tended to define the ethics of *a trauma of witnessing*. This traumatic witnessing is less a matter of remembering than a matter of repeating: counting and listing the collectivity in the form of the collection, substituting collection for recollection. But since this is the idiom of the killer and the witness both, it suggests too that the trauma of witnessing cannot be separated from what I will describe as *a triumphalism of survival*.

6. Slavoj Žižek, "'In His Bold Gaze My Ruin Is Writ Large,'" in *Everything You Always Wanted to Know about Lacan (But Were Afraid to Ask Hitchcock)*, ed. Žižek (London: Verso, 1992), p. 262. The figure who couples expert knowledge and explosive violence, dispassionate rationality and pure shattering drives, without any visible point of contact between the two, has thus become something of an icon of the serial killer. Consider, for example, the psychology student/killer Ted Bundy and the fictional psychiatrist/cannibal-killer Hannibal Lecter in Thomas Harris's *The Silence of the Lambs*. These linkages between the psycho-professional and the psycho-killer emerge over and over again in the popular representation of serial murder. This has less to do with "representative" serial killers than with the way in which such representations stand in for, and register, the rift between expert knowledge and compulsive violence in such cases. This is one reason why Bundy, scarcely a "typical" serial killer, has emerged as one of its most compelling prototypes.

The uncertain linkage between social and psychological ways of accounting for the serial killer frequently emerges in the basic contradictions that mark media reports on the phenomenon and its experts. Consider, for example, the recent report on serial killings in South Africa (Donald G. McNeil, Jr., "Gruesome Killings Bewilder South Africa," *New York Times*, 20 September 1995). Robert Ressler, a founder of the FBI's Violent Criminal Apprehension Program (VICAP) and the Behavioral Science Unit (BSU), was brought in as a consultant by the South African police. Ressler from the start dismissed the possibility that "the African psyche might seem impenetrable to an expert on the minds of American killers," despite the highly ritualized, quasi-religious, aspects of the murders. As Ressler put it, "'psychopaths are much alike . . . the same whether you're in New York or in a Zulu tribe . . . same dynamics, same paranoid ideations. To do this, you have to completely depart from human nature.'" Hence these are "rituals that look religious, but are personal . . . simply part of the killer's fantasy"

and unrelated to social conditions. At the same time, serial killing, for Ressler, is a direct product of social conditions: "Besides, he says, serial killing grows out of urban conditions—alienation, anger, anonymity—and the killings took place near cities." On one level, serial killing is strictly personal, phantasmatic and asocial; on the other, it is a direct "growth" of radically impersonal (person-canceling) social conditions. Urban conditions, it would seem, depart from human nature, much like psychosis: in both, "the personal" gives way to the general and the anonymous. It will be seen that these alternatives, social and asocial, are in fact two parts of a single formation. The psychoanalytic theorization of unconscious foundations that are "similar" or "the same" in everyone is inseparable from a sense of the traumatic failure of self-distinction in the mass.

7. See Jenkins, *Using Murder*, p. 224; and Thomas O'Reilly-Fleming, "Serial Murder: Towards Integrated Theorizing," *The Critical Criminologist* 4.3/4 (Autumn/Winter 1992): 3–4, 14. As Elliot Leyton observes of the Santa Cruz "co-ed killer" Edmund Kemper, first incarcerated in a mental hospital for violent offenders for the murder of his grandparents: "Kemper internalized both [the patients'] disordered sexuality and the hospital's psychological theories" (Leyton, *Hunting Humans: Inside the Minds of Mass Murderers* [New York: Pocket, 1986], p. 86). Nor is Kemper the only killer to consult the *DSM* in an attempt to discover himself in those general diagnoses. (See chapter 6, "Pulp Fiction: The Popular Psychology of the Serial Killer," below.)

8. Ian Hacking, *Rewriting the Soul: Multiple Personality and the Sciences of Memory* (Princeton: Princeton University Press, 1995), p. 6.

9. Quoted in Methvin, "The Face of Evil," p. 34.

10. See, for instance, Robert P. Brittain, "The Sadistic Murderer," *Medicine, Science, and the Law* 10.4 (1970); Norris, *Serial Killers*, pp. 21–49; and Masters, *Killing for Company*, pp. 230–89. The novelist Joyce Carol Oates's review article on serial killers in the *New York Review of Books* (March 24, 1994) is typical on several counts: in its almost ritual relaying of standard conceptions and misconceptions; in its coupling of lurid redescription and moralizing cliche; and in its gravitation toward nonexplanation and non-comprehension as a way of conserving the mystery of evil (conserving it by aestheticizing it). Hence the acts of the serial killer are like "nightmare artworks" and "suggest a kinship, however distorted, with the artist" (56); and the serial killer's pleasure in killing (Oates recites as her title the British serial killer Dennis Nilsen's statement, "I had no other thrill or happiness") is *simply* repeated. Thus, the kind of sexuality that can only take pleasure in destruction—the sexuality of the serial killer—registers merely *as* enigma and remains not merely unexplicated but inexplicable. The aestheticization of murder is the project of Joel Black's *Aesthetics of Murder* (Baltimore:

Johns Hopkins University Press, 1991), which acutely describes some of the representational and media components in modern murder but tends toward a reductive equation of art for art's sake and murder for murder's sake. See also Wendy Lesser's recent *Pictures at an Execution* (Cambridge: Harvard University Press, 1993), which similarly instances such a moralized aesthetics of noncomprehension, albeit along somewhat different lines. For a more critical account of the intermingling of murder and representation, see Maria Tatar, *Lustmord: Sexual Murder in Weimar Germany* (Princeton: Princeton University Press, 1995). Such an aestheticization is by no means limited to cultural studies accounts of compulsive and serial murder. The former FBI profiler of serial killers, John Douglas, puts it this way: "I always tell my agents, 'If you want to understand the artist, you have to look at the painting.' We've looked at many 'paintings' over the years and talked extensively to the most 'accomplished' artists" (*Mindhunter: Inside the FBI's Elite Serial Crime Unit* [New York: Scribner, 1995], p. 32). The popular or "fan" fascination with serial killing is neatly set out in Devon Jackson's piece in *Village Voice*, "Serial Killers and the People Who Love Them" (22 March 1994, 26–32), which focuses on the fan-zine cults that have grown up around serial killing and the manner in which they form part of the move "to professionalize serial killing" as a sort of hard-core "entertainment." This entertainment, for Jackson, includes also "quasi-academic" studies such as Joel Norris's *Serial Killers* and the work of what Jackson calls other "opportunistic, hypocritical moralizers." This mixture of moral and feral intentions in the representation of serial killing, and the representational and "entertainment" component in these cases, are, we will see, crucial to the understanding of addictive violence. I will be returning to these aestheticizations of serial murder (see chapter 7 "Lifelikeness" below). To anticipate: what is imaged as the "nightmare artwork" of the serial killer is more exactly the *primary mediation* of serial violence (a failure of distance with respect to mass-mediated representation: an identification intensified to the point of reproduction); its *substitution manias* (the addiction to analogy, substitutes, representations); and the understanding of persons as things that can be made and unmade—the *artifactualization* of the "self-made man," the prosthetic *lifelikeness* of persons. Freud observed, as we know, that every organism wants to die, but in its own way. This turn from natural life and natural death to *life and death as things that can be made*—taken into one's own hands, reproduced in the form of the "lifelike"—is rechanneled in these cases, as if this movement beyond the pleasure principle means that every organism wants to take life, but in its own way.

11. See, for instance, the purely "encyclopedic" work of Michael Newton, including *Hunting Humans: The Encyclopedia of Serial Killers*, vols. 1 and 2 (New York: Avon, 1990), and *Serial Slaughter: What's Behind America's*

Murder Epidemic? (Port Townsend, WA: Loompanics Unlimited, 1992). (Typically enough, the interpretive-causal question posed in the subtitle surfaces only in the very brief conclusion, following on the evocative and explicit, if scarcely explicated, series of quotations and isolated factoids that make up the account.) These ritual repetitions of evil kitsch, like the collections of serial-killer trading cards that have recently been marketed, are thus versions of the compulsive collecting, repetition, and compulsive seriality that form part of the addiction to addiction in contemporary culture. Such an addiction operates both within cases of serial killing and in professionalizing and entertaining accounts of them.

12. See, for instance, Jenkins, *Using Murder*, pp. 2–7, 225–29.

13. Joan Copjec, *Read My Desire: Lacan Against the Historicists* (Cambridge: MIT Press, 1994), pp. 6–7, 153–54; "Cutting Up," in *Between Feminism and Psychoanalysis*, ed. Theresa Brennan (New York: Routledge, 1989), pp. 227–43. (Central to this reading of the closed circuit of social construction are Claude Lefort's accounts of the modern democracy as a "society . . . supposed to coincide with itself." See Lefort, *Political Forms of Modern Society: Bureaucracy, Democracy, Totalitarianism*, ed. John B. Thompson [Cambridge: MIT Press, 1986], and *Democracy and Political Theory* [Minneapolis: University of Minnesota Press, 1988].) This Lacanian perspective counters extreme social-construction accounts of the subject by positing "The Real" as the limit point of "the social," as the point where the "social-symbolic order" fails. This counter-approach tends, despite its exemplary openness to the crossings of fantasy and sociality, to run aground on an utterly abstracted and totalized, even totalitarian, notion of "the social." That is, such psychoanalytic accounts tend to devolve on a quasi-totalitarian model of the historical—a totalized notion of "the social-symbolic order"—and a paranoiac model of the social—the social "assault" on the subject by "external, mechanical, symbolic" forces. The social-symbolic order appears here as a sort of *letter-bombing* of the subject. (On these tendencies, and their implications, see the concluding part of this study, "Wound Culture.")

14. The formation of such a wound culture—the formation of a public sphere bordering on pathology—is the subject of the final part of this study.

15. See Anthony Giddens, *The Transformation of Intimacy: Sexuality, Love and Eroticism in Modern Societies* (Stanford, CA: Stanford University Press, 1992).

16. See, for example, T. J. Jackson Lears, "From Salvation to Self-Realization: Advertising and the Therapeutic Roots of the Consumer Culture, 1880–1930," in *The Culture of Consumption: Critical Essays in American History, 1880–1980*, ed. Richard Wightman Fox and Lears (New York: Pantheon, 1983), pp. 3–38.

17. Ellen Herman, *The Romance of American Psychology: Political Culture in the Age of Experts* (Berkeley: University of California Press, 1995), pp. 14–16.

18. C. Wright Mills, *White Collar: The American Middle Classes* (New York: Oxford University Press, 1951), p. 7.
19. On the rise of psychology as public culture, I am here indebted to Herman, *The Romance of American Psychology*, pp. 12–15, 262, 311, et passim.
20. Quoted in Stephen G. Michaud and Hugh Aynesworth, *Ted Bundy: Conversations with a Killer* (New York: Signet, 1989), pp. 10–11.
21. Ann Rule, *The Stranger Beside Me* (New York: Signet, 1980), p. 25.
22. Quoted in Robert Cullen, *The Killer Department* (New York: Ivy Books, 1993), p. 234.
23. Allen S. Weiss, *Phantasmic Radio* (Durham, NC: Duke University Press, 1995), p. 6.
24. Stephen Singular, *Talked to Death: The Life and Murder of Alan Berg* (New York: William Morrow, 1987); cited in Peter Laufer, *Inside Talk Radio* (New York: Birch Lane Press, 1995), p. 43.
25. Ingo Hasselbach (with Tom Reiss), "How Nazis are Made," *New Yorker*, 8 January 1996, 39.
26. Slavoj Žižek, *The Metastases of Enjoyment: Six Essays on Woman and Causality* (London: Verso, 1994), pp. 54, 117.
27. See Theodor Adorno, "Freudian Theory and the Pattern of Fascist Propaganda," in *The Culture Industry: Selected Essays on Mass Culture* (London: Routledge, 1991); Russell Jacoby, *Social Amnesia: A Critique of Conformist Psychology from Adler to Laing* (Brighton, UK: Harvester, 1977); Žižek, "The Deadlock of 'Repressive Desublimation,'" in *Metastases of Enjoyment*, pp. 7–28.
28. David Riesman, *The Lonely Crowd: A Study of the Changing American Character* (1961) (New Haven: Yale University Press, 1989; 1961), pp. 14–20, 21, xxxvii–xxxviii.
29. Riesman, *The Lonely Crowd*, pp. 15–16, 22, 25.
30. Jean Laplanche, *Life and Death in Psychoanalysis*, trans. Jeffrey Mehlman (Baltimore: Johns Hopkins University Press, 1976), pp. 42–43.
31. In the final part of this study I will take up the implications of this "internal alien entity" in contemporary wound culture, in part by way of psychoanalytic conceptions of the extimate (an internal intimacy) and the limits of these conceptions (whether understood, as in Lacan, in terms of the internal alterity of the letter, or, as in Borch-Jacobsen, as crowd psychology within).
32. Daniel Bell, *The Cultural Contradictions of Capitalism* (New York: Basic Books, 1976), p. xiv.
33. Bell, *Cultural Contradictions of Capitalism*, pp. 35, xvii, xv, xxii–xxiii.
34. Barbara Ehrenreich, *The Hearts of Men: American Dreams and the Flight from Commitment* (New York: Anchor, 1983), pp. 51, 182.
35. Thomas Harris, *Red Dragon* (New York: Dell, 1981).
36. Jenkins, *Using Murder*, pp. 15, 81, 223.
37. Jack Olsen, *Charmer* (New York: William Morrow, 1994), pp. 119, 297, 216.

38. Wendy Brown, *States of Injury: Power and Freedom in Late Modernity* (Princeton: Princeton University Press, 1995), p. 67. I am generally indebted here to Brown's account of "states of injury" and "wounded attachments" in contemporary political culture.

39. Friedrich Nietzsche, *On the Genealogy of Morals*, trans. W. Kaufmann and R. J. Hollindale (New York: Vintage, 1969), p. 127.

5 · The Profile
of the Serial Killer

"Dress Him in a Suit and He Looks Like Ten Other Men"

Nothing is more visible in the proliferating, "official literature on serial killing than its relentless banality. This may be attributable in part to what counts as "expert" knowledge in the field. The governing assumption, as the sociologist Philip Jenkins observes, is that "solutions advocated were to be found in state-of-the-art information technology and behavioral science: Was not the *Behavioral Science* Unit the most quoted source on every aspect of the putative crisis?" But one basic problem with this way of locating the causes and solutions in serial killing appears just here, in the authority of the BSU profilers: "The experts who gained the widest acceptance did so not because of their academic credentials [?], but because of their personal narratives of travelling to the heart of darkness that is the mind of the 'monster among us.' This is the language of shamanism rather than psychology."[1]

Part of the authority of these personal narratives (Robert Ressler's *Whoever Fights Monsters* or John Douglas's best-selling *Mindhunter*, for example) is grounded in the extensive interviews of incarcerated serial killers conducted by members of the BSU. Yet, on this count, too, personal knowledge tends to devolve on a series of contradictions and to approach a series of clichés. The content of these interviews, as Jenkins summarizes it, amounts to this: "The successive confessions of a given killer over the years are likely to contain numerous contradictions [as to

early childhood sex abuse, for example], so that a particular claims-maker can choose whatever quotation may seem opportune for his or her cause."[2] Or, as the British serial killer Dennis Nilsen simply said: "I casually threw them [the investigators] a psychiatrist's cliché."[3]

These commonplaces, however, reveal something more than contradiction or deception. The poverty in explanation is in part attributable to the self-imposed limits of the strictly descriptive and behaviorist approach that has been adopted (most prominently by the FBI's BSU). As one FBI agent explains: "We're not interested in causes, and we're not interested in cures. We're interested in identification, apprehension, incarceration, and prosecution."[4]

But another sort of banality surfaces here. Interviews with serial killers themselves, the core of the mindhunters' authority, contribute, we are told, "an important element to the complex feedback relationship among investigators, media, and popular culture." The necessity of such a reminder is strange enough—as if the killers themselves were merely the proper name of the feedback loop between investigators, media, and popular representations. But there is more: "Though [the killers' confessions] often do little more than reflect the commonplaces of the culture and the academic environment, the offenders do this with such apparent authority that their remarks are likely to be taken as the ultimate warrant for any desired view or explanation."[5] One discovers at this point a sort of bottoming-out of "explanation." The killer's self-representations seem merely to reflect back cultural commonplaces: it is as if they have become merely the occasion of social construction reflecting back on itself.

This social mirror-effect is most emphatic in the case of Jack the Ripper, where the absence of any knowledge of the identity of the killer has made Jack the Ripper the prototype of the serial killer: the blank surface that reflects back the commonplace anxieties and crises of his culture. There is a tendency, in contemporary cultural studies from the margins and from below, to understand celebrity psychos—from Schreber or Jack the Ripper to Ted Bundy or Hannibal Lecter—as condensed symptoms of the social: as microcosmic histories either of social control or, conversely, of social breakdown; as maladies of sociality or pathologies of the soul; as types of the "over-socialized" individual (the mass in person) or the "asocial" psycho (the drive in person).[6] Such an approach in effect constructs the subject as a reflex or cliché of his or her culture ("the subjective synonym of the objective fact of the subject's construction"). In this tautological logic, the detour through the analysis of the symptomatic subject seems *merely* a detour.

Some of the thrill seems by now to be going from the rehearsal of the social construction of acts or events that *could* only take place socially and historically, that simply make no sense outside the context of a society.[7] One obvious impulse behind this approach is the move to counter ritual reassertions of the strictly individual, and nonsocial, causes of crime and violence. Predictably enough, Ronald Reagan epitomized this ritual in a presidential address on violent crime in America in September 1981: "the underlying premise" among "social thinkers" about crime (that is, among those who think of crime in terms of "the social") was "a belief that there was nothing permanent or absolute about any man's nature — that he was a product of material environment, and that by changing that environment . . . we could permanently change man."[8] Or, as the veteran true crime encyclopedists Colin Wilson and Donald Seaman simply assert: "There is no such thing as 'society,' only individuals."[9]

But the constructionist position, on its side, tends to run aground on a series of large metaphors (metaphors of "construction" and "determination") and large para-academic clichés (clichés about persons and desires as "products" or "constructs" or "symptoms," for instance).[10] It is necessary to turn this perspective. It is necessary to consider, that is, not how the psychotic and psychotic violence is "culturally representative" but instead the manner in which the psycho is *nothing but representative*: not similar to someone or something but *just similar*.

Here are some typical representations of the serial killer's typicality, terms italicized by their repetition: "Multiple murderers are not 'insane' and they are very much *products* of their time. . . . [He is] an *embodiment* of the central themes in his civilization as well as a *reflection* of that civilization's critical tensions. He is thus a *creature* and a *creation* of his age . . . in perfect harmony with the dominant culture";[11] the serial killer's "actions were *determined* largely by the society that *produced* them";[12] "serial killers are extraordinary and grotesque, but they are grotesque *in the image of the cultures that produce them*: they are a pathological *symptom* of a certain *kind* of masculinity";[13] and this is because, we are routinely reminded, "our desires themselves are *social constructs*."[14]

The hyperidentification with context seems part of the killer's abnormality — that is, his hypernormality, and explains the descriptions of the killer's "hypersexuality," "hypervigilance," "hypergraphia," "hyperreligiosity," and so forth.[15] The failure of individuality or identity or recognizable motive and the tendency to vanish in "likeness" are again and again registered in descriptions of the serial killer. The serial killer is "everyone's nextdoor neighbor" (Gacy) or "citizen X" (Chikitilo) or "the mono-

chrome man" (Nilsen) or "the devoid" (Van Arman) or "the minus man" (McCreary).[16] A psychiatric consultant in the case of the Milwaukee murderer of young men, Jeffrey Dahmer, observed of the killer: "Dress him in a suit and he looks like ten other men."[17] It was repeatedly remarked about the killer of young college women, Ted Bundy "that he never looked the same from photograph to photograph." The Chicago psychiatrist Dr. Helen L. Morrison, who has done extensive clinical interviews of serial killers (more than 8,000 hours), concludes simply that the serial killer is "a completely different individual than we have ever seen before." But this difference, for Morrison, devolves on a postindividual likeness or sameness: "These are basically cookie-cutter people, so much alike psychologically that I could close my eyes and be talking to any one of them. . . . They are phenomenally alike."[18] One rediscovers here the notion of the "chameleon-like" character of the serial killer: his tendency to blend into others or to melt into the background.

Such descriptions are characteristically offered, of course, as an explanation of the difficulty in singling out and apprehending these killers, and that is certainly part of the story. But these descriptions might be taken in an exact and literal sense: as intimations of a radical failure of singularity *at the level of the subject.* Or, more exactly, they might be taken as the traumatized intimation, at the level of the subject, that his interior states are nothing but outer or social forces and fantasies turned outside in: the subject, as it were, flooded by the social and its collective fantasies.

Such a turn in perspective makes sense of a striking convergence in constructionist accounts: the convergence of constructionism and compulsive violence. There is a strange attraction in these accounts between the conviction that bodies, desires, and persons are things that can be made and scenarios of sexualized violence.

The conviction that interior states are nothing but the social turned outside in has of course been most closely associated with the work of Michel Foucault, and particularly with Foucault's histories of bodies and sexualities, from the mid-1970s on. Yet Foucault's work—*Surveiller et punir (Discipline and Punish)* (1975), in particular—displays an interesting paradox. That history makes the case for the passing from the scene of spectacular corporeal violence, its replacement by more discrete and insidiously modern regimes of discipline. But Foucault's text, even as it makes that case, opens with an erotically albeit coldly prolonged and graphic scene of torture. That sado-dispassionate scene arguably inaugurated the splatter pop-Foucauldianism of the last two decades.[19]

There are some crucial differences, however, between this pop-Foucauldianism (one variant of the "new historicism") and the Foucauldian account. For Foucault, discipline in the modern period achieves a decorporealized discretion. But the fascination with spectacles of bodily violence clearly does not go away. The fascination, however, mutates from its "pre-modern" form. The fascination with scenes of a spectacularized bodily violence is inseparable from *the binding of violence to scene, spectacle, and representation*: not merely spectacles of sex and violence in public but a sexual violence inseparable from its reproduction and mechanical reduplication.

This binding of violence to mass spectacle largely drops out of the pop-Foucauldian account, in which the return of the body—torn, flayed, and disciplined—becomes the index of "the real" and the return of "real history." What becomes visible in these accounts is the by-now-familiar constructionist impasse. On the one side, there is an acute registration of the absolute proximities of bodies and representations. On the other, a basic indecision—a sort of "toggling" between the notion of bodies that matter and the notion that there is nothing deeper to bodies than the matter of representation. This *pas-de-deux* between bodies and signs forms part of the appeal of constructionist work (as it does in recent cultural-psychoanalytic work that tends to represent itself as the antidote to constructionism: the "Real" marking the place where the constructions of the social-symbolic order fail).[20]

This convergence—an anxious constructionism coupled with eroticized spectacles of torn bodies—finds its counterpart in popular cultural representations that, in many ways, more powerfully register its implications. In a range of novels and films from the late 1970s on, there is a direct coupling of the *realization* (in both senses) that persons and bodies are things that can be made and the drive to spectacular, repetitive violence: in the systematic hunting and killing of all too human-like replicants in *Blade Runner*, for example, and, most conspicuously perhaps, in the figure of The Terminator. That figure has become the very icon of the artifactual or constructed person as killing machine (the body builder as demolition man). The realization of the constructedness of persons and the drive to automatistic violence thus refer back to and reinforce each other at every point. These relays between an addictive self-construction and social-construction and an addictive violence are nowhere more spectacularly exhibited than in the profile of the serial killer.

Profiles of America's Most Wanted

The stranger-killer, one who is near but also far, achieves a celebrity in anonymity: the most wanted man who is also a type of nonperson. The profile of the stranger-killer constructed by the mindhunters takes off from the turn-of-the century constructions, in "scientific" criminology, of "statistical pictures" or "composite portraits" of the criminal type.[21] The profile perfects the chameleon-like yielding of identity to typicality—the statistical picture as self-portrait—that makes the serial killer the proto-typical statistical person.

In turning to the make-up of these profiles, I want less to resurvey the commonplaces of the field than to focus on three basic emphases that are unevenly registered in these accounts. First, there is the serial killer's way of understanding social construction: his fantasy of murdering "society" itself in the interest of a survivalist dream of self-origination. Second, there is his way of understanding self-construction: the turn of the fantasy of self-origination into self-originating fantasies. Third, there is the uncertain "bordering" of the social on the psychiatric that traverses these cases: the psychologistic notions of "the self" and the sociologistic notions of "society"—notions that devolve on the psychologistic theme of "boundary issues" and, in turn, on an unremitting war of "self versus society."

One of the earlier, but still influential, profiles of the compulsive killer was set out by the British psychiatrist Robert P. Brittain. Brittain's subject (his article appeared in the English journal *Medicine, Science, and the Law* in 1970) is the "sadistic murderer" and not yet the "serial killer." But elements of his profile of the "type of person" who commits such crimes have become canonical in the range of literature on serial killing (and not least in serial killer fiction and films that have proliferated in the last two decades). Brittain locates, for example, the combination of "active fantasy life" and "emotional flattening" in the killer; the childhood tendencies toward fire-starting, eneuresis (bed-wetting), and pet cruelty that have come to be referred to as "Macdonald's triad"; and, crucially, the murderer's obsessive interest in forms of photography, representation, and "mirroring" generally.[22]

Brittain's strictly descriptive account, cautionary about the limits of profiling as such, anticipates later profiles on another count as well. It devolves into a series of disconnected factoids: for instance, on family life ("A grandmother, at least in Scotland, is occasionally an important figure to these men"); on habitual behaviors ("There might be a history of an inordinate interest in under-water swimming . . . or of running through

the deserted countryside wearing only a rubber macintosh"); on intellectual tendencies ("Their continuing abnormality may be shown by their desire to learn German").[23] The profiler's attempt to outline the prototype of the murderer stalls in tautology ("He feels different from others and thus is different and isolated") and generality ("Some sadistic sexual offenders have certain of these elements but the majority may appear to be much like other people").[24]

The serial killer profile has been elaborated since the early 1970s, principally through the work of the FBI's Behavioral Science Unit. (This composite picture of the serial killer is concisely summarized in the BSU's "motivational model" for sexual homicide [see figure 6] and in the detailing of crime scene and behavioral characteristics of what has come to be called "organized and disorganized murderers" [see figures 7, 8].)[25] Notwithstanding these accretions of information, however, the profile remains either ambiguous or obvious; as one commentator on profiling early on remarked, "There is something mediocre and pretentious about it."[26]

The profiles, for one thing, are often internally contradictory. (For example, although the types of "organized" and "disorganized" killers are directly at odds, it has become routine to find apprehended killers designated as "mixed" types. It has become routine as well to attribute contradictions and shifts in the *modus operandi* of the killer to his parrying of journalistic and policial trackings of his "signature" patterns.) The descriptions are often simply self-evident or self-confirming. (For example, in cases where the victims have been women, the profiles speak of "mother hatred and 'hostility toward women'" — and without any irony or apparent awareness of how stunningly reductive an insight like "hostility" is in the context of repetitive sexual murder.)

There has been something self-confirming too in the popularization, and even celebrity, of the FBI profilers and mind-hunters — their adulatory representation, for example, in the novel and film *The Silence of the Lambs*; their adulatory self-representations in BSU autobiographies such as Ressler's *Whoever Fights Monsters* and Douglas's *Mindhunter*. Despite the profilers' high profile in the media, however, there remains a basic disagreement about what contribution this technique has made. As the ex-FBI agent and serial homicide investigator Paul Lindsay summarized it: "I mean, how many serial killer cases has the FBI solved — *if any?*"[27]

One scarcely expects the face of evil to emerge from computer composites or the fifteen-page, fill-in-the-blanks, VICAP serial-crime questionaire (although such a fantasy of the profile coming to life has entered into popular culture — for instance, in the recent film about virtuality and

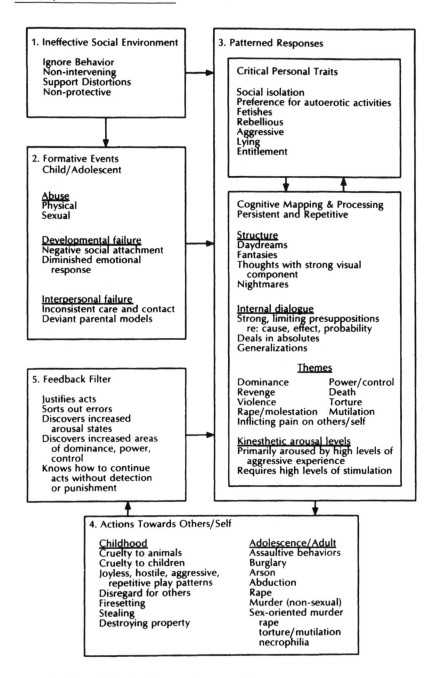

Figure 6. Sexual Homicide: Motivational Model.

Source: A. W. Burgess, C. R. Hartman, R. K. Ressler, J. E. Douglas, and A. McCormack, "Sexual Homicide: A Motivational Model," *Journal of Interpersonal Violence*, 1986, 1: 251–72.

Crime Scene Differences between Organized and Disorganized Murderers

Organized	Disorganized
Offense planned	Spontaneous offense
Victim a targeted stranger	Victim or location known
Personalizes victim	Depersonalizes victim
Controlled conversation	Minimal conversation
Crime scene reflects overall control	Crime scene random and sloppy
Demands submissive victim	Sudden violence to victim
Restraints used	Minimal use of restraints
Aggressive acts prior to death	Sexual acts after death
Body hidden	Body left in view
Weapon/evidence absent	Evidence/weapon often present
Transports victim or body	Body left at death scene

Figure 7.

Profile Characteristics of Organized and Disorganized Murderers

Organized	Disorganized
Good intelligence	Average intelligence
Socially competent	Socially immature
Skilled work preferred	Poor work history
Sexually competent	Sexually incompetent
High birth order status	Minimal birth order status
Father's work stable	Father's work unstable
Inconsistent childhood discipline	Harsh discipline in childhood
Controlled mood during crime	Anxious mood during crime
Use of alcohol with crime	Minimal use of alcohol
Precipitating situational stress	Minimal situational stress
Living with partner	Living alone
Mobility, with car in good condition	Lives/works near crime scene
Follows crime in news media	Minimal interest in news media
May change jobs or leave town	Minimal change in life-style

Figure 8.
Source (figures 7 and 8): R. K. Ressler, A. W. Burgess, J. E. Douglas, *Sexual Homicide: Patterns and Motives* (Lexington: D. C. Heath, 1988).

serial violence, *Virtuosity*). This stalling of the profile instances again the basic gap between what holds the places of private truth and expert-public knowledge in the behavioral science of serial killing. It also has the effect of holding in place one of the refrains in accounts of serial killing: the apparently *motiveless* nature of the crime.

For this is, we are told, "murder with no motive . . . we have people that commit murders like you might go out and mow the lawn. That's about as much thought as they give. A term that's been used is *recreational murder*. Nothing else to do—they go out and kill."[28] Dennis Nilsen, the British

killer of a series of young men, described his state of mind in these terms: "I wish there was a clear view on motive, conventionally speaking, then I could come to grips with the problem."[29] Or, as one recent criminological study of serial murder summed it up: "The serial murderer is motivated to kill; these are not crimes of passion in the conventional sense nor do they stem from victim precipation."[30]

One detects in these descriptions a breakdown in "the conventional sense" of motive. The notion of serial murder as motiveless effectively conserves what has been described as "the endless ritual of noncomprehension that is the modern horror experience": serial murder, that is, as a renovated version of motiveless malignity.[31] There is a sublime circularity in such an understanding of the motivation for killing as the drive to kill: nothing, in effect, drives the drive.[32] As in Poe's description of the uncanny imp or "spirit of the perverse," "it is motive not *motivirt*."[33] On this view, murder retains the pure character of the *acte gratuite*. Which is one reason why murder, from DeQuincey and Poe on, has been aestheticized as one of the fine arts (murder for murder's sake).

These accounts of the murderer's cogito ("I kill therefore I am") revolve in noncomprehension. So if "apparent and clear-cut motives are typically lacking in many serial murders," then motive, not surprisingly, is relocated within the internal "system" of the killer: "But there are *intrinsic* motive systems—typically nonrational—that originate within the individual; they govern and structure the serial killer's homicidal behavior."[34] In this way, the notion of the "senseless" killer as psycho-killer begins to coalesce.

The psycho-killer is thus routinely described as one who has put his self-enclosed ego, or self-propelled drives, in place of the world (the drive in person). He is routinely described too as the chameleon-like killer whose psychic ego has utterly yielded to the social ego, the world turned outside in (the mass in person). On both counts, he is characterized in terms of the failure of a correct distance between self and world, private and public, fantasy and act: in terms of a model of self and world premised on proper "boundary-maintenance." Hence, in the psychology-by-numbers terms of Dennis Nilsen: "The reasonable man adapts himself to the world; the unreasonable one persists in trying to adapt the world to himself."[35] But it is perhaps these large abstractions of "self" and "world," and the large war between them that on this logic ensues, that must be reconsidered, and reconsidered in terms of the killer's own versions of psychology (his pop-psychology) and sociology (his pop-sociology).

"Dead People Are All on the Same Level": The Sociopath and the Psychopath

The serial killer, we are told, aspires—like everyone else?— to celebrity under the conditions of an anonymous mass society. The serial killer, in some therefore prominent cases, exhibits the desire "to be somebody" by achieving the celebrity status of the "natural born killer."[36] A range of recent sociological studies of serial violence thus make the case that the killer's panic about the failure of self-distinction in the mass is in effect countered in the media spectacle of public violence: hence his autograph or "signature" crimes.

On this view, serial killing is to be understood above all as a sort of subpolitical class protest. This is the motive of a radical social democratization: murder as the lowest form of dead "leveling." It takes the form of a mad Ludditism, attacks on "the mass" or "the system" or (in the Unabomber's idiom) "the social machine."[37] Charles Starkweather, the Texas spree-killer, who killed at least ten people in the late 1950s and who described himself as "everybody's nobody," was at once vague about the act of murder—"Shooting people was, I guess, a kind of thrill. It brought out something"—and chillingly exact about what it brought about— "Dead people are all on the same level."[38]

This desire to be "somebody" must be understood more radically, and not least because the desire "to be somebody" is what at the same time makes him "like everyone else." These transferences onto mass-media technologies—this primary mediation—exceeds the desire for fifteen minutes of fame: the desire to be desired or "most wanted." The coupling of self-making and life-destroying exceeds, even as it radicalizes or perfects, the relentless drill in self-making that identifies the subject of the pathological public sphere.[39]

There is, for one thing, the nebulous abstractness by which a range of serial killers refer to "the system" and to "society." In Edmund Kemper's words: "I was trying to hurt society where it hurt the worst."[40] The Unabomber's manifest targeting of "the social machine" is only the most recent literalization of an anti-technology, antisystem pop-sociology. The suspected Unabomber Ted Kaczynski—like the addict-writer Jack London, intimate with machines and working at his typewriting machine— writes about "Wild Nature" and writes against what he called "oversocialization" ("reducing human beings and many other living organisms to engineered products and mere cogs in the social machine").[41] He inhabited (like London) the hair-of-the-dog logic of addiction: "tuned up by the

very poison that caused the damage." The serial bomber worked like a machine to get away from the machine; counted words and counted bodies; conflated killing and words in the form of a verboballistics (the letter bomb).

This style of mass murder encodes a general fear of the masses in a general fear of technology. The deepening intimacies of persons and technology register in inverted form, as a deepening opposition between humanity and machinery. John Linley Frazier, a California car mechanic who lived in the woods and killed six as a warning against those who wounded "Wild Nature," put it this way in a note he left under the windshield wiper of his victim's Rolls Royce: "Materialism must die or mankind must stop."[42] Either materialism, like a person, must die, or mankind, like a machine, must stop. The war between the individual and the mass (between private and public orders) thus shifts over to a war between humanity and machinery, even as these distinctions fray or collapse. This is a systemic and machinic, letter- and mass-media borne public violence, in the name of the human, the natural, and the individual.

Along the same lines, there is the sheer impassivity with which a number of these killers-by-numbers turn persons into faceless and anonymous populations or take professionally faceless persons, the clerks of the system, as their target. Ted Bundy, psychology student, was also (like Nilsen) a "professionally perfect person"; a face-man in Republican party politics in the state of Washington; and so self-identified with the mass that his speech consisted almost entirely of clichés. Bundy made psychasthenic vanishing into a career choice. There is for Bundy nothing personal about murder, as there is nothing personal about persons: "What's one less person on the face of the earth anyway?" Faceless himself, the face becomes a horror story. (In the cliché, the dead metaphor, "the face of the earth," life takes a step backward: identity—face—yields to place.) Charles Starkweather expressed the logic of the survivor—the logic of one who kills in order to survive, as the last man: "Sometimes I thought about murdering the whole human race. I never thought much about killing individuals." Peter Kürten, the Dusseldorf killer of thirty-five people (women and children, primarily), represented the mass-media coverage of his crimes as their cause ("I have already observed that the sensational reports in certain scandal sheets turned me into the man who stands before you today"). He registered this radical experience of formation from the outside in (his ambition to become "the most celebrated criminal of all time") precisely in terms of the double logic of identity and identification we have been tracing: a sheer identification with the mass

and a murderous disidentification.[43] On the one side, there is a location of identity in mass celebrity (the sheer *sociality* of the most-wanted man), and on the other, self-defense against the traumatic failure of self-distinction in the mass (the survivor's murderous *asociality*). In Peter Kürten's words: "Yes, if I had had the means I would have killed masses."[44]

This empty circuit of identity in celebrity—a self-identity bound to the mass witnessing from which it suffers—makes up one face of the serial killer-profile. The counterface of this fantasy of self-origination, in the profile, are the killer's self-originating fantasies: the psycho-killer's "intrinsic motive systems." Thus, another refrain in the profiles is "the preference for fantasy and its centrality in the life of these men."[45] These nonrational or "senseless" crimes are made sense of in terms of the compulsive yielding of the individual to fantasy. But it is not merely that these intrinsic motive systems originate within the individual. For, we are told, "one of the main reasons for behavioural try-outs [psychologese for "killings"] was the need to maintain the effectiveness of the fantasy as a source of arousal."[46] The killings, in this inversion of cause and effect, are in the service of the fantasy and not the other way around, which suggests that the motive system does not merely originate in the individual but *originates the individual*, as a pure and self-caused reserve of a radical psychic autonomy (the psycho). This amounts to an understanding of the serial killer as something like a terminal instance of the self-caused, autogenic, or self-made man: a hero of the drives.

The preference for "intrinsic" fantasy is thus a preference for having an inside and being an individual. Such a modeling of the subject is, in the most general terms, a measure of "how interiority or inwardness, a condition of being an 'individual' with an 'inside,'" is born in the modern period.[47] But if the condition of being an individual with an inside is thus protected in the "preference for fantasy," this preference is more properly a yielding: the yielding to an "alien internal entity," to what the pulp-fiction writer Jim Thompson called "the killer inside me." The killer's inside, to the very extent that it is motive not *motivirt*, seems an imp of the perverse, a foreign body within. Both in these fantasies of self-origination and in these self-originating fantasies, the borders between inside and outside, between "self" and "world," are everywhere intensified and everywhere breached. The uncertain boundaries between self and society—the spillover of psychology into public culture—is one precondition of the emergence of the pathological public sphere, a wound culture. It is also a way of understanding the publicity of the wound itself: the witnessing of the break in the skin and the break in the self bounded by the skin

is one measure of a public that meets in pathology. It is around the wound—the torn and opened body, the torn and opened person, the opening and spilling and becoming-visible of interiors—that this culture gathers.[48]

This border confusion, both within these cases and in accounts of them, has generally been registered, or parried, in the by-now clichéd and psychologistic notion of "boundary issues." One cannot, however, dismiss these clichés or the force of the psychologistic. The force of such clichés—itself as condensations of social forces at the level of the subject, as indexes of the subject shot through by the social—can scarcely be overestimated in the iconic figure of the deliberate stranger as society's most wanted man.

Boundary issues are a persistent refrain within these profiles and the metaphorics of the bounded subject surface again and again in cases of serial violence. The failures of distance and distinction between self and other and between interiors and surroundings emerge repeatedly as the diagnosis, or self-diagnosis, of disorder in these cases. Carl Pazram, who killed twenty-one people in the 1920s, registered in his journal such a pathological replacement of self by other—in effect, "I" driven out by "you": "Why am I what I am? I'll tell you why. I did not make myself what I am. Others had the making of me."[49]

"To the classic question of identity 'Who are you?' a traditional man would say, 'I am the son of my father.' A person today says, 'I am I, I come out of myself, and in choice and action I make myself.'"[50] The serial killer in Thompson's *The Killer Inside Me* says, "The child is father of the man." The serial killer's statement of where identity comes from thus conflates the enduring romantic formula of self-making and the contemporary psychoanalytic formula of the self's unmaking: the trauma.

The Illinois murderer John Wayne Gacy attributed his killings to "the Other Guy tilt to his personality," even as he described himself as "a man who gave of himself for the benefit of others": a man who "live[d] for others" and who, "community-minded," experienced this giving of himself for others as "like becoming someone else."[51] The psychiatrist Joel Fort, who examined Edmund Kemper, recorded the sort of "depersonalization" in such cases: "You lose your sense of identity, and lose the boundaries between yourself and other people."[52] On another front, the fascoid or soldier males who kill for pleasure are to be understood as "individuals who have never attained the security of bodily boundaries invested from within."[53]

The model of the subject as a bounded space operates, and "spreads,"

both within these cases and in accounts of them. But this violence seems to be elicited *in the service of this model of the subject and in the name of the singularity that it contains.* This is the sense of a surrounded and besieged singularity ("Why am I what I am?"), in the name of which I will kill others ("I kill therefore I am").

For this reason, the "boundary" or "correct distance" model of the subject seems less an explanation of these cases than one of their symptoms. These models are premised on the notion that the self as a delimited agent, immune to foreign bodies and bounded by the skin, makes sense. They are premised on the notion that marking the line between what originates within the individual and what without makes sense. It is not merely that (as Bateson expresses it) these "questions are nonsense," that "if you ask anybody about the localization and boundaries of the self . . . confusions are immediately displayed."[54] (On this account, the burgeoning of boundary issues and the burgeoning of trauma, as ways of understanding the subject, are two parts of single formation: two ways of understanding the "confusions" of inside and outside and of private and public determinations of the subject.) This confused thinking in terms of self-distance and boundary-maintenance is precisely, we have seen, the fraught logic of addiction and addictive violence: the endless battles between self and world, nature and artifice, the real and its substitutes, body and machine, mind and body that render insupportable the experience of the permeability of the self, flowing from the outside in.

The intimation of secret interiorities or buried inwardness clearly structures the understanding, and the self-understanding, of the killer in some of these cases and representations: representations, for example, of "the killer inside me" or analyses of "buried dreams: inside the mind of a serial killer."[55] Clearly too, it enters into the typical forms of serial violence—and not merely in the "gothic home" cases of John Wayne Gacy or Dennis Nilsen or Frederick West, in which the burial of bodies in cellars or beneath floorboards seems a way of encrypting or housing "buried dreams."[56] This way of understanding the subject makes for the listening to, the ripping open, and the viewing of interiors—as the externalization of the fear of one's own teeming interior. It makes for the attraction to the deserted and empty *noir* spaces, as the typical scenes of the crime— scenes that appear as the fantasy-externalizations of the killer's emptied and already dead interior. It shapes the panic about the "fusion" with other bodies and bodily masses—as the threat of self-dissolution; and shapes the desire for this fusion—the desire for self-dissolution that, at the extreme, takes the form of the killer's *black out* at the moment of

violence.[57] It shapes the taxidermic imperative that runs through some of these cases: the taking and wearing of skins and the substitution of arti-factual for natural surface-boundaries of the body and of the self. It directs the identifications with the machinic: its streamlined surfaces and encrypted, artifactual working interiors. These are, it will be seen, the kinds of *panics about and desires for* the dissolution of boundaries that make it possible for the killer to derive identity from, and take pleasure in, destruction and self-destruction. These are, in short, some of the forms the sexuality of the serial killer takes: a sexuality that is not "struc-tured in a way to allow it to play itself out between persons" but "appears capable only of being directed *against* persons," that realizes itself in an annihilating persecution of sexuality.[58]

It is not then a matter of "choosing" between social and psychological ways of accounting for the subject (its conditions or boundaries) or a matter of equating inside and outside (the "psychological and the "socio-logical"). It is precisely the boundaries between inside and outside that are violently breached and shored up, transgressed and reaffirmed in these cases.[59] These vague and shifting determinations of the subject — from the inside out and from the outside in — provide one way of measur-ing the uncertain agency of private desire and public scene, fantasy and sociality, in these cases. That is, they provide one way of understanding the traumatic relays between sexuality and public violence in episodes of compulsive killing. The sex-violence thing is bound up through and through with the private-public thing, and these crossings of sex and vio-lence are crucial for understanding the contemporary pathological public sphere.

The Sex-Violence Thing

> "There's no sex in your violence."
> — "Everything Zen," Bush, *Sixteen Stone*

The tabloid figure of the serial killer would seem to lend itself ideally to psychoanalytic accounting — and not least because "psychoanalysis is the intellectual tabloid of our culture . . . ('sex and violence' being its chief objects of concern)."[60] The sexualized violence enacted in many cases of serial killing in fact looks like nothing but a psychotic literalization of a body of infantile fantasies.

The psychoanalytic theorist Jacques Lacan traces the vectors of these aggressive intentions in the following terms:

These are the images of castration, mutilation, dismemberment, disloca-
tion, evisceration, devouring, bursting open of the body, in short, the
imagos that I have grouped together under the apparently structural term
of *imagos of the fragmented body* . . . One has only to listen to children
aged between two and five playing, alone or together, to know that the
pulling off of the head and the ripping open of the belly are themes that
occur spontaneously to their imagination, and that this is corroborated by
the experience of the doll torn to pieces.[61]

It is not hard to find such imagos fantasized, and literalized, in episodes
of serial killing. Here are the words of Edmund Kemper, the killer of his
grandparents, mother, and a series of Santa Cruz college women: killing,
for Kemper, was "more or less making a doll out of a human being . . .
and carrying out my fantasies with a doll, a living human doll. . . .
Whipping their heads off, their body sitting there. That'd get me off. . . . I
remember being told as a kid, you cut off the head and the body dies. The
body is nothing after the head is cut off. . . . Well, that's not quite true.
With a girl, there's a lot left in the girl's body without a head. Of course,
the personality is gone."[62]

For Jeffrey Dahmer, the taking apart of bodies was in part a way of play-
ing with or experimenting with mannequin dolls and mannequin-like
persons: "I want to see what it looks like inside. . . . I like to see how things
work."[63] For the pleasure-killer, as Theweleit observes, the "only means
of discovering how his body functions is to take bodies apart, as a child
might dismantle a mechanical toy. The child's aim is not to fathom the
functions of mechanics itself, but to find answers to the riddle of its own
existence. It perceives a similarity between the tiny machines and motors
it feels working in its own interior, and the motors that drive its play-
things."[64]

One might easily multiply examples such as these. And one might
easily trace the precise "fit" between such imagos of the shattered body—
such fantasy-logics—and at least some scenarios of serial killing. But one
might as easily, of course, make the case for the "fit" between such
imagos and artistic representations such as Hans Bellmer's *poupées* or
Cindy Sherman's broken dolls.[65] That is, the very ease of translation
between these "themes that occur spontaneously to their imagination"
and those scenarios would seem to mark a limit to the psychoanalysis of
public violence. Such an understanding of infantile psychotic states, and
their potential prolongation, merely suggests that "the psyche might be
murderous in itself . . . [that] murder is potentially present in the very reg-

ulation of drives."[66] It suggests that "in our unconscious we are all killers."[67] It suggests, finally, that "*in our unconscious, in the real of our desire, we are all murderers.*"[68]

One advantage of such a "failure of discrimination between normal and abnormal at a psychic level as far as murder is concerned" is that it makes it possible to understand how violence and its representations can operate as poles of attraction and identification for the general public (that is, the generally murderous but nonmurdering public).[69] It makes it possible to understand both this movement of identification and the path along which it is disavowed: disavowed or quarantined, above all, in extreme-limit cases such as the serial killer.

But the basic disadvantage of such an account resides, of course, in that same failure of discrimination. The problem is not merely in the hypergenerality of the notion of "the preference for fantasy and its centrality in the life of these men." The more basic problem surfaces in, again, the abnormal normality of the fantasies themselves. As one recent study of "sadistic fantasy and sadistic violence" explains it: "The significance of the link between prior fantasy and behaviour would be more obvious if normals did not engage in sadistic fantasy. However, a recent study of sexual fantasies in 94 allegedly normal men . . . seemed to show that they engaged in fantasy which was, in part, controlling and sadistic." On these grounds, there is a basic inability to find a distinction between what are here tellingly called "statistically normal individuals" and pathological ones. (Normality, like killing, is thus a matter of numbers: the abnormal normality of statistical persons.) There is a basic failure, that is, to locate a distinction strong enough to support anything like a singling out of the offender or his motives — other than the self-evident singularity of his offense. Such studies falter just here: "In conclusion . . . while it is clearly important to understand *how* fantasies develop, take shape and translate into behaviour, the problem of *why* some people develop these fantasies and act and on them and others do not is perhaps even more fundamental, and more intractable."[70] This approach can, again, tell us nothing about the "translation" of fantasy into act, which is, on that account, the only thing worth knowing. The surfacing of a basic continuity between normal and pathological males thus marks the "intractable" limit of such psychological studies.[71]

This limit registers very differently in a range of recent, and more interpretive, studies on the subject of sexual violence. The very normality of male sadistic violence has become one of the commonplaces of recent feminist-psychoanalytic work on sexual violence: "Feminists place serial

killing at the extreme end of a continuum of sexual violence whose less extreme manifestations are normalized by a culture structured around systemic gender inequality."[72] The failures of distinction between normal and pathological male fantasies and acts thus become legible in the normalization of violence as part of the psychopathology of male everyday life. They become legible, that is, at the expense of another form of generalization: the leveling conviction that sadistic violence is a permanent and transhistorical component of the male psyche.[73] "Critical eloquence on the subject of male sadism holds the gender bottom line" in our culture, "providing our ultimate gender story."[74]

There is a good deal more to say about that story: about the self-evident gendering of many cases of serial violence, but also about the self-evident, even tautological, character of such bottom-line gender explanations — about the manner in which they become unmoored in stereotypicality and generality. The notion of the (male) psyche as murderous in itself leads to paradox or deadlock, at least in the region of criminal violence. For, "the more you identify the aberrational and extravagant in the most fundamental workings of the mind," as Jacqueline Rose acutely observes, "the harder it becomes to use those categories to secure a social classification — to secure the social itself." On these grounds, there is a basic "paradox inherent in psychoanalysis operating in the region of the law," in that psychoanalysis can give us "no absolute or consistent theory of violence which could adequately describe it as much in its genesis as in its effects."[75] Moreover, if, as Freud posited, "the unconscious foundations are similar in everyone," and if the "genesis" of violence is "the psyche murderous in itself," then it would seem that the only difference between the psychic killer and psycho killer devolves on this: the psycho killer, on this account, is one who does what others merely think, collapsing the distance between representations and things, private desires and public acts.

Such accounts, despite their basic contribution to the understanding of the intrications of sex and violence, tend to hesitate in paradox or a fundamental generality. Collaterally, they gravitate toward an assumption of a normative or correct distance between subject and representation, representation and act, private fantasy and public spaces, such that what I have been describing as the primary mediation of the subject of machine culture becomes visible only under the sign of pathology. But it may then be possible to turn their perspective: to reconsider just this assumption as to the correct distance between subject and representation and just this suspicion about the correct distance bewteen private desire

and public act.[76] I have been tracking the manner in which serial violence is bound up with what might be described as the quickening of an experience of generality within: a psychasthenic yielding to generality, to affections with something stereotypical about them, to something statistical in our loves. Serial violence, in short, cannot be separated from experiences of a radical failure in self-difference.

In cases of serial sexual homicide, the withering of self-distinction is channeled in the direction of a distinctly gendered violence: as if the violent reaffirmation of sexual difference were one way, and in our culture the most emphatic way, of securing or reaffirming self-difference as such. The traumatic failure in *self-difference* is instantly translated into, and countered by, the appeal to a bottom line *sexual difference*, at the level of the natural body. This characteristically takes the form of a violent redemonstration of the difference between self and other as the "basic" distinction between male and female or unmale. The redemonstration of self-difference produces the torn and leaking and opened body—the un-male body—as its "proof." It is in this sense that "the stakes of the murder are not the possession of an object of love or of pleasure but rather the acquisition of an identity."[77] Along these lines, the spectre of a generality within and compulsive gendered violence begin to resonate with each other.

There is an old prophecy that "war will break out when 'men and women become so alike you can hardly tell them apart.'"[78] Or in Lacan's reprise of this prophecy: "In abolishing the cosmic polarity of the male and female principles, our society undergoes all the psychological effects proper to the modern phenomenon known as the 'battle between the sexes.'"[79] What this abolition of an absolutized sexual polarity issues in is a battle not only along the lines of sexual difference but also along the lines of self-difference—as if the first uncertainly gives way to, or allays, the second. What issues, Lacan continues, is "a vast community of such effects, at the limit between the 'democratic' anarchy of the passions and their desperate leveling down by the 'great winged hornet' of narcissistic tyranny."[80] In these transfers between an endangered self-difference and an endangered sexual difference, the singularity of the subject is threatened on two fronts at once, from within and from without. One discovers a resurgent egoism in the mass subject: the "narcissistic tyranny" that arms itself against the "democratic" anarchy of the masses and the passions both.

On the one side, for Lacan, there is then the relentless "promotion of the ego today": the "ever more advanced realization of man as individual."[81] On the other, there is what at once promotes and threatens this

advance, and threatens it by generalizing its realization in each and every one. This is the extreme ramification of equality in the vast and leveling community: the radical democratization such that the individual will "vanish in its turn in a roar of the universal ground."[82]

The democratic tie of "each to each" is thus at the same time the war of "all against all." The critical theorist of psychoanalysis and its vicissitudes, Mikkel Borch-Jacobsen, has recently specified the paradox of this rivalrous identification: the "unbinding tie" of the individual and the mass. This is the "murderous, blind identification" that provides at once the principle of sociality (the sympathetic/mimetic ties that bind) and its opposite: the radically unbinding (narcissistic) asociality by which the "envied model" of identification is immediately assimilated, "annihilated, eaten, engulfed."[83]

The paradox of the "narcissistic bond" means that: "The acme of the 'sympathetic' relationship with others is simultaneously the ultimate non-relationship with others: each imitates the 'every man for himself' of the others; here assimilation is strictly equivalent to a disassimilating dissimulation. . . . A disbanding band must be qualified as both narcissistic and nonnarcissistic; egoistic and altruist, asocial and social." By the double-logic of the mimetic compulsion, this is the subject of an hypnotic identification who, for this very reason, is traumatically detached from distinct identity and distinct relation. (Hypnotically one with the other, the other in effect vanishes. Mimetically fused with others, he is simultaneously devoid of distinct affective and sympathetic ties.) Shot through by the social, this is the psychasthenic subject who immediately assimilates others even as he is assimilated by his simulations. Not similar to something or to someone, but *just similar*, the "too normal" subject is, in this sense, at once "egoist and altruist, asocial and social."[84]

On this view, the murderer's cogito ("I kill therefore I am") is generalized as the interior state of the subject as such. The (Lacanian) theorization of a psychology premised on the radical bottom-line of sexual difference is thus also, at least incipiently, a theorization of the state of the individual in mass culture. What that theorization mimes, in the panic form of a monstrous melodrama of the vast leveling and abolition of difference, is something like a horror of the masses. That horror devolves in turn on a war between the sexes which holds the place of a cosmic polarity between the sexes. In the "ever-contracting 'living-space'" of the masses and mass society, the realization of man as individual becomes inseparable from the violent reaffirmation of the difference between male and female "principles."[85]

Such an account of the psychosexual conditions of the crowded living spaces of mass culture borders on the vulgar "culturalism" Lacan everywhere cautions against. But such a reading falls short of registering the exorbitance of Lacan's claim. For it is instead the reduction of psychology to a "vast community" of subject-effects that is precisely what mass culture itself is seen to threaten. That is, it threatens the production of the *depsychologized but besieged* subject who is also the subject of violence (the notion of aggressivity as a "correlative tension of the narcissistic structure").[86]

That violence finds its path of least resistance along the lines of sexual difference (the modern phenomenon of the battle of the sexes). For this reason, it becomes clearer why the formation of the "social ego" of the soldier-male so closely resembles what Lacan generalizes as the formation of the ego as such: the formation of the fortress ego and the armored body of the man who kills for pleasure and who takes the bloody mass (the unmale body) and the bloody masses (the unmanning social body) as his target. For this reason, too, it becomes clearer why the intimation of a vast community within—the depsychologized psychology of the mass in person—so closely resembles the radical "other-directedness" of the Lacanian subject (the "primary identification that structures the subject as a rival with himself").[87] This is the subject who finds that he is not himself, who discovers that his proper being is over there, in that double who enrages him; and who thus expels this exteriority or extimacy within, converting stranger-intimacy into stranger-violence.

Paranoid logic therefore literalizes a general logic of rivalrous identification: "*If it's you, I'm not. If it's me, it's you who isn't.*"[88] So it would seem, again, that the only difference between the normal subject (the psychic killer) and the pathological one (the psycho killer) is the passage from fantasy to act. What defines the pathological subject is the direct, traumatic communication between inside and outside, private and public spheres. The passage from fantasy to act (the literalization of word in thing, fantasy in act) is at the same time the opening of a passage between private desire and public acts.

If the psycho killer is a pole of attraction and fascination in our culture, this is then not merely because he realizes these most fundamental workings of the mind (the unconscious murderous in itself). It is also, at least in part, because public corporeal violence threatens, or promises, to close the "normative" gap between private desires and public acts. What makes these atrocity scenes pathological is not merely their violent content, and what makes for their public consumption is not merely a taste for sense-

less violence. The violent scenes that flood the pathological public sphere disclose a drive to realize private desires in public spectacle. This is the logic of public sex and public violence.

The psychoanalytic story of "the mirror stage" is, in miniature, a story of the relays between corporeal violence and public spectacle; it is also the revision of a murder story. Lacan's modeling of ego formation in the mirror stage is anticipated in his earlier essay on a case of multiple murder: the murders committed by the Papin sisters, the sister-maids who killed their mistresses.

Lacan's reading of this "crime paranoïaque" focuses in part on the work of psychotic literalization: the elimination of the barrier between fantasy, imagination, and reality; the realization of language to the letter ("for [the sisters] a common metaphor of hate, 'I'll tear his eyes out,' became reality"). It locates, more generally, the violence that issues from such transformations of resemblance and identification into identity.[89] This is what Catherine Clément calls the failure of "correct distance" between the sisters: "the danger of too much closeness," an over-identification that issues in violence.[90]

But two forms of too-closeness seem suspended in relation to each other in this case. In paranoiac violence, it would appear that two forms of rivalrous identification are folded into one. One way of understanding this mimetic rivalry involves the social and class positioning of the servants in relation to their masters. Compulsive violence has been understood, along these lines, in terms of "a defensive status hysteria": rivalrous identifications "in the social hierarchy" whose "origins lay in the social order."[91] Seen this way, paranoiac violence is a malady of power and class position: this story of murder is the story of *the maids*.

But if the danger of too much closeness erupts in the stranger-intimacy of servant and master—the insupportable intimacies of those who are near but also far—this scarcely accounts for the "delire à deux" of the sisters. Thus if, for example, Genet's representation of the case in *The Maids* foregrounds the malady of power, the more recent film version of the case, *Sister, My Sister*, largely suspends class positioning in its focus on the violence issuing from a claustrophic intrafamilial identification: the hot-house failure of distance that refers intimacy to incest and incest to homosexuality. Seen this way, this story of murder is not the story of the *maids* but the story of the *sisters*.

These coupled but opposed stories thus hold in place rival ways of accounting for the subject of violence, such that each seems nothing but a literalization of the other. From one point of view, private disorders of

identification erupt in public and social violence. From the other, social rivalries are driven within, implosively privatized in the form of an unrepentant familialism.[92]

What marks these rival accounts of the subject is, once again, a direct communication between explanations, albeit registered in reverse, as a radical noncommunication between explanations, as the deadlock between "inside" and "outside" determinations of the subject: the "psycho" reading and the "social" reading.[93] To what extent does the model of correct distance provide something like the model of this noncommunication? Put as simply as possible, there is, on the order of the individual, the distance between self and other; on the order of the social, the distance between self and others. To the very extent that the *difference* between self and other is folded into the *distance* between self and others, the impasse or gap between private and public spheres becomes the normative model of the subject. What psychotic violence in effect threatens, or promises, is the closing of the gap between private desire and public act. It is for this reason that the subject armored against the social is at the same time the subject shot through by the social. The trauma-spectacle of compulsive violence realizes something like a direct communication between public and private, social and sexual, exterior and interior, collective and individual, such that each appears simply as a replacement, substitute, or literalization of the other.

The basic deadlock in understanding the category "sexual violence" is perhaps inseparable from this normative, or default, opposition of private and public spheres: "There's no sex in your violence." In the terms of a recent commentator on representations of sexual violence, sex and violence are "'not concommitants but alternatives,' with one substituting for the other."[94]

The need to test the border lines between crimes of power and crimes of desire is clear enough, and not least in the consideration of the ways in which power relations invest, or take on the form of, sexual relations. (This need goes beyond anything like a politically correct distance between sex and violence, even if it at times reflexively takes that form.) But if there is, at bottom, no sex in their violence—if these are not concommitants but alternatives—what then makes for their strange attraction and convulsive substitution? And what then makes for the popular fascination with spectacular sexual violence in the pathological public sphere?

There is, for one thing, a deceptive symmetry in the very category "sexual violence." "In rare individuals," as one commentator on murder

and madness puts it, "for reasons that are not well understood, sexual and violent impulses *merge* early in the child's development, ultimately finding expression in violent sexual assaults, and in the most extreme cases, sadistic murders or sex murders."[95] What hesitates accounts of sexual violence again and again is the disclosure of a "merger" or "linkage" or "interlocking" or "equivalence" of sex and violence that remains, precisely, inexplicable.

The *psychopathia sexualis* of Krafft-Ebing noted this logic of equivalence, or substitution-mania, early on, with speculative reference to the case of Jack the Ripper: "He does not seem to have had sexual intercourse with his victims, but very likely the murderous act and subsequent mutilation of the corpse were equivalents for the sexual act."[96] For the psychoanalytically-minded interpreter of sexual violence, the basic impasse between psychic and social orders (and the basic stalling on the matter of equivalence, substitution, and literalization) imposes itself at this point. For if (to complete the passage earlier cited) "psychoanalysis is the intellectual tabloid of our culture ('sex and violence' being its chief object of concern), we have recently privileged—sought, indeed, to base the politicization of psychoanalysis on that privilege—the sex over the violence."[97]

What this privileging means becomes clearer in the terms of another, sociologically minded, interpreter of sexual violence. If the recurrent but underspecified sense of a "merger" of sexual and violent impulses appears in these cases, "we are left wondering *why* some individuals should link sexuality and violence, and why they must kill to be satisfied, and whether that satisfaction is sexual or social."[98] The *linkage* of sex and violence thus migrates into the *opposition* of the sexual and the social. The "interlocking" of sex and violence, the substitution of one for the other, can only remain inexplicable in the posing of the question of sexual violence in terms of the alternative satisfactions, "sexual *or* social." (On this account, either sexual violence is "really" sexual and therefore not really social, or sexual violence is "really" social and therefore not really sexual at all.) These substitution-manias in the pathological public sphere, remain inexplicable to the very extent that these accounts obscure the relays between the sex-violence thing and the private-public thing.[99]

Notes

1. Philip Jenkins, *Using Murder: The Social Construction of Serial Homicide* (New York: de Gruyter, 1994), p. 228.
2. Ibid., p. 225.

3. Brian Masters, *Killing for Company: The Story of a Man Addicted to Murder* (New York: Random House, 1993), p. 195.

4. Quoted in David Heilbroner, "Serial Murder and Sexual Repression," *Playboy*, August 1993, 147. The attitude toward the psychiatric establishment in the BSU might be epitomized by the "joke," repeated by one its organizers, "about how many psychiatrists it takes to change a light bulb — the answer being just one, but only if the lightbulb *wants* to change." See John Douglas (and Mark Olshaker), *Mindhunter: Inside the FBI's Elite Serial Crime Unit* (New York: Scribner, 1995), p. 141.

5. Jenkins, *Using Murder*, p. 224–25.

6. "In the 1980s," Philip Jenkins observes, "serial murder came to symbolize the worst manifestations of human behavior, which might be regarded either as a matter of extreme social or psychological dysfunction or else a form of simple moral evil" (Jenkins, *Using Murder*, p. 121). Slavoj Žižek broaches such accounts of Schreber and Lecter in *The Metastases of Enjoyment: Six Essays on Women and Causality* (London: Verso, 1994), p. 20, and in *Everything You Always Wanted to Know about Lacan (But Were Afraid to Ask Hitchcock*, ed. Žižek (London: Verso, 1992), pp. 250, 262–63. On Jack the Ripper, see Judith Walkowitz, *City of Dreadful Delight: Narratives of Sexual Danger in Late-Victorian London* (Chicago: University of Chicago Press, 1992), and "Jack the Ripper and the Myth of Male Violence," *Feminist Studies* 8 (1982): 543–74. On Bundy as social symptom, see especially Elliott Leyton, *Hunting Humans: Inside the Minds of Mass Murderers* (New York: Pocket, 1986), pp. 67–109.

7. See Ian Hacking, *Rewriting the Soul: Multiple Personality and the Sciences of Memory* (Princeton: Princeton University Press, 1995), p. 67; and my *Bodies and Machines* (New York: Routledge, 1992), pp. 156–72.

8. Quoted in Philip Jenkins, *Crime and Justice: Issues and Ideas* (Monterey, CA: Brooks-Cole/Wadsworth, 1984), pp. 37–38.

9. Colin Wilson and Donald Seamen, *The Serial Killers: A Study in the Psychology of Violence* (New York: Carol, 1992), p. 17.

10. On the recalcitrance of these large metaphors in constructionism and what they occlude, see, for example, Ernesto Laclau and Chantal Mouffe, *Hegemony and Socialist Strategy* (London: Verso, 1985); and Judith Butler, *Bodies that Matter: On the Discursive Limits of "Sex"* (New York: Routledge, 1993).

11. Leyton, *Hunting Humans*, pp. 290, 320.

12. Angus McLaren, *A Prescription for Murder: The Victorian Serial Killings of Dr. Thomas Neill Cream* (Chicago: University of Chicago Press, 1993), p. xiv.

13. Deborah Cameron, "St-i-i-i-ll Going . . . The Quest for Jack the Ripper," *Social Text* (Fall 1994): 151.

14. Deborah Cameron and Elizabeth Frazer, *The Lust to Kill: A Feminist*

Investigation of Sexual Murder (New York: New York University Press, 1987), pp. 143.

15. Joel Norris, *Serial Killers* (New York: Doubleday, 1988), pp. 245–46.

16. On serial killers such as John Wayne Gacy as "everyone's nextdoor neighbor," see Tim Cahill, *Buried Dreams: Inside the Mind of a Serial Killer* (New York: Bantam, 1986), p. 6; on "Citizen X" Chikitilo, see Robert Cullen, *The Killer Department: Detective Viktor Burakov's Eight-Year Hunt for the Most Savage Serial Killer in Russian History* (New York: Ballantine Books, 1993); on Nilsen's self-description as "the monochrome man," Masters, *Killing for Company*, p. 6, et passim; on the serial killer as "the devoid," Derek Van Arman's novel *Just Killing Time* (New York: Penguin, 1992); on the serial killer as "the minus man," Lew McCreary's novel, *The Minus Man* (New York: Penguin, 1991).

17. Ann Burgess, testimony in the Dahmer trial. (Burgess was an FBI consultant and coauthor, with Robert Ressler and John Douglas, of the FBI study *Sexual Homicide: Patterns and Motives* [Lexington, MA: Lexington-Heath, 1988]).

18. National Public Radio interview, KUTV Salt Lake City, November 1, 1993.

19. Foucault, *Discipline and Punish: The Birth of the Prison*, trans. Alan Sheridan (New York: Pantheon, 1977).

20. I return to this radical entanglement of corporeal violence and the materialities of representation in chapter 7 of this part, "Lifelikeness," and in the conclusion, "Wound Culture."

21. On composite or statistical pictures, and "statistical persons," see my *Bodies and Machines*, especially Part 3.

22. Robert P. Brittain, "The Sadistic Murderer," *Medicine, Science, and the Law* 10 (1970): 198–207. See also J. M. Macdonald, "The Threat to Kill," *American Journal of Psychiatry* 120 (1963): 125–30; and D. S. Hellman and N. Blackman, "Eneuresis, firesetting and cruelty to animals," *American Journal of Psychiatry* 122 (1966): 1431–85. These elements of the serial-killer profile are usefully summarized in Norris, *Serial Killers*, pp. 217–49; and Masters, *Killing for Company*, pp. 242–66.

23. Brittain, "The Sadistic Murderer," 202–203. In the post-war years, German had become the nationality of male sadism. Or, as Klaus Theweleit neatly summarizes it in his study of the "soldier-male" who kills for pleasure, this man would be happy to have his passport entry read: "Primary sexual characteristic: German." Theweleit, *Male Fantasies*, vol.2, trans. Erica Carter and Chris Turner (Minneapolis: University of Minnesota Press, 1989), p. 83.

24. Brittain, "The Sadistic Murderer," pp. 199, 198. More recently, Joel Norris's influential and usefully informed, if internally contradictory, study of serial murder (*Serial Killers*) lists twenty-one components in the "serial killer profile," ranging from the banal ("feelings of powerlessness and inadequacy," "ritualistic behavior," "compulsivity," "interrupted bliss or no bliss in childhood," the "search for help") to the tautological ("history of serious assault").

The tendency in Norris's account is toward a psychobiologistic approach to serial crime: serial killing as a biological, genetic, somatic disorder, to be treated "as a form of public health issue" (222). Noting that serial killers are often habitual drinkers, Norris suggests that this "cause" of violence makes necessary warning labels on alcohol as a public health service. One can easily imagine how such warning labels might read—"do not operate heavy machinery; may cause serial killing under certain conditions." The psychobiological turn in criminology (the return to the Lombroso school) appears also in recent fictional representations of serial killing, for example, Philip Kerr's A Philosophical Investigation (New York: Plume, 1992), which centers on the "Lombroso Project"—the identification of genetic markers as predisposition toward repetitive violence.

25. See also the fifteen-page Violent Criminal Apprehension Program (VICAP) report form initiated by the FBI and Department of Justice to coordinate and profile violent and repeat crimes. The VICAP report is reproduced both in Robert K. Ressler, Ann W. Burgess, and John E. Douglas, Sexual Homicide: Patterns and Motives (Lexington, MA: Lexington-Heath, 1988), and Michael Newton, Serial Slaughter: What's Behind America's Murder Epidemic? (Port Townshend: Loompanics Unlimited, 1992).

26. Colin Campbell, "Detectives of the Mind? Portrait of a Mass Killer," Psychology Today, May 1976: 110–19.

27. Quoted in Ron Rosenbaum, "The FBI's Agent Provocateur," Vanity Fair, April 1993; see also chapter 1, above.

28. Murder: No Apparent Motive, HBO series, 1984.

29. Quoted in Newton, Serial Slaughter, p. 38.

30. Ronald M. Holmes and James DeBurger, Serial Murder (Beverly Hills, CA: Sage, 1988), p. 19. Cf. also J. Satten, K. Menninger, I. Rosen, and M. Mayman, "Murder without Apparent Motive: A Study in Personality Disorganization," American Journal of Psychiatry, vol. 117 (1960).

31. Karen Haltunnen, "Early American Murder Narratives," in The Power of Culture, ed. Richard Wightman Fox and T. J. Jackson Lears (Chicago: University of Chicago Press, 1993), p. 101.

32. Such a diagnosis in effect returns us to the nineteenth-century category of "homicidal monomania," a category that exhausts itself in the failure to locate any symptom or character of criminality in the criminal other than the commission of the crime itself. On the emergence of the notion of homicidal monomania, see Michel Foucault, "The Dangerous Individual," Michel Foucault: Politics, Philosophy, Culture: Interviews and Other Writings 1977–1984, trans. Alan Sheridan et al., ed. Lawrence D. Kritzman (New York: Routledge, 1988).

33. Edgar Allan Poe, "The Imp of the Perverse" (1845) in Great Short Works of Edgar Allan Poe (New York: Harper and Row, 1970).

34. Holmes and DeBurger, Serial Murder, p. 19.

35. Quoted in Masters, *Killing for Company*, p. 97.
36. See, for instance, Joel Black, *The Aesthetics of Murder* (Baltimore: Johns Hopkins University Press, 1991) and Leyton, *Hunting Humans*. The Natural Born Killer is, in this view, nothing but the media-born killer. What's news about the serial killer is thus at least in part the way in which nature and the media technologies—desires, bodies, and machines—switch places. The title of the extraordinary Belgian film in which mass murder and the mass media become inextricably entwined concisely captures this definitively newsworthy inversion of nature and culture: *Man Bites Dog.*
37. For an extended account of this explanation of serial killing, see, especially, Leyton, *Hunting Humans*.
38. James M. Reinhardt, *The Murderous Trail of Charles Starkweather* (Springfield, IL: C. C. Thomas, 1960), pp. 56, 60, 104.
39. On the relays between the imperatives of self-making, the drive to self-origination, and the compulsive drive to master living life, see the account of the career of H. H. Holmes in chapter 8, "American Gothic."
40. Margaret Cheney, *The Co-Ed Killer* (New York: Walker, 1976), pp. 39–40, 143.
41. *Unabomber Manifesto*, quoted in *Newsweek*, 10 July 1995.
42. Quoted in Douglas, *Mindhunter*, p. 108.
43. Bundy, quoted in Stephen C. Michaud and Hugh Aynesworth, *The Only Living Witness* (New York: Simon and Schuster, 1983), p. 324; Starkweather, in Leyton, *Hunting Humans*, p. 221; Kürten, in Masters, *Killing for Company*, p. 254; and in Maria Tatar, *Lustmord: Sexual Murder in Weimar Germany* (Princeton: Princeton University Press, 1995), pp. 40–44.
44. I will be returning to this notion of the survivor and to this traumatic "switching" between a sheer sociality and a murderous asociality. For now, these tendencies give, at the least, some indication of a radicalized sense of social levelling that includes but exceeds "class" motives or the drive to celebrity. If mass-media representations are appealed to as the "cause" of violence in such cases, both by the killer and his interpreters, this stops several steps short of registering the intimate relays between violence and representation (or, more properly, mass-technological reduplication) that inhabit such cases. The pathologizing of the mass media in effect holds at bay these intimacies between persons, bodies, and representations: as if everyone's everyday intimacy with machines can be "owned" only in the form of pathology, violence, and wounding. Consider, for example, one typical sociological account: David P. Phillips, "The Impact of Mass Media Violence on U.S. Homicides," *American Sociological Review* Vol. 48 (August 1983), pp. 560–68. In this account, among others, the effects of representations of violence on "real life" violence and what Phillips calls the "'real life' viewer" falters on the matters of fantasy, representation, and witnessing. ("Typically, the sorts of aggression studied in a laboratory [like

hitting plastic dolls or inflicting electric shocks] have not been representative of serious, real-life violence, such as murder or rape.") Accounts of media effects on violence typically become the occasion for reaffirming the line between representations and acts, representation and real life. The binding of trauma and traumatic violence to representation will be taken up in detail in chapter 7: for example, the violence done to plastic dolls as "representative of" the violence done to persons, or the laboratory-like "experiments" in destruction conducted by the mannequin collector and serial killer Jeffrey Dahmer.

45. See Ressler et al., *Sexual Homicide*, p. 34. Cf. also M. J. MacCulloch et al., "Sadistic Fantasy, Sadistic Behaviour and Offending," *British Journal of Psychiatry* v. 143 (1983): these acts or "behavioural 'try-outs'" can be "understood in each case as flowing directly from the patient's fantasy life" (25). Candice Skrapec, along the same lines, argues that "the motive in each case is a need for a sense of self as actor; a need for power that has generally arisen out of a formative history in which the individual as a child experienced him-or-herself as powerless." ("The Female Serial Killer: An Evolving Criminality," in *Moving Targets: Women, Murder and Representation*, ed. Helen Birch [Berkeley: University of California Press, 1994], p. 244). But is there any child, on this account, who is not a serial killer in the making? The sheer generality and banality of such explanations is utterly typical of such studies of serial violence.

46. MacCulloch, "Sadistic Fantasy," p. 26.

47. See Charles Taylor, *Sources of the Self: The Making of the Modern Identity* (Cambridge: Cambridge University Press, 1989), p. 186. See also Teresa Brennan, *History after Lacan* (London: Routledge, 1993), pp. 82–88.

48. This sociality of the wound is the subject of the concluding part of this study. For now, it is the traumatic dimension of the confusion between the "self" and the "social" that concerns me. For an extended account of Thompson's novel and the popular representation of the killer's psychology, see chapter 6; on the meaning of trauma in the pathological public sphere, see the final part of this book, "Wound Culture."

49. Quoted in Thomas E. Gaddis and James O. Long, *Killer: A Journal of Murder* (New York: Macmillan, 1970), p. 165.

50. Daniel Bell, *The Cultural Contradictions of Capitalism* (New York: Basic Books, 1976), p. 89.

51. Tim Cahill, *Buried Dreams: Inside the Mind of a Serial Killer* (New York: Bantam, 1986), pp. 143–45.

52. Fort quoted in Margaret Chaney, *The Co-Ed Killer* (New York: Walker, 1986), pp. 179, 181.

53. Theweleit, *Male Fantasies*, p. 211. Such a metaphorics of insecure boundaries governs recent cultural studies of *lustmord* as well, extending from the diagnoses of cases to the mode of the analyses itself. Hence it is not merely

that this violence arises from "a blurring of the boundaries between inside and outside and between 'fantasy' and 'reality'" (the scare-quotes providing some indication that these boundaries are *inevitably* blurred). The aestheticization of violence (both its artistic representation and the ritual-aesthetic component *within* these cases) suggests how that violence "open[s] the boundaries between art and life." The study of *lustmord* thus requires "an interdisciplinary approach that turns the once closely patrolled boundaries between literature, the visual arts, and cinema into permeable borders . . . dissolving the line between historical fact and imaginative construct." (Tatar, *Lustmord*, pp. 36, 7). In short, sexual murder itself is seen as a sort of interdisciplinary violence, sex and violence "permeating" each other: it is a *"fuzzy* category with unclear boundaries" (Cameron and Frazer, *The Lust to Kill*, pp. 17–19)

54. On Bateson's "cybernetics of the self," see chapter 3, above.
55. See Thompson, *The Killer Inside Me*; Cahill, *Buried Dreams* (on Gacy).
56. On the most spectacular of these gothic murder houses, The Holmes Castle, see chapters 8 and 9 of this study.
57. On the logic of the blackout in the panic/thrill of the pleasure-killer's self-dissolution, see Theweleit, *Male Fantasies*, pp. 164–69.
58. Ibid, p. 61.
59. On this breaching and shoring up of boundaries, in the subject of violence, see above, chapter 2.
60. Jacqueline Rose, *Why War?* (Oxford: Blackwell, 1993), p. 70.
61. Jacques Lacan, "Aggressivity in Psychoanalysis," in Lacan, *Écrits: A Selection*, trans. Alan Sheridan (New York: Norton, 1977), p. 11.
62. Kemper quoted in Leyton, *Hunting Humans*, pp. 41–43.
63. Dahmer quoted in Joel Norris, *Jeffrey Dahmer* (New York: Pinnacle, 1992), p. 66.
64. Theweleit, *Male Fantasies*, 2: 23. On the "transferences" of interior states onto the machine, see chapter 2, above.
65. On the work of Bellmer and others, in relation to imagoes of the shattered body, the fascist machinic imaginary, and Theweleitian "male fantasies," see Hal Foster, "Armor Fou," *October* 57 (1991): 65–97 and *Compulsive Beauty* (Cambridge: MIT Press, 1993).
66. Rose, *Why War?*, pp. 53–54.
67. Willard Gaylin, *The Killing of Bonnie Garland: A Question of Justice* (New York: Penguin, 1983), p. 156.
68. Slavoj Žižek, *Looking Awry: An Introduction to Jacques Lacan through Popular Culture* (Cambridge: MIT Press, 1991), p. 16.
69. Rose, *Why War?*, pp. 54–56.
70. MacCulloch, "Sadistic Fantasy," pp. 27–29.
71. The blurring of the line between psychology and pop-psychology in many of these studies is also part of the internal dynamic *within* cases of serial

violence: in the cases of Ted Bundy or Edmund Kemper or in the fictional cases of Jim Thompson's *The Killer Inside Me* and Thomas Harris's *Red Dragon*, the psychology of the serial killer *is* pop-psychology. I take up these versions of the popular psychology of the serial killer in chapter 6.

72. Deborah Cameron, "St-i-l-l Going," p. 151.
73. See Tatar, *Lustmord*, p. 40; and Andrew Ross, "No Question of Silence," in *Men in Feminism*, ed. Alice Jardine and Paul Smith (New York: Routledge, 1989), pp. 85–92. In accounts such as Lynda Hart's *Fatal Women: Lesbian Sexuality and the Mark of Aggression* (Princeton: Princeton University Press, 1994), male desire and sexual violence become two ways of saying the same thing: "male violence," on this account, becomes something of a redundancy.
74. Carol J. Clover, *Men, Women, and Chainsaws* (Princeton: Princeton University Press, 1992), pp. 226–27.
75. Rose, *Why War?*, pp. 55, 70.
76. These large matters, broached in the preceding part of this study, will be taken up from several perspectives in what follows: by way of the relays between bodies and representations ("the logic of pulp fiction" chapter 6) and by way of the body-machine-image complex (the concluding part: "Wound Culture").
77. Mikkel Borch-Jacobsen, *The Freudian Subject* (Stanford, CA: Stanford University Press, 1988), p. 33.
78. Quoted in Theweleit, *Male Fantasies*, p. 51.
79. Lacan, "Aggressivity in Psychoanalysis," p. 29.
80. Ibid., pp. 26–27.
81. Ibid., p. 27.
82. Ibid.
83. Mikkel Borch-Jacobsen, *The Emotional Tie: Psychoanalysis, Mimesis, and Affect*, trans. Douglas Brick (Stanford, CA: Stanford University Press, 1992), p. 33.
84. Ibid, *The Emotional Tie*, p. 9.
85. Lacan, "Aggressivity in Psychoanalysis," p. 27.
86. Ibid., p. 16.
87. Ibid., p. 22.
88. Lacan, *The Seminar of Jacques Lacan: Book II The Ego in Freud's Theory and in the Technique of Psychoanalysis 1954–1955*, ed. Jacques-Alain Miller, trans. Sylvana Tomaselli (New York: Norton, 1991), p. 169. This paranoid logic, the "unbinding tie" of violence and identification, is realized to the letter in a range of recent films on serial murder: for example, Lars von Trier's *Zentropa* or the German film *Apartment Zero*. In the British film on female serial violence/compulsive identification, *Butterfly Kiss*, the two female characters—Eunice and Miriam—drawn into relation, and engulfed by identification, go by the nicknames "Eu" and "Mi" ("it's you or me").

89. Jacques Lacan, "Motifs du Crime Paranoïaque: Le Crime des Soeurs Papin," *Minotaure: Revue Artistique et Litteraire* (February 15, 1933), pp. 26–27.

90. Catherine Clément, *The Lives and Legends of Jacques Lacan*, trans. Arthur Goldhammer (New York: Columbia University Press, 1983), pp. 72–78; on Clément, see Hart, *Fatal Women*, pp. 146–50.

91. Leyton, *Hunting Humans*, pp. 303–304.

92. Nor is the difficulty reducible to the notion that the psychoanalytic reading, to the extent that it "props" egoistic on erotic difference, simply holds in place what has been described as "the heterosexual presumption" (cf. Hart, *Fatal Women*: "'proper distance' is the 'opposite' of the feminine," p. 150.) The presumption that the failure of difference between self and other is in effect realized in the incestuous/homosexual failure of sexual difference cannot simply be "corrected" by exposing the radical entanglement of the egoistic and the erotic as a sort of bad gender politics that should therefore go away, at least "in theory."

93. This is perhaps one reason why Elias Canetti concludes *Crowds and Power* (New York: Noonday Press, 1984), by taking up, as a sort of provocation, one of the defining cases in the case for psychoanalysis—the case of the prototype paranoiac, Schreber. Canetti's analysis insists on a "political" model of paranoia that pointedly abjures the "psychosexualization" of the psycho ("Paranoia is an *illness of power* in the most literal sense of the words" [448]). He insists on paranoia as a political disorder bound up with the crowd-phenomenon ("His delusion is in fact a precise model of *political* power, power which feeds on the crowd and derives its substance from it" [441]). What I am suggesting here are the ways in which the disorders of self-difference in the crowd and the disorders of sexual difference feed on each other in cases of paranoiac violence.

94. Clover, *Men, Women, and Chainsaws*, p. 29.

95. Donald T. Lunde, *Murder and Madness* (New York: Norton, 1979), p. 53 (my emphasis).

96. Richard von Krafft-Ebing, *Psychopathia Sexualis: A Medico-Forensic Study*, trans. Harry E. Wedeck (New York: Putnam's, 1965), p. 119.

97. Rose, *Why War?*, p. 70.

98. Leyton, *Hunting Humans*, p. 59.

99. It is possible, we have seen, to detect a registration of the conditions of the mass in person, and the typical forms of his aggressivity, in the psychoanalytic account. It is also possible to detect it at the very heart of the psychoanaltyic "attitude":

> What, then, lies behind the analyst's attitude? The concern to provide the dialogue with a participant who is as devoid as possible of individual characteristics; we efface ourselves, we deprive the speaker of those expressions of interest, sympathy, and reaction that he expects to find on the face of the lis-

tener, we avoid all expression of personal taste, we conceal whatever might betray them, we become depersonalized, and try to represent for the other an ideal of impassibility. (Lacan, "Aggressivity in Psychoanalysis," p. 13).

The psychoanalytic dialogue thus involves anything but a "renunciation of aggressivity." It is precisely the analyst as devoid—deindividualized, effaced, depersonalized—who elicits "the subject's aggressivity towards us." And this is an aggressivity elicited by way of the *stranger-intimacy* of one who, uncannily near but also far, has become indistinguishable from an indeterminate number of others. The devoided listener thus "induce[s] in the subject a controlled paranoia." For the subject who is "offered the pure mirror of an unruffled surface" paradoxically sees in that faceless and deindividualized surface what Lacan calls "an exact replica of himself" (p. 15). The paradox consists in this. In the analytic restaging of the mirror stage, the subject finds in the pure mirror of the analyst an exact replica of himself. (Such a condensation is realized to the letter, of course, in the popular figure of the psychiatrist *as* psycho killer. Here too this is a violence so unmotivated as represented that it seems to be premised on literalization as such [e.g., *Dressed to Kill*]. This is epitomized, of course, in Hannibal Lecter, whose senseless but graphic violence itself seems to proceed simply as an effect of literalization and graphesis ["Cannibal" *because* "Hannibal" and literalist *because lecteur*].) What appears in that mirror is thus not exactly the self-recognition of the subject structured as rival to himself. What appears in the mirror, vampire-like, is an exact replica of the voided and effaced subject, "a sort of nonperson." In the terms of the subject of an *un*controlled paranoia, the psycho killer: "A person was a blank."

6 · Pulp Fiction:

The Popular Psychology

of the Serial Killer

At this point, I want to shift the focus to what might be called the popular psychology of the serial killer. I mean "popular psychology" in two senses. First, the popular understanding of the serial killer that circulates not merely in fiction, film, and the mass media but also in "official" accounts of the serial killer (and, as we have seen, even for the profilers, "our antecedents do go back to crime fiction more than crime fact"[1]). And second, the uncanny manner in which the interior states of the serial killer himself seem nothing but the clichés du jour that make up a pop-psychology (the hypertypicality by which the serial killer melts into place). I want initially to consider this popular psychology by way of a piece of pulp fiction that directly engages it: Jim Thompson's remarkable prototype novel of compulsive killing, *The Killer Inside Me* (1952). I want then to look at, more generally, the logic of pulp fiction — a mass-produced genre-fiction premised not merely on the mass fascination with representations of murder but also in which clichés and killing, dead words and dead bodies, seem to feed on each other. And I want to trace, finally, how that logic seems to enter into, or to evacuate, the "inside" experience of the serial killer.

The Depsychologized Subject

The Killer Inside Me is, nominally, a first-person novel, narrated by the killer Lou Ford. But as the narrator's name itself suggests, *only* nominally:

Ford, the Model-T, mass-reproducible person, the hyper-typical deputy sheriff living in the hyper-typical American place, Central City, epitomizes the subject shot through by the social. It is not merely that he inhabits a landscape of utter typicality—a landscape of look-alike sameness, numbers, and mass-mediated representations: "It's a nice view all right. Almost unique. I don't suppose you'll find more than forty or fifty thousand billboards like that one in the United States. . . . I listened to the radio awhile, read the Sunday papers and went to sleep."[2] The view of the killer's interior or inside similarly opens to a radical generality within: he is "on the whole typical," "no more than average anyway," "one of hundreds of people" (82), "just like everyone else," "a typical Western-country peace officer, that was me" (28). He is, in short, "pretty impersonal" (21): devoid of affect ("Feel? I'm not sure I know what you mean, Joe" [18]) and without even the sensation of individuality ("I liked the guy—as much as I like most people, anyway" [4]).

Ford is then a version of what I have described as the mass in person: the uniform and uniformed individual and the standardized personation of the social law. He is a figure whose public visibility is at the same time a measure of his statistical normality—a sort of crowd of one. "Indifferently" doing the "kind of thing men and women have always been doing," he thus appears as the depsychologized subject—that is, as the oversocialized individual; as he puts it, he acts "like an overtrained dog" (78). The depsychologized subject's indifferent identity is inseparable from a flooding by the social order, inseparable from an identification with "any crowd for him to sink into" (67). Hence the first-person killer-narrator typically inhabits the third person, speaking in person only and explicitly as a matter of convenience: "Go right ahead, Mr. Ford. Just keep on using the first person. It's easier to talk that way." "'Lou Ford, speakin',' I said" (234, 108).

It is routinely argued that the criminal is the antisocial individual, unmarked by the subject's normative interpellation into the social-symbolic order: as the cliché goes, "When you look into his eyes, it seems as if 'there is nobody at home.'"[3] But at least in these cases, the criminal's interior appears not as *anti*social but rather as *directly* socialized, such that, when you look into his eyes, it seems as if "there is everybody at home." If Ted Bundy looked completely different in every photograph; if Jeffrey Dahmer, dressed in a suit, looked like ten other men; if Lou Ford looks "just like everyone else": it is as if mass social forces and forms were time-sharing their faces, their eyes, their minds, their words.

On one level, the killer's depsychologized psychology seems to oper-

ate simply as a species of camouflage: as a form of the psycho-killer's chameleon-like capacity to simulate normality. Lou Ford's conscious simulation of normality is well-marked throughout, and not least in the studied transparency of his bodily dispositions to legible social forms: in his rehearsed identification with what the sociologist Pierre Bourdieu calls the "socially informed body" (for example: "I leaned an elbow on the counter, crossed one foot behind the other and took a long slow drag on my cigar" [4]). The transparency of bodies and minds to social forms (the new historicist conviction) here appears, however, precisely *as* a form of simulation. That is, it is not just that Ford imitates or simulates normality; the notion of an unremitting imitation or simulation of normality is his way of accounting for the social order itself. For this reason, the only difference he locates between the murderer and nonmurderers is the nonmurderers' "pretendsy" simulation of normality: "He could've done it [killed] just as easy as not ... but he was just like everyone else. He was too nicey-nice and pretendsy to do anything really hard" (187). Ford's account thus accords with the popular notion that we are all killers in the unconscious of our desires, that "often a criminal is a man who does what other people merely think."[4] It is in this sense that the murderer appears as a sort of hero of the drives and a pole of attraction and identification. His thorough identification with others ("just like everyone else")—precisely to the extent that it surfaces within the experience of the subject himself—becomes, paradoxically, the measure of his difference, a difference that inheres in the traumatic recognition of a fundamental sameness or likeness.

But there is something deceptive in the understanding of simulation just as pretense. Such an understanding depends on a thinned-out notion of identification or simulation. Simulation appears simply as the same as dissimulation: the pretending to be what one is not. This posits a basic distinction between the subject and forms of representation, simulation, and identification—between the subject and what counts here merely as the "trappings" of the social order. Such an understanding in effect conserves the subject's "proper" distance from simulations and representations as his proper distance from the social order: as if the real subject, the real of the subject, resides somewhere within, anterior to and apart from its representations or identifications, anterior to and apart from his social being-in-context. On this view, the killer "inside me" is the real identity of the subject, hidden and beneath its "merely social" simulations and identifications.

This is to locate the *cause* of the subject of violence (what Ford calls "the why" of his acts) in terms of the subject's distance, or failure of dis-

tance, with respect to representation, identification, and simulation. For this reason, deep anxieties as to the status of representation surface again and again in accounts of serial killing. A good deal is at stake in localizing and pathologizing such a failure of explanation as to cause or motive ("motiveless crimes"), and such a failure of distance, with respect to identification ("the chameleon-like killer"). What is at stake, in representing the status of representation and identification, is the status of the subject as such.

What exactly, then, does the subject's "proper distance" (his critical, or cynical, distance from the social order) amount to here? If a compulsive overidentification would seem to be the measure of the killer's difference, it would also seem to be the measure of his madness. This is the madness of the sheer conformist to social forms who at the same time merely simulates those forms: the subject hollowed out and captivated by the social-symbolic network who at the same time ceaselessly simulates his captivation, reducing the social order to a "pretendsy" signifying game. For the outlaw who is also the uniform symbol of the law (the policeman-killer), this madness is scarcely personal; the policeman-killer's cynical distance from the social order and his hyperidentification with it amount to the same thing. For what if "the dominant attitude of the contemporary 'post-ideological universe' is precisely a cynical distance toward public values? What if this distance, far from posing any threat to the system, designates the supreme form of conformism, since the normal functioning of the system requires cynical distance?"[5] Complete identification with the abstractly conceived "system" and a mask-like, ironic imitation of it thus amount to the same thing. This is the serial killer as "the professionally perfect person" who is also the simulated person, a "type of nonperson." The world of pulp fiction is a world in which the "obscene underside" of the law is routinely exposed (the policeman-as-killer, for example). But that exposure scarcely loosens the hold of the law, precisely in that it is *routinely* exposed: the law never appears as anything but an arbitrary demand and an empty show. The killer's madness is, in this sense, his unremitting conformity to a normal madness: "We aren't the first to mention that the world today seems to be going crazy."[6]

The serial killer thus appears at the same time as a true "believer in the 'system'" and as a "subtly constructed reflex machine which can mimic the human personality perfectly": the serial killer "might well be a visitor from another planet, struggling to mimic the feelings of those he encounters."[7] In short, the killer appears as the depsychologized individual for whom intimacy appears as an unremitting spectacle of empty social

forms (personal relations as "socializing type" relations, as Bundy characteristically termed it). Hence the focus on the essential conformity of the serial killer: "Kemper was no revolutionary, had no desire to transform the social order under the banner of some brave new ideology: on the contrary, he identified with its most conservative symbols"; Bundy "embraced sheer legalism with a passion that is rarely encountered." Bundy was, as Elliot Leyton puts it, "forever disguising himself": "I'm disguised as an attorney today," he told the judge in his Florida trial.[8]

But disguise is not exactly the right word here: this is a matter of simulation rather than dissimulation. As Bundy's interviewers, Michaud and Aynesworth saw it, Bundy's experience of personal relations as "socializing type" behaviors resembled "an alien life form acquiring appropriate behaviors through mimicry and artifice." Or in Bundy's words: "I didn't know what made people tick. I didn't know what made people attractive to one another. I didn't know what underlay social interactions."[9] Leyton and others see this identification with conservative symbols of the system as a path to in violence when the killer fails to secure status in the system. But this passionate identification with "the system" has to be understood differently. The killer is not merely the failed conformist, the hyperconformist who thus conceals his madness. One discovers here—in the absolute conformism to the system without belief in the system—the mimetic identification without identity that constitutes that madness. This is the depsychologized individual: identified with the social order even as the social order confronts him as a dead signifying chain.

The True Romance of Serial Murder

This confrontation could not be more explicit in Thompson's anatomy of repetitive murder, nor in the killer's utter absorption in mass-produced, hypertypical, and "socializing-type" representations. Lou Ford's language is a series of "personalized" clichés: "'Haste makes waste, in my opinion. I like to look before I leap.' 'I began needling people in that dead-pan way—needling 'em as a substitute for something else.'" The "something else" for which this compulsive deadpan language substitutes is compulsive killing: "That was dragging 'em in by the feet, but I couldn't hold 'em back. Striking at people that way is almost as good as the other, the real way" (13, 5).

It is not as if Ford alone speaks in clichés in the novel: all the characters do. And pulp fiction itself is composed line by line of clichés. Ford alone *motivates* this dead unmotivated language as a substitute form of

violence. One is tempted to understand this devivified and devivifying language as something like a deadpan literalization of the Lacanian dictum, "The word kills the thing": "Speech, as we know, language—is the death of the thing."[10] But translations or equations such as these in fact explain nothing. They merely point toward something, in this case a conflation of killing words and killing persons, that still remains to be explained.[11] What sort of language works in this way, operating at once as a "substitute" for *and as a version of* compulsive killing? What sort of relays between words and things—and between forms of violence and words or images or representations or reproductions—support these processes of substitution?

This is, for one thing, language with a direct material and physical impact: a "needling" that again and again makes people twist and squirm ("She squirmed a little, and then she snickered. 'Oh, Lou, you corny so and so! You slay me.'" [15]). One rediscovers here the absolute proximities of words and acts, of bodies and representations, that, we have seen, traverse cases of addictive violence: "Because they hadn't got the point. She got that between the ribs and the blade along with it" (244). This concrete language is a version of what Michel Foucault, in his account of the early nineteenth-century family killer, Pierre Rivière, describes as the killer's *verboballistics*; Rivière invented not merely new kinds of weapons but new words for them: word-weapons.[12] But whereas the family killer's verboballistics register a conflation of independent invention and the independence of self-invention, Ford's deadpan language works in the opposite direction. Empty words are deployed as empty shells: this is not language that describes or narrates but language that targets. This deanimated language is a deanimating mechanism, taking pleasure in the annihilation of independently moving life.[13]

One way of comprehending this devivifying mechanism is as the hypertrophied, already dead language of the social order. To the extent that the social order is represented as "the intervention of the external, mechanical, symbolic order," it appears as the skin surface that covers "the real" of the subject.[14] This is to imagine the social-symbolic order, "the signifying network that structures social reality," as a dead, mechanical overlay: the social "skin," structured by language, beneath which real "living life" resides.[15] On this logic, the stripping away of the external, mechanical, dead social-symbolic order and the stripping away of the skin become two ways of doing the same thing. "One of the definitions of the Lacanian Real," as Slavoj Žižek summarizes it, "is that it is the flayed body, the palpitations of the raw, skinless red flesh."[16]

Such a logic is clearly at work in the erotics of violence enacted in Thompson's story, among many others—an erotics that takes the form of violently tearing bodily interiors open to view ("starting to undress me after I'd almost skinned her alive" [13]). So too is the relentlessly general and abstract notion of "the social" that grounds stories such as these. In Lou Ford's way of seeing, this is the paranoid perception of the "whole world" as having but "one face, a face without eyes or ears, and yet it watches and listens" (204). In Lou Ford's way of listening, this is "the voice," the commands of a generalized and faceless social order—uncertainly the pop superego of talk radio and the daily papers ("Enjoy your symptom!"; "Obey your thirst!") and the voice's traumatic dimension, a kind of internal alien entity. One detects here an exposure of private interiors so complete, a social order so absolutized in its occupation of those interiors, that the senses monitoring interiors in effect become unnecessary or redundant. It is in this sense that the characteristic settings or exteriors of *noir* representations of murder—exterior settings unremittingly claustrophic, thick, saturated—are at the same time nothing but interiors: interiors exteriorized.

But if this logic of the social and the symbolic goes some way in unpacking Thompson's species of Fordism, it is necessary to pressure this mutually abstracting opposition of "the body" and "the social," bodies and words: this way of locating "the social"—as external, mechanical, symbolic—and this way of locating "the real" of the subject, as the flayed body beneath the social-symbolic skin. Nothing is more visible, across the range of work in recent cultural studies, than "the return of the body." Yet what such a turn or return to the body itself makes visible is perhaps less self-evident. At the least, such a return of the torn body *as* the Real of the subject has come to function as something of an antidote to the inflation of the symbolic order (to the conviction that persons, desires, bodies are discursive "all the way down"). Clearly, there has been something of a naughty thrill in "historicizing" bodies, desires, and persons in the cultural studies of the last decade or so, a thrill that may by now be going or gone. This has amounted to a perpetual redemonstration of the conviction that there is nothing "deeper" to persons than their construction in the social-symbolic order. Hence the flayed body functions as the limit-point or counterpoint to accounts of the subject—the subject as nothing more than its social-symbolic construction. But a basic deadlock has emerged here between, on the one side, the ("Foucauldian") understanding of identities and sexualities as discursive and symbolic—constructions through and through—and, on the other, the ("Lacanian")

understanding of identities and sexualities (the Real of the subject) as the very point where symbolization, the social-symbolic order, fails.[17]

This deadlock should by now be familiar enough. But how then does this deadlock enter into cases of compulsive violence? And how do the assumptions on which it rests—the understanding, for example, of the social order as external, mechanical, symbolic—function within these cases?

A complex network of concerns surfaces here, concerns as to the state of the killer's interior. Collaterally, they are concerns as to the compulsive exteriorization of the killer's interior states in acts of violence: their embodiment in spectacular acts and scenes of densely corporeal violence. The intimacy with scene and spectacle is crucial. Hence these are concerns as to the relays between violence and representation, or more exactly, as to the subject's distance, or failure of distance, with respect to representation. One discovers here anything but an opposition between bodies and representations or symbolizations.

What exactly does having an "inside" look like in stories of addictive violence? For it is not merely that such interiors seem formed "from the outside." One discovers here a drive to void interiors, to force interiors to the outside and to experience interior states only to the extent that they lie outside the self. Hence the preoccupation, as we have seen, with the miming of bodily dispositions that externalize interior states, something like drills in self-evacuation: "I lay in the tub for almost an hour, soaking and smoking and thinking" (181). The equation of thinking with floods and flows—*addictive* flows of alcohol and smoke, for example—turns what it means to have an interior into a mechanical and repetitive taking in and voiding of insides. Mental processes are thus equated with external, or externalizing, habits: "I sat thinking—standing outside of myself—thinking about myself" (181). The forcing of interior states into a position of exteriority—the exteriorization of insupportable interiors—makes for the killer's experience of violence as self-expulsion: "I yelled with laughter . . . I doubled up, laughing and farting and laughing some more. Until there wasn't a laugh in me or anyone" (51). This evacuation and projection of the self, at both ends, converts the self into projectile: "Smoke suddenly poured up through the floor. And the room exploded with shots and yells, and I seemed to explode with it, yelling and laughing." (244).

What issues from the mouth and what issues from the weapon are thus drawn into equivalence: killing and speaking become two ways of doing the same thing, to the extent that both enact not the expression of interiors but an expulsion or emptying of interiors. On this logic, the killer's

target is, above all, the mouth as at once the opening to (bodily and expressive) interiors and as an emptiness (the cliché machine) into which he empties himself: "I shot him, then, right in his gaping mouth, I *emptied* the gun *into* him" (52; my emphasis).[18]

The characterization of the addictive killer as void of affect and interiority—as "the devoid"—is then not quite accurate. The devoided interior must be understood not as the cause of violence but as its desired effect: the production and externalization of voided or dead places within. This is then a sort of "corrective" violence, producing the emptiness that it then, through an internal torsion, targets.

But it is a corrective violence in another sense as well. What is insupportable about these teeming, massy interiors are the boundary-eroding, self-eroding "flows" coursing within and without. This erosion of boundaries is experienced at once as a flooding within of unconscious bodily masses (desires that must immediately be exteriorized) and as the crowding within of the crowd or mass itself (the "extimacy" of the mass in person). The vanishing of self-distinction in the mass figures alternatively, then, as the massiness of the body and of the masses themselves: the surging, deeply embodied crowd, within or without, in which all differences vanish. These are not symbols or representations or figures of interior states but embodiments of them.

It is precisely at this point that the most deeply embodied form of this corrective violence clarifies itself. In the translation of a traumatic failure of self-difference into an absolutized sexual difference, the vanishing of the distinction between self and other is corrected in the radicalized polarization male and female (unmale).

Here is the way in which the female body is represented in this story, among others: "One of those gals that makes you want to take your shoes off and wade around in her" (116). Seen this way, the female and female body is already nothing but a flowing interior, nothing but a blood bath: sexual relations and the blood bath thus become two ways of experiencing the same thing.[19] Sexual relation between the sexes is represented as the self-contaminating flowing inside of another—"putting her dirty insides inside of me" (60). Sexual relation, what the killer sees as the fusion or "coupling" of individuals, is what makes the killer "sick inside" (121): the moment of coupling is then the moment when "all their differences seemed to vanish" (122).

Most basically, this involves the vanishing of differences in the category of "woman" itself (*"one of those gals"*). For the serial killer, "all womankind bore the same face," they all "seemed pretty much alike"

(215, 133). Striking at any woman became "the same as striking at her . . . any woman who, even for a moment, became *her*." In this way, killing again is merely "kill[ing] her the second time" (132). The fundamental nondistinction projected onto the female and the female body—the violence explicitly triggered by the "strong resemblance" between one woman and another, by the inability "to distinguish between women and *the* woman"—thus ratifies, in circular fashion, the violent production of that nondistinction: producing persons as bloody masses.[20]

It also ratifies the identification (in Theweleit's terms) of the bloody mass and the masses as twin embodiments of what is at once the thrilled fusion with another and a traumatic failure of singularity. At the close of *The Killer Inside Me*, the rapid shifts in narrative voice—from first to third to second person—index the paroxysms of self-location in the killer's accelerating and explosive violence. The final act of murder and self-murder takes the form of a final identification, of a final literalization: this time a terminal collapse of "private" interior and "public" cliché, private body and public voice. Two refrains close the novel and clinch its taut logic. The killer's repeated citation of the formula for intimacy and the possibility of sexual relations—"two hearts that beat as one" (244)—folds into the citation of the formula for the vanishing of all differences—the refrain, "all of us . . . all of us" (244). The cliché is, of course, the condensed form of mass-mediated interiority—the subjectivity proper to the mass in person. Here, the collapse of relation into the true romance of the cliché (the mass idiom of the pop song and the greeting card) is the collapse of interiority into mass-mediated intimacy: the evacuation of self-difference as such.

Splatter Codes: The Logic of Pulp Fiction

In the crowd and in the mass, Elias Canetti writes, there is an "extreme *ramification* of equality": "They are close together, one often resting on another . . . density is added to their state of equivalence . . . these people really feel as one. . . . The man pressed against him is the same as himself. He feels him as he feels himself. Suddenly it is as though everything were happening in one and the same body . . . all are equal there; no distinctions count, not even that of sex."[21] For Canetti, the vanishing of self-difference is thus also the vanishing of sexual difference.

From one point of view, this proceeds too quickly: Canetti's analysis of crowds and power would seem to void, or to foreclose on, the psychosexual dimensions of both crowd psychology and crowd violence. But

from another point of view, that analysis could be said concisely to regis-
ter the paradox within the notion of a "crowd psychology" itself: the para-
doxically depsychologized status of the subject of crowd psychology, the
subject flooded from the outside in, such that anything like individual
distinctions vanish. In this way, two different models of the traumatic fail-
ure of self-difference—the first premised on the extreme ramification of
equality in the crowd, the second on the essentially traumatic character
of human sexuality—find their point of contact; and in this way, the refer-
ring of the failure of self-difference to an "ineradicable" sexual difference
finds its logic.

Extreme ramification of equality in the mass involves the elaboration
of a form of life and a form of the subject about which it becomes possi-
ble to say that there is no "proper" self-relation and that "there is no
sexual relation." In the pathological public sphere, there is in effect noth-
ing but public relations: "In the discourse network of 1900 . . . this is its
open secret—there is no sexual relation between the sexes. . . . According
to a fine tautology, men and women, who are linked together by media,
come together in media."22

These public relations have a specific form, with respect to bodies and
representation: bodily states and public spectacle are brought into an
absolute proximity. Quentin Tarantino, in mock school-boy fashion, pref-
aces his hyperviolent, hyperclichéd, hyperfilmic film *Pulp Fiction* with
two definitions of "pulp" drawn from the *American Heritage Dictionary*
(New College Edition): 1. "A soft, moist, shapeless mass of matter" . . . 2.
"A magazine or book containing lurid subject matter and being charac-
teristically printed on rough, unfinished paper." The corporeality of
bodies and the materiality of representations: the very "suspension" of
these two definitions in uncertain relation to each other poses the basic
question as to the connection between bodily violence and its mass-
public representation. This is the basic question whether representations
of violence are a substitute for real violence or their continuation by other
means. That is to say, in what sense are we to understand these processes
of substitution—as alternatives to or as components of "real life"
violence?

Here we might reconsider the eroticized shocks of contact that struc-
ture, for example, Zola's novel of sexual murder *La Bête humaine* or the
machine erotics of the Matushka case: the reproduction of the body-
machine complex as public spectacles, the public spectacle of the
simulated accident. These are the violent conjunctions of bodies, tech-
nologies, and simulations that J. G. Ballard, in the more recent novel

Crash—self-described as "the first pornographic novel based on technology"—calls "the possibility of an entirely new sexuality" in the simulations of machine culture.[23] The novel maps an erotics inseparable from media-simulated and technology-saturated landscapes: from the everyday collisions of persons and machines and the everyday intimacies of bodies and representations (representations as prosthesis). These shocks of contact are only the most exorbitantly visible in the "institutionalized" spectacle of the car crash ("the pandemic cataclysm institutionalized in all industrialized societies that kills hundreds of thousands of people each year and injures millions" [6]). What comes into view are the "elements of new technologies linked to our affections" (32). Stylized, serialized, and spectacularized: this is the possibility of an entirely new sexuality bound to that "overlit realm ruled by violence and technology" (16).

But what remains radically uncertain, in the mapping of these shocks of contact, is the nature of this contact between bodies and simulations, the nature of these substitutions. What remains uncertain is the extent to which this new sexuality and new violence are a *substitute* for "real" sex and "real" bodies or the *realization* of real sex and real bodies.

Pornography based on technology, the body seduced by the image and moved by the machine: this coming together in the media is the at once traumatized and thrilled uncertainty as to the status of persons and bodies and machines and representations. This is the true romance of machine culture. It defines, not least, the overlit landscapes of desire, violence, and technology in the recent film *True Romance*. There, the eroticized stylizations of bodily violence and mass-cultural clichés (from the film's brand-name title to its generic "movieness" to the rebirth of an undead Elvis at the close) all feed off each other with a relentless exhilaration.

These involutions of representation and violence make up the logic of pulp fiction: its "splatter codes."[24] The relays between pulp (1) and pulp (2), between bodies and codes, are of course nowhere clearer than in the intimacies between violence and the cliché reduplicated in mass-market pulp fiction. And these are the traumatic relays by which perception and representation, private fantasy and public reality, reverse places.

Thompson's *The Killer Inside Me* provides an exemplary, albeit "low-tech," version of the killer's substitution manias. Consider these two scenes of a sort of self-recognition in the novel, scenes that the killer experiences "like being lost and found again." The first scene takes place in what had been the medical office of his father: "I got up and walked along the bookcases, and endless files of psychiatric literature, the bulky

volumes of morbid psychology. . . . Krafft-Ebing, Jung, Freud, Bleuler, Adolf Meyer, Kretschmer, Kraepelin. . . . All the answers were here, out in the open where you could look at them. And no one was terrified or horrified. I came out of the place I was hiding in—that I always had to hide in—and began to breathe" (27). If this is a scene of self-recognition, what is most marked about it is perhaps the becoming-legible of interior states *as* places or scenes: a coming out into the open that "looks" at interior states as places lying outside the subject. But in this case, the places where the killer comes out into the open are "endless files" of writing, "psychiatric literature," "bulky volumes of morbid psychology": the disclosure of the killer's interior and the dense materialization of representation (in this case, writing) indicate each other at every point.

There is in such scenes nothing like a specification of what those states or what those "answers" look like. Instead, there is the sheer identification with the "endless files"—the case histories of *psychopathia sexualis*—that seems to open the subject to the very caselikeness, the very abnormal normality, of his case ("no one was terrified or horrified").[25] Like Charcot's men with little pieces of paper, the killer knows what he feels only by reading about it. And to the very extent that these explanations are experienced as unconvincing and take the form of the pop-psychology cliché, the killer's singularity seems to give way to what I have earlier described as the quickening of a stereotypicality or generality within.

In pulp fiction such as this, we are routinely presented with the killer as a text-book case in paranoia. The killer's interior states are emphatically projected, and rejected, in the form of visual and auditory hallucinations (scene and voice). And, as we know, "The mechanism of symptom-formation in paranoia requires that the internal perceptions—feelings—shall be replaced by external perceptions."[26] The replacement of internal by external perceptions in cases of paranoia underwrites the graphomanias of writing and communication: "It is impossible to overrate the importance of words for the paranoiac. They are everywhere, like vermin, always on the alert. They unite to form a world order which leaves nothing outside itself. Perhaps the most marked trend in paranoia is that towards a complete seizing of the world through words, as though language were a fist and the world lay in it."[27] Along these lines, interior states and external spectacle, fantasy and perception, words and world, traumatically "replace" each other.

The second recognition scene in the novel illustrates how this switch-

ing between representation and perception involves something like a photography at the level of the object. This is a return to a scene of childhood trauma, but a return by way of "a little two-by-four snapshot." The materiality of the image all but refuses to yield the identity of the image: "I picked it up. I turned it around one way, then another . . . I rubbed the picture against my shirt. . . . But it was old, the picture I mean, and there were kind of crisscross blurs—of age, I supposed—scarring whatever she was looking through" (104–105). What he sees, first, are the "crotch," "limbs," "stumps" of what he sees as a tree and the blurs and scars on the surface of the aged photographic image. What he sees, second, is the scarred body of a woman (the housekeeper who initiates Ford into sadomasochistic scenes she has first enacted with his father: "And those crisscross blurs on her thighs weren't the result of age. They were scars"). It is not merely that this scene stages the distorted perception (the anamorphosis) in repression. For the giving way of the sign to its materiality (the pun) and the giving way of the image to its corporeality ("I rubbed the picture against my shirt") measure the yielding of interior states to the materialities of signs and images.[28] This is not exactly a text-book scene of repressed and recovered memory of the trauma that produced the trauma. (The episode, Ford repeats, "didn't need to mean a thing" and, in the novel, it's not at all clear that it does. "The boy is father of the man," the romantic formula of self-origination, becomes not merely the formula for traumatic fixation but becomes simply formulaic; it here has the self-canceling status of a psychiatrist's cliché.) The clichéd and textbook character of the scene seems precisely the point. What the story of repression represses is the materiality of written signs and the carnal density of the image: that is, mass-mediated signs and images as, in effect, "the unconscious of the unconscious."

For Lacan (following Caillois), aggressivity is the correlative tendency of a mode of identification without reserve: a mimetic compulsion experienced as the psychasthenic "derealizations of others and of the world." This derealization is "experienced as events in a perspective of mirages, as affections with something stereotypical about them." As Lacan images it, the stagnation in stereotypicality in one of those moments is "similar in its strangeness to the faces of actors when a film is suddenly stopped in mid-action."[29] For Kittler, "methodological distinctions of modern psychoanalysis and technical distinctions of the modern media landscape coalesce very clearly."[30] What this coalescence amounts to is our traumas mimetized, reproduced in the modern media landscape of the

reproductive technologies; hence, "movies and the gramophone remain the unconscious of the unconscious."[31]

I will be returning, in the final part of this book, to this traumatic "switching" between psychoanalytic and technical distinctions and their implications: to the simulated intimacies of the pathological public sphere, the serialized and simulated privacies of the mass-mediated subject, the intimacies of "mediatronic" man. For now, I want to suggest that there is nothing "deeper," in these similarity disorders, than processes of replacement or substitution or the "just similar." In cases of compulsive violence, there is the insupportable experience of an addictive yielding to replacement or substitution as such: the *paraphilias* (substitute-loves); the serial reenactments by which one body and one person substitutes for another; the compulsive record-keeping, word counts and body counts; the repetition and reduplication of killings in photographs, films, audiotapes, or videotapes.[32] The addictive subject is addicted to substitution: this is his addiction to addiction. But it is also, on the paradoxical economy of addiction ("tuned up by the very poison that caused the damage"), his self-addiction: his way of lifting himself up by his own bootstraps. It is his way of taking in and evacuating interiors: his way of taking himself, and others, apart, tearing apart and reassembling others in the drive to reassemble himself.

The replacement of the soul with information, expert and scientific, is thus only one "local" version of this making public, this publication, of private interiors. Thompson's killer is, we have seen, not the only serial killer, written or real, to look himself up in the literature on his kind of person.[33] The diagnostic and statistical manual of mental disorders, the literature on abnormal psychology, and the literature on serial killers is routinely consulted as well by "real-life" serial killers such as Kemper and Bundy or the Seattle-area serial killer and self-described "Bundy Man," George Russell, Jr. Bundy, not unexpectedly, considered himself an expert in his field: "All he knew was serial murder, and I had trampled on his territory."[34] At the same time, however, he repeatedly acknowledged an essential lack of knowledge about himself, about his kind of person. Hence Bundy urgently and insatiably "needed information on serial killers" (455). The sense of his interior is referred, in his terms, to "a broad and complete enough data base to be making such judgments"—the "beginning" represented, as he puts it, by "the summary of the findings of a study done through the Behavioral Sciences [sic] Unit and reported [as he reports] in the August 1985, edition of the

F. B. I. Bulletin" (451). Looking for himself in person in the general database, it was like being found and lost again. In this way, the difference between persons and data, interiors and writing, private states and public bodies of information scarcely seems to function. The traumatic "looping" of private interiors and public knowledge could not in such cases be more emphatic.

Notes

1. John Douglas (and Mark Olshaker), *Mindhunter: Inside the FBI's Elite Serial Killer Unit* (New York: Scribner, 1995), p. 32; see also Philip Jenkins, *Using Murder: The Social Construction of Serial Homicide* (New York: de Gruyter, 1994), pp. 223–29.
2. Jim Thompson, *The Killer Inside Me* (New York: Vintage, 1991; 1952), pp. 143, 44; subsequent references are to this edition and included in the text. Pulp fiction is a popular form of representation preoccupied with numbers (round numbers); fiction less peopled than populated. The billboard reads, in part: "Pop. (1932) 4,800 Pop. (1952) 48,000." Another of Thompson's pulp fictions is entitled, simply, *Pop. 1280.*
3. Slavoj Žižek, *The Metastases of Enjoyment: Six Essays on Women and Causality* (London: Verso, 1994), p. 63.
4. Frederic Wertham, *Dark Legend: A Study in Murder* (London: Victor Gollancz, 1947), quoted in Brian Masters, *Killing for Company: The Story of a Man Addicted to Murder* (New York: Random House, 1993), p. 249.
5. Žižek, *Metastases of Enjoyment*, p. 72; see also pp. 17–22. Žižek is here adumbrating Theodor Adorno's account of the "hollowing out" of the psychology of the subject, his feigning and simulation of conformity, in totalitarian mass society. See Adorno, "Freudian Theory and the Pattern of Fascist Propaganda," in *The Culture Industry: Selected Essays on Mass Culture* (London: Routledge, 1991).
6. "Unabom Manifesto," *New York Times*, 2 August 1995, p. A16.
7. Ann Rule, *The Stranger Beside Me* (New York: Signet, 1989), pp. 39, 403, 397.
8. Elliott Leyton, *Hunting Humans: Inside the Minds of Mass Murderers* (New York: Pocket, 1986), pp. 64, 85.
9. Stephen G. Michaud and Hugh Aynesworth, *The Only Living Witness* (New York: Simon and Schuster, 1983), pp. 65–68; Leyton, *Hunting Humans*, p. 101.
10. Joan Copjec, "The Phenomenal Nonphenomenal: Private Space in *Film Noir*," in Copjec, ed., *Shades of Noir: A Reader* (New York: Verso, 1993), p. 183.
11. Klaus Theweleit, *Male Fantasies*, vol. 2, trans. Erica Carter and Chris Turner (Minneapolis: University of Minnesota Press, 1989), pp. 184–92.

12. Michel Foucault, ed., *I, Pierre Rivière, having slaughtered my mother, my sister, and my brother . . . A Case of Parricide in the 19th Century* (New York: Pantheon, 1975).
13. See Theweleit, *Male Fantasies*, pp. 215–217.
14. Žižek, *Metastases of Enjoyment*, p. 117. The metaphorics of surface and depth is not merely the metaphorics of the subject's "interiority" but also the idiom of the social order's exteriority, both mechanical and symbolic: "In short, relating to the body implies suspending what goes on beneath the surface. This suspension is an effect of the symbolic order; it can occur only in so far as our bodily reality is structured by language. In the symbolic order, even when we are undressed, we are not really naked, since skin itself functions as the 'dress of the flesh'" (Žižek, *Metastates or Enjoyment*, 116–17). See also Freud: "The ego is ultimately derived from bodily sensations, chiefly from those springing from the surface of the body. It may thus be regarded as a mental projection of the surface of the body" (Sigmund Freud, *The Ego and the Id, The Standard Edition of the Complete Psychological Works of Sigmund Freud*, trans. James Strachey, vol. 19, pp. 25, 27.)
15. Copjec, "The Phenomenal Nonphenomenal," p. 191.
16. Žižek, *The Metastases of Enjoyment*, p. 116.
17. If "one of the . . . definitions of the Lacanian Real" is, for Žižek, the flayed body, there are several others. See, for instance, Žižek, *Tarrying with the Negative: Kant, Hegel, and the Critique of Ideology* (Durham, NC: Duke University Press, 1993): "It is against this background that we can provide one of the possible definitions of the Lacanian Real: the Real designates the very remainder which resists this reversal [of metaphor and thing]" (43). The Real, on this account, resists the reversal, or substitution, of metaphor and thing: "'imaginary sexual act'" and "'proper' sexual act"; "real (instead of only imagined) partner," "a mere metaphorical simulation" and "blood-and-flesh reality," and so on. My point is not just that what designates the Real migrates across these accounts, nor that the Real comes to posit, as a sort of formal principle, what resists substitution and representation. The Real is taken to designate at once the flayed body and what resists the commutability of simulation and act, image and body. What is at stake here can be made a bit clearer by way of yet a third, and somewhat different, Žižekian designation of the Lacanian Real: "The Real designates a substantial hard kernel that precedes and resists symbolization *and, simultaneously*, it designates the left-over, which is posited or 'produced' by symbolization itself" (36; my emphasis). A "certain fundamental ambiguity" thus pertains to the notion of the Real. This ambiguity is bound up with a fundamental uncertainty as to the status of symbolization and representation. (The Real stalls on the matter of symbolization and representation, and this stalling itself appears as its "substantial hard kernel.") This means that the designation of the Real remains tied to a fundamental assumption as to the *insub-*

stantiality of the image. To what extent does this resistance, or stalling, on the matter of the symbol (this repression of the corporealities and materialities of simulation, representation, and image) continue an exhausted image/body dualism?

Put simply, there is a basic problem with this abstracting account of the "social-symbolic order." That account is misleading to the extent that it conserves just that series of axiomatic oppositions—words versus things, the social versus the bodily, the machinal versus the living, representations versus things themselves—that are directly under pressure in these cases. These oppositions precisely fail to account for, and in effect hold at bay, the primary mediations of machine culture and the forms of violence proper to it. Primary mediation involves not the opposition of the bodily and the symbolic but, instead, the dense materializations and corporealizations of writing, reproduction, representation, and symbolization; not the opposition between the bodily and the mechanical but, instead, the deep intimacies between the life process and the technological process. For this reason, these accounts of the social-symbolic order seem less an explanation than a symptom. For these mediations are experienced in terms of the maladies of agency and failures in self-distinction we have been tracing. If the subject of machine culture comes into being through processes of identification and mediation, and if the logic of the serial killer depends on such a primary mediation, the serial killer's own totalizing logic works in reverse: through a claim of self-determination and self-possession that suppresses all reference to its identifications and mediations. This is a suppression that, in effect, registers these internal mediations in inverted form—as, precisely, external, mechanical, symbolic. That is, mediation is experienced at the level of the subject as an insupportable violation that itself must be violently suppressed, exported, or externalized. The assumption of exteriority (this version of the "boundedness" or inwardness of the subject) thus elicits, and shapes, forms of violence in machine culture: violence enacted *in the name of* the killer's sense of his excruciated interiority and besieged singularity.

In the final part of this study I will be taking up these large questions from a somewhat different angle: To what extent does it continue to repress "the carnal density of the image," such that the notion of the Real designates the unyielding of "the romanticism of the soul" to the materiality of written and visual signs? To what extent does this designation of the Real hold on to a model of the subject as anterior to representation and exterior to the social, even as this model of the subject is exhausted or voided (what Žižek terms "the void called 'the subject'")?

18. On the coalescence of corporeal violence and the materialities of representation, we might consider the recent John Carpenter film, *In the Mouth of Madness*. Here, the detailed, material transmission of fantasy-representations of violence—typewritten, then printed, then publicly disseminated,

then filmed—are realized in a burgeoning contagion of senseless violence and mass murder. The boundaries come down between words and things, representation and what counts as the real: the film's protagonist is an insurance fraud investigator whose talent is sorting real from fictional claims of bodily damage. In this film the Cartesian cogito gives way to a mass-media production of the subject. In the words of the popular novelist, Cane, who scripts this violence: "I think, therefore you are." What proceeds *out* of the mouth of madness then are not at all specific fantasies of violence but instead the violence that issues from a materialization and literalization of representations in the everyday world, and, as a consequence, the utter absorption of the subject in representation. Hence it is as if the normative condition of the subject were an immunity to, or correct distance from, representation: an immunity that would, of course, make anything like novels such as *The Killer Inside Me* or films such as *In the Mouth of Madness* nothing more than "pretendsy." On this reductive account of representation, the primary mediation of the subject is doubly quarantined. On the one side, it is projected onto a general indictment of media-borne violence—that is, violence as media-born; mediation impinges on the subject only "from the outside," in a failure of correct distance with respect to representation. On the other side, the primary mediation of the subject is exoticized, identified with the unreal genre-fiction of the horror story. At once making visible and derealizing the primary mediation of the subject, such genre-fictions screen (in both senses) the manner in which identity, or the face ("the face-system," in Deleuze and Guattari's sense), is a horror story. (On the face-system, and on these relays between bodies, representations, and identities, see chapter 9.)

19. For this reason, the Nicole Diver/Veronica Lake figure in Thompson's noir novel is named Joyce Lakeland.

20. Mass culture, it is routinely observed, is routinely figured as "woman." But the routinization of this figuration, in cultural studies, has generally remained abstract and, precisely, *too* figural or symbolic. The *embodiment* of mass culture in the female body is literalized in these stories of sexualized violence: in these representations of sexualized violence as the vanishing of differences in the mass and in the masses. One discovers in the conversion of women to woman a conversion of persons to figures *in the process of becoming-symbolic* and serial violence is bound up with such a process of becoming-symbolic. For if the category "woman" is routinely identified with mass culture, the category is just as routinely identified with just the opposite: not a sheer culturalism but a sheer naturalism. As Klaus Theweleit summarizes it, "'Women' is a code word for the whole complex of nature, for anything at all having to do with 'feeling,' living interiors, unconscious urges" (*Male Fantasies*, p. 215). The fear of the mass (the unmale streaming body) and the fear of the masses (the unmale streaming crowd) thus stand in for each other, in that switching between determinations of trauma I have

been tracing: the trauma of self-difference and crowd panic; the trauma of sexual-difference and castration panic.

21. Elias Canetti, *Crowds and Power*, trans. Carol Stewart (New York: Noonday, 1984), pp. 15–16.
22. Friedrich A. Kittler, *Discourse Networks: 1800/1900*, trans. Michael Metteer with Chris Cullens (Stanford, CA: Stanford University Press, 1990), p. 357.
23. J. G. Ballard, *Crash* (New York: Vintage, 1985), pp. 6, 102. (Subseqent references incorporated parenthetically in text.)
24. I adopt the term from Dennis Cooper's novel of pornographic serial violence, *Frisk* (1991), to which I will be returning in the final chapter of this part.
25. The novel's pop, or pulp, psychology requisitely locates the secret interior of the subject in the place of "the law of the father" (and his psychiatric surrogates). But this too appears as nothing but a psychiatrist's cliché, "like being lost and found again." Ford's "opening" of his interior takes the form of a contentless "skimming" through a series of foreign languages. The passage continues: "I took down a bound volume of one of the German periodicals and read a while. I put it back and took down one in French. I skimmed through an article in Spanish and another in Italian." He had picked up these languages, he explains "just like I'd picked up some higher mathematics and physical chemistry and half a dozen other subjects." The subject's recognition scene thus becomes identical to the subject's picking up of half a dozen other languages and other subjects, one after another. The opening up of interiors (the coming out of the killer inside him) is thus not just an encounter with oneself as foreign to oneself; it is also an identification of interiors with "endless files" of writing matter.
26. Freud, "Psycho-Analytic Notes on an Autobiographical Account of a Case of Paranoia," *Standard Edition*, 12: 63.
27. Canetti, *Crowds and Power*, p. 452.
28. The direct binding of wound and representation is perfectly imaged in Richard Misrach's photographic series, *The Playboys*: photographs of bullet-riddled photographs (shot through pieces of paper) that not only literalize the gun/camera equation but also image the becoming inseparable of traumatic violence and the materiality of representation in wound-mediated culture. (See also the final part of this book, "Wound Culture.")
29. Lacan, "Aggressivity in Psychoanalysis," *Ecrits: A Selection*, trans. Alan Sheridan (New York: Norton, 1977), pp. 28, 17.
30. Friedrich Kittler, "Gramophone, Film, Typewriter," *October* 41 (Summer 1987): 115.
31. Kittler, *Discourse Networks*, p. 283. For a fuller discussion of this coalescence of the distinctions of modern psychoanalysis and the mass-mediated landscapes of the Discourse Network of 2000, see the conclusion of this study, "Wound Culture."

32. For an inventory of these paraphilias and substitute-loves in serial killing, see Joel Norris, *Serial Killers* (New York: Anchor, 1988), pp. 223–24.
33. In popular representations of the serial killer, such as the recent film *Seven*, tracking the killer by numbers means researching his research in the endless card files of a psychopathology library.
34. Rule, *The Stranger Beside Me*, p. 454; subsequent citations, in parentheses, are to this text.

7. Lifelikeness

Ryan noticed how newspapers and television were developing a familiar and comforting vocabulary to deal with violence. Sentences which could be read easily off the page. It involved repetition of key phrases. Atrocity reports began to achieve the pure level of a chant. It was no longer about conveying information. It was about focusing the mind inwards, attending to the durable rhythms of violence. . . . The violence had started to produce its own official literature. Mainly hardbacks, with the emphasis on the visual . . . image[s] which prompted a terrible carnality.
—Eoin McNamee, *Resurrection Man*[1]

Copycat Killers

In his recent memoir of his son Jeffrey, Lionel Dahmer presents his own version of the serial killer child as father of the man. This representation is inseparable from technologies of reproduction:

> I took up the camera again and made a videotape of my son. Through the lens I saw a handsome young man who slouched in the large stuffed chair only a few feet from me. . . . [H]e seemed to have his life under control.
> Now, when I look at that video, I see much more than I could possibly have seen before. In the chair, Jeff sits with one leg over the other, a single foot dangling in midair. At each mention of his apartment, his foot twitches slightly. With each mention that I or someone else in the family may drop by to pay him a visit, it twitches. With each mention of what he is doing now . . . of what he does in his spare time—it twitches. Something in his distant, half-dead gaze says, "If you only knew."[2]

It is not merely that the videotape replay, life under remote control, operates as a sort of polygraph test: the twitching body registering as *une*

langue inconnue of the body-machine complex. There is in the memoir—as in the career of Jeffrey Dahmer himself—a direct binding of bodies and identities to machines of perception and representation: "How could anyone believe that his son could do such things . . . this child that I had held in my arms a thousand times, and whose face, when I glimpsed it in the newspapers, looked like mine?" The pathos of this memoir is at the same time the stranger-intimacy of the mass media: as if the father's recognition of his son must pass through the glimpse of his son's face in the newspapers.

Here is how Lionel Dahmer describes his first television interview, on the tabloid news show *Inside Edition*—an interview, he informs us, "conducted by Nancy Glass":

> During the interview, I said that I felt a very great responsibility for what my son had done, along with a "deep sense of shame." Then my voice broke suddenly, and I quickly reached for a glass of cola which had been put on the table beside me, and ducked behind it. My words somewhat muffled, I continued, my voice cracking slightly as I spoke, "When I dissociate myself from this thing, I'm OK."
>
> When I look at the video now, I see a very controlled man, dressed in a blue suit and a dark tie, a man hiding behind a glass, a man . . . who wants to dissociate himself from "this thing." One can look hard for love in this video, and still not find it. . . . Watching the video, one can detect a man whose life has been stung by shame, who wants the spotlights to go off so he can return to the shadows, but it is hard to find a father racked by grief and care.[3]

What Dahmer calls "dissociation," from himself and from his son, is at once the antidote and the malady. It is the antidote in that the prophylaxis of a media-spectatorial distance dissociates the viewer from violence. It is the malady in that this very distance is the psycho-dispassionate dissociation of the serial killer: the serial killer as "the devoid." On both counts, a media distance makes for the "half-dead gaze" such that, for example, interior states are quoted rather than experienced ("a deep sense of shame"). The father's story of violence, its genealogy or cause, is everywhere "behind a glass": the television screen, the video replay, the stranger-intimacy of the public exposure of wounded and torn persons, the hiding behind the iconic commodity (the glass of cola) or behind the generic window on interiors (the inside edition, conducted by Glass). Identity and identification with others are through and through bound to

the technical apparatus: to the public reproduction, and reproducibility, of private, torn, and opened persons.

These disorders of distance and identification mark the intimacy spectacles of the pathological public sphere. These mediated intimacies orbit scenes of violence. There is a public gathering around scenes of violence, but a crowd gathering of a peculiar kind: a public at once thrilled, remote, and distanced. In his study of crowds and violence, Elias Canetti makes clear the pornographies of distance that define such a public drawn to pathology:

> Disgust at collective killing is of very recent date and should not be over-estimated. Today everyone takes part in public executions through the newspapers. Like everything else, however, it is more comfortable than it was. We sit peacefully at home and, out of a hundred details, can choose those to linger over which offer a special thrill. We only applaud when everything is over and there is no feeling of guilty connivance to spoil our pleasure. We are not responsible for the sentence, nor for the journalists who report its execution, nor for the papers which print them. None the less, we know more about the business than our predecessors, who may have walked miles to see it, hung around for hours and, in the end, seen very little. The baiting crowd is preserved in the newspaper reading public, in a milder form it is true, but, because of its distance from events, a more irresponsible one. One is tempted to say that it is the most despicable and, at the same time, the most stable form of such a crowd. Since it does not even have to assemble, it escapes disintegration; variety is catered for by the daily re-appearance of the papers.[4]

The modern crowd takes part in public violence at a "distance from events" that has, at the same time, a heightened immediacy. Seeing more, knowing more, the crowd gathered around collective bodily violence leaves its body behind: for "the newspaper reading public," information and representation replace bodies. Seriality and repetition—"the daily re-appearance of the papers"—replace the singularity of the event. A phantom public gathers around collective killing in a private consumption of scenes of public violence: no longer walking miles to see it, no longer hanging around for hours, public violence enters private interiors, as "we sit peacefully at home." It may be that this distance from events is a despicable and irresponsible one.[5] But it involves something more. The uncertain distance between viewer and event and between information and body is also the uncertain distance between private

desire and public space. If there is "a special thrill" in this mass-media witnessing, if there is a "pleasure" in this way of assembling around collective killing, this may be in part because such phantom events hold the places of the public sphere, albeit a public that meets in pathology. One discovers here an identification with others *by way of* the witnessing of public violence and its simulations.

For this reason, disorders of identification are seen to make up both the malady of the collective killer and the method of the "mindhunters" who work (generally ineffectually) to track him down. The serial-killer profiler John Douglas asserts: "You have to be able to re-create the scene in your head. . . . You have to know what it was like." Douglas derives his model of re-creation in part from the inaugural story of detection as identification: the detective Dupin of Poe's "Murders in the Rue Morgue." For Dupin, "Deprived of ordinary resources, the analyst throws himself into the spirit of his opponent, identifies himself therewith."[6] Re-creating pictures and simulating scenes within, identifying oneself, knowing by likeness: the mindhunter enters into these disorders of similarity, yielding to the mimetic compulsion.

The danger in identification as method is that one might get trapped in one's identifications. "If you put yourself in the other man's place often enough," Jim Thompson writes, "you're very likely to get stuck there." On this account, identity depends on the identifications that at the same time threaten to devour identity. "And a man has to identify himself with something. He has to be able to picture himself as being some certain thing. If he can't he's helpless. There's no motivation, no guide for his acting and thinking. . . . This man couldn't identify himself with the human race. He appeared to be able to do it with extreme ease, but actually he was losing a little of his character and personality with every contact. In the end, there wasn't anything left."[7]

Mimetic identification or simulation thus occupies an uncertain middle ground: that interval between *dissimulation* (masking or mimicry or pretense) and *transformation* (an identification intensified to the point of reproduction). So the simulations of violence that center the pathological public sphere might be understood less on the model of distance (whether correct distance or the pornography of distance) than on the model of the double-logic of prosthesis: as self-extension and self-extinction both. To the extent that the mimetic compulsion resembles a photography at the level of the object, the boundaries come down between technical processes of reproduction and the life process. At the level of the social body, the copycat killer mimes normality: a deathly mimetic

compulsion by which life takes a step backward. In recent theories of autoimmune disease, a disorder of similarity at the level of the natural body is taken to explain these diseases. The "virus's similarity to body's proteins" amounts to "a molecular mimicry: a case of mistaken identity." And what is called the "mimicry idea" is imaged exactly in terms of a copycat killer within: "The activated T cell and its troops go on a hunting expedition in the body, seeking any and all cells that show the fragment marker. When it finds such cells . . . the T cell is still bent on murder. It sets into motion a cascade of destruction."[8]

Fantasy, Pornography, Public Sex: The Violence-Representation Deadlock

One of the most compelling recent representations of the binding of simulation and destruction is Dennis Cooper's fantasy of sexual murder, the novel *Frisk* (1991). In *Frisk*, as in *The Killer Inside Me*, fantasies and perhaps acts of murder derive from a spectacle of childhood trauma—more exactly, they derive from a trauma identified with the photographic reproduction of a wounded body. In *Frisk*, however, the wounds on the body are simulated. And what becomes visible in the novel is not merely a fascination with the simulation of wounds but an understanding of simulation *as* wounding.

On one level, fantasies of violence in the novel are fantasies of frisking the body: the "urge to really open up someone" in order to gather information about interiors, to gather a "knowledge of bodies" by tearing open persons, and taking "the temperature inside that."[9] In a sort of Foucauldian sex-information system, abjection becomes information. For the fantasy-killer, "it's all information to me" (33). The urge is to "dismantle" bodies to "see how you work" (70). This is the logic of what Cooper calls "splatter codes" (76).

The fantasy of murdering someone as an "area of life" is, for Cooper, part of a more general wound culture: a culture in which people wear their physical damage like fashion accessories. The fashion of the wound, in turn, is part of the becoming artifactual of bodies and persons. The simulation of bodies takes the form of "the silhouette," "the model," "the replica," and, above all, "the lifelike" (20, 28, 31, 35). Simulation becomes inseparable from the rising to the surface of a typicality within. The body as artifact and the body as reproduction is also the body as "perfect type . . . like me": the "textbook ass" and the "prototype" or model person. The serial killer "experience[s] someone as an image" (66).

The splatter codes of the serial killer endlessly cross and recross the line between image and body, between flesh and blood and symbol. For Ted Bundy, for example:

> We're talking about images . . . and it's a terrible thing to say. Sure we're talking about images. We're talking about anonymous, abstracted, living and breathing people, but the person, uh, they were not known. To a point they were symbols, uh, but once a certain point in the encounter had been crossed, they ceased being individuals and became, well, uh [sighs], you could say *problems* . . . that's not the word either. Threats. Now, once a certain point in the encounter was passed, they ceased to have any symbolic value at all. And they ceased also to have . . . at that point, once they'd, once they became flesh and blood and once they ceased being an image."[10]

The "symbolic value" of the victim is inseparable from the anonymity and abstractness, the at once deeply embodied and strangely particularized type of the statistical person: "any number of persons," a "kind" or "type" of individual. For Bundy, among others, the urge was "to hunt down and kill the same type of woman, over, and over, and over again."[11]

Cooper's *Frisk*, inhabiting the fantasy milieu of the serial killer, centers on "spectacular violence" (54): that is, a violence inseparable from its reproduction as spectacle. This violence "resembles sex" (47), which is to say sexuality and simulation or resemblance have become inseparable, too. "The idea of death" resembles violence which resembles sex, which resembles public spectacle: "The idea of death is so *sexy and/or mediated* by TV and movies" (59, my emphasis). On this logic, the serial killer is doing what he likes to do: it is not a substitute for something else. But what the serial killer likes is substitution; his substitution-manias make up his addiction to the "lifelike"—his addiction to addiction as such.[12]

One way of understanding this addiction to substitution is in terms of an addiction to fantasy (what the profilers simply describe as the predominance of fantasy in the life of these men). In a recent interview, Dennis Cooper states that *Frisk* was "supposed to resemble a dismembered body": "I wanted to write a book in which the body of the text would be dismembered, as though the writer had dismembered a novel the way a murderer might dismember a body." If writing, for Cooper, makes possible a sort of "clinical" detachment, the understanding of fantasy as detachment is at the same time a sense of detachment literalized as dismemberment. Cooper remarks that "his horrific fantasies are really benign, like all fantasies" even as he expresses his fascination with the fantasy-aesthetics of serial murder: "That's why serial murderers are inter-

esting, because they do that [killing another person] in a methodical, thoughtful way. They hone their craft."[13]

These deep uncertainties as to the relation between fantasy and act are nowhere clearer than in the form of fantasy writing and imaging called pornography—the genre that *Frisk*, in its staging of sado-masochistic scenes, borders on or resembles. There is, in some ways, an intense moralism in the sort of sado-masochistic fantasies staged or scripted in such writing and such scenes. For one thing, the sado-masochistic act is regulated by its scripts: "doing a scene" insists on the rule-governedness of acts and their obedience to a prescriptive fantasy. Fantasy and act must perfectly image each other: "Everything must be stated, promised, announced, and carefully described before being accomplished."[14] One discovers here a sort of fantasy of fantasy (as the *cause* of acts) and a fantasy of the law (fantasy as a strict legalism that prescribes the absolute ruliness of acts).

Yet pornography necessarily entails, of course, something more: a transition from fantasy to act, the body seduced and moved by the image. It requires, that is, an understanding of fantasy or intention not as the *cause* of an act but as *part of* an act. In accounts of pornography, there is a tendency either (on the antipornography account) to collapse the distinction between fantasy and act or (on the pornography-fan account) to reaffirm this distinction, appealing to the "benign" status of thoughts of sexual violence ("really benign, like all fantasies"). There is a tendency, in recent defenses of pornography, to insist on the strictly imaginary, symbolic, and fantasmatic status of pornography. Hence it is argued that the mistake in indicting pornography as the cause of "real-life violence" is that "a real fear, rape, finds expression in a symbolic and imaginary cause: pornography." But pornography's "'violations' are *symbolic*. Treating images of staged sex and violence as equivalent to real sex and violence, or cynically trying to convince us that it's a direct line from sexual imagery to rape—as if merely looking at images of sex magically brainwashes any man into becoming a robotic sexual plunderer." On this account, prosecution for pornography amounts to the prosecution of "thought-crime."[15]

Notwithstanding the significant corrective they provide to the reductive equation of image and act in the anti-pornography position, such "fan" arguments beg some large questions. (If there is clearly no "direct line" between images of sex and violence and real sex and violence, is there an *in*direct one?) There is something magical in the understanding of the imagined or symbolic simply as the opposite of "real" sex. (As if there were not always a symbolic and fantasmatic component in "real" sex.) And there is something incoherent in the simple antinomy of "merely looking" at images and robotic or automatistic acts of sexual

violence. (Is looking merely the opposite of doing? Is there not always an element of the mechanical or automatistic in "real" sex?) There are basic problems, then, with these recalcitrant oppositions of bodies and images, bodies and machines (problems to which I will return in the final part of this study).[16] In short, neither generalized anti- or generalized fan accounts of pornographic sexual violence will do, on two fundamental counts. The simple equation of images of violence and acts of violence must of course be resisted: the thought or representation of murder is of course not equivalent to the act of murder. But the thought or representation of murder is by no means separate or apart from the act of murder: it is part of it. Murder without the thought of murder is a different sort of act too.[17] Thought is not the same as crime, but all crimes are thought-crimes.

One way of resituating this violence-representation deadlock may be, we have seen, by shifting it into relation to the public/private thing: the uncertain place of private desire in the pathological public sphere. Pornography, it has recently been noted, "would be nowhere without its most flagrant border transgression, this complete disregard for the public/private divide."[18] If pornography unsettles the division between image and act, fantasy and event, this is because the technical simulation of fantasy, in print or image, makes private desire publicly visible—indeed, binds private desire to its public visibility. The scandal of pornography is, in part, the scandal of sex in public. In *Frisk*, fantasies of sexual violence are inseparable from photographic reproduction: "Maybe . . . if I hadn't seen this . . . snuff. Photographs" (70). And technical simulation is inseparable from the sexy and/or mediated way of making interior states visible, knowable, sharable, and public: "by the time I found out they were posed photographs, it was too late. I already wanted to live in a world where some boy I didn't personally know could be killed and his corpse made available to the public, or to me anyway. I felt so . . . enlightened?" (70).

The same-sex murders in *Frisk* thus become legible in terms of the making "available to the public" of a private or secret desire, even as that secret desire seems implanted from without. I have earlier (by way of the addiction writings of Jack London) set out some of the relays between addictive violence and sexual difference. Here, I want to take that account a step further. Ted Bundy spoke of the serial killer's "virtually anonymous" character: his violence as "a small, small portion of what was predominantly a normal existence." There is, for Bundy, "the public self . . . normal self" and what it was "concealing." Or, "using a slightly different analogy," as he puts it, "homosexuals—at least in the past—concealed

a certain part of their lives." Referring to one same-sex killer, John Wayne Gacy—who killed thirty-three young men in Illinois in the 1970s— Bundy remarks that Gacy "never got in a position where he could become publicized."[19] (Bundy himself, who twice escaped imprisonment, was a well-publicized and "celebrity" serial killer long before his final murders, and ultimate capture, in Florida.) The drift of Bundy's "analogy" leaves unclear whether it is Gacy's purported, and abjured, homosexuality or his sexualized violence that, prior to his arrest, never got in a position to become "publicized." Yet it is perhaps the conflation of these two forms of "concealment"—same-sexuality and sexual violence—that one discovers, for example, in the Gacy case. This is a case in which an absolutized public/private divide, a violently pathologized same-sexuality, and addictive killing umremittingly infect each other.

Gacy, who (like the same-sex killer Dennis Nilsen) concealed the bodies of many of victims beneath his house, was also (like Nilsen) a publicly and "professionally perfect person." Gacy was "community-minded" and, in his own view, given to "living for others." (He famously was photographed at a public service media event with first lady Rosalynn Carter.) He was everybody's next-door neighbor in the pathological public sphere. And there was an utter noncommunication between his "outdoor" life and his "buried dreams." In the idiom of a mediatronic stranger-intimacy which is by now familiar:

> The day the story broke, there were shots, broadcast live, of the brick ranch house with the outdoor Christmas lights mysteriously blinking, and the neighbors, in voice-over—or, on the radio, or in newspaper columns— described the man who had lived there as gregarious, community-minded, generous. When the snow piled up on the streets, they said, John Gacy hooked up a snowplow and cleared the driveways up and down the block.

At one extreme, there is Gacy's own version of a public voice-over and face-over: his charity work dressed as Pogo the clown (later the subject of his prison "self"-portraits). As a "clown or politician," Gacy simulated normality as publicity: "When I was Pogo, I was in another world . . . it was like becoming someone else. . . . A clown does nothing but live for others." At the other extreme, of course, the clown who "delighted children" with "hand puppets" turned handcuffed boys into his puppets: the detective who searched his cellar stated, "I think this place is full of kids."[20]

Crucially, for Gacy, the difference between other-directedness and self-directedness is the difference between other (hetero)sexuality and

same (homo)sexuality. And the difference between other-sexuality and same-sexuality is, for the killer, the difference between a public and normal self-difference and a private and pathological self-sameness.[21] It is not merely that, for Gacy, "sex with a woman, involved love and tenderness . . . his goal was to satisfy [her]. That way he'd satisfy himself." Same-sexuality, conversely, meant both violence and self-sameness. As one psychiatrist who examined him testified, Gacy was "afraid of . . . a program of public disfavor. . . . [He] becomes very angry when the term 'homosexuality' is ascribed to him. He insisted that he is not homosexual . . . and that oral sex (with males) was a form of masturbation. He thinks a homosexual is a man who loves other men, and he had no such feelings for these people. They were trash whom he picked up."[22]

It is not merely, that is, that his victims were all, for Gacy, the same victim. ("The only way to think coherently about the [murdered] boys in the pictures, John thought, was to catalogue their similarities and build a composite picture of the typical victim.") Same-sexuality was a form of masturbation as killing was a form of self-killing. (He explained that he "was killing himself, committing a kind of suicide, except that a stranger . . . had become young John Gacy.") Like Nilsen, the murders were experienced as a form of suicide, except that it was always the bystander who died: "He buried all those bodies representing himself." In this way, maladies of representation and self-representation, publicity and simulation, self-difference and sexual difference are violently drawn into relation.[23]

"Their Enemy is Life Itself"

These relays traverse a case that is exactly contemporary with Dennis Cooper's *Frisk* and that strangely resonates with Cooper's fantasy of sexualized violence: the career of Jeffrey Dahmer. A brief return to that case will make it possible to gather together these components of serial killing.

Dahmer's serial killings achieved mass-media and tabloid celebrity in part because of the spectacularly horrific forms of his violence (for example, the literalization of his absolute identification with and incorporation of others in his acts of cannibalism) and in part because of the racial and sexual politics so obtrusive in that violence (the killer was white and sexually and physically violated victims who were generally Asian and black males). It does not take much interpretive work to outline the ways in which cases such as this one may be taken as virtual illustrations of psychoanalytic archetypes (e.g., incorporation) or sociological stereotypes (e.g., racialized homophobia).[24]

But the very ease with which figures such as Dahmer are rendered transparent to psychoanalytic or sociological generalization tends to obscure how that very transparency, that very archetypicality or stereotypicality, functions in such cases. Hence it is not exactly a matter of making visible Dahmer's interior states but a matter of attending to his own fascination with what having or viewing or listening to interiors amounts to.

Dahmer has been described, in terms that are by now familiar enough, as the "prototypical" serial killer, and prototypical not least because of the "uncanny camouflage" by which he seemed simply "a component of the social ecosystem."[25] This absorption in typicality and melting into place is bound up with another form of self-evacuation or devivification: a drive to make interior states audible, visible, and controllable. For one thing, there were Dahmer's anatomical and chemical experiments with bodies, animal and human: experiments in "melting down flesh," volatizing bodies. Several of Dahmer's intended but escaped victims reported that "he liked listening to people's stomachs"; "Dahmer listened to his heart when he was handcuffed on the floor." One of his examining psychiatrists stated that "Dahmer liked to have [his victims] unconscious, at best, so that he could listen to the blood and organ sounds of their bodies." Dahmer as a child went fishing with his friends but to somewhat different ends: after meticulously filleting and examining his catch, he then threw the bloody pieces into the water—feeding them back to the fish in a sort of cannibalistic loop. In response to questions about his flaying and dismemberment of his catch, he answered, *Frisk*-like: "I wanted to see what someone looked like inside. . . . I like to see how things work."[26] In this way, the killer conflates, Hannibal Lecter-like, a dispassionate experimental anatomy and a cannibalistic frenzy.

Such childhood scenes appear, of course, as rehearsals or try-outs for his subsequent killings. But such an identification with scenes of killing and cannibalism reveals something more. To the extent that this is an identification with *scenes*, the drive to make interiors visible is also a drive to make visible his own interior. If the serial killer is an individual whose own interior, "whose own body has been made secret," what are these experiments but attempts to view that secret interior but only in the form of a scene outside the subject?[27] Interiors are simultaneously opened to view and exteriorized or expelled: as if those interiors can only be recognized or acknowledged to the extent that they lie outside the self. These "experiments in destruction" are at the same time ways of achieving knowledge of interiors—of one's own interior—and of evacuating that interior.[28] It is because they are not symbols or representations of the killer's interior but

embodiments of it that the killer often imagines himself simply as witnessing the acts that he in fact performs. Repetitive killing, through an internal torsion, becomes an experiment in self-witnessing—but a self-witnessing that functions at the same time as a form of self-evacuation.

Seeing how things work means taking bodies apart, clinically examining and rearranging them. This in turn involves a radical intimacy between bodies and anatomies: the *reduplication* of bodies in representation. Enlisting in the military, a year after murdering and dissecting his first victim, Dahmer trained as a medical specialist: "He learned the fine points of human anatomy through diagrams, schematics and vivid photographs."[29] In line with this, one finds Dahmer's early erotic fascination with male mannequins; the posing and photographing of his victims (not at all atypical in cases of serial killing); the "shrine" constructed in the lethal space of the apartment that functioned as the terminal scene of his crimes—a table on which he "preserved," arranged, decorated, painted, and artifactualized the bodies of his victims.

These are, above all, experiments in the *lifelike*: experiments in reduplicating bodies and persons. Seeing how living things work involves, most basically, a fascination with what makes subjects go—something like an attempt to isolate and to make visible "life itself." These experiments in destruction demonstrate, one of Dahmer's biographers speculates, "his fascination with how things could exist independent of his own control."[30] But one discovers, more exactly, an equivalence between seeing life and controlling life and, further, controlling life through the invention of technologies for reduplicating it. One of the young men Dahmer encountered commented that Dahmer behaved as if he were on "mood altering prescription drugs": "People who have been taking mood changing drugs walk around sometimes as if they're zombies."[31] Dahmer, however, not merely moved as if he were a zombie. His ultimate project, as his defense attorney explained, was "to create 'zombies.'"[32] Dahmer drilled holes into the heads of some of his still-living victims and injected acid or boiling water, attempting to produce automata or artificial persons at his command. This is the living-dead zombie who, Dracula-like, produces zombies. And this is the addictive closed loop of a reproduction without gender: the self-duplication of an inanimacy, a lifelike lifelessness, within.

One detects here less a fascination with how things could exist autonomously, outside the killer's control, than something like the opposite. The American "taste for mindless violence," as the novelist Cormac MacCarthy traces it in *Blood Meridian*, takes the form of a targeting and

extirpating of "pockets of autonomous life."[33] "Their aim," Erich Fromm writes of one style of compulsive killer, "is to transform all that is alive into dead matter; they want to destroy everything and everybody, often even themselves, their enemy is life itself."[34] For Fromm, this is the killer in the character of the necrophiliac, the man who loves corpses because his enemy is "life itself." For Klaus Theweleit, this mistakes the character of the compulsive "soldier-male" killer—and mistakes the character, by extension, of the serial killer, even those serial killers, who, like Dahmer or Dennis Nilsen or John Wayne Gacy, surrounded themselves with the piled-up corpses of their victims. For Theweleit, following Canetti, "it is not corpses that this man loves but his own life. But he loves it . . . for its ability to survive. Corpses piled upon corpses reveal him as victor, a man who has successfully externalized that which is dead within him, who remains standing when all else is crumbling."[35]

Yet what exactly does it mean to isolate, and to target, an abstraction like "life itself"? The emergence of the biological sciences over the course of the nineteenth century was also the emergence of an "elusive and seductive object of scientific conquest." For if, prior to the nineteenth century, "biology was unknown, there was a very simple reason for it: that life itself did not exist. All that existed was living beings, which were viewed through a grid of knowledge constituted by natural history."[36] The emergence of "life itself" as an object of scientific knowledge was also the take-off point of the mechanical visualization, representation, and "intervention in the physiological 'arrangement' of the 'living being.'" These technical representations and interventions made for "a technique that joins technology and the living body." Beyond that, the graphic and cinematic methods of experiments in making visible life itself made for a "public fascination with scientific technology and its capacity to determine the course of life and death in living beings." In short, physiology and the drive to regulate life and death "had become a part of public culture by the turn of the century." By 1900, "experiments in destruction" had become public media spectacles of life and death.[37]

The atrocity exhibition binds life itself to its technical reproduction and technical reproduction to spectacles of destruction: death is theater for the living in the pathological public sphere. The serial killer's experiments in destruction join spectacle and killing in the targetting of life itself. If the serial killer's enemy is life itself, this is because life itself is experienced as a destructive force: because, through a strange torsion, the life drive and the death drive shift places.

For Ted Bundy, exhausting physical exercise in prison became, as he

put it, "the body's way of asserting itself over the destructive impulses of the mind, temporarily mindless of the body's uncompromising, unquestioning, eternal desire to survive. The body may only appear as host to the brain, but the intellect, fragile and selfish, is no match for the imperative of life itself."[38] The assertion of the body over the "destructive impulses" of the mind is thus also the mindless imperative of the body to survive: the "imperative of life itself" to survive *at the expense of* the individual mind and individual identity—the "fragile and selfish" self.

From this vantage, there is nothing more endlessly repetitive than the life process: the "blind supercession of the individual in favour of the species";[39] nothing more destructive than the body's imperative to repeat and to reproduce itself; nothing more deadly than life itself. Sexual desire turns round to blind reproduction, which turns round to blind destruction. It is along these lines that *lustmord*, the "insane dialogue of love and death," proceeds,[40] that mutilation of the reproductive body and "the murderous act . . . were equivalents for the sexual act."[41] This insane dialogue has become one of the clichés of recent pulp fiction and public violence: "Then I cut her throat so she would not scream . . . at this time I wanted to cut her body so she would not look like a person and destroy her so she would not exist. I began to cut on her body. I remember cutting her breasts off. After this, all I remember is that I kept cutting on her body. I did not rape the girl. I only wanted to destroy her."[42]

Consider one final instance of addictive violence, a schizophrenic patient's description of his hallucinatory experiences during an attack of delirium tremens:

> What I had suddenly to see there made my hair stand on end. *Forests, trees, and oceans* with every kind of dreadful animal and human figure, such as no human eye ever saw before, whirled by incessantly, alternating with the workshops of every trade, in which horrible spirit figures were working. On both sides the walls were nothing but a single ocean with *thousands of little ships* on it; the passengers were all *naked men and women*, who indulged their lust in time to music. Each time a pair had taken their pleasure a figure stabbed them from behind with a long spear, so that the ocean was coloured red with blood. But there were always fresh multitudes to succeed them.[43]

There is an astonishing condensation of the symptoms of addictive violence in this passage. There are the teeming "fresh multitudes" of an endlessly propagating life itself. There are the flooding crowd-symbols ("forests, rivers, and oceans") that form the psychotopographies of the mass in person. There are the identical series of men and women, identi-

cal in their nakedness and in their yielding to the beat of the music—which appears as something like a yielding to the unremitting beat of the death drive itself. There is the coupling of serial pleasure and serial destruction, mounting in large numbers. There is, finally, the strange "alternation" between natural reproduction and mechanical reproduction ("the workshops of every trade") in these scenes of pleasure-killing: the collapse of the distinction between the life process and the work process, the deadly and indifferent alternation between producing persons and producing things.

These components of serial killing are graphically realized in the case of the inventor/medical doctor/serial killer H. H. Holmes and it is to that case I want now to turn. This case will clarify further the maladies of the mass in person: the maladies of the self-made man at the limit. It will elaborate further what these experiments in self-construction and self-destruction look like. The alternations between material making and corporeal unmaking are, it will be seen, luridly explicit in the Holmes case. And they are luridly embodied, above all, in the elaborately constructed and highly technologized killing space, The Holmes Castle, that made up the lethal and spectacular scene of his crimes.

Notes

1. Eoin McNamee, *Resurrection Man* (NewYork:Picador,1994),pp.58,92,195.
2. Lionel Dahmer, *A Father's Story* (New York: William Morrow, 1994), p. 146. I am indebted to Alice Maurice for suggesting to me the centrality of the video apparatus in Dahmer's story and its pertinence to my argument.
3. Ibid, p. 201.
4. Elias Canetti, *Crowds and Power*, trans. Carol Stewart (New York: Noonday, 1984), p. 52.
5. For a recent account that in effect reiterates this position, see Wendy Lesser, *Pictures at an Execution: An Inquiry into the Subject of Murder* (Cambridge: Harvard University Press, 1993).
6. John Douglas (and Mark Olshaker), *Mindhunter: Inside the FBI's Elite Serial Crime Unit* (New York: Scribner's, 1995), pp. 173, 32.
7. Jim Thompson, *Nothing More Than Murder* (New York: Vintage, 1991), pp. 140, 142.
8. Sandra Blakeslee, "Virus's Similarity to Body's Proteins May Explain Autoimmune Diseases," *New York Times*, 31 December 1996, pp. C1, C7.
9. Dennis Cooper, *Frisk* (New York: Grove, 1991), pp. 54, 42, 7. Subsequent page references are included parenthetically in the text.
10. Quoted in Stephen G. Michaud and Hugh Aynesworth, *Ted Bundy: Conversations with a Killer* (New York: Signet, 1989), pp. 78–79.
11. Ann Rule, *The Stranger Beside Me* (New York: Signet, 1989), p. 131.

12. One of Cooper's narrators recites these rock lyrics: "'By this time/I'd got to looking for a kind of/substitute'" (71). Ted Bundy (in his own words, "a very verbal person") had his own word for this "paraphilic" love of substitution: "*concomitantly*—I love that word, *comcomitantly*" (quoted in Michaud and Aynesworth, *Ted Bundy*, p. 171).

13. Cooper, interview with Benjamin Weissman, *Bomb* (Summer 1994): 20–22.

14. Gilles Deleuze, *Masochism: Coldness and Cruelty* (New York: Zone Books), pp. 20, 69, 76.

15. Laura Kipnis, *Bound and Gagged: Pornography and the Politics of Fantasy in America* (New York: Grove, 1996), pp. 147, 157.

16. See "Wound Culture," below. For an excellent reconsideration of the pornography problem, see Linda Williams, "Corporealized Observers: Visual Pornographies and the 'Carnal Density of Vision,'" in *Fugitive Images: From Photography to Video*, ed. Patrice Petro (Bloomington, IN: Indiana University Press, 1995), pp. 3–41.

17. These confusions as to the relays between representation and act are not at all surprising. The notion that representations of violence cause acts of violence remains bound to an ethico-juridical model of an action, which is also a model of representation. It follows from the premise that representations—premeditations, intentions, fantasies—are not *part of* an act but the anterior *cause of* an act. What qualifies an act as an act, on this model, is the sense that the act follows from its representation (that it is, for instance, premeditated); that violence flows from the fantasy of violence (malice *aforethought*); or, most simply, that it has the coherence of an act (the effect of its cause). In this way, the violence-representation deadlock is bound up with an ethico-juridical logic of human action. On the limits of this logic, and on the implications of the understanding of intentions as part of an act rather than as the cause of an act, see my *Bodies and Machines* (New York: Routledge, 1992), esp. part 3.

18. Kipnis, *Bound and Gagged*, p. 171.

19. Quoted in Michaud and Aynesworth, *Ted Bundy*, pp. 114–15. Bundy, in his last and unsuccessful bid to stay execution, gave a videotaped interview in which he declared pornography to be the direct cause of his killings. The sheer transparency of this alibi conceals something else: the sheer transparency of the serial killer to publicly available representations of interior states. It conceals, that is, the way in which he yields to cliched and mass-produced representations, and the way in which he pathologizes—finds at once entrancing and insupportable—the primary mediations of the modern subject.

20. Tim Cahill, *Buried Dreams: Inside the Mind of a Serial Killer* (New York: Bantam, 1986), pp. 7, 144–45, 4; see also Terry Sullivan, with Peter T. Maitken, *Killer Clown: The John Wayne Gacy Murders* (New York: Pinnacle, 1983).

21. Such an opposition of heterosexuality to homosexuality as an opposition of

sex to violence enters into Tim Cahill's biography of Gacy as well. Cahill, even as he responds to the charge that his book about Gacy might be seen as contributing to a homophobic reaction, writes that "for every serial killer who has preyed on men or boys, there is one who has stalked women and whose crimes have been essentially sexual in nature" (Cahill, *Buried Dreams*, p. ix). Apparently, male antifemale serial murder is "essentially sexual in nature," whereas male antimale serial murder is essentially violent and nonsexual in nature; sex without sexual difference apparently counts as violence, not sexuality.

22. Cahill, *Buried Dreams*, pp. 118, 308.

23. Ibid., pp. 195, 197, 323.

24. On the general sociology of the Dahmer case, see Philip Jenkins, *Using Murder: The Social Construction of Serial Homicide* (New York: de Gruyter, 1994), pp. 1–3, 93–94, 166–68, 179–80; Joel Norris, *Jeffrey Dahmer* (New York: Pinnacle, 1992); and Brian Masters, *The Shrine of Jeffrey Dahmer* (London: Coronet Books, 1993). See also David A. H. Hirsch, "Dahmer's Effects: Gay Serial Killer Goes to Market," in *Disciplinarity and Dissent in Cultural Studies*, ed. Cary Nelson and Dilip Parameshwar Gaonkar (New York: Routledge, 1996), pp. 441–72. No doubt one finds in this case melodramas of identification and self-distinction: there is the same-sexness of the victims (the popular understanding of serial killing as "femicide" posits male on female — or unmale — violence); and there is, albeit not exclusively, their race-otherness (rare in cases of serial killing). For a psychoanalytic reading of Dahmer's media-hyped cannibalism as acts of "identification" and "incorporation," see Diana Fuss, "Monsters of Perversion: Jeffrey Dahmer and *The Silence of the Lambs*," in *Media Spectacles*, ed. Marjorie Garber, Jann Matlock, and Rebecca L. Walkowitz (New York: Routledge, 1993), pp. 181–205. Fuss's account acutely broaches the disorders of identification in such cases but is typical of a style of cultural psychoanalysis in which popular examples serve as emblems of psychoanalytic archetypes: a sort of pop-Hegelianism by which popular culture realizes psychoanalytic dicta to the letter. In this instance, "identification" becomes a large metaphor, or turnstile term, for the vicissitudes of meaning and interpretation *tout court*.

25. Norris, *Jeffrey Dahmer*, pp. 186, 54.

26. Ibid., pp. 149, 169, 286, 66; see also Masters, *The Shrine of Jeffrey Dahmer*, p. 159.

27. Klaus Theweleit, *Male Fantasies*, vol. 2, trans. Erica Carter and Chris Turner (Minneapolis: University of Minnesota Press, 1989), p. 108.

28. On the physiological interventions into the life process—what the later nineteenth-century medical experimenter Claude Bernard called "experiments in destruction," see Lisa Cartwright, *Screening the Body: Tracing Medicine's Visual Culture* (Minneapolis: University of Minnesota Press, 1995), pp. 17–46.

29. See Norris, *Jeffrey Dahmer*, p. 105.
30. Ibid., pp. 69–70.
31. Ibid., p. 254.
32. Ibid., p. 270.
33. Cormac MacCarthy, *Blood Meridian* (New York: Random House, 1985), p. 3.
34. Erich Fromm, *The Anatomy of Human Destructiveness* (New York: Holt, Rinehart and Winston, 1973), esp. pp. 325ff.
35. Theweleit, *Male Fantasies*, p. 19. On the serial killer's "triumphalism of survival," see the final part of this study, "Wound Culture."
36. Michel Foucault, *The Order of Things: An Archaeology of the Human Sciences* (New York: Vintage, 1973), pp. 129–30, 239–40; Cartwright, *Screening the Body*, pp. xi, 9.
37. Cartwright, *Screening the Body*, pp. 10, 14, 17–18.
38. Quoted in Rule, *The Stranger Beside Me*, pp. 218–19.
39. Lacan, "Aggressivity in Psychoanalysis," in *Ecrits: A Selection*, trans. Alan Sheridan (New York: Norton, 1977), p. 24.
40. Michel Foucault, *Madness and Civilization: A History of Insanity in the Age of Reason*, trans. Richard Howard (New York: Random House, 1965), p. 210.
41. Richard von Krafft-Ebing, *Psychopathia Sexualis: A Medico-Forensic Study*, trans. Harry E. Wedeck (New York: Putnam's, 1965), p. 119. See also, Maria Tatar, *Lustmord: Sexual Murder in Weimar Germany* (Princeton, N.J.: Princeton University Press, 1995), pp. 22–25.
42. Susanna Moore, *In the Cut* (New York: Knopf, 1995), p. 137. Moore's novel, a serial-killer thriller from the target- perspective of the female victim, here quotes from Robert R. Hazlewood and John E. Douglas, "The Lust Murderer," *FBI Law Enforcement Bulletin* 49.4 (1980): 18–22.
43. Bleuler, quoted in Canetti, *Crowds and Power*, p. 366–67; Canetti's account of the "crowd-symbols" that mark paranoia and schizophrenia directly informs my discussion here.

PART 3.

Lethal
Spaces

8 · American Gothic

Terrible Places

The **Sarah Winchester House outside San Jose,** now a tourist stop on any kitsch-tour of California's Silicon Valley, is more an antique than a machine designed for living in. But the bizarre logic of its construction makes it something of a model for what home in machine culture looks like. In its astonishing incorporation of a regressive domesticity and a compulsive, technologized violence, the Winchester House appears as a kind of landmark of corporeality in machine culture. What I mean to consider here are the relays progressively articulated between bodies and places such that the home, or, more exactly, the homelike, emerges again and again as the scene of the crime.

The construction of the Winchester House began in 1882, was interrupted by the 1906 earthquake (which extensively damaged the mansion) and continued without completion until Sarah Winchester's death in 1922. Of the perhaps 750 rooms that may have at one time made up the hodge-podge structure, about 160 remain, partly renovated as a tourist attraction — The Winchester Mystery House — complete with waxwork museum, rifle displays, and souvenir shop. But it is not entirely clear what a more extensive restoration would amount to, since the endlessly unfinished construction of the mansion was precisely the point, at least as reported in the surviving tabloid versions of the story.

Sarah Winchester was the widow and heiress of William Hirt Winchester, whose father manufactured the Winchester repeating rifle: "the

gun that won the West" and that standardized both mechanical repro-
ducibility and repetitive violence.[1] She apparently was convinced by the
untimely deaths of her daughter and husband that the ghosts of those
killed by the widow-making Winchester rifle, Indians in particular, had
targeted the family. An 1880s Boston medium confirmed that her only
defense against possession (and her own mortality) was to undertake a
ceaseless project of home construction. Winchester relocated from New
Haven to the not-quite-closed Western frontier, and there disposed of a
good part of an inherited income of $1,000 a day in the project. Crews of
workmen built and unbuilt the house, day and night, over the next forty
years, elaborating "ordinary domestic interiors" in "random, seemingly
effortless proliferation": accretions of hundreds of rooms, dead-wall
doors, stairs with two-inch risers that led nowhere, upside-down columns
and multistoried castlelike towers, and connecting passages connecting
only to deeper connecting passages in an exorbitant materialization of
private and domestic interiority.[2]

This is certainly not the only American haunted house story that turns
on disputed possession and murderous dispossession. In this case, as in
many others—from Hawthorne's *The House of the Seven Gables* to the
films *The Amityville Horror* and *Poltergeist*—the interlaced stories of
home-making and nation-making appear in a "'haunted house' horror"
that "devolves, finally, on the Indian Question."[3] The "ghosted" relation
between one form of possession and another is clear enough. But there is
then a certain modernization of horror visible in the Winchester house
story, a modernization of horror premised on the mechanization, and
mechanical repeatability, of death. By this conjunction of obsessive
domesticity and repetitive violence, home-making is imagined at once as
the expiation for that violence and as its counterpart.

There is no doubt always something outmoded about the domestic
and its constructed nostalgias—what might be called its uncanniness, if
the notion of "the uncanny" (the unhomelike) itself had not by now
become an all too homey way of naming that belatedness, its ambiguous
causalities and periodizations (in effect, a way of endorsing a sort of better
living through ambiguity).[4] It is the vexed status of the homelike itself
that I mean to define here. More exactly, it is the way in which the public
spectacle or exhibition of "the private" in machine culture—museums or
replicas of home as tourist site, for instance—seems to have become
inseparable from the exhibition of bodily violence or atrocity that I mean
to examine. These haunted homelike places—hotel and motel hells, for
example—set in high relief the "gothic" rapport between persons and

spaces, the distribution of degrees of aliveness across constructed spaces, the assimilation of the animate to the inanimate and the machinic.[5]

My central exhibit is the 1890s case of Herman Webster Mudgett. Mudgett was regarded until very recently, at least by the *Guiness Book of World Records*, as America's most prolific serial killer and as perhaps the most sensational American murderer of the turn of the century. What centered the Mudgett case, however, was not merely the body count (Mudgett confessed to twenty-seven murders, but estimates run to the several hundreds) nor merely the character of his victims (typically, but by no means exclusively, attractive young women). What centered the case was the bizarre, and relatively high-tech, building—a home and work place occupying an entire Chicago city block—that Mudgett, under the eponymous alias of *Holmes*, constructed as the primary scene of his crimes. This terrible place, which became known in the tabloid press as The Holmes Castle, epitomizes the relays progressively elaborated between a regressive domesticity and the forms of serial violence that reoccupy it.

What marks this case is, above all, an extraordinary absorption in place and place-making that becomes indistinguishable from programs of self-making and self-construction. The violence and horror precipitated by the radical failure of distinction between subject and place—by the reciprocal topographies of subject and context—are absolutely crucial in understanding cases of repetitive violence. So too is this compulsive and programmatic self-construction.

But "situating" or "contextualizing" the subject of violence is, again, one of the components in these cases, and not merely a way of explicating them. So we must approach the Holmes/Mudgett case by way of a series of detours, testing out the relays between subject and position (the inner logic of "subject-position," as it were) that become visible in these cases. Such intimacies between the subject and scene of the crime inflect, at the least, the "new historicist" conviction of the context-made subject. They will make it possible to bring into view a composite picture of these lethal persons and these lethal spaces in which they are at home.

The Double-Logic of Prosthesis

Chicago was the "shock city" of the turn of the century. The burgeoning commodity distribution center and relay point between the industrial East and the agricultural West, the city was dominated and defined by its stockyards and slaughterhouses. (In 1839, 3,000 head of cattle were butchered in Chicago; in 1871, 700,000; eventually, one of the great

packing plants had a daily quota of 60,000 head.) The apparatuses of mass slaughter and mechanized organic *dis*assembly lines constitute what Siegfried Giedion describes as the development of an elaborate "murder machinery" and the "mechanization of death."[6]

It was therefore not difficult for contemporary commentators to situate Holmes's "murder factory" in the local context of the Chicago "phenomenon of mechanized death" and in the more general context of 1890s' metropolitan crisis and urban pathology. As one newspaper commentator put it, Holmes's story "tends to illustrate the end of the century."[7] But what exactly does it mean to understand persons as illustrations of conditions, melting persons into place?

On one level, what is at issue here is the seamless continuity between, in Simmel's landmark turn-of-the-century formulation, "the metropolis and mental life." On another level, and more radically, the issue is the understanding of the metropolis *as* mental life. One detects, in the very banality of claims about persons illustrating conditions, something like the new historicist conviction by which the subject is utterly assimilated to his milieu, in which the subject is "accounted for," determined, and created by his conditions—conditions that, in circular fashion, he illustrates. I have earlier argued that this, in effect, is to understand the new historicist subject as the subject in a state of shock. For one thing, the notion of "shock" posits, we have seen, the sheer permeability or transparency of the subject to the "impact" of external conditions (the determination of the subject from the outside in, by external forces neither cognized nor recognized). It is possible here to take this a step further. For if the state of shock involves, at least in part, the permeability of the subject to his surroundings, such an experience of determination from the outside seems inseparable from the violent and erotically charged uncertainties of agency and motivation that everywhere surface in the representation of the new historicist subject. The new historicist account thus insistently gravitates toward scenes of eroticized bodily violence; it is drawn toward the uncertain causalities, the "afterward" constructions of cause and effect—the melodramas of agency—that define both the subject of shock and the new historicist subject.

If the radical constructionist *logic of the subject* posits the subject as determined from the outside in (assimilated to place), in the *subject's own logic* such a generalization of space at the expense of the individual may assume traumatic form: a psychotic, or paranoid, defense against the subject's intimation that his own interior is not merely targeted from but formed from without.

What surfaces here is an irreducibly traumatic component in the project of self-making or self-construction. The radical constructionist logic of the subject has been taken to indicate the endless, and thrilled, possibilities of self-construction (the cultural technologies of the self). Its counterside is the endlessly endured imperative of self-production (a repetitive drill in autogenesis).[8] This internally divided logic of self-construction is indissociable from the double-logic of prosthesis: the vexed intimacy with technology that defines the subject of machine culture. "The problem," as Lacan expressed it in his lecture on aggressivity, "is whether the Master/Slave conflict will find its resolution in the service of the machine."[9] The problem is the way in which the deeply ambivalent "service of the machine"—*as what one makes and as what makes one*—operates in the case of the serial killer, as a sort of limit case of the self-made man. Hence I will be focusing, in this section, on the forms of self-construction and self-invention that center what is perhaps the most astonishing of these cases— the case of H. H. Holmes. I will be focussing, that is, on the material constructions and inventions—The Holmes Castle and Holmes's patented machine, called the ABC Copier, for example—on which the case devolves.[10]

The Murder Castle

The only typical, that is to say, regularly occurring, representation of the human form as a whole is that of a *house*.
—Freud, *General Introduction to Psychoanalysis*[11]

Home. He means the castle.
—Bloch, *American Gothic*[12]

I sought devices strange, fantastic, and even grotesque.
—H. H. Holmes, *Holmes' Own Story*[13]

The Holmes Castle was constructed as a tourist trap. Hastily built in the early 1890s, it was strategically located to house, and to victimize, its share of the massive crowds from the nearby World's Columbian Exposition (which opened in May 1893). The building occupied a city block at the intersection of Sixty-third and Wallace Streets in the recently annexed suburb of Chicago called Englewood. The location rapidly became a rail and commercial center ("Sixty-third Street is acknowledged to be the most prosperous and best developed cross street in the great city of Chicago").[14] Or, as the area is described in another novel

based on the Mudgett/Holmes case, *The Scarlet Mansion* (1985)—and in a description that merges bodies and places in the idiom of a popular sociobiology that should by now be familiar enough: "Chicago was suffering growing pains, its inner city becoming much too crowded. Stretching its developing muscles, the city reached out in May of 1889 and embraced the suburbs . . . and absorbed them in its mighty maw in a devouring process called annexation."[15]

The building was one of the many hotels that, epitomizing Chicago's surreal autogenesis, "sprang up like mushrooms at the edge of the fair."[16] Reproducing in miniature Chicago's construction mania, a series of separate building crews were abruptly hired and dismissed (generally swindled and unpaid), so that Holmes alone could set in place and control the master plan of the bizarre structure. The conspicuously anachronistic facade was dominated by sham turrets, battlements, and tesselations: hence the description as the Holmes Castle. The first floor of the three-story building was occupied mainly by shops, including the pharmacy run by Holmes (who had trained at the medical school of the University of Michigan); its second floor contained thirty-five rooms, the third thirty-seven (see figures 9 and 10). These rooms were laid out in mazelike fashion, incorporating corridors leading nowhere, with concealed passages behind walls, sliding panels, secret staircases, peepholes into the rooms through the backs of pictures, and trapdoors covering metal chutes that communicated with the elaborately designed basement. This version of American gothic was, beyond that, the 1890s version of the "smart home." The interior, behind the "refeudalized" facade, incorporated the most advanced domestic technologies. The floorboards concealed electrical switches that registered on an indicator in Holmes's own office "whenever a move was made anywhere in the building"; and in the office also were the control valves for the gas outlets hidden in several of the rooms.[17] "A house," the journal *Good Housekeeping* observed in 1910, "is nothing more than a factory for the production of happiness"; it should be "equipped, accordingly, with machinery."[18] Holmes's smart home was designed as a machine for killing in: as a murder factory for the production of corpses.[19]

A fairly reliable, albeit necessarily speculative, account (the house was demolished soon after Holmes's arrest) is provided by Herbert Ashbury in his general history of the Chicago underworld:

Half a dozen [rooms] were fitted up as ordinary sleeping chambers, and there were indications that they had been occupied by the various women

Figure 9. Holmes' "Castle," 63rd Street, Chicago, Illinois.

who had worked for the monster, or to whom he had made love while awaiting an opportunity to kill them. Several of the other rooms were without windows, and could be made air-tight by closing the doors. One was completely filled by a huge safe . . . into which a gas-pipe had been introduced. Another was lined with sheet iron covered by asbestos, and showed traces of fire. Some had been sound-proofed, while others had extremely low ceilings, and trapdoors in the floors from which ladders led to smaller rooms beneath. In all of the rooms on the second floor, as well as in the great safe, were gas-pipes with shut-off valves in plain sight. But these valves were fakes; the flow of gas was actually controlled by a series of cut-offs concealed in the closet of Holmes' bedroom. Apparently one of his favorite methods of murder was to lock a victim in one of the rooms and then turn on the gas; and the police believed that in the asbestos-lined chamber he had devised a means of introducing fire, so that the gas-pipe became a terrible blow-torch from which there was no escape. . . .[20]

The lethal architecture of the place (anticipating the private concentration camp of Dr. Marcel Petiot a generation later[21]) thus made possible the efficient circulation of gas, electricity, and bodies: "Sitting comfortably in his office, Holmes, apparently, could asphyxiate at will any of his guests he had a mind to."[22]

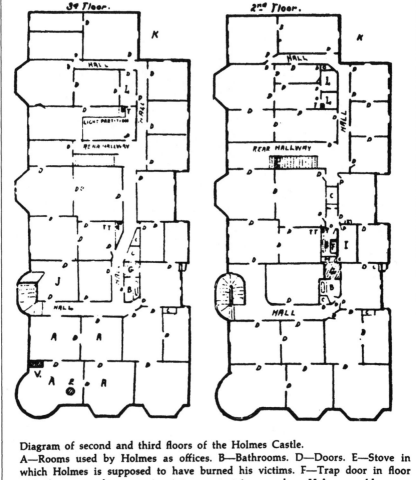

Diagram of second and third floors of the Holmes Castle.
A—Rooms used by Holmes as offices. B—Bathrooms. D—Doors. E—Stove in which Holmes is supposed to have burned his victims. F—Trap door in floor of bathroom or closet opening into secret stairway, where Holmes could escape to the street or basement through chute. C—Closets. I—Laboratories. J—Miss Williams' room. K—Alleyway. V—False vaults. G—Chute running from roof to basement. H—Blind wall and landing between secret stairway and chute. Over this landing is a secret hiding place with access only through the top of closet off from dark room I. T—Trap leading from third floor into laboratory on second. TT—Trap leading from third floor into bathroom on second. From *Chicago Times-Herald*, July 26, 1895, p. 2. Courtesy of the Illinois State Historical Library.

Figure 10. Diagram of Holmes' "Castle."

The basement of the Castle was divided into several separate, non-communicating compartments, connected to the house by secret stairs and by dummy elevators that led from the third floor and concealed "shafts large enough to accomodate a body."[23] The shafts led directly to brick vaults, six feet by three feet, filled with quicklime; to vats of acid; and to a slablike dissecting table, complete with surgical instruments. (Pieces of human skeletons were discovered near the table; some skeletons were sold to local medical schools, a scheme Holmes apparently continued from his medical training days at the University of Michigan; he sold at least three bodies through a Chicago mechanic reportedly named, uncannily enough, Charles Chopmen, who articulated the skeletons at $30 each.) The basement contained, in addition, a large kiln, the use of which was described by Holmes himself, in his quasi-fictionalized "memoir," *Holmes' Own Story*, which he sold to the Hearst newspaper syndicate (for $7,500) while awaiting execution (see figures 11 and 12):

It was so arranged that in less than a minute after turning on a jet of crude oil atomized with steam the entire kiln would be filled with a colorless flame, so intensely hot iron would be melted therein. It was into this kiln that I induced Mr. Warner [the kiln's inventor and builder] to go with me, under pretense of wishing certain minute explanations of the process, and then stepping outside, as he believed to get some tools. I closed the door and turned on both the oil and steam to their full extent. In a short time not even the bones of my victim remained.

In the basement, investigators discovered also several other "strange machines," including an elaborate structure resembling a torture rack. According to one account, this was an "elasticity determinator," a device by which Holmes tested his theory of the limits, and expandibility, of the human body.[24]

It is tempting to read such devices as a perverse and excessive literalization of a drive toward volatized bodies and weightless equivalences: that is, as a hyperbolic literalization of what might be called the capitalist drive. For Marx, for example, "the person of the capitalist" is motivated by a single passion: that of "stretching the limits of human elasticity and wearing away all of its resistances."[25] The logic of equivalence that defines market relations wears away or levels resistances in a general system of substitution and exchange (in effect, substituting an addiction to substitution as such). The drive to equate the bodily (*"the person* of the capitalist") and the economic is expressed through phantasmagorias of

Figure 11. Cover of *Holmes' Own Story*.

THE

HOLMES CASTLE

BY

ROBT. L. CORBITT

THE ONLY TRUE ACCOUNT OF THE GREATEST
CRIMINAL THE POLICE
HAVE EVER HANDLED

ENDORSED BY THE PRESS
GENERALLY

COPYRIGHT 1895
BY
CORBITT & MORRISON

CORBITT & MORRISON, PUBLISHERS
654 W. 63RD STREET, CHICAGO

Figure 12. Cover of *The Holmes' Castle* by Robert L. Corbett.

equality, exchange, substitution (the capitalist logic of equivalences, the sheer analogism of a magical thinking, such that analogy and equivalence function as cause). To the person of the capitalist, the features of equivalence, seriality, and indifference are signs of social power: a social power realized, in circular fashion, in the power to produce equivalences.[26]

Holmes, in effect, literalizes this logic of equivalence: not merely in his marketing of bodies but also in the scandalous interlacing of his murder schemes and his financial schemes. For Holmes, the pleasure in killing ("I committed this and other crimes for the pleasure of killing my fellow beings") is everywhere linked with such a pleasure in substitution and circulation: *a drive to volatilize all material resistances to the disembodiments and derealizations of exchange.*[27] The "front" for the business Holmes and his temporary partner Benjamin Pitezel ran in Philadelphia was a trade in inventor's patents ("B. F. Perry, Patents Bought and Sold"). But the real business was a trade in substitute bodies. This trade centered on life-insurance swindling schemes (begun apparently in his medical school days) by which Holmes insured and collected on the "death" of his silent partners, substituting lookalike bodies bought from morgues or bodysnatchers.[28]

Holmes's career was obsessively drawn to such substitution-manias: forms of duplication, multiplication, reproduction, seriality, and substitution. But if such an equation between pleasure in killing and the pleasures of merely circulating is tempting, there is a distinct counter-tendency in this obsession. There is a strange atavism in the alchemical transformations of bodies and in the refeudalized scene of his crimes. These atavisms become visible in the very drive toward literalization—in the violent materializations of the passion for equivalence. What becomes visible, then, is the counter-side to the stretching of the limits of bodies and persons: the murderer's passion for the reduction of persons to bodies and bodies to matter. It is as if *the dispensability of the natural body had to be passionately and violently and repeatedly redemonstrated.*

On one level, then, what surfaces here is the vexed status of the body in machine culture—and in the processing, or consumption, of bodies in cases of serial violence. The "strange devices" for melting and reducing and expanding persons begin to make clear that The Holmes Castle was at once a murder factory and a sort of invention factory. The structure was replete not merely with killing machines but also—as the terminator device, the elasticity machine, intimates—with what might be called *identity-machines.* These devices of personation realize the double-logic

of prosthesis: on the one side, the violent disarticulation of natural bodies, an *emptying out* of human agency, and, on the other, the *extension* of human agency through the forms of technology that supplement it. These opposed but coupled forms of the prosthetic—as self-extension and as self-canceling—are constituents of the body-machine complex, its logics and its erotics, its devices of self-invention or self-making. This double-logic means that killing machines and identity-machines are, in cases of automatistic violence, the same machines. And this strange and violent coupling of the atavisitic or primitivist, on the one side, and the machinal or technological, on the other, takes the form, at the turn of the century, of a sort of *techno-primitivism*.

One of the fundamental links between murder and machine culture, at the turn of the century, appears in the "naturalist" turn against the natural order and the vital order. The murderous reduction of the vital to the inanimate appears, collaterally, as a reinvention of the vital in the process of technological invention itself. Not surprisingly, one of the patent medicines Holmes marketed was an "elixir of life," in effect a species of extended or artificial life; in Stoker's terms, "life, living life, is not the only thing than can pass away." But such an antinatural and antibiological bias entails, in turn, not merely the substitution of the machine process for the life process but also the expansion of the life process through the machine process itself. What this amounts to is a reaffirmation of the irreducibility of "the human" to the vital order: the repeated and violent redemonstration of the artifactuality of persons.

The artifactuality of persons, in these cases, devolves on two closely related forms of identification: the derivation of identity from a hyperidentification with place and the derivation of identity from a hyper-identification with the machine. The intimate relays between the vital process and the machine process appear, in part, in the reciprocal construction of persons and spaces: a self-construction materialized in the construction of machines for living in. The merger of individual and surroundings involves, at one extreme, the gothicization of space—the projection of semi-alive spaces that appear as the prosthetic extension of persons. It involves, at the other, the "melting" of persons into place or ground: an absorption experienced at once as self-extension and as a tendency toward self-extinction.

In this way, the tendency toward self-extinction merges with the tendency toward self-affirmation: a reaffirmation of the irreducibility of the human to the vital order that takes the form of "the compulsion to demolish life."[29] This indicates something like a convergence between the

experience of prosthesis: in machine culture and the enigma of the death drive, as formulated from Freud on. The formulation of the death drive is bound up with the transpositions of the machinic and the vital, with the obsessive redrawing of the vague and shifting line between the animate and the inanimate. Such a radical insecurity, along these lines, defines at least in part both the body-machine complex and the death drive. One detects something like a convergence between the problem of the body in machine culture and what the psychoanalytic theorist Laplanche calls "the strange chiasmus" by which life and death, the vital and the machinic, again and again shift sides in the psychoanalytic account of the death drive.[30]

The subject of machine culture is defined by a yielding intimacy with technology. But the identification with technology that seems to empty out the very category of the subject (the determination of the subject from the outside in) may thus be turned around in an identification with technology that promises the subject's self-determination or autogenesis—in effect, machinic production as self-production. This conversion of processes of identification into claims of identity appears, most emphatically, in the appeal to the inherent machine-likeness of persons. Hence the tendency toward the inorganic and inanimate appears as the reaffirmation of the irreducibility of persons to the natural or vital order. By this circuitous route, the identification with the machine is converted into the production—albeit the compulsive and deadly production—of identity-machines.

The ABC Copier

The compulsion to demolish life and the production of artifactual life appear as two parts of a single formation: a strange chiasmus re-enacted in the pathologized forms of self-making, or autogenesis, that mark cases of serial violence. One might instance here the turn of the century shift (somewhat tentatively located by Foucault in *The History of Sexuality*) in the political and social administration of life and death. This is the shift in styles of power from the fiat of imposing death to the function of administering life: "One might say that the ancient right to *take* life or *let* live was replaced by a power to *foster* life or *disallow* it to the point of death." What such a shift involves, in short, is the progressive evolution of political and social apparatuses as life-support systems: the social, in effect, as prosthetic body and as influencing machine.[31]

The reverse side of this transposition of life and death is the emergence

of an enigmatic "determination to die." One discovers, in the sphere of sociological analysis, the emergence of the enigma of suicide (Durkheim), and, in the sphere of psychoanalysis, the emergence of the enigma of the death drive (Freud). "Floated" across these different ways of accounting for persons, there is a strange testimony to the "individual and private right to die": the individual's right to take or to disallow life, in his own way.[32]

Most basically, this is to imagine human life itself as unnatural, irreducible to the natural or vital order—as prosthetic or machinic.[33] The imbrications of psychoanalysis and cybernetics (explicit, for example, in Lacan's work) concisely register, on one level, the collapse of the distinction between living and inanimate systems.[34] Systematic management, on another level, is premised on the nondistinction between the administration of things and the administration of persons. As the arch-inventor and self-inventor, Thomas Edison, expressed it: "Problems in human engineering will receive during the coming years the same genius and attention which the nineteenth century gave to the more material forms of engineering."[35]

Edison experimented simultaneously on the electric light and the electric chair. He speculated simultaneously on the prolongation of life through artificial illumination and on the irreducibility of "life units" to mere organic form. He invented one form after another of technological reproduction, duplication, substitution, and transmission.[36] These experiments in controlling and extending life indicate not merely the erosion of the distinction between the life process and the machine process. These experiments convert that failure of distinction into an affirmation of the "constructedness" (the sheer culturalism or even voluntarism) of life and death.

Consider, for example, Edison's conception of what he called the "units of life," as set out in his extraordinary notebooks. For Edison, nature is a balance of "predatory mechanisms" and man is a systematically managed corporate machine:

> What we call man is a mechanism made up of . . . uncrystallized matter . . . all the colloid matter of his mechanism is concentrated in a countless number of small cells. . . . [T]hese cells [are] dwelling places, communes, a walled town within which are many citizens. . . . [T]hese are the units of life and when they pass out into space man as we think we know him is dead, a mere machine from which the crew have left so to speak. . . . [T]hese units are endowed with great intelligence. They have memories,

they must be divided into countless thousands of groups, most are workers, there are directing groups. Some are chemists, they manufacture the most complicated chemicals that are secreted by the glands.[37]

This fantasy of incredible shrinking men hesitates two very different conceptions of the forms of life. It not merely represents the person as machine ("man is a mechanism") but also counterposes the notion of the body as "mere machine" to the immortal—and irreducibly personlike—vital forces housed within it (as crew to ship). It combines, beyond that, a technocratic futurism (systematic management within, at the level of the organism) with an uncanny archaism (the feudal states of units of life, personated as the inhabitants of medieval "walled towns"). Such hesitations between futurism and archaism reappear in the programmatic representation of the massive Edison research and development corporation as magic shop (Edison as "the wizard of Menlo Park" and the modern Merlin). Representing corporate capitalism anachronistically in terms of a sort of alchemist's shop, the impersonally dispersed industry of invention is represented as a species of personal and untutored intuition. By this route, the light bulb, for example, appears not at all as the product of the corporate invention factory, and not merely as the idea and product of a single mind but, finally, as the very icon of the single mind: what it looks like to have an idea.

Perhaps the most compelling intimation of the crossings of technology and archaism in Edison's case appears in Villiers' novel *L'Eve future* (1886). And it appears most compellingly in the scene of the fictionalized Edison's subterranean castle-home. Morbidly technophilic, antinatural, and antifemale, the scene epitomizes the paradoxical form of techno-primitivism. The scene, for one thing, links the machinic and the taxidermic: the twinned forms of the naturalist reproduction of life. It draws into relation the taking of life (for instance, in the conspicuous displays of the skins of animals) and the production of artificial and simulated life (for instance, in the artifactual animals and plants that semi-animate the scene). It registers the naturalist logic of substitution: above all in the part-by-part disarticulation and reconstruction of the female body and female automaton that centers the novel. Such a taking apart and reassembly of "life itself" is inseparable from the taxidermic and technophilic exhibitions of an antinatural and antifemale violence.[38]

The Holmes Castle was not, of course, Edison's invention-factory. But it was something like the Edison fortress-home—technophilic, antinatural, and antifemale—imagined in Villiers' novel. Its couplings of a goth-

icized bodily violence and technological enthusiasm inhabit the same scenario. The popular representation of such violence as archaic, feudal, and regressive is clear enough. Holmes was insistently seen as the Bluebeard of Chicago, and medieval terminology was consistently applied to his crimes: "Holmes the Arch-Fiend," operating from his "castle," innocent lives "sacrificed to the monstrous ogre's insatiable appetite."[39]

Such images have become routine in the mass-media reproductions of the serial killer: "whoever fights monsters."[40] Routine too is the fascinated intimacy with machinal and media reproductions that marks the cases themselves. The scene of the crime is also the scene of invention. Holmes, in his lethal career, was obsessively drawn to substitution manias: forms of duplication, multiplication, reproduction, seriality, and substitution. There was, in addition to the substitute body operations, his serial monogamy or, better, serial pathogamy: the marriage to, and murdering of, an overlapping series of women, whose bodies were "processed" at the Castle.

This form of serial indifference blended into another: a number of the women Holmes targeted—perhaps as many as fifty—worked in "the new female occupation of stenographers."[41] The vulnerability of working women newly entering the public streets and public sphere may in part explain Holmes's choice of victims.[42] But the entanglement between writing machines and serial violence, between reproduction technologies and automatized bodies, goes deeper. What might be called the writing of writing in machine culture couples mechanics and erotics. It devolves on an intimacy with machines and a reproducibility without gender. In "naturalist" discourse generally, sexual relations are thoroughly mediated by technologies of reproduction, duplication, and registration. Such a primary mediation defines *une langue inconnue* of the body-machine complex. And the radical entanglement between word counts and body counts is compulsively mediated by the automated female figure of the typewriter/stenographer/mechanical reproducer.

Holmes's graphomania is everywhere evident. It registers in his employment, seduction, and murder of a series of female stenographers or "typewriters" (the term first referred indifferently to the machine and its operator). It registers in the conspicuous display of the still-recent invention of the typewriter machine in his "front" offices. And it registers in the obsessive management of his own story in the mass media—as writer, art editor, executive editor, production manager, and sales manager.[43] The burgeoning popular representations of serial violence func-

tion then as much as *extensions* of the relays between writing bodies and bodily violence as accounts or explanations of them.[44]

Among the strange graphic devices Holmes designed was an elaborate cipher code, by which he communicated with his partners and through newspaper personal advertisements. The decoding depended on the word "republican."[45] Finally, the single legitimate invention Holmes marketed was a machine called the ABC Copier, an early version of the multigraph or mimeograph duplicating machine.[46] The eroticized violence in the Holmes Castle is indissociable from these strange machines and technologized interior of the house. It is indissociable as well from these proliferating writing technologies and their automatized female operators.[47]

The utter assimilation to the "discourse network" of 1900—its technologies of reproduction and registration and its mediated sexualities—is remarkable enough in Holmes's case[48] and is one measure of the case's hypertypicality: Holmes can be seen as something of a poster child for machine culture and its primary mediations. (In pop-Hegelese, we might say that in Holmes, as in the typewritten *lustmord* of *Dracula*, the discourse network of 1900 arrives at its truth.) The mediated intimacies of bodies, persons, and machines are at once generalized in machine culture (as the abnormally normal state of the subject of machine culture) and anxiously localized and pathologized (for example, in the subject, or failed subject, of automatistic violence).

Identity-Machines

Machinic identification entails something more, however, than the assimilation of persons to technology: it entails the elaboration of technologies of autonomous self-production. The identification with the machine is channeled into programs of self-identification and self-making. An identification with the machine turns into the construction of identity-machines, the transference onto the machine is converted, by a circular detour, into a species of autogenesis.[49]

One of the commonplaces in recent accounts of the serial killer is the understanding of the serial killer as a strikingly perverse version of the self-made man.[50] Correlatively, one way of understanding the emergence of the self-made man, *homo autotelus*, is on the model of the emergence of modern "automatic" machinery. As the historian of technology Otto Mayr has recently demonstrated, the appearance of "republican" man in early modern culture—the self-generating and self-governing individual—

is modeled on the invention and spreading of self-moving and self-regulating machines, such as clock mechanisms and associated automata.[51] The self-regulating mechanism is thus a kind of identity-machine: the instrument of a miraculated self-production. The clockwork mechanism or automaton provides the model for an idealized self-presence, an idealized and autonomous self-sufficiency. The mechanism that works all by itself thus appears at once as the model for the human and as its replacement.

The vexed agency of the self-made man is governed by the double-logic of prosthesis. It is not surprising then that the code word in Holmes's writing system is the code name for the self-made man ("REPUBLICAN"), nor that the subject's fantasies of self-making are realized in the transferential relation to the machine: an identification with technology realized at once as self-extension and as self-extinction.[52] Forms of violence in machine culture, and, specifically, forms of male repetitive violence, are indissociable from the addiction to self-making and its machinic prostheses. This is not merely to see the serial killer as a perverse form of the self-made man. It reveals the perversity and violence latent in the program of autogenesis as such.

For the popular murder-historian Colin Wilson, for example, "It has to be recognised that, in his ghoulish way, Holmes was as much the exponent of the American dream as Henry Ford or Horatio Alger."[53] There is of course a leveling banality to such associations, although it would be possible to make a general connection between Holmes's killing machines and the corporeal violence latent in Henry Ford's fantasies of prosthetic workers (workers at once unmade and remade by the machine process), or between Holmes's identity-machines and the melodrama of frayed masculinity latent in Horatio Alger's fables of self-invention (all but named in Alger's "ragged dick" stories).[54] But the leveling banality in such popular accounts is, from another point of view, absolutely central. For if the imperative of self-distinction drives the career of the self-made man, the failure of self-distinction is premised, paradoxically enough, on the very generalization of that drive: the indiscriminate assimilation into the democratized mass or crowd of indistinguishable self-made or republican men, such that the republican subject in effect dissolves back into an indeterminate number of others.[55] The abnormal normality of repetitive bodily violence depends at least in part on the routinization of self-invention in machine culture.[56]

The autogenic apparatuses, or identity-machines, constructed in cases of serial violence epitomize this circular logic. These devices seem to

take on two competing, albeit counterpart, forms: self-mobility and self-containment. From his childhood on, Holmes, for example, speculated in business ventures. But, as he later wrote, their "failures were nothing compared with the collapse of the innumerable air castles which had depended on the result of these speculations."[57] One of these "air castles" was a complex apparatus that was to have solved the problem of perpetual motion.

One discovers again and again, in the subject of male repetitive violence, a fascination with, and fantasmatic identification with, apparatuses of perpetual mobility and perpetual self-generation. Sociological and psychological studies of the serial killer intermittently register the vicious circularity of self-generation in these cases. In part, they account for it simply in the substitution of "internal circumstances" for "external circumstances."[58] In the most reductive terms, this represents a simple choice of fantasy over world. As Robert Brittain expresses it in an influential study of serial violence, the "sadistic murderer" pathologically "incubates" devices and fantasies "of his own invention."[59] As Joel Norris images the serial killer's "prolonged fantasy": he exists "only in a world of his own creation ... the ritual of killing has become bound up with an autonomic survival mechanism."[60] Or, as another recent group study of sadistic murder summarizes it: "Patients in our sadistic group described how the content of their fantasies was commonly extended to maintain arousal and pleasure until *in vivo* trials were begun."[61]

A basic complication emerges in the normative relation posited in these accounts between the "invention" or "incubation" of fantasy and its acting out. The "normal" sequence of cause and effect, intention and act (fantasizing "until" acting begins) is exactly inverted. The effect, it turns out, arouses the cause: "It became apparent from information volunteered by these patients that one of the main reasons for behavioral try-outs was the need to maintain the effectiveness of the fantasy as a source of arousal."[62] What becomes apparent, then, is the by-now familiar "retroactive" logic of "deferred action," the retroactive causality that discloses, in psychic life, the motive of the "priority of synchrony over diachrony"—that is, the priority of "the symbolic rewriting of the past" over "the past in its 'factual purity.'"[63] It would appear that the *in vivo* "tryouts" of their fantasies are in the service of the fantasy and not the other way around. This amounts to a double reduction: the fantasy of self-generation reduces to the self-generating character of fantasy, and the self-generating character of fantasy reduces to the self-generating character of the subject.

The readiness by which such accounts collapse into banality and generality is one indication of their larger cultural work. Such accounts conserve *at all costs* the character of "the subject answerable as subject": the subject as self-generating, self-contained, self-moving. But by localizing and pathologizing that character in the figure of the serial killer, they conserve it *at no cost*. The "dangerous individual" would thus appear as a sort of reservoir of a dangerous, and alluring, individuality, and the "abnormal normality" of the psycho-killer as a sort of reservoir of the psychic order itself.

This is, in short, the scapegoat reading of the serial killer. As Slavoj Žižek puts it, "We *are* murderers in the unconscious of our desires." But by localizing "our" guilt "in a single subject" — through a "hallucinatory projection of our guilt onto a scapegoat" and thus exculpating all the others — "our desire is realized and we do not even have to pay the price for it."[64] Or, as another commentator, following Žižek, summarizes this position: "Identification with a psychotic murderer provides gratification of a death wish against others while simultaneously ensuring exculpation through the projection of all guilt onto the self-same cultural anomaly: 'the monster of perversion.'"[65]

The scapegoat reading has its own banality, and not merely in its eternalizing and universalizing of an utterly generic unconscious ("our desires").[66] Yet it would seem that there is something more involved here than the "localization" of a "universalized, free-floating guilt" "in a single subject." What is involved is less the localization of guilt than the localization of the single subject itself: the possibility of singling out one person from an indiscriminate number of others. And this possibility, in turn, depends less on an identification with violent desires for which we need not pay a price than on a discharging of the drive to identification itself.

For it would appear, in the accounts of the prolonged fantasies of the serial killer, that what separates the *psychic*-killer and the *psycho*-killer is simply this: the matter of a correct distance with respect to identification, on the part of the psychic-killer, the radical failure of distance with respect to identification, on the part of the psycho-killer.[67] What is at stake, again, is the subject's normative distance with respect to fantasies or representations: the collapse of that distance appears as the pathological fantasy-state of the sadistic killer. This is to suggest that the "gratification" of "identification with a psychotic murderer" involves something other than the matter of the murderer's disorderly truth — "a death wish against others." It involves the disorders of identification, the deadliness of others as "self-same."

It is now possible to locate the abnormal normality of the subject of serial violence a bit more precisely, to locate it in terms of the twin paradoxes that converge in the figure of the republican or self-made man: the time paradox and the machine paradox. The time paradox can be detected in the mandate of "the People" to give birth to itself in the constitution of the republican state and republican citizen. Or, on the level of the individual: "How can somebody who does not yet exist deputize the mission to create himself? How can somebody who still waits to be created precede his own conception?"[68] The machine paradox can be detected in the double-logic of prosthesis: "How can the subject of machine culture invent the devices through which he invents himself?" What is disclosed, on both counts, is a sort of missing link in the causal sequence: the impossible point of origin, from which the subject attempts to "cause" himself. The sadistic murderer, on this account, plays out in pure form the Sadeian/republican fantasy of a radical annihilation as the precondition for the creation, *ex nihilo*, of the new man: what Zola, in *La Bête humaine*, calls "destruction for fuller possession" (that is, fuller *self*-possession).

But, again, it is not enough to invoke these general paradoxes, and not least because the experience of a generality within is a central component in these cases. The general connection between the technophilic imaginary and male fantasies of autogenesis is by now familiar enough. It is necessary, however, to measure the very different uses to which these connections are put and the very different forms of violence they seem to solicit.

Consider, then, these two, brief examples of repetitive male violence. First: the 1970s American serial killer Leonard Lake, like many others, was (Renfield-like) an obsessive record keeper. These records consisted of scrapbooks and an elaborate set of home videotapes and photographic souvenirs of his crimes. These recordings and reproductions made possible his compulsive return to the scene of the crime. But they also made possible the conflation of the return to the scene of the crime and the compulsive return to another traumatic and primal scene: the missing scene of one's own origin and reproduction. In his childhood, it turned out, Lake "maintained active studies about the life cycle of rats. From these recorded observations, the gifted child became a self-taught geneticist."[69] Self-taught, self-made, self-caused: the apparatuses of genetics and photographic reproduction are this serial killer's identity-machines, his technologies of the self.

Second: the identification with apparatuses of self-generation defines the career of the family-murderer Pierre Rivière, in postrevolutionary and

nominally republican France. Rivière was utterly obsessed by the inven-
tion of his own word systems (the performative language that Foucault
described as the murderer's *verboballistics*). He was obsessed too with the
invention of little devices—what he described as the invention of
"completely new instruments" that govern themselves and which are
"produced only in my imagination." The murderer's inventions included
a device to "churn butter all by itself," a "carriage to go all by itself," and
also the courses of improvement for "bettering myself." These self-
referential and autopoietic systems project machinal production as self-
generation; these completely new instruments are the killer's identity-
machines. They project self-generation as the pleasure of a sublime and
tautological self-containment: "I amused myself all by myself."[70]

There are basic historical differences between these cases: between the
private inventions of the family-killer Rivière, on the one side; and the
absorption in mass technologies of reproduction, publicity, and systemic
generation of the serial killer Lake, on the other. There are basic differ-
ences, that is, between, the murderer of his mother, his sister, and his
brother, and the stranger killer.

These differences provide a way of reframing the Holmes case, which
might in fact be seen as a sort of interim and hybrid instance, on several
levels: referring back to the republican-familial violence of the Sadeian
murderer, referring ahead to the systemic-addictive violence of the serial
killer. This cross-referencing is epitomized in the conflation of private
and public spaces in the home/factory of The Holmes Castle itself and,
beyond that, in the rival genres of bodily violence in his career. At one
extreme, there is the antifamilial violence that broke the story: Holmes's
murder of Pitezel and his two children. Collaterally, a nostalgic and
unrepentant familialism runs through his confessional-tabloid autobiog-
raphy *Holmes' Own Story* and, perhaps, in Holmes's eponymous linkage
with the homelike itself. Yet, at the other end, there is the lethal absorp-
tion in modern graphomanias and modernist inventions: anonymous
technologies of duplication, reproduction, and substitution, murdered
stenographers and ABC copiers.

The uncanny temporalities of the case are, however, not merely a sign
of its interim status in the history of repetitive violence. These bizarre
temporalities seem to structure the scene of the crime itself: the gothic
castle at the heart of the modern city. What becomes clear here are a
complex series of relays between the archaic, the outmoded, the primi-
tive, on the one side, and a technologized modernism, on the other. The

reciprocal topographies of identities and places, bodies and scenes, assume their most extreme form in the fantasy castles constructed by the self-constructing killer. Hence in the next chapter, I mean to set out just what this network of relays between primitivist and technological scenes—the techno-primitive—looks like, in the subject of serial violence and his lethal spaces. It is necessary then to turn again to The Holmes Castle and to the larger scene of Holmes's crimes.

Notes

1. See Manuel De Landa, *War in the Age of Intelligent Machines* (New York: Zone, 1990).
2. See John Ashbery, "Mystery Mansion," *House and Garden*, March 1987, 148–53.
3. Carol J. Clover, *Men, Women, and Chainsaws: Gender in the Modern Horror Film* (Princeton: Princeton University Press, 1992), p. 134.
4. Susan Stewart provides a brief but compelling account of these modern domestic-suburban nostalgia machines in *On Longing: Narratives of the Miniature, the Gigantic, the Souvenir, the Collection* (Durham, NC: Duke University Press, 1993), pp. 1–2.
5. As one fascinated visitor to the Winchester House—the poet John Ashbery—expressed his experience of this semi-alive space: the windows, made of large sheets of optical glass, "draw into the rooms what can only be described as an intense pallor," and the "impression one retains is of a strong absence of color, or a color like that of ectoplasm" (Ashbery, "Mystery Mansion," p. 298)
6. Siegfried Giedion, *Mechanization Takes Command: A Contribution to Anonymous History* (New York: Norton, 1969), pp. 209–256. See also Daniel Pick, *War Machine: The Rationalization of Slaughter in the Modern Age* (New Haven, CT: Yale University Press, 1993), pp. 178–88.
7. Quoted in David Franke, *The Torture Doctor* (New York: Hawthorn Books, 1975), p. 200.
8. On these drills in male autogenesis, see chapter 4 above. See also Niklas Luhmann, "The Individuality of the Individual: Historical Meanings and Contemporary Problems," in *Reconstructing Individualism: Autonomy, Individuality, and the Self in Western Thought* (Palo Alto, CA: Stanford University Press, 1986). Luhmann traces how the unremitting drill in self-origination is the discovery of the "autopoietic subject": the discovery of "the subject and its boredom" (that is, the subject who, in circular fashion, refers back to nothing but himself) marks the individuality of the self-made individual, from the late eighteenth century on.

9. Jacques Lacan, "Aggressivity in Psychoanalysis," in *Écrits: A Selection*, trans. Alan Sheridan (London: Tavistock, 1977), p. 27.
10. The Holmes case has been well documented. In what follows I will be relying on, in addition to Holmes's confessional writings and contemporary accounts of the case, Franke, *The Torture Doctor*, and Charles Boswell and Lewis Thompson, *The Girls in Nightmare House* (New York: Fawcett, 1955). Harold Schechter's more recent *Depraved: The Shocking True Story of America's First Serial Killer* (New York: Pocket, 1994), largely reprises this material, albeit, as his subtitle indicates, in the shock idiom of the by-now standard, true-crime mode. I will be drawing on as well the "novelizations" of the case: the novels of Robert Bloch (*American Gothic* [New York: Simon and Schuster, 1974]) and Alan W. Eckert (*The Scarlet Mansion* [Boston: Little, Brown, 1985]). But Holmes was his own first publisher, publicist, and mass-media marketer and not merely in his sensational tabloid autobiography, *Holmes' Own Story*. Holmes's true crime mania and his graphomania form, it will be seen, two parts of single formation, making visible at every point the logic of "pulp fiction"—*pulp* in the double sense I have been tracing.
11. Sigmund Freud, *A General Introduction to Psychoanalysis*. Trans. Joan Riviere (New York: Pocket, 1953), p. 160.
12. Bloch, *American Gothic*, p. 183.
13. H. H. Holmes, *Holmes' Own Story* (Philadelphia: Burk and McPetridge, 1895).
14. Franke, *The Torture Doctor*, p. 205.
15. Eckert, *The Scarlet Mansion*, p. 81.
16. Phil Patton, "Sell the Cookstove if Necessary, but Come to the Fair," *Smithsonian* 24.3 (June 1993), p. 39.
17. Boswell and Thompson, *The Girls in Nightmare House*, p. 90.
18. Cited in Cecelia Tichi, *Shifting Gears: Technology, Literature, Culture in Modernist America* (Chapel Hill, NC: University of North Carolina Press, 1987), p. 19.
19. We might consider here Stephen Crane's novel of the body-machine complex, *The Red Badge of Courage* (1895), which centers on the war front as a labor front and on the war machine as a factory to "produce corpses." I will be returning to Crane's inaugural stories of the emergence of a wound culture, a culture centered on the mass spectation of torn bodies, in the final part of this study.
20. Herbert Ashbury, *Gem of the Prairie: An Informal History of the Chicago Underworld* (New York: Knopf, 1940), quoted in Franke, *The Torture Doctor*, p. 87.
21. On Petiot, see Thomas Maeder, *The Unspeakable Crimes of Dr. Petiot* (London: Penguin, 1980).
22. Boswell and Thompson, *The Girls in Nightmare House*, p. 90.

23. Franke, *The Torture Doctor*, p. 89.

24. *Holmes' Own Story*, quoted in Franke, *The Torture Doctor*, p. 91; Boswell and Thompson, *The Girls in Nightmare House*, pp. 92–93.

25. Karl Marx, *Capital*, 3 vols. (New York: International Publishers, 1987), 1.4, chap. 15, sec. 3a; see also Didier Deleule, "The Living Machine: Psychology as Organology," in Jonathan Crary and Sanford Kwinter, *Incorporations* (New York: Zone, 1992), p. 223

26. See, for example, Jonathan Crary, *Techniques of the Observer: On Vision and Modernity in the Nineteenth Century* (Cambridge, MA: MIT Press, 1990), pp. 11–15.

27. Quoted in Franke, *The Torture Doctor*, p. 184.

28. In the case of Pitezel—the case that broke Holmes's career as fraud and murderer and led to his arrest—Holmes simplified matters, killing his partner rather than locating a substitute. One irony of the case was that Holmes was originally charged only with insurance fraud, not murder; he was nearly released since the fraud charge was negated by the discovery that the body was indeed Pitezel's and not a substitute one. It is worth noting that press coverage was preoccupied with Holmes as fabricator as much as it was with Holmes as murderer. See Frank P. Geyer, *The Holmes-Pitezel Case: History of the Greatest Crime of the Century and of the Search for the Missing Children* (Philadelphia: Publishers' Union, 1896).

29. Jean Laplanche, *Life and Death in Psychoanalysis*, trans. Jeffrey Mehlman (Baltimore: Johns Hopkins University Press, 1976), p. 123.

30. Laplanche, *Life and Death*, p. 124. Clearly, this is to identify neither the *external*—cultural or technological—grounds of the death drive nor the *internal*—psychic—basis of machine culture. On both accounts, it's the outside or inside boundaries, or topography, of the subject that are in question. The problem of the subject and problem of topography or place are therefore indissociable. What is in question *as* the question of "the subject" is its ground or basis or location or context: *the topography of the subject.*

31. Michel Foucault, *The History of Sexuality, Volume 1: An Introduction*, trans. Robert Hurley (New York: Pantheon, 1978), p. 138. The notion of the subject as "determined" by his/her social context implicitly understands the social as a kind of "influencing machine." I am referring to the prosthetic construct, dreamed by certain schizophrenics, as governing, and technologizing, the subject from without. The psychoanalyst Victor Tausk described the subject's "need for reference" as issuing in the "delusion of reference," and the delusion of reference taking the form of an elaborate, albeit imaginary, machinic construction: what he calls the "machine dream" of the "influencing machine." The imagination of the machine in these terms—the understanding of the machine as symptom—in effect equates reference and the delusion of reference. From "within" the imaginary of the influencing machine, there is nothing but machinic determination; the machine

functions as absolute and determining referent and cause. From "without," there is nothing but projection: the appeal to the machine is a mistake about externality, the outside counting as nothing but projection and externalization. (See Victor Tausk, "The Influencing Machine" [1919], reprinted in Crary and Kwinter, *Incorporations*, pp. 542–69.) Hence we might say that the *projection* of determining force, in the appeal to the abstraction "the social" as cause and ultimate referent, in effect constructs the social not just as the "machine dream" of the influencing machine (locating the "real" of the subject without) but also as the "dream machine" (implanting subjectivities within).

32. Foucault, *History of Sexuality*, p. 139.

33. If the formulation of the "death instinct" (in Freud's *Beyond the Pleasure Principle*) is bound up with a thermodynamic energetics, this represents something more than the anachronistic scientism to which it is typically referred. The "concepts of thermodynamics," as the historian of biology François Jacob traces, "completely upset the notion of rigid separation between beings and things . . . the conservation of energy applies equally to events in the living and in the inanimate world" (François Jacob, *The Logic of Life: A History of Heredity*, trans. Betty E. Spillman [New York: Pantheon, 1975], p. 194). From this viewpoint, both the life process and the machine process appear as "living systems," as self-reproducing programs, as nothing "deeper" than the processing and communicating of information. For a more detailed account of the erosion of the distinction between the machine process and the life process, see my *Bodies and Machines* (New York: Routledge, 1992), especially Introduction and Part 1, and my "Writing Technologies," *New German Critique* 57 (Fall 1992): 170–81.

34. See Jacques Lacan, *The Seminar of Jacques Lacan, Book II*, ed. Jacques-Alain Miller, trans. Sylvana Tomaselli (New York: Norton, 1991), pp. 294–308.

35. Quoted in David F. Noble, *America by Design: Science, Technology, and the Rise of Corporate Capitalism* (Oxford: Oxford University Press, 1977), p. 257; see also, David E. Nye, *The Invented Self: An Anti-Biography from Documents of Thomas A. Edison* (Odense: Odense University Press, 1983).

36. See Nye, *The Invented Self*; Lisa Cartwright, *Screening the Body: Tracing Medicine's Visual Culture* (Minneapolis: University of Minnesota Press, 1995), pp. 109–126.

37. Thomas A. Edison, *Diary and Sundry Observations of Thomas Alva Edison* (New York: Philosophical Library, 1948), pp. 203–244.

38. On taxidermy, replacement nature, and male addictive violence, see chapter 3, above.

39. On the representation of Holmes in these terms, see, in addition to print materials and illustrations reproduced in Franke, *The Torture Doctor*; Philip Jenkins, "Serial Murder in the United States 1900–1940: A Historical

Perspective," *Journal of Criminal Justice* 17 (1989): 377–92, especially 383; N. K. Teeters, *Scaffold and Chair* (Philadelphia: Philadelphia Prison Society, 1963), p. 114; Geyer, *The Holmes-Pitezel Case*, 1896; G. T. Bisel, *The Trial of Herman W. Mudgett, Alias H. H. Holmes, for the Murder of Benjamin F. Pitezel* (Philadelphia: George T. Bisel, 1897); *Holmes, The Arch Fiend, or, A Carnival of Crime* (Cincinnati: Barclay, 189–); Robert L. Corbitt, *The Holmes Castle* (Chicago: Corbitt and Morrison, c. 1895); S. P. Wright, ed., *Chicago Murders* (New York: Duell, Sloan, and Pearce, 1945). The image of the Chicago Bluebeard, it may be noted, was revived a few years later, in the case of Johann Hoch, the "Stockyard Bluebeard" who may have killed dozens of wives and who, the newspapers "reported," had once been a janitor in The Holmes Castle.

40. See Philip Jenkins, *Using Murder: The Social Construction of Serial Homicide* (New York: de Gruyter, 1994), especially chapters 4 and 5.

41. Franke, *The Torture Doctor*, p. 101.

42. See Judith A. Walkowitz, "Jack the Ripper and the Myth of Male Violence," *Feminist Studies* 8 (Fall 1982): 543–74.

43. Boswell and Thompson, *The Girls in Nightmare House*, p. 112.

44. See Schechter, *Depraved*, pp. 266, 282.

45. The capital letters "REPUBLICAN" represented A,B,C,D,E,F,G,H,I,J; the lower-case letters "republican" stood for the next ten letters of the alphabet, with the remaining six representing themselves. (I will return to the significance of this key word in a moment.)

46. John Bartlow Martin, "The Master of the Murder Castle: A Classic of Chicago Crime," *Harper's Magazine*, Dec., 1943, pp. 76–85; Colin Wilson, *A Casebook of Murder* (New York: Cowles Book Company, 1969), p. 206.

47. The confession that was later reprinted by the Hearst syndicate as *Holmes' Own Story* "flooded newsstands and bookstalls"; it was authenticated (as the framing media accounts repeat) by "the stenographer [who] took down every word he said." Allan W. Eckert's novelization of the case, *The Scarlet Mansion*, imagines Holmes's bedroom conversations with his typewriter/mistress in these terms: "'I'll bet I know something about the book [Twain's *Life on the Mississippi*] that you don't.' 'Apart from the fact,' [Holmes] interjected with exaggerated innocence, 'that it was the first book manuscript written on one of those typewriter machines'" (25). The main character of Bloch's *American Gothic* is a "new woman" investigative reporter, undercover as a stenographer at work at Holmes's "new typewriting machine" (33). These are the relays systematically articulated between flows of information and serial violence, between ink and blood, from Dracula's or Holmes's Castle to Inkster (see chapter 1) and beyond.

48. On what Friedrich Kittler has called the "discourse network of 1900," see chapter 1, and on its renovations in the splatter codes of the modern

Discourse Network of 2000, see the final part of this study, "Wound Culture."
49. See chapter 4 of this book, and my *Bodies and Machines*, especially part 5, "The Love-Master."
50. See Elliot Leyton, *Hunting Humans: Inside the Minds of Mass Murderers* (New York: Simon and Schuster, 1986), pp. 276–324; Ronald M. Holmes and James De Burger, *Serial Murder. Studies in Crime, Law and Justice*, vol. 2 (Newbury Park, CA: Sage, 1988), pp. 40–46. See also chapter 4, above.
51. See Otto Mayr, *Authority, Liberty and Automatic Machinery in Early Modern Europe* (Baltimore: Johns Hopkins University Press, 1986). Or, as Jacques Lacan situates the modern ("Cartesian") fantasy of self-generation: "So there were clocks. They weren't miraculous yet, since it was a long time after the *Discourse on Method* before there was a real one, a good one, with a pendulum. . . . It was obviously necessary for us to cover a certain distance in history before we realized to what extent it is essential to our being there, as they say, to know the time. A lot can be said about this time not being the real one, it still passes there, in the clock, all alone like an adult" (Lacan, *Seminar*, pp. 73–74). For an erratic but suggestive commentary on the technology question in what Lacan calls "the ego's era," see Teresa Brennan, *History After Lacan* (New York: Routledge, 1993).
52. In the first part of this study, I argued that the *addiction to self-making* in machine culture makes visible the attempt to shore up a fundamental uncertainty about the locus of the personal and bodily boundaries of the self: a fundamental "leakiness" in the self. I suggested further that the epistemological uncertainties about identity—the uncertain boundaries of the self and the uncertain difference between self and other—are insistently referred to the oppositional terms of sexual identity. The uncertain difference between self and other is urgently translated into the "basic" difference between male and female. By this circular logic, the appeal to a basic and ineradicable sexual difference translates, and ratifies, the difference between self and other that, in turn, becomes the equivalent of sexual difference. In short, self-difference and sexual difference are equated along these lines: if self-mastery is seen to depend on an opposition between leaky selves and bounded ones, this is translated, in turn, into an opposition between the defined and bounded body and the body of insupportable openings, leaks, and flows. Thus, the very evidence of the torn and leaking body retroactively ratifies the difference between bounded identities and torn ones *as* the difference between male and female.
53. Wilson, *A Casebook of Murder*, p. 206.
54. On Alger, see Michael Moon, "'The Gentle Boy from the Dangerous Classes': Pederasty, Domesticity, and Capitalism in Horatio Alger," *Representations* 19 (Summer 1987): 87–110. On some of the vicissitudes of the American self-made man, see, for example, Karen Haltunnen, *Confidence*

Men and Painted Women (New Haven, CT: Yale University Press, 1982), pp. 198–220; and Christopher Lasch, *The Culture of Narcissism* (New York: Warner, 1979), pp. 53–59.

55. What counts as the republican citizen is what makes persons countable: formally equal, substitutable, and identical (the statistical person). What these individuals have in common is not some common attribute or identity that they share. Rather, what they share is their commonality, their identification with an indeterminate number of others. As Claude Lefort concisely outlines it: "Number replaces substance." The abstraction of the social bond, in the modern state, its disincorporation into a system of merely formal differences, may lend itself, as in the cases under examination, to the violent reembodiment of differences, along group type, racial, national, and especially gender lines. (Lefort, *Democracy and Political Theory* [Minneapolis: University of Minnesota Press, 1988], pp. 18–19). See also Foucault, *History of Sexuality*, on the counting of populations (statistics as "state numbers"); and Joan Copjec, "The Phenomenal Nonphenomenal: Private Space in *Film Noir*," in *Shades of Noir: A Reader*, ed. Copjec (London: Verso, 1993), pp. 167–98, on the abstraction of persons in democratic commonality. On the 1890s version of the "statistical person," see my *Bodies and Machines*, especially part 3.

56. We might consider here, again, the obsessive theorizations of "the crowd" and crowd violence from the turn of the century on, and, more exactly, the relentless gendering of the crowd as female, and, collaterally, the relentless figuring of the crowd as a promiscuously violent torrent or flood. One finds a triple elision of the mass, the flood, and the female in the theorization of the crowd and crowd violence (in the work, for example, of Gustave Le Bon, *The Crowd*, or Georges Bataille, *Erotism: Death and Sensuality*, trans. Mary Dalwood [San Francisco: City Lights, 1986]). As we have seen, failures of self-distinction—the dissolution of the man in the flood/crowd—are instantly referred to the terms of sexual difference and the terms of sexual difference to spectacular public violence.

57. Quoted in Franke, *The Torture Doctor*, p. 118.

58. See M. J. MacCulloch et al., "Sadistic Fantasy, Sadistic Behaviour and Offending," *British Journal of Psychiatry* 143 (1983): 20, 22–23.

59. Robert P. Brittain, "The Sadistic Murderer," *Medicine, Science, and the Law* 10: 198–207, 199–201; MacCulloch, "Sadistic Fantasy," p. 27; H. J. Eysenck, "A Theory of the Incubation of Anxiety/Fear Responses," *Behaviour Research and Therapy* 6 (1968): 309–21.

60. Joel Norris, *Serial Killers* (New York: Doubleday, 1988), p. 24.

61. MacCulloch, "Sadistic Fantasy," p. 26.

62. Ibid.

63. Slavoj Žižek, *For they know not what they do: Enjoyment as a Political Factor* (London: Verso, 1991), pp. 198–203. This has become something of a

refrain, if an unexamined one, in the literature of serial murder. As Joel Norris, without comment, registers this causal paradox: "The event being reenacted is *primary*" (Norris, *Serial Killers*, p. 31; my emphasis). The manner in which the event is a product of its repetition, in cases of traumatic violence, is just what remains underexamined in these descriptive and behaviorist accounts of serial killing.

64. Slavoj Žižek, *Looking Awry: An Introduction to Jacques Lacan through Popular Culture* (Cambridge: MIT Press, 1991), p. 59.

65. Diana Fuss, "Monsters of Perversion: Jeffrey Dahmer and *The Silence of the Lambs*," in *Media Spectacles*, ed. Marjorie Garber, Jann Matlock, and Rebecca Walkowitz (New York: Routledge, 1993), p. 200.

66. See Sigmund Freud, *Group Psychology and the Analysis of the Ego*, trans. and ed. James Strachey (New York: Norton, 1959), on "the unconscious foundations, which are similar in everyone" (p. 9). This "average character" of the unconscious foundations of the subject is also, in Freud's wavering account of the relations between group and individual psychology, one way in which the individual appears as "just similar"—something like a group of one or the embodiment of the crowd or mass within: the mass in person.

67. In a sense, one achievement of the psychoanalytic account (at least in its Lacanian version) is to disclose, on the contrary, the fantasy status of the subject answerable as subject: that is, proper distance or self-containment itself as fantasmatic. But only "in a sense." This is because the priority of the motive of synchrony (the "symbolic 'rewriting of the past'") over diachrony ("the past 'as such,' in its factual purity") in effect *conserves* the priority of the subject. (Žižek, *For they know not what they do*, pp. 202–203.) The presumption of the priority of synchrony over diachrony is the presumption of the subject. The psychoanalytic model in effect secures the priority of the subject by submitting the subject to an endless insecurity. This amounts, in some cases, to the endorsement of impossibility or difficulty or paradoxicality as such. (The priority of the order of the subject is conserved by way of an acknowledgment of the difficulty of the subject, in what at times becomes an endorsement of difficulty itself.) It amounts, in others, to the understanding of what is portentously called "the historical" strictly on the model of the subject and its vicissitudes. On the level of the individual, the subject is submitted to an endless troubling. But it is reinvented on the level of the group or the race or the nation. In these cases, psychic conditions—trauma, mourning, the uncanny, deferred action, and so on—are simply "swapped" with historical conditions and the articulation of their relations or mediations thus remains a black box. In this way, the model of the subject, emptied out on the level of the individual, is recovered on the level of "the historical," is reconceived on the model of the subject, albeit the *wounded* subject.

68. See Žižek, *For they know not what they do*, p. 262, who is drawing on Lefort, *Democracy and Political Theory*, pp. 87, 79.

69. Norris, *Serial Killers*, p. 232. As Norris adds: "His record keeping and neurotically compulsive attention to repeating the same patterns of behavior formed one of the basic patterns of his life." The faltering of explanation into tautology—the pattern of repeating patterns of repetition—is typical of the way in which accounts of serial murder virtually register the tautology/contradiction of self-making. This amounts to a pathologized version of the "technological enthusiasm" that Thomas Hughes calls, neatly enough, "American genesis" (see Hughes, *American Genesis: A Century of Invention and Technological Enthusiasm* [New York: Penguin, 1989].)
70. Michel Foucault, ed., *I, Pierre Rivière, having slaughtered my mother, my sister, and my brother . . . A Case of Parricide in the 19th Century*, trans. Frank Jellinik (Lincoln: University of Nebraska Press), pp. 49–52, 101–104.

9 • Techno-Primitivism and Mass Violence

Scenes of Regression

What surfaces in terrible places such as The Holmes Castle is a rapport between persons and places such that the techniques of the habitat and forms of personation become indistinguishable—a failure of distinction that precipitates effects of horror. But what mode of persons and what modes of place figure in such cases? How do these strange regressions of persons and strange replications of outmoded places come together in the form of techno-primitive violence that makes up the modern American Gothic?

It is necessary to approach again, from a somewhat different perspective, the architecture of The Holmes Castle. I am referring to the multiplication of sealed rooms within rooms that made up the Castle; the asbestos-covered, sheet-metal walls; the enclosures and vaults in which Holmes trapped, asphyxiated, and incinerated some of his victims; the elaborately constructed and insulated boxes in which he suffocated and transported others.[1]

From one point of view, the hypertelic drive toward enclosure is the exact counterface of the sheer mobilities of bodies and commerce and identities traversing Holmes's career in serial violence. The bizarre instructions Holmes left for the placement of his own body make utterly explicit such a drive toward fortification and self-fortification as prophylaxis against the disembodying mobilities of the market and the volatization of natural bodies in the machine process. These instructions look

like "the principle of self-preservation gone wild"[2]: the construction of an impenetrable barrier or shield about Holmes's own body. This protective shield was explicitly designed to protect the body both from the forensic dissections of the criminologist and from the mass market in monstrosities and spectacular violence.[3] Immediately following his execution by hanging, Holmes's body was placed in a coffin that was then filled with cement. The coffin, in turn, was sealed under several tons of concrete: " 'I want no one to get the body, either by buying it or stealing it. You've arranged the cement?' "[4] In this way, the already dead subject, wholly identified with its prosthetic inventions and constructions, prepares and observes its own style of survival.

The drive toward enclosure and deep embodiment thus may be understood as a form of self-insulation against market and machinic disincorporation: a version of the armored, self-fortifying, and rationalizing ego in which self-preservation and destruction, or self-destruction, become identical. This is, at least, Theodor Adorno's way of reading the "regression" to archaic or outmoded spaces in the modern city. For Adorno, the gothic revival of the late nineteenth century is a direct, if perverse, response to forms of "highly industrialized mechanization." If the turn-of-the-century railway station takes the form of "the phony castle," this archaic housing is "not simply anachronistic" but instead one version of "the distinctly modern character of regression."[5] The phony castle represents a "compulsive attempt to avoid the loss of experience involved in modern modes of production and escape the domination of abstract equivalence through self-made concretion." In sum, the construction of outmoded spaces such as the replica castle expresses "the human demand for the concrete," a demand at odds with the abstracting equivalences of mass production and mass consumption. Seen this way, The Holmes Castle, and the Holmes tomb, appear as hyperbolic, surreal literalizations of the regressive demand for self-making through "self-made concretion."[6]

But what notion of the self and its "housings" is at work here? Adorno explicitly distinguishes his account of "the distinctly modern character of regression" from "Freud's psychological theory," insisting that "regression cannot be determined solely in terms of 'man' and his psyche."[7] Yet it would seem that positing an essential "human demand for the concrete" does precisely that. Something more complicated than a simple *opposition* between the sociological and psychological theorizations is at work in such regressions to archaic places.

Consider, for example, the terms of what is perhaps still the dominant

psychoanalytic model of the uncertain formation of "the subject." "The formation of the I," as Jacques Lacan expresses it in a familiar passage,

> is symbolized oneirically by a fortified camp . . . establishing from the interior area to its outer enclosure, its periphery of rubbish and marshes, two opposed fields of struggle where the subject is caught up in the quest for the lofty and distant chateau, whose form (sometimes juxtaposed in the same scenario) symbolized the id in a striking fashion. And in the same way we find realized, here on the mental level, those structures of the fortified work the metaphor of which rises up spontaneously, and as a result of the very symptoms of the subject, to designate the mechanisms of inversion, of isolation, of reduplication, of annulation."[8]

This account, in its rich metaphorics, posits an homology between the subject and space: what Lacan, following Caillois, calls "the captation of the subject by the situation." But it does so in terms of a double and contradictory story of "the space in which the image of the ego develops."[9] The rapport between subject and space is understood at once as a securing of the boundaries of the self (the establishing of an interior area and its outer periphery) and as the breaching of those boundaries (in the discovery of a distance within: the quest for the interior is the quest for the high and distant castle). The uncertain relation between these competing topographies epitomizes, in effect, the unsettled boundaries and localizations of the subject itself. It indicates, however, not merely the fundamental "relation existing between the dimension of space and a subjective tension."[10] For this way of imaging the subject—in the terms of Lacan's feudal castle or, for that matter, in the terms of Edison's medieval "walled towns" within—posits the very category of the person as anachronistic or as outmoded: as outmoded as the gothic castle in the modern city. The subject itself appears as a sort of gothic revival.

This is to connect subject formation not merely to "isolation" or "fortification" but also to an identification with outmoded spaces.[11] And it is to connect the identification with outmoded spaces to what Lacan, albeit only in passing, calls a "mechanism" of "reduplication."[12] This mechanism of imitation (the mimetic faculty [Benjamin] or corporeal mimesis [Caillois] is crucial to the understanding of modern styles of regression and its primary mediations. There is, of course, a basic tie between notions of degeneration and regression and processes of replay or reduplication: the reproduction or recapitulation of anterior states and primitive scenes.[13] But how exactly to understand the status of these

mechanisms of reproduction or mimetic repetition—as psychical or bio-
logical, phylogenic or sociogenic—is not at all clear.

The theorizations of degeneration and regression, which begin to pro-
liferate from the late nineteenth century on, are in fact premised on just
such uncertain distinctions between internal and external determina-
tions of the subject: sociology and biology and psychopathology are
scarcely distinct in the complex, and internally contradictory, under-
standing of degeneration/regression.[14] For one thing, if the "individual
had been defined as a social being," the social itself was "conceived in
terms of a determining physiological and neurological past ('infracon-
scious depths'), a whole subterranean world of racial inheritance . . .
[hence] the modern world was bound up in an ambiguous biological and
cultural regression."[15] The diagnosis of degeneration/regression moves
unsteadily across the boundaries of sociology, evolutionary anthropology,
and innate psychology: "images of depraved women, political unrest, bio-
logical degeneration, and the threat of levelling or homogenisation con-
tinually run into each other."[16] Degeneration/regression consists in part
in the threat of a primitive running together or homogeneity: in a radical
failure of distinction that, in circular fashion, is taken as the sign or symp-
tom of "the primitive" itself.

There is then a distinctly modern form of the primitive. What from
one point of view appears as the radical failure of individuality in regres-
sion is, from another, the emergence of the modern, mass, or statistical
individuals. The statistical person appears as the embodiment of the
homogeneity of merely formal equality and merely formal (statistical or
serial) distinction. The mode of interaction that Sartre described as seri-
ality involves a new type of unity: the "basic relationship to other people
is something that might be described as statistical anonymity, with all that
those words imply of isolation and at the same time profound uniformity
with everyone else." It involves, in other words, mechanisms of redupli-
cation, a mimetic contagion or contagious modeling: "All the while I am
modeling myself and my behavior on the being of other people outside
me, all the rest of them are doing exactly the same thing; in fact, there is
no Other, only an infinite regression."[17]

The internal link between this style of infinite regress in the mass and
the theorization of regression is what becomes clear here. The theoriza-
tion of regression, for this reason, devolves on the problem of the group,
the mass, or "the crowd"—on what the urban sociologist Masterman
called, in 1909, that "homogeneous substance: the City Dweller."[18] In the
modern crowd, "the traits of individual distinction have become merged in

the aggregate." This merging into the aggregate is uncertainly psychological ("the crowd of ancestors" within) and sociological (the "city Crowd" in which "personal characteristics vanish").[19] Either way, the crowd is "the place of an inevitable regression."[20]

There is, we have seen, a radical entanglement between serial violence and the problem of the crowd or the mass: the typical scene of serial violence is the psychotopography of the mass in person. For if the crowd is "*the place* of an inevitable regression," the merging of the individual into the crowd is precisely the merging of person into place. Large questions emerge at this point. Is such an assimilation of person to place (as Caillois would have it) at the expense of the subject? Is it not perhaps the conflicted condition of the mass subject's emergence?

The tendency is to imagine the contagious similarity of the crowd, by which individual characteristics "vanish," as a collapse into the "just similar." The governing tendency, in the critique of mass man, is in effect to understand simulation as a synonym for *dissimulation*, as if simulation and identity were each simply at the expense of each other. This posits the mass subject as a sort of nonsubject, the serial individual or statistical person merely as a simulated person: "mass-man, the anonymous and faceless crowds in the streets and factories of the industrial world."[21] But the emergence of the serial or statistical person represents not exactly the vanishing of individuality but rather its remodeling. This remodeling of the "faceless" subject depends on the incorporation of mechanisms of reduplication (the techno-primitive) and the social production of the physiognomy of the subject of machine culture (the face-system). These are the conditions of the subject that I want to test out here.

The Techno-Primitive

One place that exactly exemplifies the scene, and physiognomy, of the techno-primitive is Chicago's 1893 Columbian Exposition, a short distance from which The Holmes Castle was constructed.[22] Contemporary accounts of the Holmes case easily counterposed the neoclassical "White City" of the fair and the dark gothic murder castle as face and counterface of turn-of-the-century machine culture: the technophilic city of light and life and the tech-noir factory of death. But this scarcely registers the strange crossings between life and death, between the archaic and the machinic, between the primitive and the modern that define both these scenes and the relays between them.

One of the defining moments of the Columbian Exposition was

Frederick Jackson Turner's delivery of his thesis on the significance of the frontier in American history. The frontier thesis secured, most basically, the merging of place and identity as the basis of an American history as such: the understanding of history as psychotopography. But this merger of national place and national identity is a bit more complicated. For in locating such a psychotopography in the now foreclosed past, the frontier thesis also posited an uncanny relation between a progressive national history and the repetition of, or regression to, primitive acts and scenes. This in effect makes American identity the symptom of a radical belatedness and compulsive return.[23] The new frontierism takes the form of the future-anterior: the new-frontier as the new-past. American identity becomes inseparable from the recapitulation of the scenes of a violent primitivism.

The closing of the Western frontier signaled in part the relocation of the frontier to the imperialist scene and in part its relocation to the surrogate frontier of the male natural body. What makes these relocations operational is a primary identification: a constitutive analogism linking persons, bodies, and landscapes. Crucially, the "pretechnological" terrain of these fantasies is permeated by technologies of reproduction and mechanisms of reduplication: the very notion of "the primitive" scarcely separable from its reproduction.[24] Such a recapitulation, or reduplication, of primitive and archaic scenes was everywhere in evidence at the Columbian Exposition.

It was in evidence not least in the 1893 program of "Buffalo Bill's Wild West," expanded to accompany the Exposition. This spectacular re-enactment of the "epochs" of American history amounted to an acting out of the Turner thesis. Presented as a "living monument" of the settling of the West, the spectacle incorporated "the aid of historical characters and living animals [in] a series of animated scenes and episodes": scenes in which "the participants repeat the heroic parts they have played in actual life."[25] The very name of the event, "The Wild West," was a designation, as Richard Slotkin observes, that "identified it as a 'place' rather than a mere display or entertainment." What this amounted to was the construction of a "mythic space ... in which history, translated into myth, was re-enacted as ritual," a consummate "*confusion* of the theatrical and the historical."[26] But something more than a "confusion" between history and theater is at work in these re-embodiments of the scenes of frontier violence. "The Wild West" serializes American history as the history of repetitive and compulsive violence. In the reoccupation of these scenes, and in the re-creation of American violence as a form of

mass recreation, these scenes provide a virtual model of the techno-prim-itive and its mechanisms. Even as these scenes solicit a primary identifi-cation with place, they deploy a sort of "technical surrealism": the event itself necessarily competes with, or gives way to, a fascination with the technical means and special effects by which it is reproduced.[27] This is not finally a matter of "regeneration through violence" but the discovery of a mechanism for generating pleasure in spectacular public violence: the pleasure in a violence bound up with the possibility of its reduplica-tion or repetition in spectacle, the pleasure in the spectacle and tech-niques of reduplication itself. This exceeds the *distancing* of bodily violence in spectacle: it measures the *entering* of the spectacle into the interior of repetitive bodily violence and its public pleasures. The mass mechanisms of repetitive corporeal violence become overt in the return to the scenes of these crimes. The Wild West thus appears as a species of "wilding": a simulated primitivism mass-mediated throughout by tech-nologies of reduplication, by the *replicant nature* and prosthetic persons of machine culture.

The White City of the fair provides a somewhat different model of the modern character of regression, its own relays between the archaic and the machinal. The fair was designed as a replica city: a model city of some 400 buildings covering nearly 700 acres of reclaimed swamp land.[28] Presiding over the central Court of Honor was Daniel French Smith's sixty-seven-foot female figure of "The Republic." The monumen-tal buildings of the court consisted of steel-frame structures. But there was a conspicuous discrepancy between the modern-functional interiors and the anachronistic exteriors of these structures. The steel frames were covered by uniformly white neoclassical facades constructed from "staff," a conspicuously insubstantial facing of plaster, cement, and jute fiber. These uniform, and symmetrical, structures included the Electricity Building (housing inventions of Edison and Tesla) and the massive Machinery Hall (its interior filled with gigantic dynamos, turbines, and engines, powered by steam or electricity).[29]

What the "neoclassical" White City achieved then was an illusionist representation of machine culture *as* republican culture. The central court competed, however, with a "parallel display."[30] Set across from the Court of Honor stood the midway Plaisance. If the court was a replicant city, the midway was designed as a display of replica habitats. The White City consisted, of course, of a "city without residences." But it was not without its simulated home sites. These ranged from the exhibition of the new smart home (with its prototype electric kitchen and electric lights) to

the exhibition of "living ethnological displays" that lined one side of the midway, a "living museum of humanity."[31] The displays were modeled on the "History of Human Habitations" exhibited at the Paris Exposition of 1889 and paralleled as well the "animate" spectacles of the "Wild West." These simulated "native habitats" or "culture areas" were to realize a lesson in evolutionary anthropology: "Entering the avenue a little to the west of the Women's Building [one] would pass between the walls of mediaeval villages, between mosques and pagodas, past the dwelling of colonial days, past the cabins of South Seas islanders, of Javanese, Egyptians, Bedouins, Indians, among them huts of bark and straw that tell of yet ruder environment."[32]

The midway thus distributed a "sliding scale of humanity" across its constructed landscape. Exhibited was a series of gradations from the White City to the Dahomeyan Village, the village's sixty-nine inhabitants "blacker than buried midnight and as degraded as the animals which prowl the jungles of their dark land."[33] And if "undoubtedly, the best way of looking at these races is to behold them in the ascending scale," there was, of course, a reverse-way of experiencing these living scenes: "What an opportunity was here afforded to the scientific mind to descend the spiral of evolution, tracing humanity in its highest phases down almost to its animalistic origins."[34]

The coupling of technological progress and the solicitation to regression could not be more evident.[35] But as if it were not yet evident enough, it was re-enacted, in a different register, in the displays and entertainments that lined the opposite side of the midway. These included the pleasure booths, girlie shows, and amusement park diversions that preoccupied the largest crowds of the Exposition, diversions centered by the massive machinery of the Ferris Wheel. Two models of regression and recreation are thus "floated" in relation to each other on the two-sided landscape of the midway: one a lesson in evolutionary anthropology, the other a lesson in weekend vitalism.[36]

One detects, in the modern turning away from the character of modernity, a constructed or simulated nostalgia. As one early twentieth-century commentator on the strange temporal-spatial logic of the modern city wrote: the city-dweller experiences "a nostalgic preoccupation with the past, a stylization. *Half believing, half dissembled* . . . [n]ow he strives with cunning to regain what has been lost and plants little shrines in his mechanized world, just as roof gardens are laid out on factory buildings." These outmoded places thus figure something like the outmodedness, or extinction, of the subject itself. That is, one finds, in the quasi-cynical revival of

these outmoded places, the planting or maintenance of little shrines to an "older" image or model of the subject: "Only in the old centers of the cities . . . residues of physiognomical peculiarities are still maintained as almost extinct showpieces, while in the surrounding districts, no matter whether in the direction of the factories, residential or recreational areas, the international world warehouse extends."[37] The modernist turning away from the modern appears as an attempt to recover the lost unity of the subject: the subject thus imagined as extinguished by mechanization or volatilized in the global extensions of exchange.[38]

A peculiar physiognomy of the subject emerges in such scenes: a physiognomy, or face-system, premised not on the *extinction* of the subject through these mechanisms of reproduction but, instead, on its *production* through these mechanisms. The model habitats and culture areas of the Columbian Exposition, for example, were meant to make visible "the living connection between persons and things."[39] But the design of the White City made visible nothing so much as a basic *dis*connection. Mechanical interiors were concealed behind outmoded and illusionist facades; the structures' interiors and surfaces simply did not belong to each other. The temporal-spatial order of the White City, like The Holmes Castle, foregrounds an absolute break between interior and facing or, more exactly, a formal division between technophilic interiors and anachronistic surfaces.

The Face-System

> The face is a horror story.
> —Deleuze and Guattari, A Thousand Plateaus

This arrangement of the machinic and the primitive is, I have been suggesting, one model of the prosthetic identities of machine culture. There is a resemblance between these two-tiered structures and another technical achievement in the simulation of life at the turn of the century: the trompe l'oeil technology of taxidermy, the reconstruction of natural life and its model habitats, the naturalist form of representation par excellence. The natural skin surface conceals an elaborate mechanical infrastructure; the taxidermic form of life is something of an emblem of the body-machine complex.[40] The illusionist disconnection between outmoded surface and technologized interior poses the natural person and the natural body as something like a facade or mask: the mask of the techno-primitive.

These skin games have had a remarkable cultural resonance and are brought into play, not least, in the logic of serial violence. We might consider here the career of the serial killer Ed Gein. Gein—the model for the taxidermist killers of Bloch/Hitchcock's *Psycho* and Harris's *Silence of the Lambs*—stripped, preserved, and wore the skins of his female victims. The stripping and wearing of female skins become the natural/female surfaces of the self-made male's unnatural/prosthetic self.[41] The skin games of male serial violence are updated in the "terminator" form of the cyborg. The automaton-killer (whose ultimate target is, of course, the mother—natural reproduction itself) displays not merely a merging of body and machine but also the formal arrangement of the bodily and the machinic as (outmoded/natural) surface and (high-tech/machinic) interior. In Artaud's terms: "Under the skin, the body is an over-heated factory."[42]

The machine under the skin also makes up the logic of the modernist industrial design of *streamlining*, whose appeal consists in this: "Industrial skins discourage the user from intervening in a machine's inner regions." The seamless metallized "skin" that screens the complicated mechanism within is imagined as converting the machine into "a naturalized element of the domestic environment." The machine is thus anthropomorphized and domesticated, the natural body replaced by the naturalized body. But here, too, a barely submerged scenario of sexualized violence surfaces. One industrial designer explained his preference for the "organic" skin of the streamlined machine in terms of this little fantasy: "[Betty Grable's] liver and kidneys are no doubt adorable, though I would rather have her with skin than without."[43]

The naturalized skin surface screens the working mechanisms within. It also solicits a ripper-style violence that would strip away these screens: a desire to gain knowledge of interior states by tearing them open to view. These are the abnormally normal models of identity in machine culture. Such identity-machines make the shattering of natural bodies and persons the condition for the prosthetic reconstruction of bodies and persons. The peculiar physiognomy of the subject of machine culture appears in these stylized assemblages of bodies, mechanisms, and landscapes. The configuration of identity in outmoded surfaces and machinic interiors that do not belong to each other appears, above all, in the configuration of that surface of the body that does not quite belong to the body: the face itself.

There is, as Georg Simmel observed, in a brief essay of 1901, an "aesthetic significance of the face," which consists in the projection of "an

unmistakable personality." The "symmetry" and "inner unity" of the subject depends on a sort of internal mimesis: "the achievement of the face in mirroring the soul," the imaging of "the absolute encompassment of each detail by the power of the central ego." This is an encompassment and organization of the body as well. Hence any failure of the mimetic power of the face effects a violent "despiritualization," which takes the form of imagos of the shattered body—baroque "figures, whose limbs appear to be in danger of breaking off . . . repugnant because they disavow what is properly human."[44] It is in this sense that, as Deleuze and Guattari set out in detail, "the body, head included, has been *overcoded* by something we call the Face."[45] It is in this sense, too, that we can begin to locate, in the *aesthetic* significance of the face, its specific *social* significance.

What Deleuze and Guattari call "the face-system" is a "special mechanism" of personation that "draws the entire body" into the "abstract machine of faciality" and extends beyond the body into the housings or landscapes of the subject. This involves putting in place a distinct physiognomy of the subject so that "the face refers back to a landscape" in tautological fashion. "There are," in short, "a number of face-landscape correlations": "Architecture positions its ensembles—houses, towns, or cities, monuments or factories to function like faces in the landscape they transform."[46] The face-system of machine culture is what I have been mapping here: the effects of pleasure and horror generated by the intensification of these "correlations" or reciprocal topographies linking bodies, mechanisms, and landscapes.

The social significance of the face-system and its "correlations" in machine culture is nowhere clearer than in the distinct physiognomy of degeneration/regression. One of the distinguishing signs of regression is, of course, "an irregular or unsymmetrical conformation of the head, a want of regularity and harmony of the features."[47] To return to the Holmes case, one final time: consider Holmes's experience of the accelerating and "ominous changes in his physical appearance," subsequent to his arrest. Although, as Holmes himself traced (in *Holmes' Own Story*), the "searching Bertillon [biometrical] system of measurements" initially detected no defects, in prison his "rapidly deteriorating condition" was startlingly legible. It consisted above all in a deteriorioation in the symmetry of his face:

The principal defects that have thus far developed and which are all established signs of degeneracy, are a decided prominence upon one side of my head and a corresponding diminution upon the other side; a marked defi-

ciency of one side of my nose and of one ear, together with an abnormal increase of each upon the opposite side. . . . An expert criminologist in the employ of the United States Government who had never previously seen me said within thirty seconds after entering my cell: "I know you are guilty."[48]

The face-system and the legal system here exactly image, and corroborate, each other.

The lethal impostor Holmes is, in this story, perhaps simply imitating the indexical signs of regression. But it is just such pathologies of imitation, reduplication, copying, and (over)identification that his career embodies. Such a collapse of identity into (over)identification is scarcely separable from the logic of regression/degeneration. What becomes perspicuous in this case are the mechanisms of reduplication that make one individual indistinguishable from an indefinite number of others: the collapse of unmistakable personality into the sheer typicality ("all established signs of degeneracy") that is one sign of the regressive "decline in the feeling of personality and life."

The collapse of the face-system into the merely typical operates in another direction as well. The transformation and distortion in Holmes's physical appearance are distinctly in line with what he described as "the blackened and distorted faces of his victims." The governing image of crowd-regression takes the form of a disintegration of what Deleuze and Guattari call the "black hole/white wall system" that structures the social significance of the face.[49] The crowd is insistently imaged in these terms: "little white blobs of faces borne upon little black and twisted or misshapen bodies." The collapse of identity into sheer body (black, twisted, or misshapen) or into sheer matter (little white blobs) is also the assimilation into the place of the crowd. These "crowd-symbols" (in Elias Canetti's terms) register the giving way of "the boundaries of the personality" in the densities of a crowd in which "no distinctions count": "Suddenly it is as if everything were happening in one and the same body. . . . Suddenly everywhere is black with people and more come streaming from all sides as though streets had only one direction. . . . [The] goal is the blackest spot where most people are gathered."[50] On this logic, the subject's captation by mechanisms of reduplication within is at the same time the subject's merger into the typical and faceless and convulsive streets of the crowd without.

In his landmark essay on the effects of the mechanical reproducibility of the work of art, Walter Benjamin traces the decline of the "aura" in

machine culture and, more exactly, its "ultimate retrenchment" in "the fleeting expression of the human face." The face is the "focal point" of early photography. For Benjamin, however, this last retrenchment of the aura in the human countenance gives way, around 1900, to another photographic image: the exhibition of eerily deserted city streets, the crowd conspicuous in its absence. Instancing Atget's photographs, Benjamin observes that "it has justly been said of him that he photographed them like scenes of the crime. The scene of the crime, too, is deserted; it is photographed for the purpose of establishing evidence."[51] No doubt there is a policial aspect to these images. But the turn from the human face to the scene of the crime perhaps involves something else too: something like a resemblance, even an identification, between the face and the scene of the crime. "No face is surrealistic in the same degree," Benjamin elsewhere notes, "as the true face of a city."[52]

We are now perhaps in a position to draw into relation these three forms of personation: the blurred composite photograph of an indefinite number of others from which emerges the statistical picture of the criminal; the white outline of the body drawn on the deserted ground of the scene of the crime; the identification of the scene of the crime as the profile of the killer. What surfaces in these cases is something like an identification between the human face and the scene of the crime. And if the assimilation to scene that marks the disturbance in the relations between personality and space is one of the essential components in serial violence, then these emptied public spaces perhaps make up the composite portrait of the stranger-killer: the mass in person.

Notes

1. David Franke, *The Torture Doctor* (New York: Hawthorn Books, 1975), p. 71; John Bartlow Martin, "The Master of the Murder Castle: A Classic of Chicago Crime," *Harper's Magazine*, Dec., 1943, pp. 76–85.
2. Peter Sloterdijk, *Critique of Cynical Reason*, trans. Michael Eldred (Minneapolis: University of Minnesota Press, 1987), p. xx.
3. During Holmes's trial for the murder of Pitezel in Philadelphia, a small Holmes dime-admission museum of horrors was set up, exhibiting artifacts and photographs of Holmes, his victims, and his crime scenes. It included a large pile of human bones, a human skull, and a miniature replica of the Castle in Chicago. See Charles Boswell and Lewis Thompson, *The Girls in Nightmare House* (New York: Fawcett, 1955), p. 46.
4. Allan W. Eckert, *The Scarlet Mansion* (Boston: Little, Brown, 1985), p. 491; see also Franke, *The Torture Doctor*, p. 185.

5. Theodor W. Adorno, "Veblen's Attack on Culture," in *Prisms*, trans. Samuel and Sherry Weber (Cambridge: MIT Press, 1981), pp. 85–86.

6. Ibid., p. 86.

7. Ibid.

8. Lacan "The Mirror Stage," in *Écrits: A Selection*, trans. Alan Sheridan (London: Tavistock, 1977), p. 5.

9. Lacan, "Aggressivity in Psychoanalysis," in *Écrits*, pp. 27–28. On the modernist captation of the subject by mass-mediated spaces, see, for example, Beatriz Colomina, *Privacy and Publicity: Modern Architecture as Mass Media* (Cambridge: MIT Press, 1994).

10. Lacan, "Aggressivity in Psychoanalysis," p. 28.

11. On the uncanny status of "outmoded spaces" in modernist experiences of regression, see Hal Foster, *Compulsive Beauty* (Cambridge: MIT Press, 1993), pp. 157–91.

12. The understanding of constructions such as the castle strictly as "symptoms of the subject"—its "symbols" or "metaphors" or "images"—has the effect of conserving the priority, or anteriority, of the subject to its representations. At the same time, however, it posits an intimacy with representation or symbolization or identification that jeopardizes, or at least hesitates, that priority. The uncertain boundaries between the subject and its constructs makes visible the uncertain formation of the subject from the inside out and from the outside in. It would seem that the "distinctly modern character of regression" involves not exactly a collapse or disintegration of the subject. It points to the centrality of processes of reproduction, mimesis, or reduplication in the formation of the subject, what I have been describing in terms of a primary mediation.

13. In the final part of this study, "Wound Culture," I will take up the insistence of such scenes in terms of the category of the trauma.

14. My intent here is not to review the vast literature on degeneration and regression or to rehearse the often conflicting demarcations between these categories. I mean instead to focus on the centrality of mechanisms of reduplication and reproduction to both. One tendency has been to set up a series of ratios that function as "periodizations": along these lines, degeneration is to regression as the bodily/biological is to the psychic/ psychoanalytic as shock is to trauma as naturalism (or modernism) is to modernism (or postmodernism). One effect of this tendency is to shift the interest from the object (bodies or events) to its theorization, building that theorization into the object itself. (This shift from the object to its theorization—to "the priority of synchrony over diachrony"; the priority of symbolization or theorization over body or event—is in fact one way of locating the claim of "the postmodern" as such.) It is precisely such periodizations and priorities that are under pressure in what I want then provisionally to call "degeneration/regression." Accounts of degeneration/regression, it will appear, hold steadily visible the

uncertain grounding of identity in the bodily or the psychical, and the uncanny periodizations and reduplications, in play at the level of the subject.

15. Daniel Pick, *Faces of Degeneration: A European Disorder, c. 1848–1918* (Cambridge: Cambridge University Press, 1989), p. 212.

16. Ibid., p. 86.

17. On Sartre's description of seriality, see Fredric Jameson, *Marxism and Form* (Princeton: Princeton University Press, 1971), pp. 247–52.

18. C. F. G. Masterman, *The Condition of England* (1909; reprinted London, 1960), p. 160.

19. Ibid., p. 161. On crowd-regression, see also Le Bon, *The Crowd*, and Elias Canetti, *Crowds and Power*, trans. Carol Stewart (New York: Noonday, 1984); and on the imbrications of group psychology and ego formation, see Mikkel Borch-Jacobsen, *The Freudian Subject*, trans. Catherine Porter (Palo Alto, CA: Stanford University Press, 1988); on the threat of "homogeneity" and "dissolution," see Georges Bataille, *Visions of Excess: Selected Writings, 1927–1939*, trans. and ed. Allan Stoekl (Minneapolis: University of Minnesota Press, 1985), pp. 137–38.

20. Pick, *Faces of Degeneration*, p. 91.

21. Jameson, *Marxism and Form*, p. 250.

22. The Castle was hastily gotten up in part to "accommodate" the fair's vast crowds. "Every night the rooms on the two upper floors of the Castle were filled to overflowing" (Boswell and Thompson, *The Girls in Nightmare House*, p. 87). During its six months of operation, the Fair was visited by 27 million people, roughly equivalent to half the national population.

23. And this is also one way in which social and psychological notions of regression converge on the matter of "the primitive." Such a convergence is by now familiar enough; primitivism has thus come to serve as a point of contact between historical and psychoanalytic accounts of identity formation, in places a way of "swapping" between these accounts. It is the dependence of modern primitivism on technologies of *reduplication* and on the repetition and spectation of traumatic or murderous scenes that centers my account here.

24. On the simulated primitivisms of machine culture, see my *Bodies and Machines* (New York: Routledge, 1992), especially part 5: "The Love-Master."

25. Quoted in Richard Slotkin, "Buffalo Bill's 'Wild West' and the Mythologization of the American Empire," in *Cultures of United States Imperialism*, ed. Amy Kaplan and Donald E. Pease (Durham, NC: Duke University Press, 1993), pp. 165, 175.

26. Slotkin, "Buffalo Bill's 'Wild West,'" pp, 166, 168; my emphasis.

27. One of the small melodramas Buffalo Bill Cody re-enacted was his murder of a young Indian warrior named Yellow Hand. This was a murder committed *for the purpose of its reproduction* — in effect, the turn of the century version of the snuff film. Having temporally abandoned "play acting" for "the real

thing," Cody had returned to the army as a scout; engaging a small party of Cheyenne, "Cody singled out and killed Yellow Hand; then, as troopers swept toward him, walked to the corpse, scalped it, and waved his trophy in the air." Prior to the killing, Cody had changed his usual clothing for one of his stage costumes. Subsequently, on stage in "The First Scalp for Custer," the stage costume he had assumed for the act became the index of the authenticity of its re-enactment (see Slotkin, "Buffalo Bill's 'Wild West,'" pp. 167–68).

28. It is worth recalling that land reclamation, at the turn of the century, figured at once the achievement of civil engineering and the achievement of identity formation *tout court*. Hence Freud's model of the colonization of the id by the ego as the draining of the Zuider Zee (Sigmund Freud, *New Introductory Lectures, The Standard Edition of the Complete Psychological Works of Sigmund Freud*, ed. James Strachey [London: Hogarth, 1953–74], 22: 80). See also Freud's account of the domain of fantasy as a sort of nature-museum:

> The creation of the mental domain of phantasy has a complete counterpart in the establishment of "reservations" or "nature-parks" in places where the inroads of agriculture, traffic, or industry threaten to change the original face of the earth rapidly into something unrecognizable. The "reservation" is to maintain the old condition of things which has been regretfully sacrificed to necessity everywhere else; there everything may grow and spread as it pleases. . . . The mental realm of phantasy is also such a reservation reclaimed from the encroaches of the reality-principle. (Freud, *General Introduction to Psychoanalysis*, p. 381.)

> The toggling between *preservation* and *reclamation* (nature and its reduplication) in this account of the topography of fantasy is exactly the strange temporality of archaic places I am examining here. (For a more extensive account of the relays between civil engineering and self-making, see my *Bodies and Machines*, part 5.)

29. See Alan Trachtenberg, *The Incorporation of America: Culture and Society in the Gilded Age* (New York: Hill and Wang, 1982), pp. 208–234; and Robert W. Rydell, *All the World's a Fair: Visions of Empire at American International Expositions, 1876–1916* (Chicago: University of Chicago Press, 1984), pp. 38–71.

30. Quoted in Trachtenberg, *The Incorporation of America*, p. 216.

31. Quoted in Trachtenberg, *The Incorporation of America*, p. 209, and Rydell, *All the World's a Fair*, pp. 64–65.

32. Hubert Howe Bancroft, *The Book of the Fair*, 2 vols. (New York: Bancroft, 1894), quoted in Edward Wagenknecht, *Chicago* (Norman, OK: University of Oklahoma Press, 1964), pp. 14–15.

33. Edward B. McDowell, "The World's Fair Cosmopolis," *Frank Leslie's Popular Monthly* 36 (October 1893): 415.

34. "Through the Looking Glass," *Chicago Tribune*, 1 November 1893, quoted in Rydell, *All the World's a Fair*, p. 65.

35. As Adorno concisely states "the compulsive element in modern archaism":

> Perhaps it is possible to formulate the relationship between progress — "modernity" — and regression — "archaism" — in the form of a thesis. In a society in which the development and the stifling of energies are inexorable consequences of the same principle, each technical advance signifies at the same time a regression. . . . Barbarism is normal because its does not consist in mere rudiments but is steadily reproduced along with and in direct proportion to man's domination of nature.

> (Adorno, "Veblen's Attack on Culture," pp. 85–86.)

36. "What the Fun Fair achieves with its Dodgem cars and other similar amusements," Walter Benjamin notes, "is nothing but a taste of the drill to which the unskilled laborer is subjected in the factory." One discovers in the Fair a drill in "the art of being off center," or, more exactly, a drill in the distracted rhythms of machine culture: the disciplinary drill, recreated as recreation, and nowhere more explicit than in the stilled bodies incorporated into the moving machine of the giant pleasure wheel. The connection between these twinned forms of regression — the internal links between forms of wilding and forms of disciplinary individualism — define the scenes of the Midway. This is, as Benjamin further observes, "the true connection between wildness and discipline." (Walter Benjamin, "On Some Motifs in Baudelaire," in *Illuminations*, trans. Harry Zohn [New York: Schocken, 1969], p. 176).

37. Walter Rathenau, *On the Critique of the Times* (1912), quoted in Sloterdijk, *Critique of Cynical Reason*, p. 438.

38. Hence if the premodern and premechanized are reinvoked in these scenes, they are reinvoked precisely by way of modernist mechanisms of reduplication and simulation: simulated in the form of the temporal-spatial orders by which "the natural," "the archaic," and "the primitive" are reproduced, and reproduced as mass spectacle.

39. Otis T. Mason [Notes for Chicago Exhibit], National Anthropology Archives.

40. On epidermism and taxidermy, see my *Bodies and Machines*, part 5, and chapter 2, above.

41. On Gein, see Harold Schechter, *Deviant* (New York: Pocket, 1991).

42. Antonin Artaud, "Van Gogh, the Man Suicided by Society," *Artaud Anthology*, trans. Mary Beach and Lawrence Ferlinghetti (San Francisco: City Lights, 1965), p. 158.

43. Raymond Loewy, *Never Leave Well Enough Alone* (New York: Simon and Schuster, 1951), p. 220; Ellen Lupton and J. Abbott Miller, "Hygiene, Cuisine and the Product World of Early Twentieth-Century America," in

Incorporations, ed. Jonathan Crary and Sanford Kwinter (New York: Zone, 1992), pp. 509–510.

44. Georg Simmel, "The Aesthetic Significance of the Face," *Georg Simmel, 1858–1918*, ed. Kurt H. Wolff (Columbus: Ohio State University Press, 1959), pp. 276–81.

45. Gilles Deleuze and Félix Guattari, A *Thousand Plateau: Capitalism and Schizophrenia*, trans. Brian Massumi (Minneapolis: University of Minnesota Press, 1987), pp. 168–71.

46. Ibid., pp. 168–74.

47. Henry Maudsley, *Body and Mind: An Inquiry into their Connection and Mutual Influence Especially in Reference to Mental Disorders*. The Gulstonian Lectures, 1870 (London, 1870), pp. 62–63; see also Pick, *Faces of Degeneration*, p. 209. See also Norris, *Serial Killers*, for a Lombrosan account of the phylogenic and regressive aspects of the serial murderer's constitution: "Researchers have suggested that if an individual has at least three to five physical anomalies, such as webbed skin between his fingers or earlobes that are connected to the sides of his head, it is likely that he also has a genetic disorder of the primal brain. Because the development of the fetal brain takes place at the same time that the skin develops, any skin or cartilage abnormalities are usually indicators that the brain, too, has not completely developed" (246–47). Norris proceeds by listing twenty-three indicator abnormalities, most of which refer to malformations in head and face.

48. Holmes, quoted in Franke, *The Torture Doctor*, pp. 183–84.

49. That is, the exact convergence of the "black hole/white wall system" of faciality and the conditions of the subject in the place of the crowd is what becomes legible here.

50. Canetti, *Crowds and Power*, pp. 15–16.

51. Benjamin, "The Work of Art in the Age of Mechanical Reproduction," *Illuminations*, p. 226.

52. Benjamin, "Surrealism," in *Reflections*, trans. Edmund Jephcott (New York: Schocken, 1978), p.182. The apposite American counterpart to the Atget scenes are the depopulated city streets and deserted home sites in Edward Hopper's paintings: dark images virtually reproduced in serial-killer films such as Hitchcock's *Psycho* or Terence Malick's *Badlands*. More contemporary versions of the links between American violence and exorbitant site-specificity might include Joel Sternfeld's 1994 photographic exhibition, "On This Site . . .," which incorporated now-empty murder and death places, from the motel in Memphis where Martin Luther King Jr. was killed to the place in Central Park where Jennifer Levin's body was found, as well as a newspaper photo of a "too normal" young man over the caption "serial killer." Or, it might include Tom Philbin's *Murder U.S.A.*, subtitled a "true-crime travel guide to the most notorious killing grounds in America" (Tom Philbin, *Murder U.S.A.* [New York: Warner, 1992]).

PART 4.

Wound
Culture

10 • Wound Culture

Serial killing, I have argued, has its place in a culture in which addictive violence has become a collective spectacle, one of the crucial sites where private desire and public fantasy cross. I have been tracing some of the ways in which the mass attraction to atrocity exhibitions, in the pathological public sphere, takes the form of a fascination with the shock of contact between bodies and technologies: a shock of contact that encodes, in turn, a breakdown in the distinction between the individual and the mass and between private and public registers. One discovers again and again the excitations in the opening of private and bodily and psychic interiors: the exhibition and witnessing, the endlessly reproducible display, of wounded bodies and wounded minds in public. In wound culture, the very notion of sociality is bound to the excitations of the torn and opened body, the torn and exposed individual, as public spectacle.

It may not be entirely perverse to suggest that the "opening" of bodies and persons to public experience is intimated in the very notion of the public sphere as *öffentlich*, "openness" (the etymological root of the German word for public). For Habermas, of course, the notion of the *öffentlichkeit*, the public sphere, is the alternative to the sphere of public violence (the domain of the state and of the police): the substitute for the deeply embodied particularity of persons by way of the public sphere's principles of generality and abstractness.[1] But this perhaps indicates a basic limit to this older (eighteenth-century) model in accounting for the pathological public sphere. To the extent that private and public communicate in the opening of bodies and persons and in the gathering

around the wound, one detects a radical mutation and relocation of the public sphere, now centered on the shared and reproducible spectacles of pathological public violence.

The uncertain relays between private desire and public space in wound culture are nowhere clearer than in the surfacing, or resurgence, of the category of "the trauma" (Greek for wound) on the contemporary scene. It has become something of a commonplace to observe that "postmodern art has an interest in probing the wound and exploring the effects of the repetition of the trauma."[2] The contemporary public sphere represents itself to itself, from the art and culture scenes to tabloid and talk TV, as a culture of suffering, states of injury, and wounded attachments.[3] The resurgence of trauma as a flashpoint of psychological and social ways of locating the subject and its vicissitudes is thus perhaps by now self-evident. But the category itself, and what exactly it provides evidence of, has in fact remained something of a black box.

I want in these concluding pages to shift the large question of the meaning of the trauma or wound in the direction of this coalescence, or collapse, of private and public registers: the convergence that makes possible the emergence of something like a pathological public sphere in the first place.[4] The pathological public sphere, we have seen, is everywhere crossed by the vague and shifting lines between the singularity or privacy of the subject, on the one side, and collective forms of representation, exhibition, and witnessing, on the other. Along these lines, the trauma has surfaced as a sort of crossing-point of the "psycho-social." The very uncertainties as to the status of the wound in trauma—as physical or psychical, as private or public, as a matter of representation (fantasy) or as a matter of perception (event): these uncertainties are markers, on several levels, of this excruciated crossing. The notion of trauma has thus come to function not merely as a sort of switchpoint between bodily and psychic orders; it has, beyond that, come to function as a switchpoint between individual and collective, private and public orders of things. The wound and its strange attractions have become one way, that is, of locating the violence and the erotics, the erotic violence, at the crossing-point of private fantasy and collective space: one way of locating what I have been calling the pathological public sphere.[5]

The Abnormal Normality of Trauma

One popular "take" on these matters can provisionally be located by way of a recent best-selling novel on serial sexual violence, Caleb Carr's

The Alienist.[6] This highly popular, albeit relentlessly unimaginative, novel tells a story of serial killing in New York at the end of the nineteenth century; it is presented as an origin story of the age of the sex crime. The novel's popularity may in part reside in its unimaginativeness: much of the novel sets out the results of the author's studious research in the historical actors, architecture, and street life of the city in the 1890s. But part of its popularity, as signalled from its title on, may reside in the giving over of the understanding of such cases to the expert in psychopathology: the proto-psychoanalyst or "alienist." The name that the narrator again and again gives to the newly discovered way of accounting for the sex crime and the sex criminal is "context." But it remains radically unclear in the novel whether context refers to material and historical conditions, with which the narrative is exorbitantly replete (its realism), or, instead, to the formative conditions of childhood trauma that turn out to mark (in markedly perfunctory and by now predictable ways) the novel's child-killer (its psychologism). It is arguably the very noncommunication between these senses of context that makes for the popular appeal of this novel, among others: the alienist as the expert in noncomprehension, where pathological violence is concerned.

It has become routine in serial killer fiction—from the earliest instances such as Zola's *La Bête humaine* (1890) to more recent ones such as Jim Thompson's *The Killer Inside Me* (1952) or Thomas Harris's *Red Dragon* (1981), or Dennis Cooper's *Frisk* (1991)—to flashback repeatedly to the traumatic event that is taken, retroactively, to motivate addictive killing. (In the case of Zola's prototype serial killer novel, this amounts to a cartoon-like flashback to a sort of cave-man, antifemale violence.) But these motivating explanations routinely have a transparently perfunctory character, as if the mere invocation and repetition of "trauma" fills in, or counts as, cause. These invocations of trauma generally have the unconvincing character of a sort of dime-store psychology. In the terms of Thompson's killer, for example, the psychology of the trauma reduces to the cliché: "the boy is father of the man."[7] Or as the British serial killer Dennis Nilsen summarized the explanation he gave for his acts: "I casually threw the police a psychiatrist's cliché."[8] To the extent that these explanations take the form of pop-psychology and the cliché—that is, to the very extent that they are *experienced as unconvincing*—they in effect conserve the subject's secret singularity, even as that secret is renamed "the trauma."

The recourse to trauma as "cause" thus poses some basic problems, and not least because of the general inflation of the categories of trauma

and abuse in a wide range of contemporary discourse (the "abnormal normality" and generality of the category). The governing psychoanalytic assumption of the "*essentially traumatic nature of human sexuality*" gives some indication of how trauma stands in for rather than defines the causes of repetitive violence.[9] For if "normal" disorders of identification structure cases of repetitive aggressivity—if sexuality, violence, and trauma endlessly loop back on each other in the psychoanalytic account: if "we are all killers in the unconscious of our desires" (Žižek), if "the pysche might be murderous in itself" (Rose)—what exactly counts as trauma in these cases?[10]

The assumption that the cause of compulsive violence resides ultimately in childhood trauma has become canonical, in criminological and in popular accounts. This is scarcely surprising. On one level, the recourse to the trauma of child abuse or sexual abuse as explanation simply follows from "twentieth-century beliefs that childhood experience forms the adult" (that is, the basic premise of psychoanalysis).[11] Such an explanation has become virtually automatic in the literature (factual and fictional) on serial killing, assuming a peculiarly *a priori* status, even

Figure 13. *Lethal Spaces* (Municipal Archives, Department of Records and Information Services, City of New York; reproduced in *Evidence* by Luc Sante, 1992).

where evidence for it is conspicuously absent. Typical enough are the reports on the recent case of the convicted English child-killer Robert Black, whose "pathological fascination with child sex," we are simply told without any further specification, "may have stemmed from abuse."[12] As the forensic psychiatrist Helen Morrison observes, the foundational status of trauma in serial killing is, at the least, open to question: "A serial killer may complain that he was abused as a child, either physically or sexually. Little or no evidence has demonstrated, however, that these complaints are consistent or that the alleged abuses have any real foundation."[13]

But posing the matter of foundations in this way reposes the same question on another level: the basic uncertainty as to what counts as the "real foundation" of trauma is bound up with what counts as trauma in the first place. For if trauma is, first, the wound, it is second, a wounding in the absence of a wound: trauma is in effect an effect in search of a cause.[14] "'Psychological pain,'" as Nietzsche pointed out early on (1887), "does not by itself seem to me a definite fact, but on the contrary only an interpretation — a causal interpretation — of a collection of phenomena that cannot be exactly formulated — it is really only a fat word standing in place of a skinny question mark."[15]

Such a questioning of trauma as cause does not reduce the category of the trauma to a pseudo-concept, though it is certainly to identify it as a category that leaks. Nor is it to disqualify the evidence of abuse (physical and sexual) in the etiologies of some compulsive killers. It could not be clearer in a range of cases: in the unremitting childhood physical and sexual abuse of the Texas serial killer Henry Lee Lucas, for example, or in the 1960s' German case of Jürgen Bartsch, a tortured child-killer whose torture-killings rehearsed, radicalized, and externalized his own experience as victim. Bartsch took his living victims apart, opening their interiors to view. As Bartsch's psychoanalyst succinctly expressed it, in the title of his study of this murderer, this is the logic of "The Murderer as Victim."[16]

One reason for the resistance to trauma as cause, in a range of governmental and quasi-official accounts of serial violence, is a resistance to just this reflexive logic of the victim: the victimizer as victim — in effect, an equivalence, an hypnotic identification, of murderer and victim. On this model, the killer-victim is one link in the chain of traumatic repetitions: abused and victimized as a child, abusive and victimizing as an adult. This amounts to a mimetic coalescence of self and other: a mimetic identification intensified to the point of reproduction.

Conversely, one reason for the attraction to the explanation of public violence in terms of childhood trauma is that it makes possible a strictly

private accounting for public violence. This is part of a more general movement of *privatization*, one that governs the contemporary "personalization" of politics and public life: the narrowing of public experience to scenes of privacy, and not least the scene of the trauma; in effect, the notion that "the personal is the political" has been reversed, turned round to the notion that "the political is the personal."[17]

The relays between private and public are, however, a bit more complicated here. A sort of hypnotic mimetic identification is crucial to the understanding of the trauma. Trauma is, at least in part, an extreme expression of the mimetic compulsion—a photography at the level of the subject. But in this mimetic compulsion, I have argued, one detects a minimalist model of a sociality (the mimetic contagion of self and other as the basis of the social bond). One detects the model of a sociality bound to pathology. In short, the opening of relation to others (the "sympathetic" social bond) is at the same time the traumatic collapse of boundaries between self and other (a yielding of identity to identification). In this way, the opening of a possibility of relation to others also opens the possibility of violence: the mimetic identification *at the expense of* the subject and a violence *in the name of* a violated singularity and self-difference. In this way, too, the opening toward others is drawn to the collective spectacle of torn and open bodies and persons: a wounding and gaping toward others in the pathological public sphere.

There is a good deal more to be said about this sociality of the wound. But for the moment it will be seen that there are basic limits to the behaviorist or reflex model of the trauma. This reflex model in effect substitutes post-facto description for explanation: it makes visible the basic intimacy between description and tautology in such accounts of trauma or abuse as cause. It conserves, beyond that, a reductive shock model of the wound, by which the "impact" of external events turns the subject of trauma into a duplicating machine (the trauma victim as the "Mr. Xerox" of Dennis Cooper's *Frisk*: the subject as a reproduction of external events turned outside in).

The questioning of trauma as cause—the notion of trauma as a collection of phenomena that cannot be exactly formulated, as an indefinite fact—points to something else, in the more properly psychoanalytic conception of the trauma. The psychoanalytic conception of the trauma does not abandon the relays between trauma and mimesis (mechanisms of reduplication): it interiorizes these mechanisms. This interiorization defines the shifting from a medical to a psychoanalytic conception of the wound that is the trauma. As Laplanche summarizes it, "From the model of physi-

cal trauma we have moved to psychical trauma, not through any vague or unthematized analogy from one domain to the other, but through a precise transition: the movement from the external to the internal. What defines the psychical trauma is not any general quality of the psyche, but the fact that the psychical trauma comes from within." The wound is thus reconceptualized on the order of the subject. A good deal is at stake in this transition from the external to the internal. For at stake in this shifting within of the foundations of the trauma is the foundational status of psychoanalysis itself: "the inaugural notions of *psychical trauma* and *traumatic hysteria*" that found psychoanalysis's specificity as a certain field of knowledge.[18]

What is being recalled in the notion of "the originary character of the reflexive moment for the [traumatic] constitution of human sexuality . . . is the *autonomy* of the field of human sexuality as the field of psychoanalysis."[19] Or, as Slavoj Žižek recently restates this point: denials of the strictly psychic nature of trauma "are blind to Freud's fundamental insight into the phantasmic character of trauma—that is to say . . . it denies the *autonomy* of the psychic domain."[20] For this reason, the assault on the phantasmic status of the trauma has amounted to an assault on the status of the field of psychoanalysis itself.[21]

But what exactly do such assertions of the radical *autonomy* of the psychic domain amount to, with respect to the matter of the "trauma"? What exactly does it mean to found the autonomy of psychic domain—in effect, to recontain the integrity of the subject—by way of the trauma? For is not the notion of the trauma itself, *within the psychoanalytic account itself*, bound up with a fundamental *breakdown* in the autonomy of the subject: a fundamental shattering or *breaking-in* of the boundaries between the external and the internal?

The psychical trauma "comes from within" but in the form of the breaking of an outside in.[22] There is, on the one side, a precise transition from a (medical) notion of trauma, as physiologically caused, to a (psychoanalytic) notion of trauma, as an "entirely 'psychical'" wound (a "paralysis due to ideas"). And yet, on the other, the psychoanalytic conception of trauma functions as something of an internal alien entity within psychoanalysis itself: as an internal limit or boundary of psychoanalysis. (One might say of the trauma what Freud said of the instincts: the trauma "appears to us as a borderland concept between the mental and physical."[23]) It is not only that the rupture in causality and representation that marks the trauma jeopardizes the integrity of the subject. It threatens to rupture as well "the integrity of psychoanalytic theory regarding the subject . . . to critique the function of the concept of trauma

itself."[24] The concept of trauma is, on this view, foundational to psychoanalysis even as it undermines its foundations and the specificity of its domain. That is, the psychoanaltyic conception of trauma exactly pressures, on one level, the separation between physical and psychical, external and internal determinations that it posits, on another. There remains, however, a sort of internal communication between these rival determinations. It remains, above all, as a tension *within* the psychoanalytic conception of trauma itself: "So clear a separation between what is purely somatic and what is purely psychical in the trauma has never been sustained within the Freudian tradition."[25]

Is it possible then to shift the conception of trauma: to trace out what this very *impurity* within the concept indicates? How might this very breakdown between the psychical and the bodily, and between private and public registers, define the borderland concept of the trauma itself? The understanding of trauma, I am suggesting, is *inseparable from the breakdown between psychic and social registers*—the breakdown between inner and outer and "subject" and "world"—that defines the pathological public sphere. What if the critique of the function of the concept of trauma itself within psychoanalysis—trauma as psychoanalysis's internal alien entity—were "turned"? What if it were turned toward what C. Wright Mills, writing at the emergency point of "psychology as public culture," called the strange "bordering of the social on the psychiatric"?[26]

This bordering returns us to the relays between trauma and mimesis: a mimetic coalescence of self and other, self and representation, to the point of reproduction. The problem that the trauma poses is a radical breakdown as to the determination of the subject, from within or without: the self-determined or the event-determined subject; the subject as cause or as caused; the subject as the producer of representations or their product. These breakdowns devolve on a basic uncertainty as to the subject's and the body's distance, or failure of distance, with respect to representation. The psychoanalytic understanding points to the manner in which the interpretation, representation, or reduplication of the event (real or posited) is inseparable from the concept of trauma—the manner in which the insistence of the trauma depends on the sense, or non-sense, the subject retroactively (that is, retroactively representing itself *as* subject) makes of it. For this reason, it is not ultimately a matter of choosing between abuse-as-fact and abuse-as-fantasy. The attribution of trauma, in any event, bends event-reference to self-reference, transferring interest from the event (real or posited) to the subject's (self-)representation.

Seen this way, the trauma is something like the compulsive return to

the scene of the crime: not merely in that the trauma is the product of its repetition, but also in that it is the product, not of an event itself, but of how the subject repeats or represents it to himself.[27] One detects here what might be described as *a binding of trauma to representation or scene*: in order for this return to the scene of the crime to take place, time must be converted to place, act into scene; cause and effect, act and fantasy, perception and representation must change places.[28]

I now want to turn to the binding of trauma, in the pathological public sphere, to the matter of representation — or, more exactly, to mass-mediated spectacles of torn bodies and torn persons. I want to take up, in part, contemporary popular representations of the wound: that is, the popular understanding of representations as having the power to wound. The contemporary understanding of the subject of violence makes visible a traumatic *yielding* to representation (a yielding of bodies and persons to representation intensified to the point of reproduction). This amounts to the "assault" or "bombardment" of the subject by the burgeoning materialities of communication, reproduction, and representation (in effect, the "literal technologies" as *letter bombs*). The understanding of the subject of violence as the subject in a state of shock or trauma is inseparable from an understanding of the social as "the social-symbolic order." And it is inseparable, in turn, from the understanding of the "impact" of the social-symbolic on the subject *as* violation and wounding (*the sociality of the wound*). These are the relays between bodies and signs, wounding and sociality that make up a wound culture.

Letter Bombs

The popular understanding of trauma makes the binding of trauma to representation clear enough. For one thing, in a range of recent popular films and novels, trauma and virtual reality have become two ways of saying the same thing, each standing in for other. As one recent novel on pornographic serial violence in the high-tech "virtual reality" industry — Stephen Greenleaf's *Flesh Wounds* — represents it: "'That [father-daughter seduction] sounds a little Freudian.' 'It's a lot Freudian. Which makes me part of a noble tradition of daughters who've been screwed by their daddies.' 'You don't mean literally, I hope.' 'What difference does it make? Figuratively hurts just as much.'"[29] The popular notion of trauma is premised on a failure of distinction between the figurative and the literal, between the virtual and the real: representations, it seems, have the same power to wound as acts.

The popular understanding of trauma tends, therefore, to turn its focus on the violent impact of images or reproductions of violence: in the simplest terms, to the representation of violence as the cause of violence. Hence one recent *Newsweek* piece—called "What's So Bad About a Little Trauma?"—registers the alamodality of trauma in this way: the danger is the lifelikeness of images (on *Jurassic Park*: "These beasts look state-of-the-art real. And they *eat* people") and the literalization of fantasy (children, particularly, it is argued, "usually have trouble distinguishing between fact and fantasy").[30]

Typically enough again, two coupled but different versions of the violence of representation are here folded into one. The notion that representations of violence cause acts of violence ("monkey see, monkey do") is conflated with something else: with the violence intrinsic to the penetration of representation into real life. This is to imagine that representations were not part of real life but its other or its opposite: that representations normally impinged on the subject only "from the outside." The danger then is not merely violent representations but a failure of distance with respect to representation: the danger, on these popular accounts, is that one might be devoured by representations.[31]

Figure 14. *Wound Landscapes*: Richard Misrach, Dead Animals #294, 1987–89.

In the recent serial-killer movie *Virtuosity*, the computer composite or profile of the serial killer comes to life and takes life. In the recent serial-killer movie *Copycat*, there is no deeper motive to serial killing than turning oneself into a copy of someone else. In both, the copy or profile takes on the reality ceded by real-life characters who have yielded their souls to a traumatic repetition. Compulsive killing becomes indistinguishable from the mimetic compulsion, which, in turn, becomes indistinguishable from mass, machine-produced representations come to life and taking life. Along these lines, and across a range of recent popular culture, the paranoiac and the paranormal, psychoanalytic fiction and science fiction — psy-fi and sci-fi — find their point of contact.

There is nothing "deeper" to psychological motivation in these instances than imitation and repetition (virtual profiles or "statistical pictures" of killers taking on bodies; mimesis or copycatting as motive). Psychology in such representations reduces to the repeated, uncertainly "internal" flashback that, in turn, cinematically looks just like, and cannot be distinguished from, "external" events. The virtual and the figurative look just like, and hurt just as much as, the literal and the real: perception and representation change places — which is one way trauma is understood in these popular spectacles of the force of the mass spectacle.

From one point of view, the techno-thriller simply dispenses with psychology, transferring interest from interiors entirely to technology-saturated exteriors. But, from another, of course, these exteriors are nothing but interiors — psychotopographies — a psychology not housed in persons but distributed across landscapes and public spaces. This is not to say that these landscapes are simply "metaphors" of interiors. They are what private interiors look like — spectacles of public violence, wound landscapes. There is, again and again, in such thrill-kill, tech-noir films, the ostensible opposition between humanity and technology (torn bodies and killing machines), the driving apart of private interiors and public spaces. (In *Copycat*, for example, privacy is reduced to the locked space, the pathological privation, of agoraphobia: being inside and having an inside becoming two ways of saying the same thing.) But these interiors — whether bounded by the walls of the home or bounded by the wall of the skin — are governed by a deepening intimacy with machines. That locked, private interior (in films such as *Copycat*, *Virtuosity*, or *Strange Days*) is directly "wired" to the virtual public sphere of the Net: "the switchboard of the soul."[32]

One can longer tell whether this switchboard of the soul is the literalization, or realization, of interior states (the delusion of reference of the

influencing machine) or the impact of the literal technologies of mass-mediated public culture (machinic influence). One can no longer tell whether this is a matter of (self-)representation or (worldly) reference, psychosis or sociology. This uncertainty as to the cause of the subject is not separable from the anxieties and appeals of the body-machine-image complex: it is another, and traumatic, way of inhabiting the body-machine-image complex.[33]

The boundaries have come down between inside and outside. Or, more exactly, there is an endless switching between them, along the lines of this binding of trauma to mechanisms of representation and reduplication. As one recent mapper of America's pathological public sphere, the novelist Steve Erickson, expresses it: there is a "deep fault line running from my psyche through my brain out my door ... straight to Melrose Avenue and the feet of Justine. ... Justine is a billboard."[34] These are the terms of the everyday, traumatic "fault line," or relay, binding private desire and mass public dream spaces.

The switch-point, or crash-point, between inside and outside is, above all, the wound. This is nowhere more incisively set out than in the work of J. G. Ballard, one of the compulsive cartographers of wound culture. Thus, in Ballard's novel *Crash*, the shock of contact between bodies and machines (eroticized accidents: real, planned, simulated) is also the trau-

Figure 15. *Technoir:* Volatile Memory, 1986.

matic reversal between private fantasy and the public sphere: "In the past we have always assumed that the *external* world around us has *represented* reality, and that the *inner* worlds of our minds, its dreams, hopes, ambitions, *represented* the realm of fantasy and imagination. These roles, its seems to me, have been reversed."[35] This reversal of the real, along the axis of representation, is, we have seen, one way of describing the switching between inside and outside that is called the trauma: the subject in a state of shock who appears, at the same time, as the subject shot through by the social. The subject of wound culture is not merely subject to recurrence but to the recurrence of recurrence itself: this traumatic "failure of his psyche to accept the fact of his own consciousness" is what Ballard calls "our traumas mimetized" (in effect, the mimetic compulsion mimetized) in the transfers between what is inside us and the machine.

In the preceding parts of this study, I have traced some of the forms these transfers take: the inseparability of materialities of communication and forms of violence in machine culture; the becoming visible of the materialities of writing and representation; the radicalization of the technology of writing in general; the generalization of the literal technologies (*une langue inconnue* of the body-machine-image complex); the rewriting of production in the idiom of information; the correlative collapse of the distinction between the life process and the machine process, as two interconvertible forms of information processing. As the systems theorist Niklas Luhmann has recently summarized it: "The system of society consists of communications. There are no further elements, no further substance than communications."[36] Or, as Norbert Wiener expressed it, in his earlier study of "the human use of human beings," both persons and machines may be understood as "communicative organisms."

Whereas the first industrial revolution "concerned the machine purely as an alternative to human muscle," what Wiener termed the Second Industrial Revolution concerns "the field in which the communicative characters of man and of the machine impinge upon one other." The traffic between persons and bodies and machines thus becomes visible as "two types of communication" in a "continuity of process." And this effectively collapses the distinctions between production and processing, between bodies and machines, and between matter and information. The erosion of the difference between "living beings and inanimate matter" means that, as Wiener dispassionately registers it, "the distinction between material transportation [bodies] and message transportation [codes] is not in any theoretical sense permanent and unbridgeable."[37]

In the Discourse Network of 2000, the unremitting flood of numbers,

codes, letters is popularly seen as replacing real bodies and real persons, threatening to make both obsolete. But what it really makes obsolete is the difference between bodies and information. This is not to say that this dispassionate representation of the erosion of the difference between living life and machinic life has at all become the governing or popular representation. The collapse of the distinction between bodies and codes registers instead as *splatter codes*; the switchboard of the soul as *soul murder*; the literal technologies as *letter bombs*. This sense of the literal technologies as letter bombs cannot be separated from the representation of modernity—from Freud and Simmel to Benjamin and beyond—in terms of the assault or bombardment of the senses of the subject: "to the theorization of modernity as trauma or shock."[38] It cannot be separated from the psychoanalytic conceptualization of consciousness as a *"protection against* stimuli"*: the protective shield notion of consciousness, the "consciousness-system" as something like a psychic V-chip, screening and screening out violence.[39]

Here it is possible to indicate a basic limit, or stalling point, in the psychoanaltyic conception of that violence: a stalling on the matter, the materiality, of representation. This conception of compulsive violence devolves, we have seen, on the notion of the "psyche murderous in itself" (Rose): on the notion that "we are all killers in the unconscious of our desires" (Žižek). On this view, the difference between the psychic-killer and the psycho-killer means this: the psychotic is one who takes things literally, acting out what others merely think, collapsing the distance between representations and things, private desires and public acts.

But what exactly does it mean in the Discourse Network of 2000—in the age of the "information society" and the era of the "literal technologies"—to take things literally? What does it mean, right now, to take the literal literally: to realize the literal technologies *to the letter*? The becoming-visible of the materialities of communication appears not merely as the condition of the psychotic and the traumatic: they are the condition of digital culture itself. What then can this convergence of the psychic and the social on the matter of the literal—the insistence of the letter in the unconscious and in the social orders both—tell us about contemporary accounts of the subject and, more exactly, the subject of violence?

Torn Persons

To the extent that the understanding of the modern subject has become inseparable from the categories of shock and trauma, modernity has come

to be understood under the sign of the wound. If shock appears as the subject's way of *parrying* the assault, or flooding within, of mechanisms of mass reproduction, trauma appears as the subject's assimilation to these mechanisms ("the transfer of what is inside us onto the machine"). Accounts of shock or trauma hesitate at this point—hesitate on whether this assault is a matter of representation or event (projection: "influencing machines" or implantation: machinic influence). This endless switching between inside and outside, private fantasy and public reality, is one way of marking the character of trauma in machine culture.

It may also mark the limit of the strictly psychoanalytic conception of the trauma. Stated as simply as possible, on the psychoanalytic account, the insistence of the letter, the "impact" of the symbolic order, are directly registered, but in the register of pathology: the subject's bombardment by "the social-symbolic order." "All of Freud's case histories," Friedrich Kittler observes, "demonstrate that the romanticism of the soul has yielded to a materialism of written signs."[40]

But to the extent that the materialism of signs registers as a *yielding* of the soul, the spread of the literal technologies throughout the social body registers as soul murder ("the word kills the thing"). This is modernity as verboballistics (letter bombs). The social order is imagined in terms of shock or assault or intervention, as "the *intervention* of the external, mechanical, symbolic order" and the Real of the subject as the point where the social-symbolic order fails.[41] To what extent, then, does such an account hold in place a "romantic" antimodernism? To what extent is the primary mediation of the subject itself parried as pathology? (Parried as the wounding of the subject's proud autonomy and singularity? Disavowed in the notion of the symbolic simply as "mechanical" and the mechanical simply as "external"?) To what extent, finally, does such a notion of the intervention of an external, mechanical, symbolic order devolve on paranoia to provide its model of "the social" and the psychotic to provide its model of "the symbolic"?

These large questions are at least in part questions about the way in which the notions of shock and trauma are bound up with the discourse network of 1900: how these notions register, or stall on, the "impact" of the literal technologies, the materialism of written signs and machinic images. Kittler, for example, traces in detail how the discourse network of 1900—the writing-down systems of the Second Industrial Revolution—"shadow" psychoanalysis. In the context of an extended account of the "nerve-language" of the prototype psychotic Schreber—the codiscoverer, with Freud, of the "psychic information system," "the transposition of the

268 | Serial Killers

body into a [written] corpus" — Kittler tracks how psychoanalysis directly registers these registration systems and how it effectively represses them.

There is, on one level, Schreber's war with the discourse network of 1900: his "soul-murder" through the invasion of psychophysics and experimental neurology (his direct confrontation with the neurophysiologist Flechsig). This is replaced, on another, with "Schreber's so-called father problems." Hence the family romance of the unconscious is revealed at the moment when it becomes dysfunctional: "The discourse network of 1900 places all discourse against the background of white noise; the primal soup [the media-data stream] itself appears in psychoanalysis, but only to be articulated and thus sublimated via writing proper."[42]

It is not merely that all of Freud's case histories demonstrate how the romanticism of the soul has given way to the materialities of the media. They demonstrate also the repression of what they demonstrate: "Movies and the gramophone remain the unconscious of the unconscious. Psychoanalysis, the science born with them, confronts sequences of images with a primal repression and sequences of sound with their distortion into chains of signifiers." The notion of modernity as the bombarding of the soul of the subject appears as the repression of this repression.[43]

In this way, the romanticism of the soul (not least the romances of the psycho and of the criminal as hero) is conserved, under the sign of pathology: shock and trauma; states of injury and victim status; the wound, the disease, the virus, and epidemics of violence; disaster, accident, catastrophe, and mass death; the abnormal normality of paranoia and psychosis; the pornography of mass-mediated desires and other forms of addiction and artificial life. The subject, on this model, can experience the social only as an intervention or invasion from without: the unremitting invasion, the letter bombing, that is both soul murder and socialization.[44] Along these lines, history and psychology, reality and fantasy, change places.

"Systems" thinking about the subject of the literal technologies — what Bateson called "the cybernetics of the self" — would seem long since to have yielded, or abandoned, this popular, exhausted model of the subject. Or, rather, it never quite abandons this abandonment. It rehearses the addiction to this model, as the model of addiction: the closed loop of self-yielding and self-recovery, of self-addiction and self-abandonment, consumer and consumption, that make up the *addiction to addiction* and the melodramas of uncertain agency.[45] There has been a remarkably long delay in acknowledging or yielding it in the cultural studies field.[46] The *nerve-language* of the Discourse Network of 2000 continues to be

rewritten in the form of *neuromances*.[47] There is a basic "stalling" on the matter of the literal: on the yielding of this model of the subject and the sign/body dichotomy on which it depends. This stalling is at least in part bound up with the captivation of a range of postmodern cultural studies by a version of the psychoanalytic paradigm: that is, by a sort of ritualized rehearsal of the paradigms — routinely abstracted and absolutized — of the "social-symbolic" and "the Real." (These ritual repetitions are the more captivated by the very plasticity and fraying of these paradigms.)

The materialities of writing and the "carnal density" of vision, progressively elaborated in the latter part of the last century, amounted to the emergence of "a new model in which the boundaries between body and world on the one hand and body and machine . . . on the other begin to blur."[48] In the observer's and the body's new relation to the image, there is the pressuring of a long tradition of mind/body and image/body dualism, by which all bodily sensations provoked by images are experienced as suspect.

This tradition of suspicion is only the most evident in the persistence of the model of the disembodied and distanced, and therefore empowered, (male) gaze or in the understanding of pornography as the pathological yielding of body and soul to mass, machine-produced images. The thrilled proximities of bodies, machines, and images are reduced to a story of victimage and bodily violation. On one side, there are the everyday erotics of the body-machine-image complex (only the most visible, for instance, in the manual erotics that extend from the basic flip book to the hand-held remote control). On the other, there is the understanding of pornography, for example, simply in terms of the reduction of sexuality to the body moved, and seduced, by the image and by the machine — as if sexual activity does not always have about it both an element of the mechanical and an element of the representational, elements of the automatistic and the fantasmatic. On the one side, that is, there is the erosion of the boundaries between body and world, body and image, body and machine. On the other, there is its direct pathologization: trauma as the collapse of the distinction between inner and outer, observer and scene, representation and perception, as the failure of the subject's proper distance with respect to representation ("the external, mechanical, symbolic"), a collapse of proper boundary maintenance — the opening and wounding of bodies and persons.[49]

One sign of the replay of this exhausted but unyielded model of the subject is the compulsive pas de deux between signs and bodies that continues to dominate postmodern critical discourse: the endless turning

from bodies to signs, the endless return of the body from the time of the sign. Nothing is more visible across the range of recent cultural studies than "the return of the body" and "the return of the real" (and, of course, "one of the definitions of the Lacanian Real is that it is the flayed body, the palpitation of the raw, skinless red flesh").[50] To what extent are these returns the worn variants on the mind/body and image/act dichotomy?[51] To what extent are these oppositions conserved, in this toggling between signs and bodies? (Conserved by way of an image/body dualism? Conserved by way of periodizing these returns?)

To the very extent that these accounts stall on the matter of the image and the matter of the literal, these claims to historical periodization sometimes resemble the fashion industry's seasonal claims that The Body, or Real Style, is back, again, this season. But this very resemblance may then function as one popular way of staging wound culture and trauma in the pathological public sphere.

For if the toggling between signs and bodies is nowhere clearer than in the rhythms of the fashion industry, this is not to dismiss these claims, but to indicate their contemporary force. The relays between bodies and signs

Figure 16. *Torn Persons*: Richard Misrach. *Playboy* #157 (Dennis Quaid), 1989–91.

could not be more explicit than in the model body as leading economic indicator (its bioeconomics) and as mass-mediated spectacle (the excitations of the body-machine-image complex). The fashion victim has, beyond that, emerged as something of a model trauma victim. I am referring in part to the traumatized look of the fashion model on the runway: to the stylized model body on display, a beauty so generic it might have a bar code on it; bodies in motion without emotion, at once entrancing and self-entraced, self-absorbed and vacant, or self-evacuated; the superstars of a chameleon-like celebrity in anonymity.

There is, as everyone knows, a longstanding association between death and reproduction, modernized in the tight association of death, or taking life, and photography (what Oliver Wendell Holmes described, early on, as "hunting and skinning" with a camera). In the public dream spaces of the fashion world, one detects something more: erotic encounters with bodies yielding to the inorganic; a disturbance in the relations between personality and space, in the form of a sort of publicly staged psychasthenia; a photography at the level of the object.[52]

Benjamin represented the assimilation of the animate to the inanimate in the world of fashion in these terms: fashion "couples the living body to the inorganic world," "it asserts the rights of the corpse." This is "the sex appeal of the inorganic."[53] The antifemale violence implicit in such targetings of the sex appeal of the inorganic is made explicit in the everyday identification of fashion victim as zombie, the predead or undead (one of the recurrent "signatures" both of the serial killer and his victims).[54] It is made utterly explicit in the casual brutality of fantasies such as this one: the models on the runway are "pale, like ghosts. Tall pretty ghosts . . . who played the part of the zombie. . . . They don't appear to be thinking anything at all. I mean they seem vulnerable in the profound sense of the word: you could stuff any one of them into the trunk of your car and she would go willingly because, like the runway, it's just another place to be."[55] These are the relays between the erotic and the inorganic; between vulnerably exposed, fetishized, bodies and the witnessing and wounding crowd; between the seduction of public dream spaces and fantasies of violence. These are some of the everyday scenes of a wound culture.

Live Witnessing: The Triumphalism of Survival

Public spectacles such as these are models of a convening of the crowd around displays of exposed and violated bodies and persons. They couple the trauma of witnessing and the triumphalism of survival. It is this

coupling to which I want now to turn, from a somewhat different angle. Here we might consider, again, the notion of the murderer as victim: the strange logic, that is, of referring to the murderer (as the title of one account of the serial killer Ted Bundy puts it) as "the only living witness." What sense does it make to refer to the perpetrator, the killer, as witness? What does this switching of places between killer and witness, this binding of crime to spectacle and killer to spectator, mean?

The psychologistic understanding of trauma as causal explanation (abused and victimized as a child, victimizing and abusive as an adult) posits, we have seen, the subject as victim: one relay in the chain of traumatic repetitions. The shifting between witness and victim, along the axis of identification, would thus seem to be a prolongation of what has been called the childhood "evidences of a normal transitivism": "the child who strikes another says that he has been struck; the child who sees another fall, cries."[56] On one level, this transitivism is by now familiar enough. It resembles the ambivalence that surfaces in watching spectacles of pain: the alternation between a sympathetic-masochistic identification with the victim and the sadistic pleasure that such an identification may "cover."[57] But such an abiding in ambivalence does not quite articulate the relays between striking and seeing, at least in the case of addictive violence: in the case, that is, of the killer who survives, in his own eyes, as the only living witness. What emerges, in this transitivist indistinction of self and other, is a sociality bound to pathology.[58]

Across a range of recent cultural studies—from studies of the holocaust to victim studies generally—a great deal of attention has been given to the trauma of witnessing and, collaterally, to the killer himself as trauma victim. In a cultural context marked by the burgeoning inflation of the categories of trauma and victim both, it may be useful to redirect this attention: to redirect it to the uncanny reversal by which the victor experiences himself and, in a literal sense, sees himself as witness or spectator of his own acts. It may be useful to redirect attention from the trauma of witnessing to the deadly logic of the survivor: to killing as a form, albeit the lowest form, of surviving.

The *triumphalism of survival* becomes starkly visible in a range of these cases—for example, in the case of Edmund Kemper, the California serial killer who "preserved" the decapitated and dismembered bodies of his victims. In Kemper's words: "What I wanted to see was the death, and I wanted to see the triumph ... the triumph of survival and the exultation over the death. They were dead and I was alive. That was a victory in my case."[59] This is, it would seem, the killer who escapes death by

apportioning it to others and who externalizes the fear of his own pulpy and secret interior in the conversion of another body into the bloody pulp he then witnesses. The drive to see one's own interior is coupled with the drive to survive that opening of interiors: a survival ratified by the fact of witnessing. This instances, it would seem, the uncanny reversal by which the killer again and again sees himself as the passive witness of his acts: the process of substitution that involves at once a sheer identification ("That's me, over there!") and a murderous disidentification ("It's him or me!"). Killing is, it would seem then, in the service of witnessing, such that witnessing ("I wanted to see") is converted into survival ("That was a victory in my case").

Something more surfaces here than the parrying of death by representation, killing by witnessing. At work is a somewhat different relation between seeing and wounding, between representation and violence. At work is the mimetic compulsion of the addictive killer: an identification without reserve, by which life takes a step backward. The desire to see the death, for Kemper, is self-described as a kind of addiction: "It was like eating, or a narcotic, something that drove me more and more and more." And Kemper's method of killing and witnessing, bound to the process of substitution that provides evidence of a "normal transitivism," is bound in turn to the addiction to addiction.

It is possible to trace this series of substitutions, in pure form, in the Kemper case. For Kemper, who ritually decapitated his victims, the target is above all the head: "She had a rather large forehead and I was imagining what her brain looked like inside." The desire to view interiors (which is the desire to view his own interior) makes for what he describes as the excitations of separating mind from body. Kemper everywhere absolutely distinguishes between control of mind and control of body: "My body was quivering . . . and my mind was slowly beginning to unravel. I had lost control of my body. . . . I just completely lost control of myself. But as far as my mind went, I had realized what was going on and I couldn't stop it. In this case my body was just exhausted and my mind was starting to go." The taking apart of oneself and of others is the coming apart of mind and body. But it is also the objectification and witnessing of the self that survives, as "I" witness, the coming apart of mind and body.[60]

The mind/body separation is here literalized in the most sensational auditory and visual form: in the "pop" when the head is separated from the body and in the triumphal witnessing of that separation. "You hear that little pop and pull their heads off and hold their heads up by the hair. Whipping their heads off, their body sitting there. That'd get me off." The

redemonstration of the difference between head and body is also, for Kemper, the redemonstration of the difference between person and body. Decapitations—or, as he expressed it in '60s' Californian, "head trip fantasies"—were "a bit like a trophy. You know, the head is where everything is at, the brain, eyes, mouth. That's the person. I remember being told as a kid, you cut off the head and the body dies. The body is nothing after the head is cut off." And the difference between mind and body and between person and body is also for Kemper, again, the difference between male and female: "Well, that's not quite true. With a girl, there's a lot left in the girl's body without a head. Of course, the personality is gone."[61]

The annihilation of personality is in the service of an absolute possession of others ("I wanted the girls for myself—as possessions"). But the drive to possess others is the drive to self-possession ("I wanted them to be a part of me—and now they are"). The identification with others, in this fashion, makes for the destruction of others—for what Zola, in his version of the Jack the Ripper story (*La Bête humaine*), called "destruction for fuller possession": that is, destruction for fuller self-possession. The stakes of the murder are thus not finally the possession of an object of love or pleasure but *self*-possession: the repeated, and repeatedly failed attempt, to pass through identification to identity.

This stalling of identity in identification is yet more complicated. There is, on the logic of addiction, one final relay in this chain of substitutions (mind/body, self/other, male/female). In accounts of the Kemper case, among others, one rediscovers a basic noncommunication between psychological and sociological determinations of the serial killer. Kemper's serial victims were a number of Santa Cruz "coeds." But his first victims were his grandparents and the last his mother and her friend. On some accounts, then, his killings were an expression of "sexual mania" and sexual possession. Collaterally, they were an expression of "mother rage," displaced upon surrogate or substitute victims.

This strictly "private" (psychic) motive is, however, seen as at once coupled with and opposed to a "public" (social) one. Kemper described his choice of victims in terms of "my little social statement. I was trying to hurt society where it hurt the worst, and that was by taking its valuable . . . future members . . . these snobby, happy brats." Kemper (not unlike another coed killer, Ted Bundy) targeted "only society's finest young girls." And the targeting of his mother is itself directed at her endless verbal "upbraid[ing] for lazing about . . . and not *making something of myself.*" Hence for the sociologically oriented interpreter of serial murder, Kemper's violence is, above all, "a response to his niche in society," a

matter of "status hysteria" and the social imperative to "create himself"—the terminal logic of the self-made man.[62]

But this "choice" between external and internal, sociological and psychological determinants is, we have seen, essentially a basically misleading one—and not merely because the imperative of male self-creation or autogenesis (the imperative of giving birth to oneself) is scarcely separable from an antifemale, antimaternal violence. Kemper's victims may be surrogates or substitutes for his mother-rage. But serial violence sets in motion addictive processes of substitution that take precedence over the discrete qualities of objects and the discrete subjects of violence. It realizes the most extreme and deadly form of the analogical thinking in substitution manias: the substitution of one body and one death for another. The uncertain agency of psychic and social determinants thus appears less an explanation of addictive violence than a symptom or component of that violence It is yet another version of the intensification, to the breaking point, of the mind/body, self/other, private/public series of oppositions that make up the addiction to addiction and addictive violence.[63] (And oppositions such as these are like phosphorous: they burn brightest at the moment they are about to die.)

Sexual difference and self difference become two ways of saying the same thing. The mimetic rivalry of self and other turns toward the endlessly ramifying rivalry of self and others. On this logic, it no longer makes any sense to speak of a choice between private and public, psychic or social, motives.

The "switching" between witnessing and wounding is the local form of a traumatic switching between inside and outside, private and public, psychology and sociality. To the very extent that the notion of the public sphere has become inseparable from the collective gathering around sites of wounding, trauma, and pathology, sociality and the wound have become inseparable.

This brings us a bit closer to understanding the mimetic compulsion at work in addictive violence: to understanding an identification that looks very much like its opposite—a murderous disidentification: "*If it's you, I'm not. If it's me, it's you who isn't.*"[64] One measure of the becoming inseparable of violation and sociality is the *contagious* nature of addiction and of addictive violence: the spreading outward from the wounded individual to a wound culture (the opening toward the "collective-subjective").[65]

This psychosocial contagion has been routinized in the notion of "epidemic" violence. In Kemper's words, "I had thought of annihilating the entire block that I lived on. . . . Not only the block that I live on but the

houses approaching it." The epidemic spreading of violence forms the plague psychology of the survivor: the psychology of killing in order to survive all others, as the last man, and the psychology of killing as self-defense.[66]

The moment of survival, as Elias Canetti discloses in compelling detail, is the moment of power:

> The satisfaction in survival, which is a kind of pleasure, can become a dangerous and insatiable passion. It feeds on its occasions. The larger and more frequent the heaps of dead which a survivor confronts, the stronger and more insistent becomes his need for them. The careers of heroes and soldiers [and serial killers] suggest that a kind of addiction ensues, which in the end becomes incurable. The usual explanation for this is that such men can only breathe in danger; to them an existence without danger is stale and flat; they find no savour in a peaceful life. The attraction to danger should not be underestimated, but what we tend to forget is that such men do not set out on their adventures alone. There are others with them who succumb to the danger and this affords them the continually repeated pleasure of survival, which is what they really need and what they can no longer do without.[67]

A kind of addiction ensues in the passion of survival: self-preservation, in the name of the singularity of the individual, takes the form of the "single individual confronting the crowd of victims." He faces the epidemic of violence that he alone survives and from which he alone emerges, as if invulnerable.[68]

The Sociality of the Wound

If the survivor is the only living witness, this is then because the passion for standing "live witness" to things has become inseparable from the exultation of surviving the increasing crowd of victims: "He wants to kill so that he can survive others; he wants to stay alive so as not to have others surviving him."[69] For Dennis Nilsen, "I was always killing myself, but it was always the bystander who died."[70] In short, the logic of the survivor entails a contagious identification with others: a mimetic opening to others through the opening of others. Killing in order to survive devolves on the mimetic compulsion: its strange attractions and its strange repulsions. The mimetic compulsion provides the model of the serial killer's form of sociality: his identification, or binding, with others. But it

provides at the same time the wounded form of that sociality: an insupportable identification, at the expense of anything like a discrete identity.

In Kemper's case, for example, it is not exactly that killing annihilates the other ("of course, the personality is gone"). The killer would later confess that he himself had "no personality at all"—that he was "a type of nonperson."[71] This is, in miniature, the model of a social bond premised on pathology: an hypnotic identification with others that is, in turn, the mutual evacuation of identity. And this is exactly the style of identification that one discovers in the prototype of the killer as trauma victim: the shell-shocked soldier male.

Consider this description of the traumatized soldier: "There was a marked *absence of the facial mimicry* associated with emotional expression . . . he had *the usual stony masklike facial expression* . . . there was no feeling of contact or interest; *he was completely detached.*" There is, in this complete detachment (the affective undeadness of the serial killer as devoid or zombie) an absolute absence of the mimetic reflex.[72] Here is "the perfect image of defense against the world"—a masklike nonpersonality and a radical asociality. This is the protective shield of the man dead but not gone.[73]

But the death mask represents something more. It represents (extending Borch-Jacobsen's account) not the failure of identification but an identification without reserve. For the death mask represents the face of the dead man with whom the soldier male hypnotically and mimetically identifies: "The mask is thus also the image of the traumatic *failure* of defense, the mimetic identification that defines the trauma: in short, the social. 'When he first woke us from his unconscious state he was, he said, like a rubber ball. When anyone touched him 'he would jump sky-high. . . . He was completely identified with the world in so far as it was a hostile place. . . . He readily identified with anyone meeting an untoward accident.'"[74] The hypnotic identification of the traumatized soldier thus indicates not just the binding of trauma to mimesis but also the psychasthenia of the mimetic compulsion: the decline in the feeling of personality and life.

There is one final turn here. It may be that, at least in part, the "mimetic identification . . . defines the trauma."[75] But it is as if, for the soldier male, identification with others can proceed, or becomes tolerable, only if he identifies with what amounts to the failure, or petrification, of the capacity to identify. In this way, the condition of trauma seems the excruciated crossing of the social and asocial: the boundaries between public and private come down, in the face of the wound. To the extent

that trauma serves as another name for the subject in wound culture, it holds the place of a sociality premised on the wound. Hence one discovers the sociality that gathers, and the public that meets, in the spectacle of the untoward accident and in an identification with the world in so far as it is a hostile place: the pathological public sphere.

I want to close by providing several final images of this wound culture, its advent, and its routinization. If the serial killer emerged as a kind of person at the turn of the last century, so too did a more general wound culture. The abnormal normality of trauma and the atrocity exhibition; the fascination with the probing of the wound and with the subject as "Wound Man";[76] the relays between killing for pleasure and the passion for standing live witness to scenes of violence; the public convening as living witnesses to the spectacle of violated bodies: all are nowhere more powerfully represented than in the writings of Émile Zola or, on the American scene, the writings of the journalist and novelist Stephen Crane.

Crane's work compulsively returns to the popular fascination with spectacles of fallen persons and torn bodies. His most popular story, *The Red Badge of Courage*, is a story about the wound. The red badge of courage is, of course, the wound or tear on the surface of the body. But the torn body is immediately a model for something else. It is instantly translated in two directions, psychic and social: into the sign of interior states (courage) and into the sign of social status (the badge). The wound is where private and public cross—the transit point between the individual and the collective, between the body of the individual and the collective body of men.

The sight of the torn body is the occasion for the mimetic identification that defines the trauma and that takes the form of the "usual stony masklike expression": "he was for moments turned to stone before [the dead man]. The dead man and the living man exchanged a long look."[77] The relation between shock and sociality is here everywhere explicit. It is explicit in what Crane calls "the shock of contact" between bodies and machines and between one body of men and another. The shock of contact is at the same time the occasion for contact: "In the lane was a blood-stained crowd streaming to the rear. . . . The youth joined this crowd and marched along with it. The torn bodies expressed the awful machinery in which the men were entangled." Torn bodies express also the promise of this awful entanglement, the sociality of the wound: "At times he regarded the wounded soldiers in an envious way. He conceived persons with torn bodies to be peculiarly happy. He wished that he, too, had a

wound, a red badge of courage." This points to the pleasure in joining the crowd and marching along with it, the "bloody minglings" made possible by the tearing open of the self bounded by the skin. But it points to something more. The thrilled insecurities about bodily and sexual boundaries and identities are turned toward the soldier male's regimen of killing for pleasure: the "quiver of war desire" and the body of men "wild with one desire."[78]

That Crane's story about war and regimentation is also a story about a more general process of socialization—about the advent of the everyday-ness of a wound culture—is made clear in another and lesser known of his fictions of the 1890s. The name of that very brief story might serve as the signature of that culture: "When Man Falls, a Crowd Gathers." "There were men who nearly created a battle in the madness of their desire to see the thing." The thing that the faceless crowd of individuals desires to see is the "inert" and "rigid" but living body and "livid visage" of a man who has collapsed onto the sidewalk, apparently in a kind of seizure. The impassioned struggle to witness inanimated bodies, or bodies whose animation has been suspended, is a recurrent scenario in Crane's work.[79] The "spell of fascination" exerted by the horror show of the fallen body in the public street may be seen as the momentary but thrilled rupture of the mechanical routines of mass commuting and mass consuming that frame the story. ("Over the heads of the crowd hung an immovable canvas sign, 'Regular dinner twenty cents' . . . there was a horror to be seen. . . . [T]hey fully anticipated a sight of blood . . . and they scrambled and dodged for positions . . . apparently insane to get a view of it.")[80] The sight of blood is a spectacular alternative to these bloodless routines and regularities. But it seems also more than the return of the body to a disembodied mass culture (more than the eruption of the "the Real" as the torn and palpitating body).

"The crowd, suddenly there where there was nothing before, is a mysterious and universal phenomenon," Canetti writes: "Suddenly everywhere is black with people and more come streaming from all sides as though streets had only one direction. . . . It seems as though the movement of some of them transmits itself to the others." The boundaries of the individual—"the repugnance to being touched" in the crowded places of stranger-intimacy ("in a busy street, in restaurants, trains or buses")—gives way to the excited press of bodies, a contagious transmission, the excitations of identification with others ("He feels him as he feels himself. Suddenly it is as if everything were happening in one and the same body").[81]

The fallen man, in Crane's story, is not quite a subject. Even prior to his collapse, he is nothing but a collection of "mumbl[ed] soft syllables" and "quick egotistical gestures." The "endless parade" of faceless strangers that populates the streets prior to the incident are not yet subjects. The gathering crowd is the becoming-subject. "Instantly, from all directions people turned their gaze upon the prone figure. . . . Two streams of people coming from different directions met at this point to form a crowd." The collective witnessing of the fallen body is what transforms the "mob" of strangers into the unity of the crowd form. And the forming of the crowd is the emergence of the subject-form: one that has achieved what Crane calls "psychological authority." The collective subject has achieved an interiority, a boundary, and a voice: it is "the crowd from whose safe interior the defiant voices had emerged."[82] Individual psychology (for Crane, as for Freud) is group psychology first, and not the other way round. The crowd that gathers around the fallen man is the fleeting coalescence of psychology and collectivity: the emergence, by way of the wound, of the collective-subjective, the mass in person.

Public corporeal violence has become a way of keeping open the possibility of the shared social spaces of the public sphere itself.[83] The contemporary routinization of the spectacles of a wound culture—the fascination exerted by figures such as the serial killer, for example—participates in the same fraught logic. The crowd gathered around fallen bodies, the wrecked machine, and the wound has become commonplace in our culture. These are the spectacles of persons, bodies, and technologies that make up a wound culture, and the scenes that make up the pathological public sphere.

These scenes are the lethal spaces crossed by the serial killer who tells his story in one the most extraordinary recent representations of the pathological public sphere: Lew McCreary's novel, *The Minus Man*.[84] For the serial killer, the victims are "statistically measurable" statistical persons and he himself behaves in an "innocent statistical way(9)": "My thirteen were just a drop in the bucket of official sadness" (238). He inhabits the landscapes of stranger-intimacy: "the kinds of places where people don't look at each other much, where many come in alone and eat alone" (156). Face and identity yield to, melt into, space: "the familiar process of disappearing from the face of the earth—beneath the skin of the face of the earth—which I have never had to be taught" (7). Identity everywhere gives way to identification: an "automatic imitation" (53) and an automatistic way of "giving allegiance easily to others" (171). The resistless identification with others is bound to the processes of primary

mediation in the Discourse Network of 2000. Interior states, "the life inside," become identical to "the radio glow in his eyes" (53)—"an invisible beam brightening my interior" (237)—and become identical to the public spectacle of private exposure on confession TV. The boundaries come down between "all these happy strangers," between the wounded and the witnessing crowd: "I turn on the television and watch a line of women in chairs telling of how they kept up secret lives for years before they were discovered, or else confessed. . . . They look so happy to be there . . . the barriers break down between the audience and the guests. . . . and there is only love flowing everywhere . . . How strange it is to have one life come close to and mingle with the other" (172–73, 174). Gathering around trauma and the wound, "outside was in, inside was out" (160); there is a thrilled and contagious merger of "the TV image and the person standing nervously in front of him in the room" (182). In the Discourse Network of 2000, the "TV is the third organism" (195). In these devouring, mass-mediated spaces, "the place is alive" and death is theater for the living. The serial killer experiences himself as the mass in person: "I looked into the flesh of a riot and believed I was looking into myself" (75).

Notes

1. Jürgen Habermas, *The Structural Transformation of the Public Sphere: An Inquiry into a Category of Bourgeois Society*, trans. Thomas Burger (Cambridge: MIT Press, 1989; 1962).
2. Susan Stewart, *Crimes of Writing* (New York: Oxford University Press, 1991), p. 280.
3. Wendy Brown, *States of Injury: Power and Freedom in Late Modernity* (Princeton: Princeton University Press, 1995), pp. 52–76.
4. I set out, in preliminary form, how these breakdowns between inside and outside and between individual and collective orders provide one way of understanding the subject in a state of shock or trauma in chapter 2, above.
5. It has become routine to understand the difference between shock and trauma in terms of an *opposition* of the physical to the psychical, and, by extension, of the order of the social to the order of the subject. Hence it may be argued that "these *shocks* may exist in the world, but they occur in the subject. Certainly they develop as *traumas* only in the subject" (see Hal Foster, "Death in America," *October* 75 [Winter 1996]: 45). The propping of the world/subject distinction on the shock/trauma distinction is propped, in turn, on the notion of a decisive *break* between medical and psychoanalytic conceptions of the wound. And—*pace* Simmel, Freud, and Benjamin—it leads to the notion of a radical *discontinuity* between a modernist culture of

shock and a postmodern culture of trauma. These distinctions and peri-odizations have their place, and I will taking them up in the pages that follow. But there is also a way in which the recognition of the conditions of wound culture have stalled in these oppositions. Such oppositions tend to understate or to repress, for instance, how, on the Freudian account, trauma remains a borderland concept between the physical and the psychical. Along the same lines, such periodizations tend to rewrite the tensions *within* notions of shock and trauma as a tension *between* them. (That shock, for example, refers both to the impact of the event and to its effect, the concept already encrypts the deferrals, or "afterwardness," of cause and effect that, in part, defines the trauma.) Finally, the very notion of a "culture of shock" or a "culture of trauma" points to the fundamental *breakdown between individ-ual and collective orders* that centrally concerns me here: the openings between private and public orders (between "subject" and "world") that a wound culture holds steadily visible.

6. Caleb Carr, *The Alienist* (New York: Random House, 1994).
7. See chapter 5, "Pulp Fiction: The Popular Psychology of the Serial Killer."
8. On Nilsen, see Brian Masters, *Killing for Company: The Story of a Man Addicted to Murder* (New York: Random House, 1993), p. 195.
9. Jean Laplanche, *Life and Death in Psychoanalysis*, trans. Jeffrey Mehlman (Baltimore: Johns Hopkins University Press, 1976), p. 105.
10. Slavoj Žižek, *Looking Awry* (Cambridge: MIT Press, 1991), p. 16; Jacqueline Rose, *Why War?* (Oxford: Blackwell, 1993), p. 53. Along these lines, the psychoanalyst Christopher Bollas, in the course of an account of the "structure of evil" in serial killing, speculates that serial killing "would seem the outcome of a trauma of some kind." But, and not at all atypically, the psychoanalyst can merely "postulate" some kind of trauma, albeit avowedly in the absence of specific evidence, and merely posit that the killer reenacts what he calls the "recurrent killing of the self throughout his child-hood": "the serial killer—a *killed* self—seems to go on 'living' by transform-ing other selves into similarly killed ones." Such an account depends on a logic of transitivism reduced to simple circularity. And that logic depends in turn on a large metaphorics (what amounts to large metaphors of "killing" and "living" and to the punning into equivalence of killing persons and the "*killed* self".) The serial killer, Bollas concludes, is "the perfect executioner for a population that has come to feel increasingly serial and meaningless." (*Cracking Up* [New York: Farrar, Straus, and Giroux, 1995], pp. 180–220.) Killed persons kill persons, and serial and meaningless crimes perfectly fit a serial and meaningless population: thin analogy here stands in for psycho-analytic explanation, as thin tautology stands in for sociological explanation, and, at this level, the two explanations scarcely seem related. But the point again is not to abandon this metaphorics or to bypass these impasses. The point is to turn their perspective: to specify how such a metaphorics

becomes *operational* in cases of serial violence, how such analogies are transformed into causes and tautologies into explanation, both in accounts of these cases and within the self-understanding of the killers themselves.

11. See Ian Hacking, *Rewriting the Soul: Multiple Personality and the Sciences of Memory* (Princeton: Princeton University Press, 1995), p. 60.

12. *Times* (London), 20 May 1994, p. 4.

13. Helen Morrison, *Serial Killers and Mass Murderers* (Lincolnwood, IL: Publications International, 1991), p. 8.

14. This is why, as Laplanche neatly expresses it, "it always takes two traumas to make a trauma" (*New Foundations of Psychoanalysis*, trans. David Macey [London: Basil Blackwell, 1989], p. 88.) More exactly, in the trauma the recurrence itself is primary: the trauma insists as a past that has never been present.

15. Friedrich Nietzsche, *On the Genealogy of Morals*, quoted in Ian Hacking, *Rewriting the Soul*, p. 197; and see also chapter 13 of Hacking's study, "Trauma."

16. Paul Moor, *Jürgen Bartsch: Opfer und Täter* (Rowohlt Verlag, 1991).

17. See, for example, Lauren Berlant, "The Face of America and the State of Emergency," in *Disciplinarity and Dissent in Cultural Studies*, ed. Cary Nelson and Dilip Parameshwar Gaonkar (New York: Routledge, 1996).

18. Laplanche, *Life and Death in Psychoanalysis*, pp. 42, 129.

19. Ibid., p. 122.

20. Slavoj Žižek, *The Metastases of Enjoyment: Six Essays on Women and Causality* (London: Verso, 1994), p. 7.

21. This is precisely the assault on the truth of psychoanalysis mounted by Jeffrey Masson, Frederick Crews, and, more recently, Mikkel Borch-Jacobsen.

22. Hence the notion of "the phenomenon of *pain* as an effraction of the boundary," the understanding that "pain is a *breaking in*." "Everything comes from without in Freudian theory, it might be maintained, but at the same time every effect—in its efficacy—comes from within, from an isolated and encysted interior"—and this encysting of the exterior within is a kind of "*internal-external* instance," a sort of "internal alien entity" (Laplanche, *Life and Death in Psychoanalysis*, pp. 105, 82, 42–43).

23. Sigmund Freud, *General Psychological Theory: Papers on Metapsychology* (New York: Collier, 1963), p. 87.

24. Stewart, *Crimes of Writing*, p. 277. As Laplanche and Pontalis explain it, "It may thus be seen how psycho-analytic investigation throws the concept of traumatic neurosis into question . . . the notion of traumatic neurosis appears as nothing more than an initial, purely descriptive approximation which cannot survive any deeper analysis of the factors in question" (Jean Laplanche and J.-B. Pontalis, "Traumatic Neurosis," *The Language of Psychoanalysis*, trans. Jeffrey Mehlman [Baltimore: Johns Hopkins University Press, 1976], p. 472).

25. Laplanche, *Life and Death in Psychoanalysis*, p. 131.

26. C. Wright Mills, *White Collar* (New York: Oxford University Press, 1951), p. 160. On the emergence of psychology as public culture, see chapter 4, above.

27. The killer, we have seen, compulsively returns to the scene of the crime, the second time, to witness and to experience *as scene* what he enacted, without experiencing, the first time.

28. On the scenic character of fantasy for the Freudian subject, see Laplanche and Pontalis "Traumatic Neurosis"; on the implications, for the Freudian account of the subject, of such a binding of fantasy to scene and, thus, the binding of the subject to representation, see Mikkel Borch-Jacobsen, *The Freudian Subject*, trans. Catherine Porter (Palo Alto, CA: Stanford University Press, 1988).

29. Stephen Greenleaf, *Flesh Wounds* (New York: Scribner's, 1996), p. 108.

30. *Newsweek*, 12 July 1993, 66.

31. The binding of the subject of trauma to the matter of correct representations and correct distance with respect to representation perhaps makes a bit clearer the striking coemergence of trauma studies and the "culture wars." Both devolve on the matter of distance, or failure of distance, between act or perception and representation. It also perhaps makes a bit clearer the appeal of the trauma in recent psychoanalytically inflected cultural studies. No doubt the "traumatic" shifting of interest from the event to its self-representation or theorization makes up at least in part the general gravitation of modernist/postmodernist discourse to the categories of shock/trauma. For if the trauma is marked by the disruption or reversal of causal interpretation (an effect in search of a cause), there is, on this level at least, an exact fit between such a definition of trauma and the "deconstructive" notion of the subject as that which breaks with linear causality and determination and the notion of the subject as that which unremittingly "puts itself in question." On this view, "the subject 'is' this very gap that separates the cause from its effect" (Žižek, *Metastases of Enjoyment*, p. 122). Žižek, it will be recalled, directly opposes the Lacanian account to the deconstructive account: "the substantial hard kernel of the Real" is irreducible to the effects of representation. But the Real remains bound to what he calls "a fundamental ambiguity" as to the status of representation (Žižek, *Tarrying with the Negative: Kant, Hegel, and the Critique of Ideology* [Durham, NC: Duke University Press, 1993], pp. 36–43). It is this pivoting of the Real of the subject on the matter of representation that concerns me here.

32. The phrase "the switchboard of the soul" is spoken by one of the characters in Kathryn Bigelow's recent film about violence and mediated intimacies, *Strange Days*, one of a range of recent films that tests out the double-logic of technology as prosthesis in what I have described (extending Kittler) as the Discourse Network of 2000. Such popular representations of digital culture

and "virtual reality" test out the ways in which the materialities of communi-
cation can by no means be understood simply as external to the order of the
subject, as mechanical (rather than human), as symbolic (rather than bodily).
At the same time, this double-logic of prosthesis seems ultimately insupport-
able: the thrill of self-suspension in the body-machine complex ultimately
gives way to an equation of prosthesis and trauma, virtuality and violence.
Hence in such representations (*Terminator 2* and the *Alien* films, the serial
killer films *Virtuosity* and *Copycat* might be instanced here as well), mechan-
ical reproducibility is countered by a return of the natural body (the more
deeply embodied racialized and female body) and a return of natural (mater-
nal) reproducibility. The final and paradoxical turn in these returns, of
course, is the way in which it is the utter identification with the machinic
medium (the "lifelikeness" of the cinema) that "manages" this rescue plot.
My sense of these matters has been catalyzed by the compelling short film
Volatile Memory (1986), directed by Sandy Tait and Gretchen Bender. The
film (Cindy Sherman is the central actor) makes visible the prosthetic tech-
nologies and noir landscapes of self-construction; but it redirects attention
from the technophilic effects that dominate blockbuster tech-noir films to the
abjection of persons and bodies, centrally the female body, in construction
(that is, the traumatic or "volatile memory" of wound culture).

33. Again, the binding of trauma to the subject of representation pressures not
merely these popular accounts but also the governing psychoanalytic
account as well. On the psychoanalytic account, Borch-Jacobsen has
argued, "the 'content' of the unconscious is defined essentially as represen-
tation" (*The Freudian Subject*, p. 9). The logic of representation and the
logic of "the Freudian subject" are inseparable: the priority or "correct dis-
tance" of the subject with respect to identification and representation posits
the priority of the subject. Trauma in the pathological public sphere regis-
ters not merely the failure of this correct distance, with respect to the sym-
bolic order. The generalization of the category of trauma, such that it
becomes coterminous with the category of the subject *tout court*, registers
on one level the failure, the incoherence or wearing out, of this model of the
subject. But the *wearing out* of this model of the subject has become the
alamodality of the subject: trauma is nothing if not in fashion today.

34. Steve Erickson, *Amnesiascope* (New York: Holt, 1996), pp. 15–16.

35. Ballard, "Introduction" to the French edition, *Crash* (reprinted in New
York: Vintage, 1974), p. 5; emphases added.

36. Niklas Luhmann, "Modes of Communication and Society," *Essays in Self-
Reference* (New York: Columbia University Press, 1990), pp. 99–106.

37. Norbert Wiener, *The Human Use of Human Beings: Cybernetics and Society*
(Garden City, N.Y.: Doubleday, 1954), pp. 98, 136.

38. Mary Ann Doane, "Temporality, Storage, Legibility: Freud, Marey, and the
Cinema," *Critical Inquiry* 22 (Winter 1996): 314.

39. Sigmund Freud, *Beyond the Pleasure Principle* (1920), in *The Standard Edition of the Complete Psychological Works of Sigmund Freud*, vol. 18, trans. and ed. James Strachey (London: Hogarth, 1955), p. 27.

40. Friedrich A. Kittler, *Discourse Networks: 1800/1900*, trans. Michael Metteer with Chris Cullens (Stanford, CA: Stanford University Press, 1990), p. 283.

41. Žižek, *Metastases of Enjoyment*, p. 117.

42. Kittler, *Discourse Networks*, p. 288. It is articulated and sublimated, that is, in the *re*articulation of writing and identity—in "writing proper" as the property, and proper name, of a subject, in Freud's sublimation of white noise into the narrative form of case histories: psychophysics into novels.

43. Ibid., pp. 280–304. See also Kittler, "Gramophone, Film, Typewriter," *October* 41 (Summer 1987); 115: "Methodological distinctions of modern psychoanalysis and technical distinctions of the modern media landscape coalesce very clearly."

44. In this way, too, cultural psychoanalysis gravitates toward paranoia and psychosis to provide its models of the historical and toward totalitarianism/fascism, or its preconditions, to provide its models of the social. The subject appears as the subject of history to the extent that he is psychotic (the subject in a state of shock, shot through by the social, realizing the social symbolic order—the literal technologies—to the letter). The soul-murdered subject is psychotic to the extent that he is utterly socialized and social to the extent that he is psychotic.

45. On systems theory, addiction, and the maladies of agency, see chapter 3, above.

46. On the cultural and social registration, and parrying, of the radicalization of the technologies of writing at the turn of the last century, see my *Bodies and Machines* (New York: Routledge, 1992).

47. The understanding of cybernetics as letter bombing persists against the grain of cyberpunk novels such as William Gibson's *Neuromancer* (New York: Ace, 1984) (in which the romanticisms of soul and the nostalgias of the natural body could not be more explicit), or Neil Stephenson's *Snowcrash* (in which computer hacking and body hacking become two ways of saying the same thing). There is, as Stephenson identifies it in his more recent novel *The Diamond Age: or, A Young Lady's Illustrated Primer* (New York: Bantam, 1995), a "neo-Victorian" turn at work here, in the very return of the cybernetic back to the form of the novel (the conversion of nerve-language into the neuromance). This neo-Victorianism is one version of the regression *by way of* technology—the *techno-primitivism*—that marks the intimacies between splatter-punk and cyber-punk, grunge and nerd, in the pathological public sphere. The recent novels of the English writer Jeff Noon—*Vurt* (New York: Crown, 1993) and its sequel *Pollen* (New York: Crown, 1995)—intensively pressure these regressions, these turns and returns: in their explorations of the collapse of the boundaries of identities,

bodies, and technologies; of the epidemics of addiction and addiction to representation; of contagious public violence as the form of sociality proper to a wound culture.

48. Linda Williams, "Corporealized Observers: Visual Pornographies and the 'Carnal Density of Vision,'" in *Fugitive Images: From Photography to Video*, ed. Patrice Petro (Bloomington, IN: Indiana University Press, 1995), pp. 3–41.

49. See Williams, "Corporealized Observers." For a more general account of the "carnal density of vision," the haptic dimensions of image and observer, see Jonathan Crary, *Techniques of the Observer* (Cambridge, MA.: MIT Press, 1990). As Crary summarizes it in his more recent "Unbinding Vision: Manet and the Attentive Observer in the Late Nineteenth Century": "The second half of the nineteenth century was a critical historical threshold, during which any significant qualitative difference between a *biosphere* and a *mechanosphere* began to evaporate. The relocation of perception into the thickness of the body was a precondition for the instrumentalizing of human vision into merely a component of new machinic arrangements. This disintegration of an indisputable distinction between interior and exterior became a condition for the emergence of spectacular modernizing culture" (*Cinema and the Invention of Modern Life*, ed. Leo Charney and Vanessa R. Schwartz [Berkeley: University of California Press, 1995], p. 47). But this process of "evaporation" of the distinctions between body and vision, body and machine, interior and exterior—however indisputable from the second half of the nineteenth century on—continues to be only haltingly registered at the close of this one. (The very emphasis on the "instrumentalizing of the human" in Crary's account, for instance, displays residues of this resistance: it borders on a pop-Foucauldian invasion scenario of a "spectacular modernizing culture" as the colonizing of natural bodies by the surveillance modalities of modern power.) This is in part because (as Crary traces) the redirection of attention to the "fully embodied observer" also made possible what looks like its opposite: a process of radical disembodiment. The turn to the body—through the new science of psychophysics and through the spreading of the new corporeal disciplines across the social field—made possible the rendering and regularizing of bodies and sensations as measurable and quantifiable, as general and abstract. In this way, the body-machine-image complex continues to register as the vaporization or volatization of bodies (even as the "thickness" of the body is emphasized, there is panic-thrill of the melting of all that is solid into air). And, in this way, the disintegration of distinctions continues to register as the very condition of trauma (the traumatic disintegration of the distinction between inside and outside). It might be suggested that the very "belatedness" or afterwardness of accounts such as Kittler's or Crary's—or my own—provides one measure of the continued resistance to or stalling in the

registration of the Discourse Network of 1900, its renovations and implications: it is as if its memory has only been recovered with the advent of the Discourse Network of 2000, in the belated recognition of the condition of belatedness and literalization that make up, in part, the trauma. There is, crucially, a basic shift from the "private" writing-down systems of the typewriter or gramophone (the Discourse Network of 1900) to the public and mass-media reproduction and witnessing of private interiors and wounds (the Discourse Network of 2000). These are the disintegrations of the distinction between inside and outside and between private and public—the opening of private interiors to mass witnessing—that define the trauma spectacles of the pathological public sphere. There could be no more concise formulation of the "switching" between social and psychic orders than in this direct binding of the trauma to the materialities of communication.

50. Žižek, *Metastases of Enjoyment*, p. 116. On "the return of the body," see my "The Body," in *A Companion to American Thought*, ed. Richard Wightman Fox and James Kloppenberg (Oxford: Blackwell, 1995). Hal Foster provides an indispensable account of what these returns have come to look like, and what they mean, across a wide range of contemporary art and culture scenes, in *The Return of the Real: The Avant-Garde at the End of the Century* (Cambridge: MIT Press, 1996).

51. I have in mind the reoccupation of the tensions between "the social-symbolic" and "the Real"; abstraction and empathy; theatricality and absorption; conceptual art and performance art. Opposed on part of their surface, these different accounts perhaps communicate on another level—as switch points of the mind/body and image/act dualisms I have very briefly set out.

52. The direct binding of wound and representation is, again, perfectly imaged in Richard Misrach's photographic series, *The Playboys*: photographs of bullet-riddled photographs (shot through pieces of paper) that not merely literalize the gun/camera equation but also image the becoming inseparable of traumatic violence and the materiality of representation in a wound-mediated culture.

53. Walter Benjamin, *Reflections*, trans. Edmund Jephcott (New York: Schocken, 1978), p. 153.

54. See Joyce Carol Oates's novel, loosely "based" on the Dahmer case, *Zombie* (New York: Dutton, 1995); and my brief account of the Dahmer case in chapter 7, above.

55. David Sedaris, "Fashion Victim," in the "Humor" section of *Mirabella*, March 1994, 40. The deer-in-the-headlights look of the model on the runway was literalized in the Donna Karan Spring 1994 tent show, in New York: the one thousand viewers were given flashlights to wear on their heads, as the spotlights aimed at the models. The crowd's absorption in celebrity spotting in the crowd led, however, to the scatter-shot spotlighting of points of the crowd itself, as the models stumbled across a darkened runway. (My thanks to Ani for this example, and for pointing me to its implications.)

56. Jacques Lacan, "Aggressivity in Psychoanalysis," *Écrits: A Selection*, trans. Alan Sheridan (New York: Norton, 1977), p. 19.

57. See, for instance, Sigmund Freud, "Instincts and Their Vicissitudes," *General Psychological Theory: Papers on Metapsychology* (New York: Collier, 1978), pp. 83–103; Laplanche, *Life and Death in Psychoanalysis*, pp. 85–102.

58. See Borch-Jacobsen, *The Freudian Subject*, pp. 38, 72.

59. Kemper, quoted in Leyton, *Hunting Humans*, pp. 41–44; and in Morrison, *Serial Killers and Mass Murderers*, p. 8.

60. See Leyton, *Hunting Humans*, pp. 25–66.

61. Ibid, pp. 42–43.

62. Ibid, pp. 44–47. Kemper, after bludgeoning and decapitating his mother, extracted her voice box and obliterated it in the garbage disposal. Bundy, "a very verbal person"—a Mr. Xerox drawn to "personal stationery" as one of life's necessary luxuries—experienced his mother's voice, we have seen, as a mechanical series of cultural clichés—as a semi-animated greeting card, expressing sentiments in devivified and devivifying words. He experienced his mother, Mina Harker-fashion, as an impersonal dictation machine—as a function of writing-down systems of the Discourse Network: "My mother taught me the English language. . . . How many times did she type my papers as I dictated them to her? [She] gave me great verbal skills. . . . My mother and I . . . didn't talk a lot about real personal matters. . . . She's not a socializing-type person" (Stephen G. Michaud and Hugh Aynesworth, *Ted Bundy: Conversations with a Killer* [New York: Signet, 1989], pp. 7–8).

63. On addictive violence and sexual difference, see chapter 3, above.

64. Jacques Lacan, *The Seminars of Jacques Lacan: Book II The Ego in Freud's Theory and in the Technique of Psychoanalysis 1954–55*, ed. Jacques-Alain Miller, trans. Sylvana Tomaselli (New York: Norton, 1988), p. 169. The theorist of psychoanalysis and it vicissitudes, Borch-Jacobsen, has recently specified the paradox of this rivalrous identification: the "unbinding tie" of the individual and the mass. (See also chapter 4, above.) This is, it will be recalled, the "murderous, blind identification" that provides at once the principle of sociality (the sympathetic/mimetic ties that bind) and just the opposite: the radically unbinding (narcissistic) asociality by which the "envied model" of identification is immediately assimilated, "annihilated, eaten, engulfed." The paradox of the "narcissistic bond" means that: "[t]he acme of the 'sympathetic' relationship with others is simultaneously the ultimate nonrelationship with others: each imitates the 'every man for himself' of the others; here assimilation is strictly equivalent to a disassimilating dissimulation. . . . A disbanding band must be qualified as both narcissistic and nonnarcissistic; egoistic and altruist, asocial and social." By the double-logic of the mimetic compulsion, this is the subject of an hypnotic identification who, for that very reason, is traumatically detached from distinct identity and distinct relation. Shot through by the social, this is the subject who

immediately assimilates others even as he is assimilated by his simulations. Not similar to something to something or to someone, but *just* similar, this is the "too normal" subject who is at once "asocial and social" (Borch-Jacobsen, "The Primal Band," in *The Emotional Tie: Psychoanalysis, Mimesis, and Affect* [Stanford: Stanford University Press, 1992], pp. 8–9). This bordering of the social on the pyschiatric—this experience of mediation and mimesis as insupportable, as pathological—is perfected, we have seen, in the serial killer as a type of person, or nonperson.

65. The plague has long since served as the model of a sociality bound to pathology, and not merely because quarantining and regimentation of plague victims provided a take-off version of modern social organization and discipline. (See, for example, Foucault, *Madness and Civilization*.) This is the plague model of a contagious sociality: an unremitting transmission between private bodies and public orders. The invidious notion of a plague born of *public sex*—a plague seen as born of a pathological collapse of the boundaries between public and private orders of things—is only the most recent, and most virulent, version of this model.

66. See Leyton, *Hunting Humans*, pp. 33, 59.

67. Elias Canetti, *Crowds and Power*, trans. Carol Stewart (New York: Noonday, 1984), p. 230.

68. Ibid., pp. 274–75.

69. Ibid., p. 251.

70. Nilsen, quoted in Masters, *Killing for Company*, p. 271.

71. Quoted in Leyton, *Hunting Humans*, p. 64.

72. This is the reflex that forms a sort of unconscious sociality: the sympathetic reflex that makes it possible for the infant, in his first hour, to imitate on his own face the facial expressions he sees—this before he can recognize a face, or have any sense of having one.

73. For this description of the traumatized soldier in the records of the psychoanalyst Abram Kardiner, I am indebted to Ruth Leys, "Death Masks: Kardiner and Ferenczi on Psychic Trauma," *Representations* 59 (Winter 1996): 62–63. See also Leys, "Traumatic Cures: Shell Shock, Janet, and the Question of Memory," *Critical Inquiry* 20 (Summer 1994): 623–62, and "Mead's Voices: Imitation as Foundation, or, The Struggle against Mimesis," *Critical Inquiry* 19 (Winter 1993): 277–307.

74. See Leys, quoting Kardiner, in "Death Masks," p. 63.

75. On this view, the mimetic identification that defines the trauma also defines the state of the subject: the subject-form and the subject of trauma become inseparable. For Borch-Jacobsen, imitation is what brings the subject into being, even as the subject's logic is "to see oneself . . . by suppressing all reference to mimetic identification." As Leys glosses it, proceeding along the lines Borch-Jacobsen sets out: "The traumatic situation is a situation of unconscious imitation of, or emotional identification with, the traumatic

event or person. . . . [T]he psychotic refuses or disavows the traumatic perception, thereby creating a gap or rent in the psyche" ("Death Masks," 59). Yet since this "unconscious mimicry or hypnotic openness to impressions" ("Death Masks," 60) is inseparable from the situation of the subject in general, and since the refusal or disavowal of identity-in-identification is inseparable from the condition of the subject, it becomes possible to see that the category of the subject and the category of the trauma have themselves been drawn into an absolute proximity. In this way, the abnormal normality of trauma comes to provide the model of the subjectivity, and the sociality, proper to a wound culture.

76. In Thomas Harris's novel of serial killing, *Red Dragon* (New York: Dell, 1981), the serial killer Hannibal Lecter reproduces on the bodies of his victims the battle injuries represented in *"Wound Man*—an illustration they used in a lot of the early medical books" (55). The representation of the effects of violence serves as the cause of violence. In pulp fiction, we have seen, the intimacies between violence and representation, between pulp and fiction, are exorbitantly explicit: pulp fiction is premised on a corporeal mimesis intensified to the point of reproduction and a violence inseparable from a complete yielding to representation.

77. Crane, *The Red Badge of Courage* (New York: Norton, 1976; 1895). Crane's story about becoming a man is at once (as I have argued elsewhere) a war story and a love story. This moment of turning to stone, for example, might be read as a version of the "Medusa scenario" about the trauma of sexual difference and castration panic. It might equivalently be read as about the trauma of self-difference and crowd panic. (This is everywhere a story about dismemberment, in both senses; in Crane's terms, about being a man or a member.) Here again there is an endless shifting between traumas (erotic and egoistic): it is as if each trauma allays the other. Yet to the very extent that group psychology continues to haunt the psychoanalysis of the ego, to the very extent that the notion of the mass is inseparable from the gendering of the collectivity as female or unmale, these two determinations of trauma appear at once as equivalents and as alternatives. It is possible, I have been suggesting, to locate what has come to count as the fat word trauma precisely in this switching between sexual and self-difference, by which the roles of the inner world of our minds and external world around us have been reversed. (For a more extended account of Crane's writings, along these lines, see my *Bodies and Machines*, part 3.)

78. Crane, *Red Badge*, pp. 103, 44–45, 46.

79. Crane, "When Man Falls, A Crowd Gathers," in *Stephen Crane: Prose and Poetry* (New York: Library of America, 1984), pp. 602–603. So too is what Crane calls the "magnificent passion" for "abstract statistical" information: the powerful investment of affect in the generic or statistical and the rendering of the most highly individualized and particularized ("What's his name?

Where does he live?") as simultaneously abstract and general. One detects here something like a passion for *cases*. "Falling down" or "fear of falling" has of course become the standard way of "becoming a statistic," from the later nineteenth century on. (The word "case," it may be noted, derives from, and remains linked to, *casus,*or fall.)

80. Crane, "When Man Falls, A Crowd Gathers,"pp. 602–603.

81. Canetti, *Crowds and Power*, p. 16.

82. Crane, "When Man Falls, A Crowd Gathers,"pp. 603–604.

83. This opening of a sociality in the wound is taken up by Jean-Luc Nancy, *The Inoperative Community*, trans. Peter Connor, Lisa Garbus, Michael Holland, and Simona Sawhney (Minneapolis: University of Minnesota Press, 1991); and Maurice Blanchot, *The Unavowable Community*, trans. Pierre Joris (Barrytown, NY: Station Hill Press, 1988). Both draw on Bataille, Caillois, and the "sacred sociology" of the surrealists in setting out a notion of a social bond irreducible to identity and premised on a wounded but therefore opened singularity.

84. Lew McCreary, *The Minus Man* (New York: Penguin, 1991); page numbers in text refer to this edition.

Index